THE FORCE OF CULTURE:
VINCENT MASSEY AND CANADIAN SOVEREIGNTY

The Force of Culture

Vincent Massey and Canadian Sovereignty

KAREN A. FINLAY

UNIVERSITY OF TORONTO PRESS
Toronto Buffalo London

© University of Toronto Press Incorporated 2004
Toronto Buffalo London
Printed in Canada

ISBN 0-8020-3624-4

Printed on acid-free paper

National Library of Canada Cataloguing in Publication

Finlay, Karen
The force of culture : Vincent Massey and Canadian sovereignty /
Karen A. Finlay.

Includes bibliographical references and index.
ISBN 0-8020-3624-4

1. Massey, Vincent, 1887–1967 – Contributions in Canadian culture.
2. Massey, Vincent, 1887–1967 – Contributions in Canadian nationalism.
I. Title.

FC611.M37F55 2004 971.063′092 C2002-904603-3
F1034.3.M37F55 2004

University of Toronto Press acknowledges the financial assistance to its
publishing program of the Canada Council for the Arts and the
Ontario Arts Council.

This book has been published with the help of a grant from the Canadian
Federation for the Humanities and Social Sciences, through the Aid to
Scholarly Publications Programme, using funds provided by the Social
Sciences and Humanities Research Council of Canada.

University of Toronto Press acknowledges the financial support for its
publishing activities of the Government of Canada through the
Book Publishing Industry Development Program (BPIDP).

*In memory of John
and for my parents, sisters, daughter, and son*

Contents

Foreword:
The 1951 Report of Canada's Royal Commission on National Development in the Arts, Letters, and Sciences

Nobody today is sure what the word 'culture' is supposed to include. It can mean anything from music to manure. One of my dictionaries defines it as 'the sum total of the attainments and activities of any specific period or people.' At the other extreme is Quentin Crisp's definition of culture as 'television programs so boring they cannot be described as entertainment.' We have *corporate culture, police culture, gang culture, aromatherapy culture* ... In Calgary recently I read that 'the saving grace for Mr. Klein is that he governs a province where the culture of opposition is weak.'

What's notable about these uses of the word is that they refer to *the way things are being done* in a certain milieu – to the *status quo*. But the root sense of 'culture' had to do with the opposite: with growth, as in *agriculture* or *pisciculture* – with creating, raising, nourishing. And it's in that radical sense that 'culture' is used in what has come to be known as 'The Massey Report' of 1951.

In 1885, a couple of years before Vincent Massey was born, the famous historian of the Renaissance, Jakob Burckhardt, wrote: 'Our moral criticism of past ages can easily be mistaken. It transfers present-day desiderata to the past. It views personalities according to set principles, and makes too little allowance for the urgencies of the moment.'

In today's critical light the royal commission was, first, appointed from among those with the right connections. Its chair, Vincent Massey, was a patrician with a roman nose and a visibly high brow whose family fortune came from a multinational corporation. Three of his four fellow com-

Adapted from an address to the National Policy Conference of the Canadian Conference of the Arts, Toronto, Ontario, 29 November 2001

missioners were academics – including the sole woman and a Catholic
priest. The fourth was a Quebec engineer and businessman – to add,
perhaps, a touch of practicality to the proceedings. No representative
from labour, First Nations, visible minorities, the Jewish community, the
media, nor indeed a single leading figure from the arts, letters, or
sciences. Not a promising set-up, one may say, for a visionary blueprint
for all Canadians.

Yet it's clear now that the report, if not all-wise, was far-sighted in
crucial ways – rather like the famous seventeenth-century innovator
Robert Burton, of whom it's been said that while he was 'far ahead of his
contemporaries on more than one topic, he could not avoid sharing
their ignorance on others.' One of Burton's theses was that lunatics
should be unshackled and treated with sympathy – a hypothesis that took
more than 200 years to catch on while Burton was faulted for his igno-
rance of psychiatry. In hindsight it behoves us to salute foresight where
we find it.

The commissioners of 1951, despite their ignorance of multiculture,
rock concerts, space travel, websites, and so on, grasped three crucial
lines into the future.

The first was that culture *in general* is a key element of governance and
sovereignty. 'The problem of relating cultural to political forces,' said
Northrop Frye later, 'is one of the central social problems of our time.'

The idea wasn't new. As our first minister to Washington (1927-30),
Massey saw how quickly Americans had grasped the power of culture and
woven it into domestic and foreign policy. The American credo, accord-
ing to two eminent U.S. scholars, has long been: '"Make up your own
mind" and "do your own thing" rather than allow yourself to be influ-
enced too much by other people and the external flow of events.' In
1928 the United States appropriated almost all the radio wavelengths in
North America, and Massey was forced to beg to get a few back for
Canada.

Then as wartime high commissioner to London, Massey was well-
informed (I was a junior member of his intelligence staff) on Britain's
adept use of science and the arts in propaganda and on its elaborate
postwar plans conceived on an international scale, for the British Coun-
cil and the Arts Council of Great Britain.

After the war the United Nations established UNESCO – its educa-
tional, scientific, and cultural organization – to meet the worldwide
challenges of illiteracy, exchange of teaching materials, mutual igno-

rance, and the like. 'The demand for human betterment,' said the UN's Xavier Pérez de Cuéllar, 'was pressing.' Everywhere countries were marshalling their cultural resources – except foot-dragging Canada, where there was no national education policy, no television policy, absurd tax regulations for educational and cultural imports, and UNESCO was considered an exercise in frivolity.

The commission therefore found it necessary to raise the government's consciousness of already widely recognized needs. Lobbying by the arts community was only one factor in a broader agitation from many groups. The new women's organizations saw education, the fine arts, and the sciences as important ways forward for women. Out of the west, with its millions of new Canadians, came the adult education movement. Labour had its Workers' Educational Association. In 1949, when I first took the annual revue *Spring Thaw* on tour, the organization booking shows and concerts into Sudbury was the communist-led Mine, Mill and Smelter Workers' Union. Schools had new language and skills challenges, universities had global research problems, publishers faced an international copyright jungle.

These were not 'elitist' agendas imposed from the top down.

The strongest of the 'urgencies of the moment' (in Burckhardt's phrase) was perhaps television. While U.S. stations fed viewers in border cities, their programs were not visible in Ottawa; and very few federal politicians made the connection between having Canadian television and having a country. But it was understood in the United States. By the 1990s, with U.S.-made movies taking in 88 per cent of the international box office, an American film official said: 'We're living in a time of cultural hegemony that can be compared to the Roman domination in the first and second centuries A.D.' The royal commissioners, however, got the point as early as 1949 and winked as the CBC set up a television cadre just as the commission began assessing its feasibility.

The commission's second crucial foresight was that the separate elements that they had been asked to study (and some they hadn't) were interlocking. They knew that education, the arts, and technology are interdependent – film-making, for example, needs writers, historians, designers, directors, actors, musicians, camera operators, and now digital wizards. Such knowledge and creative experience are in turn needed for the growth of self-images, a sense of our capacities at home and abroad. This self-image, and the image that we present to the world, are in turn prime factors in our politics, commerce, and defence.

Some people today see this not as foresight but as a blind alley. They insist that under globalization commerce will rule culture, borders disappear, and nation states wither. But this picture seems already out of kilter with a world in which borders are being solidified. Harvard historian Samuel Huntingdon has observed: 'As advanced communication, trade and travel multiply the interactions among civilizations, people will increasingly accord greater relevance to their identity based on their own civilization ... [They] use politics not just to advance their interests but also to define their identity ... Nation states remain the principal actors in world affairs.'

That is, if they are prepared to act.

The royal commission's third foresight was that cultural activity is not primarily economic – not that it *can't* make money but that its benefits, especially in so spread-out a country, can't properly be measured by commercial profit. Nowadays that view is widely if precariously accepted. McGill's Henry Mintzberg argues in the *Harvard Business Review* that if we are so avid to scrutinize what doesn't belong in government, we should be 'equally diligent' scrutinizing what doesn't belong in business.

In 1949, however, what the federal government did *not* count on when it set up the royal commission was a blueprint for 'culture' in its radical sense of growth, requiring substantial and immediate government financial support. One can gauge its surprise by the six years it took to adopt the recommendation for a Canada Council.

Whatever the royal commissioners were ignorant of, insensitive to, or insufficiently prescient about, the revolutionary leaps that they took were amply justified by the ensuing burst of creative energy. Our private sector may also have been inspired by this success to emulate the American private sector's relatively much greater *pro bono publico* investment in education, scientific research, and the arts both 'classical' and 'popular.' In return, the Canada Council for the Arts gave the United States a valuable model for its later National Endowment for the Arts.

The Massey Report maintained that education and creative activity were fundamental to sovereignty. In the face of new challenges to sovereignty, Canadians should not be deluded into separating them.

Mavor Moore
Victoria, BC
February 2002

Preface

My investigation of Vincent Massey's place in Canadian cultural history began when I was a junior curator in the European Department of the Art Gallery of Ontario during the 1980s. A routine part of my work was selecting paintings for the gallery's members' lounge. I was able to draw on an assortment of paintings that languished in the gallery's vaults. Among them was a sizeable group of British pictures from the first half of the twentieth century. Most had entered the collection in the period immediately following the Second World War and seemed an anomaly in an institution long captivated by the New York School. My curiosity yielded a small exhibition and catalogue that attempted to situate in a wider context the gallery's close relation with Henry Moore, the one modern British artist whose work was a featured part of the collection. Research for the exhibition awakened my appreciation of a British bias in Canadian art collecting after the war, and Massey's part in that vogue.[1]

My exploration of Canadian–British relations during the 1940s and 1950s led to a full-blown preoccupation with Canadian cultural history of the period, the terrain of my doctoral work at the University of Victoria. While my home discipline continued to be art history, I ventured into the apparently more nebulous and certainly more fragmentary area of cultural studies. The interdisciplinary enterprise is fraught with worries beyond standard academic paranoia, especially concerning audience. Will, for example, the art historian find common ground with the historian of religion and education? In the course of my research, I became convinced of the inseparability of Massey's ideas in the fields of education, the arts, citizenship, and Canadian sovereignty. The present study, at one level, is about this interconnectedness.

The research has been largely archival, and I thank, first, Massey College in the University of Toronto for permission to use the Vincent Massey Papers. This collection (now housed at the University of Toronto Archives) and the Massey Family Papers (National Archives of Canada) constitute the primary resources for this investigation, and I would like to record my appreciation for the assistance that I have received at both depositories – at the former, from Garron Wells and Harold Averill, and, at the latter, from Sarah Montgomery and Andrée Lavoie. I have also gratefully received co-operation and assistance from the Art Gallery of Ontario Archives (Karen McKenzie and Larry Pfaff), the National Gallery of Canada Archives (Cyndie Campbell), and the Victoria University Archives and United Church Archives (Ruth Dyck Wilson and Ken Wilson), the British Council Archives (Victorine F.-Martineau), the British Council Visual Arts Department (Andrea Rose and Veronica Burtt), the National Gallery (London) Archives (Jackie McCormish), the Public Records Office, Kew, and the Tate Gallery Archive (Jennifer Booth and Adrian Glew), and the Chautauqua Institution, Chautauqua, New York (Alfreda L. Irwin, historian). Welcome assistance has also come from Janet M. Bessey formerly the manager of Hart House Theatre at the University of Toronto; Myra Emsley in the Hart House Warden's Office; Scott James, archivist at the Arts & Letters Club, Toronto; the registration and curatorial staff at the Royal Ontario Museum, Toronto; Marie Korey, the librarian at Massey College; Barry Simpson, registrar at the Art Gallery of Ontario; Greg Spurgeon, registration staff member at the National Gallery of Canada; Bob Stewart, United Church of Canada Archives, Vancouver; and the Thomas Fisher Rare Book Libary, University of Toronto.

To those who have taken time to be interviewed or have corresponded with me about Vincent Massey, I am extremely grateful, particularly to members of the Massey family – the late Hart Massey, Freeman Tovell, Rosemarie L. Tovell, Rosita Tovell, and Vincent Tovell – and to the late Claude Bissell, Robert Fulford, and David Silcox. I would like to thank Victoria Baster of the Lethbridge University Art Gallery, who shared her deep interest in modern British art and its relevance to Canada in preparation for an exhibition (not realized) at the Art Gallery of Greater Victoria during the early 1990s. The exhibition research was funded by a Museums Assistance Exhibition Grant from the Federal Department of Communications, which I gratefully acknowledge. At the University of Victoria, I have received invaluable counsel and collegiality from Drs Mavor Moore, Joan Backus, Gordana Lazarevich, Patricia Roy, and

Christopher Thomas, all at one time or other members of my doctoral committee.

At the University of Toronto Press, I thank Siobhan McMenemy, former editor, Canadian history, literature, and semiotics, for steering the manuscript through its review process and her successor, Len Husband, as well as Frances Mundy, editor, Managing Editorial Department, and John Parry, copy editor, for his vigorous and knowledgeable interventions.

I would also like to acknowledge with appreciation that this book has been published with the help of a grant from the Humanities and Social Sciences Federation of Canada, using funds provided by the Social Sciences and Humanities Research Council of Canada.

Above all, I wish to honour my late husband, John Lawrence Finlay, QC (1950–2001), my most tender kindred spirit, by expressing a profound gratitude for his vigour, candour, humour, curiosity, deep sense of ethics, generous spirit, and abiding love. To the rest of my family, especially my mother, Margaret Lilian Harper Phibbs, for her tireless faith and loving determination, and my father, Dr Murray Kenneth Phibbs, for his inquiring mind and quiet honour, and to my children, Elspeth Margaret and Evan Christopher, sources of deep love, pride, and joy for John and me, I am overwhelmingly grateful.

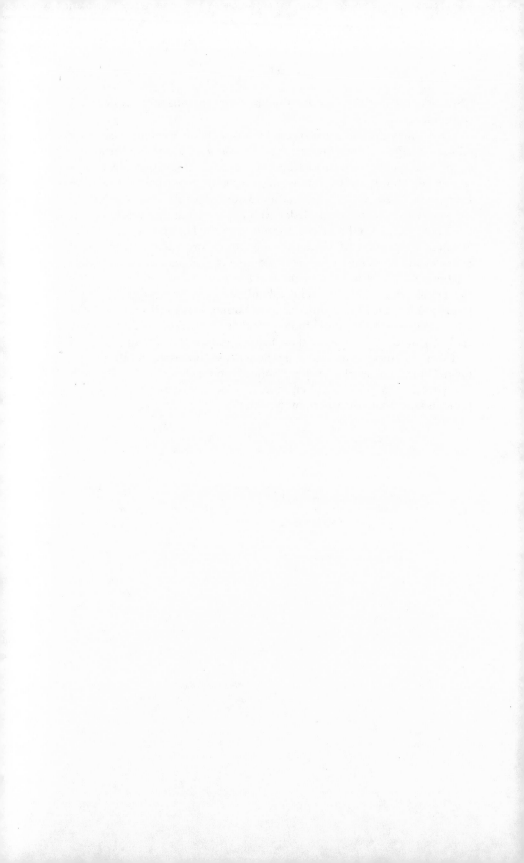

THE FORCE OF CULTURE:
VINCENT MASSEY AND CANADIAN SOVEREIGNTY

Introduction:
Character, Citizenship, and Culture –
Massey's 'Other Canada'

In Canada, a country distinguished for its cultural reticence, Vincent Massey (1887–1967) was that anomaly, a champion of culture. His contributions in the cultural field were numerous, significant, and profoundly influential. They spanned his lengthy career as university lecturer, businessman, diplomat, cultural policy-maker, and governor general. His embrace of culture was, however, neither sweeping nor unhesitating. Massey's attitudes were deeply ambivalent, as well as being riddled with biases of gender and race. His view of culture illuminates much about Canada's cultural understatedness, about its propensity to ignore, even deny, its culture, and about the morass of often-conflicting assumptions that continue to conspire against culture's recognition. In the final analysis, Massey's contribution eludes strict categorization; his views were complex, nuanced, and invariably the product of consummate compromise.

Of one principle, Massey became convinced: Canadian sovereignty was at heart a cultural matter. In culture, he found what he considered to be the major antidote to the forces of colonialism and imperialism that have long plagued the Canadian condition. He believed that economics should court culture, not that culture was a postcript to economics. To conceive of culture, let alone national sovereignty, as in any sense distinguishable and independent from economics, politics, or military security was novel and continues of course to be deeply contested.

To those who might ask whether Massey was a reactionary or a progressive, I would say that he was most definitely a progressive. But his was both a rearguard and a frontal attack on the status quo. On one hand, he resisted progress. He decried advancing consumerism, specialization, and dehumanization. He clung to outmoded ideas about co-education and the role of women. He also long subscribed to racial assumptions

about Canada as a nation of northern peoples. On the other hand, he brought a visionary understanding of the role of culture in a community's well-being and lobbied hard, both rhetorically and practically, for recognition of a wide variety of cultural issues. He sought to reinvigorate Canadian democracy by making its duties and benefits integral to every citizen's experience, and he understood Canadian society as multi-ethnic. In response to the adage that 'privilege is always reactionary,'[1] one might ask how the affluent and privileged Massey came to adopt a progressive stance and what exactly his progressivism entailed. Certainly some of the answers emerge in a study of Massey's ideas on that complex subject, culture.

Best-known as Canada's first native-born governor-general (1952–9) and as an heir to the Massey-Harris (later Massey-Ferguson) farm-implement manufacturing empire, Massey figured prominently in a wide range of educational and artistic endeavours. He chaired a Methodist commission bent on educational reform (1919–21). During the 1910s, he masterminded the building of Hart House at the University of Toronto, an innovative and widely emulated centre for undergraduate students (with only male members until after his death), which made painting, music, and theatre a centrepiece of its activities. From 1923 to 1926, he was president of the National Council of Education, created to promote a desperately needed national dialogue on education. He actively supported the successful bid for national public broadcasting in the 1930s that led to creation of the Canadian Broadcasting Corporation (CBC), and he was first chair of the Dominion Drama Festival (founded 1932).

Massey also tirelessly promoted Canadian art abroad as Canada's first minister in Washington (1927–30) and as high commissioner in Britain (1935–46), viewing culture as integral to foreign affairs. He and his wife, Alice (Parkin), were enthusiastic and often discriminating collectors of contemporary Canadian and British art. Massey sat on the boards of the National Gallery of Canada, the Art Gallery of Toronto (now the Art Gallery of Ontario), and the National Gallery and the Tate Gallery in London. He headed a committee on Britain's national art collections and subsequently chaired Canada's Royal Commission on National Development in the Arts, Letters, and Sciences, which produced a landmark report in 1951.

Despite these and countless other initiatives, Massey adopted an apologetic tone when he spoke about the arts, especially to business audiences. He referred with modesty, or perhaps false modesty, to his and his

wife's 'little' art collection, which, by the mid-1930s, was the largest private assemblage of contemporary Canadian art in the country. While he later valued the fine arts highly, early in his career he viewed them as utterly peripheral to the liberal arts. In 1921, for instance, he recommended excising music programs from the curricula of some of the Methodist colleges that he was commissioned to examine. At this stage, he considered the fine arts to be trivial, ornamental, non-theoretical, and generally without cultural value. Throughout his career he used the word 'culture' with discomfort, referring to it as 'degraded,' even 'loathsome.'[2] He wrote about 'the word "culture" floating like a menacing cloud' over the Massey Commission's proceedings.[3]

Massey's views on culture reflect both ambivalence and transformation, at the same time shedding light on the role of culture in Canadian notions of nationhood. While his belief system drew on a host of unresolved assumptions, he was nevertheless at the forefront of an effort to frame a cultural model of Canada. This he referred to in the 1930s as 'the other Canada.' Presumably 'other,' for him, connoted a lesser-known or less-valued Canada. Early conceptions of the make-up of Canada had tended to be narratives about the march from colony to self-government or were predicated on environmental and economic factors.[4] Massey held, in contrast, that it was Canada's spiritual foundations, traditions, values, and aspirations that rendered it a community and a nation. He argued for the force of culture over what he called the 'force(s) of geography.' Only by taking its culture seriously might Canada overcome its sectionalism and thwart the forces of colonialism, past and future. Of the prominent business and government figures of his generation, he was clearly the most literate in the cultural sphere, promoting the cause of culture through a wide variety of projects and a succession of public addresses and written statements.[5]

Despite the many contradictions that his view of culture drew on and perpetuated, it was deeply resolved in another key respect. It held education as its bedrock – specifically a liberal arts education, as distinct from technical or professional training. The beneficiary of training in the liberal arts, he believed, exhibited independence of mind, was capable of serving excellence rather than self-interest, displayed flexibility and tolerance, and, in turn, contributed to societal harmony and cohesion. Culture, in this sense, *was* the source of community. His notion of culture was, of course, deeply indebted to a liberal humanist tradition that prized individualism, freedom, and tolerance, but was strongly moderated by an equally insistent commitment to community and the public

good. He spoke frequently about inculcating students with a sense of 'the common life,' so that they might assume roles in adulthood that were properly mindful of the collective nature of existence.

Virtually inseparable from Massey's notion of culture were the concepts of citizenship and character. The building of character – the ultimate goal of a liberal arts education – entailed engaging the 'whole' person, both the moral and the intellectual faculties. Massey esteemed the idea of character both for its implied commitment to a greater good, however defined, and, seemingly paradoxically, for its resistance to conformity and standardization. He often aligned 'character' with 'virility' and juxtaposed it with effeminacy. Effeminacy had various negative associations: with the feminine, with anything southern (often American), with European influences (understood as outmoded), and with technology (which became virtually synonymous with a trend towards conformism and anonymity).

National character and citizenship became refrains in Canada in the 1920s.[6] To speak of 'national character' was not only to affirm the upstanding and enterprising nature of Canada's citizenry, but to prize its virility as a nation whose identity was constructed on resistance to the forces of homogenization. The principle of uniqueness and, in turn, diversity acquired a profound import for Massey as a means of countering American cultural imperialism, the rise of consumerism, and a concomitant loss of identity. Although, like many of his contemporaries, he feared immigration as a threat to the so-called fabric of Canadian society and probably took some comfort in Canada's then-rascist immigration policy, he later recognized Canada's regional and ethnic diversity as a source of constant renewal. He came to champion diversity as a primary source of Canada's ability to achieve sovereignty.

Of course, the extent to which this cultural model – that is, a liberal arts education aimed at developing character and good citizenship – actually eclipsed or fostered difference warrants debate. Since at least mid-century, Western liberal democracies have been assailed for their hypocrisy in advocating freedom while in practice repressing dissent. Whether Massey can be cleared of any complicity in this fraud is unlikely. Nevertheless, his espousal of the principle of diversity went well beyond mere rhetoric. He helped to legitimize ethnic and regional diversity as state policy and as a cornerstone belief among Canadians.

Massey viewed education as the chief means of sustaining and developing Canada's value system and, ultimately, its sovereignty. He understood education to be a deeply humanistic project aimed at enablement, not at

indoctrination. He recognized the power of education to mould a nation, but he specifically sought a system that fostered well-informed, so-called independently minded members, not a proletarianized workforce in the service of industrial capitalism or a passive citizenry in the sway of state propaganda. While "well-informed" may merely be code for being well-schooled in a particular point of view, culture became for Massey the cultivation of active, critical citizenship in the Canadian democracy. His view of culture belongs within a broad transformation of belief systems, from one predicated on absolutes to one, still guided by strong moral precepts, that admitted a greater multiplicity of perspectives. While his model of culture was littered with quirks, biases, and limitations, and remained heavily Eurocentric, it helped to validate the multicultural society that Canada has become.

The fine arts, slow to gain acceptance in Canada generally, only belatedly secured a foothold in his scheme. Massey's own early involvement in the arts had the air of a clandestine pastime. Steeped in Methodism, he never adopted a pure doctrine of art for art's sake. He came to understand, however, that the arts, without being moralizing, could serve a moral and cultural purpose: the construction of national community. Under the influence of the Group of Seven – particularly his close friend and colleague the painter and art theorist Lawren Harris – he awakened to the fine arts as agents of culture. Without being programmatic, the arts embodied principles critical to the society that Massey valued. His belief in diversity bears comparison, for example, with Harris's deeply held view that diversity was a prerequisite for creativity, that 'a people only live when they create ... or [they] remain sterile, subservient, sallow.'[7] Both men found conformity an anathema. Reinforced by Group of Seven rhetoric, Massey recognized that meaning came not only from the so-called cultural centre or large urban sites, but from the margins as well. The local in all its multiplicity was a tremendous source of renewal for art and, in turn, for national sovereignty.

Deeply influenced by British models of state-supported art while Canada's high commissioner in London, Massey increasingly allied Canada's cultural well-being with the state, especially the federal government. On his return to Canada in 1946, he campaigned for a significant realignment and augmentation of government within Canadian society, in an effort to bolster resistance to American-style free enterprise economics and an undue deference to technology. He always distinguished firmly, however, between state control and state intervention. His was a compro-

mise between political detachment and engagement. The substitution of excellence and diversity for authority and political exigency as moral imperatives in the construction of the state was the key to his recommendation of state-supported culture and art for Canada (Massey Report, 1951). He saw excellence and diversity as, above all, twin strategies of anti-conformism. The principle that Massey sought to honour, in accord with a humanistic tradition in Canada that valorized morality and collectivity, was community without uniformity. Often accused of elitism, he was, in certain respects, a democratizer and even a populist, who firmly believed that difference need not divide.

Massey's views on education, art, and citizenship are symptomatic of wider ambivalences and transformations in Canadian attitudes towards culture. In a country where culture is both elusive and pervasive – one might say sublimated – many regard it with suspicion, uneasy that it might still be shrouded in a lingering elitism. Some people never tire of calling it a 'frill.' None the less, it is arguable that Canadians have developed a sense of culture as somehow integrally related to the country's nationhood. Outcries over the countless rounds of cutbacks to the nation's public broadcaster, the CBC, during the 1980s and 1990s commonly expressed concern for its diminished role in 'holding the country together,' at a time when people identified few other forums for national dialogue.

Attempting to discern the 'contours of Canadian culture,'[8] while fascinating, is fraught with difficulties. Despite voluminous writing,[9] which testifies to culture's deep and sustained hold on Canadian thought, and a wealth of archival material, the historiography of culture is extremely fragmented and rudimentary. This is more surprising, given the vastness of the topic. From broadcasting and telecommunications to cultural policy and support systems for culture, from issues of national and regional identity to multiculturalism and the cultural implications of globalization, from the fine arts to popular culture, the field is nothing if not daunting. In Ioan Davies's words, 'everything in Canada can be defined as cultural.'[10] As David Chaney has argued, culture has become 'the dominant topic and most productive intellectual resource in ... our understanding of life in the modern world.'[11] Yet there remains in Canada a great distance, even divide, between culture's significance and its recognition.

Douglas Owram has suggested that historians ignored Canadian culture until well after the Second World War, 'perhaps taking to heart the

lament made by many ... that there was none.'[12] Only in the past decade
or so have Canadian history textbooks (surely one of the most telling
measures of a subject's validation) routinely included a chapter or even a
section on culture. The most sweeping statement of the place of culture
in Canada has perhaps come from Carl Berger. In his study of historical
writing in Canada, he has tracked schematically the rising concern with
culture in the period immediately after 1945, when historians began to
admit the significance of beliefs, values, and ideas in the country's make-
up. As evidence, he cited the publication of J.B. Brebner's *Scholarship for
Canada* (1946), the Massey Commission, and the writings of Harold
Innis on communications systems and culture.[13] But despite Berger's
recognition of what has elsewhere been called magisterially the interna-
tional 'cultural turn' over the past fifty years,[14] he confined his consid-
eration of Canadian culture to religion, higher education, and science,
reflecting, as he noted, the limited view of Canada's cultural history
taken by historians generally. He did not include as cultural the rich
discourse on national identity, which in Canada tends to be culture's
rallying cry (or whimper). This omission in itself underlines the need to
assess more clearly and fully culture's cogency as a concept in Canada,
both historically and today.

In the early 1990s, Will Straw surveyed the progress of cultural stud-
ies, including cultural history, in Canada and pointed to its continuing
fragmentation. He divided Canadian culturalists into two camps – those
influenced by British cultural studies since the 1970s, and those English-
speaking academcs, who had generated a diverse assortment of writings
on Canadian culture that either ante-dated the British infusion or re-
mained untouched by it.[15] Dating from the late 1950s and early 1960s
and driven by the New Left, British cultural studies initially addressed
two areas that radically altered the boundaries of cultural analysis –
working-class and youth culture. Both preoccupations were vitalized by
Britain's shifting social matrix after the war – that is, the breaking down
of its class system and the massive influx of American popular culture.
Canadians, of course, have struggled with the latter phenomenon, one
of the foci of post-colonial debate, since at least the late nineteenth
century.

Whether one concurs with Straw's placement of the theoretical fault-
line or even accepts the relevance of the British school in Canada, it is
easy to agree that there is little consensus about the parameters and
nature of cultural studies in Canada (this is true of cultural studies in
general). Employing a tripartite approach to research – documentation,

contextualization, and theorization – Canadian cultural history remains poorly served by all three. Even Canada's strong documentary (one might say self-effacing) tradition – in, for example, literature, film, and broadcasting – has not attended to its cultural history-writing well, and rich archival repositories await exploration.

In addition to the traditional neglect of culture there is the more recent trend to transnationalism. Efforts to theorize (more often to politicize) the study of culture have given expression to a body of thought and experience that is sometimes quite unrelated to the Canadian experiment, that trashes nationalism in principle, and that hence disavows the practice of Canadian cultural historiography. This denial may of course be symptomatic of Canada's renewing colonialization. None the less, there have been some recent attempts to recover/uncover some semblance of a national perspective on culture in Canada. Whether these efforts will build towards any kind of consensus (theoretical or historiographical) or even sustained debate remains to be seen.[16]

While Massey's initiatives in the cultural field were far-ranging and his influence defining, his efforts have also invited a surprising lack of acknowledgment and examination. One historian has dismissed him as lazy, dull, and preoccupied with trivialities.[17] He has been maligned, as much by innuendo as by outright criticism, as an elitist and an unmitigated anglophile; both accusations, while not without validity, do Massey a major disservice.

His own autobiography, *What's Past Is Prologue*, curiously downplayed the cultural side of his career, dwelling upon his political, diplomatic, and business activities. His role as a trustee of the National Gallery of Canada for over twenty-five years, for instance, earned only a couple of paragraphs. Massey's biographer, Claude Bissell, partially redressed this imbalance in a fruitful and moderate two-volume account based on his then-exclusive access to Massey's voluminous papers at the University of Toronto.[18]

Various authors have tackled the complex intellectual and cultural milieu surrounding the Massey Commission (1949–51). Most notable is Paul Litt's treatment, which, despite its thorough examination of sources and much suggestive analysis, seems fundamentally unresolved, combining relentless charges of elitism with apparently reluctant admission of commendable intentions on the part of the commissioners and the intellectual elite that they purportedly represented.[19] Otherwise, only snatches of Massey's activity in the cultural field have been assessed, in sources ranging from Catherine Siddall's exhibition catalogue on Hart

House and the Group of Seven to David Silcox's recent book on David Milne, which examines the artist's troubling relationship with Alice and Vincent Massey as patrons.[20]

Generally Massey's fortune as a subject of cultural study by historians and others rather echoes the fate of a book that he conceived of but never realized, which languishes as a schematic outline among his diaries at the University of Toronto Archives. In it he mapped out the arts in Canada as he had come to know them. Indicative of their unrecognized, perhaps even covert place, he referred to them as 'the other Canada,' which tellingly describes the ambiguous, often hidden face of culture that survives in Canada today. It remains to be seen, in the wake of the terrorist attacks of 11 September 2001, the ensuing war on terrorism, and the pressures on Canada to form closer military and political ties with the United States, whether the place of culture in Canadian sovereignty acquires any sharper focus.

PART ONE
Culture and Education

1

A Methodist Educator, 1908–1921

Culture is surely one of the most complex concepts in current discourse.[1] The bearer of multiple meanings, sometimes in conflict, it seems to defy easy or precise definition. To explore Vincent Massey's notion of culture is to enter a rich storehouse of accreted belief, value, and association in the history of English-speaking Canada and of Canadian Methodism. Far removed from the view of culture found in the North American Free Trade Agreement (NAFTA) of 1992, where it was little more than a basket of commodities with which to bargain, for Massey, culture was nothing short of the intellectual, moral, aesthetic, and spiritual foundations of the country.

Massey was direct heir to a debate about culture that gained momentum in late nineteenth-century Canada. It crystallized into a campaign led by Protestant theologians and educators – with Massey perhaps the most influential – to catapult the notion of culture into a front-ranking position. Its proponents assumed that culture bore heavy moral import, virtually equated it with education – that is, a liberal arts education – and deemed it to rival religion as an antidote to materialism. This conception of culture – and the intertwining notions of education, citizenship, and nationalism – profoundly informed Canadian Methodist thought and shaped the Massey family's intellectual and moral milieu. I look briefly at this model of culture, before turning to Vincent Massey's early activities in education.

Culture: From Herder to Arnold

The notion of culture has long been problematic. Like democracy, it is largely a modern concept.[2] Before the sixteenth century, it was a term

whose reference was confined invariably to plants and animals, hence horticulture and agriculture. Only gradually did it become meaningful to speak of human culture – for example, the tending or culture of the mind. In the wake of the Enlightenment, and the growing conviction that humankind could better itself independent of divine intervention, the idea of culture or cultivation became firmly predicated on a belief in the human capacity for self-improvement and progress.

The foundation of the modern notion of culture is located in the late eighteenth and early nineteenth centuries in German Historicism. Reacting against the primacy given the physical sciences by Cartesianism, Herder and others validated the study of history and language and, in turn, the whole realm of the humanities or human sciences.[3] Culture came to designate the very process of human cultivation and actualization. It married human capability with the goal of infinite perfection, previously the domain of the mystic at his or her god's behest, and was subsumed by the moral imperative of modernism for self-improvement. Culture began to signify the collective fruits and achievements of this process of cultivation. The outcome was the abstract noun 'culture,' meaning a body of accrued wisdom and shared practice uniting a society over time. In response to the anxiety that the industrial revolution generated about the ills of an unrestrained quest for material improvement, culture came to be seen as the primary antidote to materialism. There would be various debates in the century that followed about the sources of culture – whether poetry, criticism, history, or the fine arts – and about its arbiters – whether theologians, intellectuals, critics, or artists. But there was a growing consensus that culture, as much as or more than religion, was materialism's polar opposite.

It was Herder who reflected on the collective nature of culture in another sense. He used the word 'culture' in the plural, referring to the growth of particular societies and eras as distinct from one another, with none as absolute.[4] Here lay an important root of the connection between culture and nationalism and the notion that specific circumstances of time and place gave rise to unique national characters. Here too lay one source of the formidable alliance between citizenship and culture, wherein culture actually signified the cultivation of membership in a particular national group. Thus while culture came to describe a group's communal beliefs and practices, it also signified the cultivation of what was unique to that group. Moreover, culture, which increasingly framed the non-material realm, empowered and ennobled nationalism as a spiritual quest.

Culture became a highly topical subject in the English-speaking world as a result of the writing and lectures of English poet, critic, and educator Matthew Arnold. His book *Culture and Anarchy*, published in 1869, made culture a virtual battlecry. He asserted that culture was 'the great help out of our present difficulties' – namely the increasingly 'mechanical and external' nature of the modern world.[5] Acutely concerned about the great wealth flowing to British coal barons, the poverty of the urban working classes, and other excesses of industrialization, he viewed society as being on the brink of anarchy. He was one of those who attempted to position culture as the counterweight to extreme liberalism, unbridled individualism, consumerism, and over-dependence on science and technology.

Inspired by Arnold, Protestant theologians, educators, university students (including Vincent Massey) and the popular press in Canada hotly debated the relative merits and significance of culture and religion.[6] Some greeted the demotion of religion with stiff resistance; others welcomed a co-mingling of religion and culture in the task of countering materialism. The fact remained that culture was gradually supplanting its rival.

Methodism: From Conversion to Culture

One site of the advancing role of culture was the Methodist Church of Canada. Methodism, founded principally by John Wesley in the early eighteenth century, began as an effort to revive the Church of England and make it more ethical and more spiritual. A reaction against doctrinal esoterism and empty ceremonial, Methodism sought to imbue Anglicanism with new rigour and vigour. Wesley emphasized self-discipline and the methodical, first-hand study of scripture, seeking in turn to foster a more lived sense of salvation.

Methodism came to Canada in the later eighteenth century, securing a foothold first on the east coast during pre-Loyalist days and later in Upper Canada with the arrival of the United Empire Loyalists.[7] Methodism's system of circuit riders/preachers had a particular relevance for rural and frontier society. So did its practice of holding revivals, which typically took the form of camp meetings – large, open-air gatherings aimed at inducing conversions. In a sparsely populated land where churches were scarce, these revivals, invariably lasting several days, fostered a sense of community. By 1884, when the branches of

Canadian Methodism amalgamated, they formed the largest Protestant denomination in the country.[8]

While Protestantism in Canada displayed a certain cohesiveness,[9] Methodism exhibited distinctive features. Premised on a high degree of free will, it taught that everyone, not just the so-called elect, could be saved.[10] It placed particular store in the moral foundation of Christianity, which offered the promise of regeneration to all. The sect was suffused with the optimism both of inclusiveness and of a belief in the perfectibility of existence on earth through self-improvement and service to community. In this sense, Methodism was very much a faith born of Modernism and the idea of progress. Yet, conditioned by the revival between 1780 and 1860 known as evangelicalism, it was also anti-modernist. Markedly in Canada – more so than in the United States, in Gauvreau's account – Methodism expressed a constraint on the Enlightenment's unbridled faith in the intellect and affirmed other sources of knowledge, such as emotion and revelation.[11] Conversion, in the sense of sudden revelation, was long the focus of Methodist religious practice. Increasingly, however, the concern with conversion gave way to a preoccupation with culture.

While the Methodist embrace of culture was neither swift nor unwavering, as early as the 1840s the Methodist church acknowledged culture's place in securing converts, as its primary Canadian literary organ, the *Christian Guardian*, indicated: 'Twenty, thirty, perhaps forty or fifty [people] have been brought out of darkness during the meeting [that is, been converted]; but owing to the omission of an immediate and constant culture of the plants of piety, before the year rolled round, few have remained to need culture.'[12] 'Culture' here simply meant 'cultivation'; even so, human agency now ranked highly.

Reliance on culture, however, engendered palpable disquiet. As late as 1907 in a letter to Nathanael Burwash, president of Victoria College, the Methodist college of the University of Toronto, S.T. Bartlett wrote worriedly about a trend away from converting Sunday school children. '"Culture" is taking the place of conversion,' he stated with some alarm.[13] Indeed culture – cultivation or education – was increasingly paired with conversion as a complement to the process of achieving salvation. By the early twentieth century, culture had become the predominant route to grace. Meanwhile, Methodism was instrumental in the policy-making and institutionalization of education in Canada.

There are seemingly conflicting accounts of the place of education in the Methodist faith in Canada. Gauvreau claimed that 'the early Methodists set little store by a college-educated ministry ... , intellectual refine-

ment and the liberal arts,' adding that until the 1870s the Methodist ministry in Canada was itinerant. Yet his study has emphasized 'the early and highly visible role' of the Methodist and Presbyterian churches in the promotion of institutions of higher learning.[14] In 1882, *Canadian Methodist Magazine* countered the charge that Methodism had neglected literature and culture by noting its record as a prolific publisher of books and periodicals and its enterprising creation of schools, which now included two universities, three theological colleges, and three other educational institutions in Canada.[15]

According to Neil Semple, education was central to the Methodist evangelical mission.[16] The words of a Methodist church report in 1897 were unequivocal on this point: 'the genius of Christianity is educational.'[17] From Methodism's inception, John Wesley had sought an educated clergy and laity. Wesley and his brother, a celebrated hymnist, encouraged adherents to sing: 'Unite the pair so long disjoined – / Knowledge and vital piety; / Learning and holiness, combined / With truth and love, let all men see!'[18] The emphasis on personal study and knowledge of scripture, rather than reliance on priestly authority, was a leitmotif running throughout Canadian Methodism and its heir, the United Church of Canada.

Methodists led the way in contesting the Church of England's position as Upper Canada's state religion and sole beneficiary of the funds allocated for higher learning. The debate ended in 1849 when a Reform government removed university control from church hands.[19] With pride, the Methodists claimed that they had 'never asked anything for themselves or their own community except upon the principles of equal justice and rights to all religious denominations and classes, and ... made the first and most persevering exertions by voluntary efforts to promote academical education in the country.'[20] Methodism was also instrumental in securing universal, compulsory education in Canada. Methodist minister Egerton Ryerson is considered the primary founder of Ontario's system of public education, its cornerstone legislation the School Act of 1871. He was unequivocal: 'To leave children uneducated' is 'to train up thieves and incendiaries and murderers.'[21]

Despite their unswerving support for public education, the Methodists saw a place for denominational schools, as long as state funds, if available, were equally accessible to all. As early as 1836, in Cobourg, Ontario, the Methodists founded Upper Canada Academy. Five years later, it became Victoria College, the flagship of Methodist education, now Victoria University, part of the University of Toronto.[22] In arguing for its creation, Ryerson declared that it would not compete with any

provincial college or university but would 'be a tributary to it ... by imparting to youth and children the elements of a classical education.' Adding that 'scholars of every religious creed will meet with equal attention and encouragement' there and that its terms will be as 'moderate and easy' as possible, he stated that it was intended above all 'to be a place of learning where the stream of educational instruction shall not be mingled with the polluted waters of corrupt example.'[23] In what would be a recurrent refrain, the *Christian Guardian* reiterated: 'Education without moral principle is a curse rather than a blessing.'[24] The fact that Victoria College did not admit females between 1842 and the 1880s appears not to have confused those who claimed wide accessiblity to Methodist schools.[25]

Nathanael Burwash, who entered Victoria as a student in 1852[26] and later became its president, added that the college was created so that Methodists might provide 'for their children and for their rising ministry an adequate higher education free from all objectionable influences of Americanism on the one hand, and Churchism [i.e., Anglicanism] on the other.'[27] A pro-British and anti-American bias, indeed, ran throughout Canadian Methodist thought. The editor of the *Methodist Magazine and Review*, Dr W.H. Withrow, encouraged Canadian business leaders to follow the moral model of British industrialists rather than what was viewed as the more materialistic American example.[28] S.D. Chown, who was to become secretary of the Methodist church's Committee on Sociological Questions in 1902, stated: 'We may regard the United States as typical of that kind of civilization [i.e., a materialistic one] to-day ... What a change has come over the Republic! At the beginning of the last century there were four million people who loved freedom; now it is said there are 75 million people who love money ... It is evident that material wealth does not exalt a nation.'[29]

Canadian Methodism's commitment to education deepened, and its initiatives in education grew infinitely more complex, as the nineteenth century drew to a close. In 1883, the year before Methodist union, the founding General Conference of the branches of Methodism created a Committee on Education to work out the relationships among their colleges. This committee set up the Educational Society to raise money to help maintain the Methodist schools. The society's second annual report opened with an urgent appeal: 'Never in the history of Canadian Methodism was our educational work more important than at the present time. The consolidation of our churches in all parts of the land has given us greater relative prominence and influence in the community, and calls more loudly than ever for trained men in all departments of church

work.'[30] The nationalizing and educational agendas of Canadian Methodism were in fact to become increasingly inseparable.

By the mid-1890s, the Educational Society received its first major bequests, including that of Vincent Massey's grandfather Hart Massey. By the time of the General Conference in 1910, the church colleges were reported to be flourishing. The society's income was on the increase, and it took on many significant ventures. It committed itself, for example, to raising $400,000 for the founding of a Methodist college in Regina. In 1918, the tenth General Conference recommended establishment of a department of education under the church's Board of Education, which would unify all streams of its education programming including the Sunday schools and the Young People's Societies. By this time, Canadian Methodists had built an impressive network of secondary schools and colleges across Canada, including, in addition to Victoria College: Albert College, Belleville; Alberta Colleges, North and South, Edmonton; Alma College, St Thomas; Columbian College, New Westminister; Mount Allison University, Ladies' College, and Boys' Academy, Sackville; Mount Royal College, Calgary; Ontario Ladies' College, Whitby; Regina College, Regina; Ryerson College, Vancouver; Stanstead Wesleyan College, Stanstead; and Wesley College, Winnipeg. Methodist College, St John's, was also considered part of the school system.

The creation of denominational institutions, despite Methodism's firm commitment to state-run education, was fuelled by the belief that the public system did not adequately protect Christian moral precepts (despite the efforts of Ryerson and others to the contrary). By the late 1890s, a report of the Educational Society expressed concern that the Bible no longer figured as a text in the public schools.[31] While the Methodist school system was a complex and, in many respects, inconsistent enterprise, two themes figured prominently in its educational policy – character and citizenship. The discourse of character education, with its own fascinating genesis,[32] had extraordinary potency and longevity in Methodist circles.

'Education,' stated Reverend Samuel Nelles in 1857, 'is the broad & symmetrical culture of the whole mind, and this embraces the conscience, the affections, the imagination, & the will, as well as the mere intellect.'[33] Gauvreau describes Nelles, who became president of Victoria College in 1854, as 'a principal architect of the Methodist balance of faith and learning.' Nelles proposed the term 'character,' which signified both moral and intellectual development, to describe the desired end result of a college education.[34]

The theme of developing the 'whole' person was reiterated on count-less occasions.[35] One author wrote that 'all one-side culture' was to be avoided.[36] The annual report of the Educational Society in 1897 stated that 'Christianity ... asks that men worship God and serve Him with the intelligent assent of their intellect and the glad consent of their will, that the whole manhood, in the wide range of its faculties, be consecrated to Him who loved us and gave himself for us. An *intelligent piety* is the true ideal.'[37] Neither moral nor intellectual faculties were to be neglected.

Like other Christian denominations in Canada did to varying degrees, Methodism extolled the virtues of the liberal arts. They provided a theoretical framework for cultivating the whole person and became virtually synonymous with character education, as becomes evident be-low. Victoria College maintained the theological and liberal arts pro-grams on a par.[38] In contrast, Knox College (Presbyterian) and Wycliffe College (Anglican), two of the other colleges that eventually federated with the University of Toronto, gave up their arts program to the state to focus on theology. Among the fruits of Victoria's liberal arts orientation was a long list of literary luminaries, including Charles N. Cochrane, Lorne Pierce, E.J. Pratt, Northrop Frye, Margaret Avison, and Margaret Atwood.[39]

An emphasis on character development was integral to Methodism's preoccupation with community. Methodism had long valued commu-nity – or what, on a Christian and more personal level, might be called 'fellowship.' Achieving community was nothing less than a sacred quest. As Vincent Massey often commented, it was the 'common life' that elevated existence above the material and even the sordid. Arguably, all religious adherents seek the warm embrace of union, whether as subli-mation of the self into a larger oneness or, one might observe more cynically, as the extension of personal sovereignty. In the case of Methodism, at the turn of the twentieth century, the commitment to a common life was widely and quite specifically understood as a campaign to construct a broad-based, classless earthly citizenry. Of course, the actual inclusiveness, by ethnicity, religion, or gender, of this vision of community remains to be fully assessed (but appears to have been reasonably broad by the standards of the time). Regardless, there is little doubt that educational and social equity and in turn the widespread dissemination of knowledge (admittedly, a heavily loaded term) became increasingly central.

Perhaps as a result of its rural roots, Canadian Methodism had a particularly acute sense of the fragmentary nature of community in Canada and hence of the accommodation required to find a common

life therein.[40] Here too Methodism's egalitarian and totalizing approach to education was pivotal. Methodist schools and colleges were less cloistered sanctuaries for like-minded adherents than strongholds from which to promulgate a vision of a morally based education. Methodists were strongly committed to what might now be called 'outreach.' They founded a host of supporting organizations to embrace individuals at various stages in their lives and in various venues, from the Epworth League to the Young Men's Christian Association. Invariably, education was a key element in their initiatives. The Fred Victor Mission in Toronto, created largely from funds made available by Hart Massey, not only nourished those who were poor physically and ministered to them spiritually but taught them to read and write. Methodist outreach through education was so successful because, while it was Christian, it was relatively nonsectarian. At Upper Canada Academy, for instance, instructors and students were not required to be practising Methodists, although it was expected that they be faithful Christians.

The ultimate goal of a Methodist education was the creation of good citizens. For many, citizenship long referred quite simply to membership in the kingdom of heaven. A good citizen was, presumably, one who could be trusted to be both faithful and well-behaved. But, according to Nathanael Burwash, as early as the 1820s 'Methodists ... had already very decided convictions as to their rights and duties as [earthly] citizens.' He praised, for example, their readiness to sever connections with American Methodism 'in order to vindicate their loyal British citizenship.'[41]

By the late nineteenth century, connections between education and citizenship were explicit and recurrent, and a loyalty specifically to Canada, as distinct from Britain, was increasingly discernible. In appealing for funds for the Methodist schools, John Potts argued that a church-guided education was critical to the development of Canada's state leaders and citizens, who 'will mould the future of our youthful nation.' He continued: 'The thorough harmony in a Christian spirit and effort of home and school, of conference and college, of preacher's pulpit and professor's chair, will ensure a bright succession of intelligent, faithful and godly ministers and laymen to carry on the highest work of Church and State.'[42]

In its commitment to developing character and preparing citizens, Methodism became explicit about civic responsibilities. The 1902 General Conference stated: 'We urge our people to do all they can, as citizens, to free their own political parties from any suspicion of guilt in regard to violations of the sanctity of the ballot. We recommend that *at*

least once a year the duties of Christian citizenship be made the subject of lessons in Sabbath Schools. We recommend that in the Epworth League more attention be given to the good citizenship work. We recommend that letters be sent to the educational authorities in all the Provinces of the Dominion, asking that in the Public Schools on Empire Day some part of the programme be devoted to the sacredness of the ballot and the duties connected therewith.'[43]

In 1905, the church also criticized the funding of separate schools on the grounds that they were not mandated like the state to teach Canadian citizenship to immigrants and that their sectarianism undermined national unity.[44] Throughout the early twentieth century, there was enormous unease about the large numbers of immigrants arriving to settle, especially in the west. Methodist leaders often took their message outside church and school. At Canadian Clubs and Empire Clubs, they addressed subjects such as 'the Duties of Citizenship' and 'Nation-building in Canada.'[45]

Historians agree that the Methodist church was a major voice of Canadian nationalism between 1884 and 1925. Writes Goldwin French: 'Of all the Canadian denominations, they were the most nationalist, the most anxious to settle Canadian problems in Canadian terms and the most willing to envisage the parallel expansions of Canada and the Methodist Church.'[46] In 1902, Rev. James Woodsworth asked: 'What shall be the characteristics of the nation – intellectual, moral, spiritual – whose foundations are now being laid? The Methodist Church cannot escape its share of responsibility in determining the answer to this question. Should we not rejoice in so glorious an opportunity?'[47]

Motivations to seize this 'glorious opportunity' included the thrill of western expansion, commitment to an equitable society, and rivalries with other religious/value systems. While Methodism was by no means exempt from the paternalism of the white settler communities towards First Nations, certain qualities ideally suited it to the task of forging national community. Characterized by Goldwin French as 'mediating,' 'flexible,' 'pragmatic,' and 'tolerant,' Methodism was adaptable to 'a rapidly changing intellectual and social scene' and 'found it easy to visualize one common form of Christianity for Canada.'[48]

The Methodists led the movement for church unification that culminated in the creation of the United Church of Canada in 1925. The Presbyterians and Congregationalists, while joining forces with them, were more divided about union. Some of their congregations retained their former denominational name and identity, while Methodism dis-

solved itself virtually entirely into the new organism. Salem Bland, among Methodism's most progressive leaders, referred to the new United Church as one of the 'two most original and distinctively Canadian things Canada has so far produced' – the other being the Group of Seven.[49]

Methodist nationalism advanced hand in glove with the increasing radicalization of the denomination's social mission. Described by Michael Bliss 'as the most radical religious denomination in North America' by 1918,[50] Methodism positioned itself at the forefront of the social gospel movement. Running its course between the 1890s and the 1930s, the movement sought to extend Christian ethics beyond the church in a concerted effort to redress the large-scale social ills of industrialization. This effort expressed itself, for example, in the setting up of urban missions for the poor and, as early as 1902, endorsement of the right of workers to organize.[51] What is perhaps less recognized for its part in disseminating Methodist values is what might be called the 'education gospel,'[52] the mantle of which the Massey family and no less Vincent Massey adopted as their own.

Methodism and the Masseys

Until the late nineteenth century, Canadian Methodism, historically a faith of the rural working class, had few wealthy members. This changed in the 1890s, leading to considerable anxiety about Methodism's betraying its roots and becoming a voice for business.[53] The Massey family had made a donation to a Methodist church as early as the 1840s, but in the 1890s its giving escalated dramatically. In memory of his youngest son, Fred Victor, who died in his early twenties, Hart Massey built the Fred Victor Methodist Mission, which opened in downtown Toronto in 1894.

The Massey family, however, made its defining mark as benefactor in Methodist education. Hart Massey, who attended Upper Canada Academy in the 1840s,[54] became one of its staunchest supporters. Vincent Massey recounted with pride how his grandfather, despite having lobbied vigorously against Victoria College's move from Cobourg to Toronto, promptly gave $40,000 to endow a chair of the English Bible for the college in its new home in 1892.[55] Hart Massey became an active member of the Methodist church's Building and Executive Committees and worked for Victoria College's new building project, including spearheading negotiations for an enlarged plot of land to accommodate future expansion.[56]

C.B. Sissons has credited the Massey family with placing the college

'on its feet' during the 1890s and largely creating the modern Victoria University.[57] Hart Massey, who died in 1896, left $200,000 to Victoria College in his will – $50,000 of it for the building of a women's residence and the rest for an endowment fund. As well as making sizeable bequests to Mount Allison University and to Wesley College in Winnipeg, among others, he left approximately $2 million to be distributed in religion and education at the discretion of his executors, his three surviving children – Chester (Vincent's father), Lillian, and Walter.

Walter Massey, who became a member of Victoria College's Board of Regents after his father's death, endowed a chair in Greek philosophy and was instrumental in securing land and raising money for the creation of the college's campus.[58] With her mother and two sisters-in-law, Lillian Massey took up the cause of a women's residence at Victoria, Annesley Hall, which opened in 1903, the first in a series of Massey benefactions aimed at creating and enhancing the residential and collegial life of the student.[59] In her will, Lillian Massey (died 1915) left $300,000 as a general endowment for Canadian Methodist theological colleges and named Victoria the residuary legatee. Much of the estate was in Massey-Harris stock, which eventually yielded the college over $1,350,000.[60]

After Walter Massey's death in 1901, his brother, Chester, Vincent's father, replaced him in 1902 on Victoria's Board of Regents[61] and directed a succession of benefactions to the school. In 1909 he wrote to the board as chair of his father's estate: 'We will be pleased to erect and furnish for the College a men's residence [to become Burwash Hall] to accommodate one hundred students.'[62] At the time of the proposal, residences were virtually non-existent at the University of Toronto.[63] In Sissons's words, 'again Victoria had pioneered; there was nothing comparable to Burwash Hall in any Canadian university.'[64] By 1914–15, gifts to the University of Toronto from Hart Massey and his estate for building and endowments had reached $960,000.[65]

Methodist Heir

The childhood home of Vincent Massey was devoutly Methodist. The family was affiliated with a breath-taking assortment of Methodist churches, educational institutions, missions, committees, and projects, yet also supported a variety of other Christian groups and programs, including the Ontario Sunday School Association, the World's Student Christian Federation, the Ontario Lord's Day Alliance, and the Chautauqua Institution.

Vincent Massey – termed by his nephew philosopher George Grant an 'ambitious Methodist'[66] – inherited his Methodist faith from both sides of the family. Not only was his grandfather Hart Massey one of the so-called Methodist millionaires who dramatically improved the denomination's financial fortunes in the late nineteenth century. On his mother's side was the prominent Methodist bishop John Heyl Vincent, co-founder of the Chautauqua summer school in New York state – an educational mecca for various religious denominations and the model for 'chautauquas' across North America and around the world.

According to Claude Bissell, however, Massey rejected much of his Methodist upbringing.[67] He converted to Anglicanism in 1926,[68] perhaps not coincidentally, shortly after his father's death earlier in the year and not long after the unification of the Methodist, Presbyterian, and Congregational churches as the United Church of Canada (1925).[69] He was not buried with his forebears in the Methodist family tomb in Mt Pleasant Cemetery in Toronto. From his university days, his diary recorded periodic stabs at the foibles of the Methodist church and its practices. On 22 February 1910, Massey complained that 'intellectuality is not a strong point of the Methodist Church.'[70] On another occasion, he expressed contempt for those who attended Chautauqua.[71]

Certainly Massey parted company with his austere father on the subjects of abstaining from alcohol and attending professional theatre, two contentious issues for Canadian Methodism. Massey commented frequently on the stultifying effects of Puritanism, which he equated with Methodism. None the less, he acknowledged that 'the Puritan tradition, when it is honestly observed, is something for which I have very great respect.'[72] Both as Puritanism's child and in his reactions against his family's faith, Massey's relationship with Methodism invites further examination. Particularly in the area of education, Methodism's blend of moralism and liberalism made him a zealous reformer. Massey always viewed education as tantamount to salvation. He adopted a democratizing, inclusive, and ecumenical (though largely Christian) approach to learning, and, saturated with Methodist nationalism, he strongly identified education with Canadian citizenship.

Vincent Massey became deeply involved in Methodist education, as an executor of the Hart Massey Estate beginning in 1908 (on his twenty-first birthday), as Victoria College's first dean of residence from 1913, and later as chair of the 1919–21 Massey Foundation Commission on the Secondary Schools and Colleges of the Methodist Church of Canada and as a member of the Commission of Nine (1921–2). Hart House, which he conceived about 1910, also had a profound educational mission.

His own early education was public, until, in the absence of a Methodist secondary school in Toronto, he attended St Andrew's College, a Presbyterian school in Toronto near his family's home, from 1903 to 1906. He would later urge the Methodist church to establish its own elementary school for day pupils in Toronto.[73] He did not attend Victoria College as an undergraduate, contrary to family tradition and his father's express wishes; he chose instead the non-sectarian University College, where he studied from 1906 to 1910.[74] On graduation, however, he became a member of Victoria's Board of Regents,[75] and as early as September 1911 he appears to have been on its Executive Committee.[76]

Massey's diaries record his assorted commitments to Methodist functions and, as late as 1910, his regular teaching at Metropolitan Methodist Church, Toronto, on Sunday afternoons. The Methodist church had the largest Sunday school program of any denomination in Canada.[77] One of the events that most excited him as a young man was the World Missionary Conference in Edinburgh in 1910. He attended the conference as a delegate of the Methodist Church of Canada. His diary entry reveals that he was swept up in a spirit of ecumenism:

> The Confce [Conference] has been intensely interesting. Missions are now in the hands and under the influence of really sane men. The absurd fanaticism which once was prevalent in this dept. of life seems to be giving place to a more sober enthusiasm. Efficiency, a tolerant & intelligent attitude towards heathen religions, sympathetic views as to the actions of gov'ts and above all a most wonderful spirit of co-operation between the churches. High Church bishops have fraternized with Methodist local preachers. [A]nd what is most remarkable – in place of there being a sort of artificial glossing over of differences there has been a frank admission of points of diffce [difference] and a tolerant spirit of sympathy for these points all of which have been frankly expressed. By the next Confce in 1920 it may be that the Greek and Roman churches may come in with us. Again the speeches in this Confce have shown a feeling of respect for native governments and it is at last realized that the church in China and India & everywhere must not be an alien church but must develop along national lines.[78]

In early 1911, he gave a paper at Victoria College on 'Missions and Education,' based on the Edinburgh conference.[79] Education constituted, in his view, the most promising avenue to international collegiality. His expression 'coming in with us' did not preclude a keen respect for

difference; he believed firmly, as he would later state: 'It is not hatred which divides nations but rather ignorance.'[80]

Some of Massey's earliest recorded comments on education date from his trip to Edinburgh. He visited various universities in Scotland and England with a view to studying models that might be relevant for two building projects by the Hart Massey Estate at the University of Toronto: Burwash Hall, the men's residence at Victoria College, and Hart House, the main recreational facility for male undergraduates at the university.

He was much more favourably impressed by the English than by the Scottish examples. With reference to Edinburgh, he wrote disapprovingly: 'Man there is taught thru' books and books alone; ... living in a solitary boarding-house room and grinding at lectures & writing exams & doing nothing else is *not* an education.' He acknowledged: 'The medical faculty is better & patronizes the Residential Halls & also the Union as it does in Glasgow but the [liberal] arts man in both places is a pitiful grubbing creature. At Oxford & Cambridge they have got far enough to realize that second class honours often indicate a more symmetrical, more able man than do first. May Canada reach this goal rather than that of Scotland.'[81]

Meanwhile, he expressed a commitment to addressing Methodist standards of education. Following a meeting about the proposed Methodist college in Regina, he wrote: 'The Methodist Church at present is an apotheosis of mediocrity – especially in what we are pleased to call education. Someday if I [live?], it will be improved, in the little area that I can infce if not more.'[82]

In August and September 1911, Massey made a journey through western Canada, visiting Methodist colleges. In Regina, at a meeting with the Board of Trustees of Regina College (opened 1910), convened because Massey was in town, he was asked to speak on the subject of the ideals of the college. He used the opportunity to rail at length about the 'evils of co-education,' which he regarded as the principal fault at Regina College.[83] In Calgary, after a visit with Rev. G.W. Kerby of Mount Royal College, he wrote that he did not think much of his ideas on education, although he conceded that 'his conception of the meaning of education is not so vague as that of others in the Methodist Church.'[84]

On 1 September he was in Vancouver. The local press reported that Massey was making a tour of Methodist schools to assess their progress and conditions and generally to acquaint himself better with his family's extensive benefactions in education.[85] In a letter to his father about the trip, he wrote: 'In Vancouver I have again become deeply involved in

Methodist education. I have carefully inspected Columbian College in Westminster & was shown the site of the new University of B.C. and the new Meth. divinity school.'[86] He met many of the board members of both Methodist institutions, and the board of the Theological College called a special meeting for his benefit. To his father he reiterated his concern for reform, but did not elaborate. Intriguingly, he wrote: 'On my way back I want to see Dr. Sparling of Winnipeg & learn a little more about Wesley College. Seeing these Meth. schools & colleges is teaching me a great deal about our educl. problems & when I get home I want to tell you a good deal about the decisions I have come to in this matter. I am satisfied that there should be a complete reversal of policy on the part of the [Hart Massey] Estate – But I can go deeper than that in my reconstructive ideas. However I shall wait till I see you.'[87]

Shortly before he left for Oxford later in September, Massey lunched with N.W. Rowell, a prominent Methodist and Liberal, also involved in the Metropolitan Church Sunday School.[88] They discussed creation of a commission on Methodist secondary education in Canada[89] – a subject to which Massey would return at length.

Collegial Life at Victoria

On completing his studies at Oxford in 1913, Massey returned to Toronto and became closely affiliated with Victoria College. Massey and his father had been members of a committee responsible for the planning and realization of the men's residence, Burwash Hall. The facility was to include a dining hall for 250 students, as well as five separate houses, a junior and a senior common room, and a dean's residence. Architect Henry Sproatt designed it in a collegiate Gothic style. Although it was completed while Massey was at Oxford, he was intimately involved in its planning.[90]

In 1913, Massey resigned from the college's Board of Regents to become dean of residence of Burwash Hall, a position that he retained until 1919.[91] Alice Parkin, whom he married in 1915, became dean of women at Victoria College.[92] According to Sissons, the Masseys were very active in college life.[93] Massey explained: 'I was asked to become dean of residence of Victoria College ... and "break in" the building that I had played an active role in planning.'[94] In a diary entry in 1914, he wrote that 'the residence work is interesting – an eminently constructive task.' Elsewhere he commented: 'I think I have been able to convince people

that the introduction of Gothic architecture and collegiate life is not a conspiracy to rob the Canadian of his birthright, nor is it an attempt to superimpose "Oxford customs" on the freedom-loving Toronto student ... I am working as far as possible through the House Committees and I find them understanding and sympathetic. Civilization is a slow process but I am satisfied that we are making some progress.'[95] Above all, 'a "college" is essentially a community,' he wrote, and he was especially pleased with the role played by the dining hall and common rooms.[96]

In 1919 Massey proposed a further innovation to strengthen Victoria's collegial nature – the building of professors' residences. A board meeting in February authorized the allocation of $75,000 for the purpose. Vincent and Alice Massey were commended for their 'foresight, unselfishness and hospitality' in wishing to share with the college's faculty 'the magnificent lot to the south of the College' – 71 Queen's Park Crescent, the site of their home, owned by Chester Massey. Rev. R.P. Bowles wrote to Chester Massey about the plan: 'Vincent has put his finger on the weak spot in Victoria. Living down here by Victoria College, he was the only member of the Staff closely in touch with the life of the College all the time. Our professors, owing to the great cost of land near the College, have had to go far out and they are now living at altogether too great distances from Queen's Park. We are trying to cultivate the English ideal of a college, in which the social life of the students is so important a factor.'[97] Despite Chester Massey's blessing and his stated willingness to transfer title of the property to Victoria College, the scheme was not realized.[98]

Hart House: The 'Whole' Student and the 'Common Life'

In 1910 Vincent had proposed to his father that the Hart Massey Estate provide a student centre for undergraduates at the University of Toronto.[99] No mention was made at this stage that the facility was for male undergraduates only.[100] As a student at the university himself from 1906 to 1910, Vincent Massey was acutely aware of the fragmented nature of the campus and the lack of facilities for social activity among undergraduates.[101] The old gymnasium south of Wycliffe College was grossly insufficient for its task, as was the students' union. A new YMCA building was also needed. The 4 March 1910 issue of the *Varsity* – the undergraduate student newspaper – reported that the Hart Massey Estate would be financing the erection of three buildings on a site that presently encompassed the old gym at the northeast corner of University

College. The announcement stated: 'The centralization thus effected will minister to the mind, body and spirit of the students.'[102] An accompanying plan showed the buildings arranged on three sides of a quadrangle.[103] A subsequent issue of the *Varsity* reported that the complex would also probably include 'a fine Gothic hall to seat 600 students (for debates, student meetings, etc.), a new swimming tank in a separate building, and a hall in one of the buildings to be used for banquets, receptions, and the like.'[104]

By early 1911, there was considerable change in the plans. The various functions and components of the facility were now resolved into one building, with the quadrangle enclosed on four sides. The conception was praised for bringing together in such a comprehensive manner 'the different branches of student activity, athletic, social, religious and executive' and for ushering in 'a new era in the history of student organizations in this University.'[105] Certainly the massing together of so many student functions was a unique conception, and the building remains a focal point of today's sprawling campus.

Massey's initiatives at the University of Toronto drew attention from the local press. Under the title 'The New Civic Spirit,' the *Globe* (Toronto) observed that he was 'head and front of a movement for lessening the perils of the student, who leaves home influences behind when he comes to Toronto for his education, by the erection of a great group of buildings for Y.M.C.A. and social union purposes.'[106] Such words are reminiscent of an address by Hart Massey in 1892 to the Methodist Social Union of Toronto.[107] He advised students of Victoria College to shun companions and places that might betray their high moral path and encouraged them to find a Christian church as a home away from home. Providing a home life to students proved to be one of the greatest challenges that the university faced, according to Nathanael Burwash. Local pastors, whose congregations were swelled by student members, opposed a separate college church.

While Hart House was not affiliated with Victoria College, Methodism, or any other denomination, Massey considered it important that the facility concern itself with students' religious well-being under an interdenominational mantle. At the time of Hart House's conception, the Young Men's Christian Association needed new space. Massey was intent that the YMCA join forces and not compete with his brainchild. The Young Men's and Young Women's Christian Associations (founded 1892 and 1895, respectively), though not able to take the place of a church,

had, in Burwash's words, 'done a great service and ... formed a unifying bond in College Christian life and work.'[108] But, as Massey later explained: 'there was an imminent danger ... of dividing the men students into two groups, one under the auspices of the Young Men's Christian Association and the other enjoying the amenities of an ordinary social club. The result would have been obvious.'[109]

The YMCA authorities were persuaded to participate in Hart House (with control over a group of offices on the north side of the south wing), while relinquishing proprietorship of club rooms that might compete with the rest of the House. 'This was a very important understanding to arrive at,' Massey maintained, 'and was incorporated in the original administrative plan of the building.'[110] As on many other occasions, Massey managed to implement his vision by locating a common cause. This arrangement circumvented competition and helped to foster a comingling of the spiritual and the social dimensions of student life.

Massey was also supportive of a new religious organization, the Canadian Student Christian Association. Before the First World War, student departments of the YMCA and YWCA were the primary vehicles of formal religious activity among students. At a national conference in Guelph in December 1920, however, the Canadian Student Christian Association was formed.[111] In early 1922, Massey endorsed this breakaway group in a letter to Rev. George Kilpatrick, whom he, Robert Falconer, and Burgon Bickersteth, second warden of Hart House, hoped to entice into the position of general secretary of the new organization's operations at the University of Toronto. Massey wrote that the YMCA was 'practically defunct' in the religious life of students at the university, and that half of them were now involved with the Student Christian Movement (SCM). 'The S.C.M., which is largely run by the students themselves, is a demonstration of the fact that they are only awaiting adequate leadership to develop a very powerful spiritual movement.'[112]

In 1923, the YMCA and the SCM agreed to unify their operations in Hart House. The Massey Foundation paid half the salary of the new organization's secretary, who became in essence 'chaplain of Hart House.'[113] As late as 1938, Alice and Vincent Massey felt strongly enough about the SCM's work at the university that they arranged for a special donation of $2,000.[114]

The Masseys ensured, too, that Hart House had a small interdenominational chapel – particularly significant in view of the hard-fought battle to convert the university into a secular institution earlier in its

history.[115] Bickersteth commented: 'The Chapel occupied a central place in Hart House, and purposely so. That in itself set us apart from any other centre I know of for undergraduate life.'[116]

Massey also insisted that Hart House, like Burwash Hall, incorporate a grand dining hall. 'My own view is that the educational effect of a dining hall of noble proportions and beauty of detail is as real as it is subtle,' he wrote. 'Sordid habits are too often the result of unworthy surroundings.'[117] By the time it was completed in 1919, Hart House also included common rooms, reading room, library, music room, photographic darkrooms, gymnasia, swimming pool, track, rifle range, billiard room, sketch room, and theatre.

Shortly before the building's opening for students' use, delayed until 1919 due to the First World War, the Hart Massey Estate was, on Vincent Massey's urging, reconstituted as the Massey Foundation, to extend its life beyond the twenty years specified in his grandfather's will. Its assets at that time were roughly $3 million.[118] The trust also affirmed its commitment to 'educational experiment,' within which Hart House squarely belonged.[119]

At the building's opening ceremonies, Massey summarized the role that he envisaged for it: 'It is perhaps not incorrect to say that the House as it now stands is intended to represent the sum of those activities of the student, which lie outside the curriculum. These activities are not unimportant; indeed, I would submit ... that the truest education requires that the discipline of the class-room should be generously supplemented by the enjoyment, in the fullest measure, of a common life. A common life, of course, presupposes common ground.'[120]

Hart House became a model in the student union movement around the world during the 1920s and 1930s. It contrasted with the largely social, rather than cultural, nature of similar facilities in the United States.[121] In response to inquiries some years later in connection with London House, a residence planned in the British capital, for students from the Commonwealth, Massey explained that Hart House was 'an experiment in providing the men students of a large and rather scattered university population with some of the academic "atmosphere" and equipment which, in universities like Oxford and Cambridge would normally be found in the colleges.' While Hart House, unlike London House, had no residential accommodation, he regarded their purposes as similar. 'They both aim to encourage corporate social life and to provide an academic environment and an atmosphere of comfort and dignity for a large group of students who otherwise would be scattered and frequently living a solitary and generally inappropriate existence.'

He continued: 'The danger which we faced in connection with Hart House was that the building might have become little more than a well-equipped club without academic quality or corporate life or educational significance.' He felt that its activities, its administration, and the 'humanizing' influence of Warden Bickersteth had averted this danger.[122] An indication of its educational significance, its warden had and still has the same academic status as a college principal or a faculty dean.[123]

Massey's focus in Burwash Hall and even more with Hart House was to engage the 'whole' student, again on the premise that education was a means of developing character. Character was fostered first by a formal education in liberal arts, but it was augmented within an extracurricular environment that was morally, spiritually, socially, and intellectually engaging. Massey understood education to be this totalizing enterprise; it became the unifying ethos that guided him in his quest for the common life. Above all, he believed that education bred understanding and harmony and as such was the primary route to community. His approach was not so much to deny the existence of difference among people as to assume that it was possible to understand difference through education and thereby find commonality. His mission, it would seem, was to create an environment that was conducive to a sense of community; believing that human nature was innately reasonable and congenial, the rest, in his view, would follow. Fostering what might be called an anti-utilitarian environment would be a leitmotif of his career. Of course, this ideal environment was not immune to arbitrary exclusions, be it of a particular type of music or, most notoriously, of women.[124] Massey's views on character education in relation to women and co-education are elaborated on in the next section, in the discussion of his involvement in a 1919–21 Methodist commission on educational reform. The implications of the opening of Hart House for the female population at the University of Toronto are considered in chapter 3, specifically in regard to the fine arts.

Methodist Commissioner and a Massey Report, 1919–1921

While the focal point of Massey's activities at the University of Toronto shifted from Victoria College to Hart House at the end of the 1910s, he remained very active in another area of Methodist educational endeavour. As the war drew to a close, the spirit of reconstruction gripped the country and, within the Methodist community, expressed itself in a fervent progressivism aimed at social reform. At its 1918 General Confer-

ence, the Methodist church went so far as to reject capitalism.[125] Where Vincent Massey stood in regard to this matter we may only surmise: while positioned on the progressive side of Methodism – and, as future president (1932–5) of the National Liberal Federation, of Liberalism – he would hardly be expected to reject the economic system outright. Indeed, until after the Second World War, his criticisms of Canadian society were not generally framed in terms of economic restructuring, except that economic concerns should not exclude the spiritual and moral.[126] For the time being, he contented himself with seeking a reformulation of the ideology guiding Canada's education systems.

In January 1919, Massey wrote to the Methodist church on behalf of the Hart Massey Estate,[127] offering to set up a commission to 'enquire into the conditions and work of the educational institutions of the Methodist Church.'[128] The church's Board of Education, of which he was a member, approved the proposal at its annual general meeting later that month and created the Massey Foundation Commission on the Secondary Schools and Colleges of the Methodist Church of Canada.

The product of an educational fervour that escalated in the wake of the First World War, the commission was intended to address a variety of concerns. It was asked to recommend an improved system of classification for the various types of Methodist-affiliated colleges, to assist in harmonizing academic goals, and to set minimum standards for physical plant, resources, and staffing.[129] The board appointed to the commission George H. Locke, chief librarian of Toronto; Professor J.C. Robertson of Victoria College; and Rev. James Smyth, principal of Wesleyan Theological College in Montreal. Massey served as chair.[130]

Massey formally presented the commission's 153-page report at the Board of Education's annual meeting in March 1921; the document was sent to all the members of the General Board of the church and to the principals and governors of each of the Methodist colleges. It claimed to be the first attempt to determine the functions of the Methodist schools and colleges and assess the degree to which they were fulfilling their task. As well, it argued that such a study was of great significance, given the wide extent of the educational work of the Methodist church. Its findings will surprise those who have come to regard Massey as a champion of the fine arts.

The report began with a fundamental question: 'What justification is there for the Methodist Church, through her educational institutions, undertaking what would seem to be the duty and concern of the State – the provision of the education needed to fit young people for the duties

of citizenship? This work is assigned by the B.N.A. Act to the several provinces of the Dominion; it is elaborately organized and, on the whole, well done under the provincial departments; and for it the people in each province are heavily taxed. Why should the church duplicate what the State should furnish, and in fact does furnish?'[131] The question is revealing, not least for its assumption that the purpose of formal education was to equip students for citizenship.

The commission provided several reasons for Methodist involvement in education. It pointed out that secondary education was still not available to large numbers of Canada's scattered population, and in the west this was also true of primary education. Many parents sought the 'advantages generally recognized as coming from the common life and careful supervision of a good residential school.' Echoing the aim of the Massey Foundation itself, the report also argued that the Methodist schools could 'be made to serve as valuable laboratories of experiment in education.'[132]

The commissioners were dissatisfied with various aspects of the Methodist schools and divided their report into two parts – 'The General Problem' and 'Individual Schools and Colleges,' in which they tackled the particular weaknesses of the eleven schools that they considered. Above all, they were discontented with the lack of control exercised by the church; they regarded some of the schools as little different from an 'independent commercial school in Halifax, or Kingston, or Saskatoon, whose principal may happen to be a Methodist.' Greater financial involvement by the church would, they argued, allow it to dictate standards and priorities.

The commission made several recommendations regarding such priorities. One concerned the role of religious education. While many of the colleges offered Bible study, few recognized religious education as part of the curriculum and had it taught by qualified staff. 'The existence of church schools is chiefly justified by their ability to give education a Christian background. The importance of religious education can ... scarcely be overstated ... Only familiarity with the life and personality of the Founder of Christianity will give the student a sense of the *positive* element in religion and will teach him his obligation to the community, which is religion's finest expression.'

The extent to which the emphasis on Christian content reflected Massey's thinking is difficult to assess. Certainly an 'obligation to the community,' stated as a sacred mission, was a recurrent theme in his writing. The significance of Christ as a person was consistent with the

humanistic cult of personality evidenced elsewhere in the report: 'Education ... is served chiefly by the contact of mind with mind, by the influence on immature boys and girls of fine personalities.' The report stated that 'boys are hero worshippers' and urged that there be less concern with 'extravagant buildings' and more with the quality and remuneration of teachers.

The commissioners were also displeased that theological training was spread out over many schools, each with only a small enrolment. They urged that theological training be centralized and that it not be affiliated with a ladies' college or a boys' academy, but rather with a university. 'To a university it can make a two-fold contribution, viz.: (a) a Christian influence that will counteract the secularization so often associated with state universities; (b) the provision of hostels in which Arts students may live in right surroundings and atmosphere.'[133]

Central to the report was its concern with the overall curriculum of the secondary schools and, in particular, two issues – the role of the liberal arts in relation to the fine arts and the matter of co-education – which we now look at in turn. The report noted that in addition to work in languages, mathematics, history, and science, which was in keeping with provincial high schools, there was instruction in 'music (vocal and instrumental), art (drawing, painting, modelling, china decoration, metal work, woodcarving), elocution, manual training, agriculture, household science, commercial education (including book-keeping, stenography and typewriting, and in one case also telegraphy).'

The schools justified offering this diversity of subjects by arguing that 'not one of these varied subjects ... might not be an element in the education desirable for some future enlightened and well-equipped member of society and of the church.' The commissioners acknowledged that the addition of one or possibly more of these subjects to a student's curriculum was often useful in developing a young person's special aptitudes, but they remained generally unconvinced about such a diversity of subjects. Especially worrisome, they claimed, was the schools' other reason for offering this range – it simply attracted pupils and generated revenue.

The statistics provided in the report give a startling picture of the emphasis on the fine arts, especially music. At Alberta College North, Edmonton, for example, 1,050 students enrolled in the 1919–20 session were taking what were listed as the art, expression, or music programs, including 550 taking the 'full course' in music. This compared with

326 enrolled in the 'academic or high school courses.' Of Mount Royal College, Calgary, the report stated: 'There are 263 non-residents in attendance, all but 40 of whom take only such subjects as music and fine art.' Virtually all the colleges had an active music program; at least eight offered a program in 'Expression,' and at least six in 'Art.'[134]

The development of art education in the Methodist school system remains to be charted. In Egerton Ryerson's *Report on a System of Public Elementary Instruction* of 1847, he included 'linear drawing and music' among the subjects that might form part of his education system.[135] But among Methodists, attitudes towards the fine arts were conflicted, when not downright resistant.

With few exceptions, art education seems to have played little role in nineteenth-century Canadian public education,[136] although it did gain momentum in denominational schools during the 1880s and 1890s. At least one Methodist educator in Canada – Benjamin Fish Austin, principal of Alma College (incorporated in 1877) in St Thomas – was resolute about the virtues of artistic education. In cataloguing the instruments of higher learning in 1882, he emphasized the need for an appropriate building: 'It should, in every feature, meet the demand of the public for beauty, and thus be capable of appealing to and developing the aesthetic nature of its students.' He continued: 'Especially should its Fine Art department, in its arrangements and furnishings, be made a silent yet powerful educator of public taste. Here should be collected a number of models in all departments, a selection from the works of masters, to give their constant inspiration toward excellence in Art. It should hardly be said that the instruction given in a building in which every object pleases the eye and appeals to the finer nature is immeasurably more beneficial than that given in a rude, dull or dreary structure.'[137] Austin emphasized that music and 'fine arts' (presumably visual arts) required both theoretical and practical courses and examinations.[138] Austin was trying to attract endowments to help furnish his newly completed school building, which included an art department. By 1890, the *Methodist Magazine* reiterated Austin's endorsement of the fine arts: 'A knowledge of architecture, sculpture, and painting is a very important part of a liberal education in colleges and universities.'[139]

The annual reports of the Methodist church's Educational Society – later the Board of Education (1884–1925) – provide a profile of the growth of art education at its schools.[140] The report for 1888–9 mentioned that Alma Ladies' College had erected an addition forty by eighty feet and five stories high that included 'an Art room, said to be the finest

in America. It is well-lighted with a skylight 40 × 8 feet, and thoroughly furnished with apparatus, etc.' Meanwhile, Wesleyan Ladies' College in Hamilton (opened in 1861) had expanded its music department into a full conservatory. The following year, Stanstead Wesleyan College, now affiliated with McGill University, offered programs in music, painting, and drawing. In the report for 1890–1, the Ontario Ladies' College at Whitby noted that its 'music pupils are prepared for the degree of Bachelor of Music. The Fine Art, Elocution and Commercial Departments are not surpassed, if indeed equalled in Canada.'

In 1890 at Mount Allison Ladies' College (founded 1854), Sackville, 'The Department of Music developed into a regular Conservatory of Music, employing six teachers, and a commodious building was erected especially for its use. During the present year a collection of pictures, valued at $50,000, known as *The Owen's Art Gallery*, has been transferred to the College, and the Fine Arts Department has been placed under the direction of an R.C.A. of eminence, with two associate instructors.' By the 1893–4 report, a new stone building costing $25,000 was in progress – a 'structure ... 115 × 65 ft ... [with] three connected galleries and a suite of work rooms for Art classes.' Reports provide assorted details about other schools, their fine arts curricula, facilities, and degree-granting status, especially in music, the art form most esteemed by Protestant Canadians historically.

By the time of the Massey Foundation Commission, music and, to a lesser extent, visual art and 'expression' were clearly an established part of Methodist education. Why then did the commissioners strenuously argue that subjects such as music, art, and expression were not among the church's responsibility to offer? 'Our objection is not that this sort of work is undignified,' they wrote, 'but that it is fundamentally wasteful, dissipating the time and energy that the agents of the church should be devoting to their proper calling, and diminishing thereby the due effect of that devotion.'[141] They blamed the attention given to these subjects as 'primarily responsible for many of the unsatisfactory conditions found, ... for instance, the very general congestion or lack of adequate facilities in classrooms, bedrooms, kitchens, and dining-rooms, lavatories, gymnasiums, etc.'

The commissioners urged a cost analysis to determine likely losses should the Methodist schools 'give up these alien activities and confine itself to its proper task.' Separate billing from the main school tuition points to the tentative nature of these subjects' inclusion. But the admission that their eradication would be costly somewhat contradicted the

commissioners' claim that teaching them caused congestion and lack of adequate facilities. Surely such extra revenue helped to sustain and even expand facilities. In any case, the report recommended that the church make up the resulting financial loss and, to press the point, added: 'It would in this way deliver its colleges from a necessity which is as great a reproach to the Methodist Church as if it should leave its pastors and missionaries to eke out a too scanty allowance by engaging in some employment which distracts them from their true calling and wastes their time and strength.'

The second part of the report, on the curricula of specific schools, reiterated the complaint about fine arts in more detail. With reference to Albert College, Belleville, the report was explicit: 'A large proportion of the work in music, art and expression are [*sic*] of little intrinsic value in furthering those ends which the church has in view in maintaining secondary schools and academies ... There is no reason why they should be kept in their present form in any ideal scheme of reorganization, and if the Colleges can be put on a proper financial footing, the small amount of surplus revenue with not be missed.' In regard to Alma College, St Thomas, it recommended: 'That pupils taking special courses in music and commercial work be required to supplement the narrowly technical instruction by a due proportion of cultural subjects.'[142] With respect to Ontario Ladies' College in Whitby, the report observed:

> The subject of music is given great prominence in this College, and a very extensive course of study has been organized in association with the Toronto Conservatory of Music. It is a rule of the College that 'students who are specialists in music will be expected to take one or more literary studies for the profitable employment of their time, unless they can show that their time is otherwise fully occupied' – we presume in piano-practice chiefly. This rule, admirable as far as it goes, would be much improved by the omission of the last clause, 'unless, etc.' We ... would again reiterate our opinion that our secondary colleges should not be content with sending out 'graduates' who have considerable technical proficiency, whether in music or art or commercial branches, but whose education in general culture has been neglected. Skill of hand will seldom go far with an ill-furnished head.[143]

The commissioners were positively scornful of teachers of drawing, dramatic reading, domestic science, and commercial subjects: 'Whether

the number of the staff engaged in these subjects or the extent of the work covered can justify the somewhat pretentious titles of College of Fine Arts, School of Expression, College of Domestic Science and Art, and Commercial College seems very doubtful.' Whether they deemed these labels pretentious because they exaggerated the substance of the programs or because they were used with reference to the fine arts is unclear. What seems to have offended the commissioners most, however, was that these subjects were not integrated into a balanced, academic program.

With regard to Stanstead Wesleyan College, the commissioners repeated: 'We believe a greater proportion of cultural work should be combined with the technical training, even for those preparing for a professional career. These pupils are to be men and women and citizens, and not simply accountants and secretaries. If the opportunity is not seized now it will probably never recur.'[144]

The report was highly critical of Stanstead's Conservatory of Music. In its view, there was no place in the secondary school for such highly specialized training in music, even though such a program 'might with advantage be made less technical and the element of general culture which they now contain greatly increased.' At Wesley College in Winnipeg, the commission recommended 'that the College cease to make provision for instruction in music' and pointed out that if it eliminated the space used for music 'the present buildings might serve for the needs of all genuine college work in Arts and Theology.'

The commissioners thus made very clear what subjects warranted the schools' focus. Whether children were preparing for a return to farm or home life or for a career in business, 'the greatest care should be taken that, through literature, history, the study of social ethics and of the principles of citizenship, they become conscious of their duties and their privileges as members of the State and inspired to realize their high calling and destiny as human beings.'[145] The commission wanted education that developed citizens, not only able workers.

The report continued: 'Music, art and book-keeping would then no longer be self-contained courses for those who desire to specialize in them merely to gratify some taste or to qualify as rapidly as possible for a salaried position; but they would become elements in carefully-thought-out and well-balanced schemes of education that would take due account of all the capacities that call for development if the pupil is to be prepared adequately to fill his place in the. community.' This latter passage conceded some role for the fine arts, and in one place the report

referred to music as 'a most desirable element of culture,' as long as it was an adjunct to a liberal arts education. Regardless of this concession, the report referred to the fine arts with varying degrees of condescension. It called 'art, commerce, music and elocution' 'pot-boiler subjects,' included them among 'alien activities,' and labelled them 'ornamental'; it described piano practice, along with shorthand and typing, as 'mechanical operations.'

The Massey Foundation Report used the word 'culture' quite clearly to refer to the liberal arts, not to the fine arts. It invariably distinguished 'culture' from scientific and business training and juxtaposed 'cultural studies' with 'technical instruction.' On occasion, it used the phrase 'physical culture' to refer to what is now called physical education. In one instance, the report wrote of the Methodist college's purpose as fostering 'a well-rounded life under the influence of Christian culture.' Despite these variations, however, it presented 'culture' overwhelmingly as the product of learning within a particular group of core subjects – literature, history, social ethics, and citizenship; it also promoted the study of French out of a respect for Canadian French–English diversity. These were the subjects that it believed engaged the intellectual and moral capacities of the student and were juxtaposed with the technical and the artistic.

At the university level, too, the curriculum was expected to centre on the liberal arts, with character development as the end product. Essential were English and history, especially modern history. Additionally, 'in economics, the aspects ... the church college is chiefly interested in are sociology and the principles of citizenship; in philosophy, ethics rather than advanced history of philosophy or experimental psychology.' These subjects, with a strong emphasis on morality and citizenship, were to constitute the cultural domain at every level of formal education.

The commissioners completely ignored any notion of visual art as a liberal art, even though art academies in Europe had long promulgated its status as such. This validation was premised on the assumption that the fine arts had a theoretical as well as a practical nature. The Massey commissioners, however, persisted in referring to the fine arts as technical and used this as grounds for restricting and, in some instances, eradicating fine arts programs in Methodist schools. It remains to uncover why they had so much difficulty envisioning the fine arts as cultural.

Fine art was only one of two targets of the commissions' zeal to reform. The other was co-education. The relationship between them pertains to

the limits that the commissioners placed on the fine arts. About two-thirds of the Methodist schools were co-educational. The remaining were girls' schools, except for one boys' academy. The rise of ladies' colleges was due both to girls' being excluded from other educational venues and to the belief that women had more control over their education in a female-only context.

Massey had long had a bias against co-education. As early as 1911, writing about the newly opened Regina College, he railed against the 'evils of co-education,'[146] viewing it as a major source of the mediocrity of contemporary education. While Massey was an undergraduate at the University of Toronto from 1906 to 1910, the controversy on co-education that had woven its way through nineteenth-century Canada flared up again. Massey's history professor and mentor, George Wrong, wrote a report on the subject in 1908, recommending establishment of a women's college at Toronto. Response was mixed, but the proposal was finally rejected by women, who feared that it would ultimately compromise their funding.[147] Claude Bissell, Massey's biographer, has attributed his aversion to co-education to Wrong's influence. His attitudes towards co-education may well have hardened at this time, but he was heir to a deep family commitment to education – both men's and women's – and he must have been well-apprised from an early age of the debate about co-education among Methodists.

The Massey family had displayed considerable support of women's education. One of the bequests of Hart Massey's estate in 1896, in the amount of $35,000, had rescued Alma College from financial crisis.[148] The women of the family were instrumental in the creation and building of the first residence for women at the University of Toronto – Annesley Hall (opened 1903), part of Victoria College – and Lillian Massey Treble set up the Lillian Massey School of Household Science (opened in 1903) at the university.

Massey clearly came from a tradition with a firm commitment to the higher learning of women. The family gave generously to co-educational institutions such as Victoria College, yet some of its support had well-defined gender boundaries – it gave financial backing for school and residence buildings specifically for females and for a discipline deemed particularly appropriate to the orbit of women – domestic science.

The Massey Foundation Commission's report perpetuated a commitment to higher learning for females – both within and outside gender boundaries. In its assessment of Mount Allison University, for example, it was critical of the affiliated Ladies' College for not functioning as more

of a feeder school like the Boy's Academy.[149] One suspects that the commission was disappointed that more girls from the Ladies' College were not advancing to a degree program in home economics. It complained that the program did not have a scientific enough basis, surely an indirect reference to the model provided by the Lillian Massey School of Household Science.

The most compelling evidence of the commission's commitment to female education is its determination that both boys and girls receive what might be referred to as a cultural education. In this sense, it was strikingly egalitarian. Johanna Selles has argued that its report 'represented a backward step in Methodist education' – because of its downgrading of so-called auxiliary subjects in favour of 'a more balanced scheme of education ... girls [would be prepared] to be housewives only.'[150] But the equation was not quite so direct. Such an assumption does not do justice to the report's firm and universal commitment to a liberal arts education. Such an education, with its goals of character development and good citizenship, was important for both genders in the commission's view. The report aimed to discourage, for example, female students who took courses in shorthand, typewriting, and bookkeeping 'merely using [Alma College] as a convenient boarding-house while they are getting ready to earn money in an office.'[151] The point is that the commission attacked vocational education generally. The Massey Foundation Commission followed a long Methodist tradition of resisting an educational system that was driven purely by utilitarianism and specialization.

This, however, does not acquit the commission of gender bias. It clearly had different views of female and male character, which became evident in its bias against co-education, especially at the secondary school level. It argued:

The matter for inquiry concerns the case of boys and girls at the plastic age covered by the interval between the age of puberty and the entrance on university study or professional training. The question is whether the development of the whole individual, physical, intellectual, social is adequately attained in colleges where such boys and girls live under the same roof, mingle in the same dining-room and classrooms and meet more or less frequently in social intercourse; or whether more satisfactory results in the production of the highest type of young men and women are more readily secured in institutions devoted exclusively to the education of one or other of the sexes. It is important to state the matter in this way because the

prevalent conception of what constitutes education has changed in recent
years. The aim, it is now recognized, is not simply to impart information,
however important that may be, but to insure the fullest and best develop-
ment of character and personality.[152]

The sexism of the report became more flagrant: 'Now there are
qualities of personality which we aim at developing in boys quite differ-
ent from those which a true education seeks to produce in girls. The
femininity which is admirable in girls is contemptible in boys. It is
scarcely to be expected, therefore, that a mixed school of boys and girls,
living and being taught under the same conditions, will be able to do
justice to the natural call for discrimination in ideals.'

Aside from the distractions that resulted from a mingling of the sexes,
then, there was deemed to be a threat to masculinity: 'One of the most
desirable qualities to be developed in boys is "masculinity," and it is
argued that while in maturer years the companionship of young women
is desirable and necessary, yet in boys of the adolescent age association
with girls is liable to produce effeminacy. In other words, the system we
are discussing hinders boys in the development of distinctively "manly"
traits of character.'[153] Of course, 'effeminacy' was a highly loaded term.
Its usage here accentuates the assumed link between character develop-
ment and masculinity. But the charge of effeminacy sometimes also
encoded a racial bias against those who were descended from southern
stock.[154] Moreover, accusations of effeminacy were frequently levelled
against European models. In all these contexts, the threat to virility
appears to have been an underlying concern.

The report argued that male teachers were necessary for boys, and
female teachers for girls. 'It is usually found also that in such institutions
one strongminded individual dominates the situation and that the influ-
ence of the place therefore tends to masculinity or femininity, as the case
may be, but not to both.' This statement illuminates the emphasis on
individualism in the report's conception of character and reveals the
commission's project as a determined rear-guard effort to contain the
forces working to efface personal autonomy in modern society. While
not necessarily an ill-advised priority, the issue of autonomy was under-
stood to be of particular relevance for males. On these grounds, the
commissioners were unanimous in their opposition to co-education.[155]

The commission also made gendered assumptions about vocational
training for male and female students. As noted above, the commission-
ers especially promoted home economics for girls. At Mount Allison

Ladies' College, the commissioners attributed lack of enrolment in house-hold science to poor equipment and facilities and seemed to be genu-inely bewildered by the fact that art and music were much more attractive to female students.[156]

It remains to determine what bearing, if any, the commission's gender bias had on its denigration of visual art, music, and elocution. The alignment that had developed between art training and female educa-tion cannot have escaped the commissioners' notice. As meagre as art training was in Canada at the turn of the twentieth century (after all, that was why so many Canadian artists of the period went to study in Paris), one of its venues was the ladies' college. Prior to the 1880s, the study of art, particularly for women, was commonly situated in the context of 'the accomplishments.' It was aimed at girls from families of comfortable means who sought amusing ways to spend their leisure time and who desired to enhance their caché as a spouse. In the later nineteenth century, those to whom this type of education was available expanded in number. As well, by the 1880s and 1890s, there was a move to develop the vocational applications of female artistic training.[157] Benjamin Fish Aus-tin, principal of Alma College, for example, argued that women's educa-tion in general needed to be more practical. In *Woman: Her Character, Calling, and Culture* (1890), he gave statistics on the vocational possibili-ties of art training for women.[158] Indeed, a demand for applied art helped to overcome some of the bias against fine art. This trend, how-ever, was patently ignored by the commission.

Even keeping in mind the commission's self-appointed mission to centre education in the liberal arts, it remains curious that it made no acknowledgment of the vocational possibilities of the arts for females. Surely it is possible to advocate a character-building education *and* ac-knowledge the place of vocational training. On the one occasion that it conceded usefulness to the study of visual art, it placed the subject in a gendered context: 'art training should be closely connected with house-hold decoration.'[159]

The commissioners' difficulty in validating the fine arts thus had sev-eral faces. They displayed absolutely no appreciation that learning in the field was enriching or inherently meaningful, let alone spiritually or morally elevating. They ignored any claim that the fine arts were liberal arts or had any relevance for character development. On the basis that the arts were primarily technical in nature, they relegated to the voca-tional realm music, painting, drawing, and elocution, which thus fell victim to the commission's anti-vocational sweep. As well, Methodist edu-

cation aligned the fine arts with female schooling. Not only did the commission remain insensitive to the prospect of women earning wages in the art field, but the affiliation with female education may have made the fine arts all the more easy to discount as ornamental and effeminate.

Certainly Massey's uneasiness about masculinity echoes a long-held bias against the fine arts, with specific reference to the issue of character. The Victorian archbishop Richard C. Trench, for example, asserted that painting, music, and sculpture were 'the ornamental fringe of a people's life, [and] can never, without loss of all manliness of character, be its main texture and woof.'[160]

With respect to gender issues and the fine arts, the report displayed attitudes that did a disservice to both. While women's education was striving to overcome its insubstantial character and become more grounded in a viable, wage-earning capacity, Massey and his colleagues were conducting an all-out war on the overly practical orientation of mainstream male education. While the commission was to be commended for trying to further an education system that yielded good citizens, not only efficient, unquestioning workers, and for elevating women's education from the so-called ornamental to the academic, its myopias illuminate some of the problematic attitudes towards the fine arts that then had currency. As chair of the commission, Massey must be held accountable for its outright denigration of the fine arts. This is particularly curious in light of Massey's growing personal involvement with the arts (chapter 3) and a signal of his conflicted, gendered, and transforming attitudes towards the parameters of culture.

The Commission of Nine and After

With the tabling of the report of the Massey Foundation Commission and its publication in early 1921, Vincent Massey's commitment to Methodist education did not end. The 37th annual report (1920–1) of the Educational Society of the Methodist Church of Canada undertook to further the commission's work by announcing appointment of a Commission of Nine.[161] As one of the nine, Massey attended a commission meeting on 4 November 1921, which articulated a set of principles for 'any college to which the church lends the prestige of its name, or gives direct financial support.'[162] The principles were largely a reiteration of the points made in Massey's report: first (moved by Massey), 'that religious education constitute a recognized subject of the curriculum under a specially qualified instructor' and, second, that all courses have a liberal arts education

as their foundation; and that 'commercial, technical or artistic subjects should be taken only as a part of the broader course.'[163]

The commission's interim report in late 1921 or early 1922, 'The Common Problem,' laid out nine basic principles and affirmed the church's broad educational stance. Quoting from resolutions passed at the church's Nova Scotia Conference in 1921, it stated the education gospel at its most unequivocal:

> The church exists to bring in the Kingdom of God ... The last two thousand years have shown that this will not come around either of itself or through the agency of exterior forces, natural or supernatural. It is evidently through man's own effort that the better day will come. *Religion has its greatest contribution to make through the process of education.* The student must be led to realize the presence, the power and the joy of God in his own heart, to form good habits and build up solid Christian character to establish a right outlook on life and find his place in society ... Not only must he be prepared for his own responsibilities as parent and citizen, but he must be encouraged to think things out for himself and to grapple with the vital social, political, economic and religious problems of the day (emphasis added).[164]

On one point the interim report departed from the earlier Massey recommendations; it reaffirmed the Methodist commitment to music in formal education. While agreeing that music should not be taught on its own, but rather in conjunction with liberal arts subjects, it stated: 'Music should be an optional subject in all courses and credit should be given for it. In the High School course for the Province of Alberta music may be substituted for Geometry, for Algebra, and for some other subjects ... Group singing should be taught to all students, and made an outstanding feature of the College life.'[165] Given Massey's lesser role in this second commission, we may conclude that this departure was not reflective of his views on music in formal education or that his views had changed since the Massey Foundation Commission report less than a year earlier.

Its penchant for creating commissions now established, the Methodist church in 1925 founded another commission on education, the Commission on Colleges and Higher Education, to address issues of upcoming church union as they pertained to educational institutions. While Vincent Massey was not a member, it reiterated many key points of his commission's 1921 report, even its phrasing. Further, it shed light on the rationale for Methodist involvement in the teaching of liberal arts at the university level: 'the experience at Victoria College shows that by possess-

ing an arts college the church is able to exercise a real and effective influence on higher Education, such as it could not have wielded had it not a direct voice in the determination of the educational policy of the Province.'[166]

Massey made at least one further effort to put educational renewal on the Methodist agenda. Shortly before the Massey Foundation Commission reported in early 1921, he urged A.E. Ames of the Methodist National Executive Committee to include education on a proposed survey of the entire workings of the church. Massey was elected an additional member of what became the Methodist Church Survey Commission,[167] but, much to his disappointment, the commission disbanded after issuing a couple of modest interim reports.[168]

Massey referred to his work in connection with Methodist educational policy in his memoirs in 1963 and noted perhaps rather bitterly that 'none of their [the Massey Foundation commissioners'] recommendations bore fruit.'[169] Despite the failure to find concordance, his views were deeply indebted to the Methodist faith in education. Whether Massey himself recognized the extent of this debt is unclear. The Massey Report stated: 'The prevalent conception of what constitutes education has changed in recent years. The aim, it is now recognized, is not simply to impart information, however important that may be, but to insure the fullest and best development of character and personality.'[170] As we have seen, however, character education was far from a novel concern in Methodist circles. In essence, the commissioners and their successors were attempting to reclaim education from what they perceived as creeping utilitarianism. The teaching of the liberal arts was deemed the surest protection from this fate.

Massey in his memoirs championed the independent school as progressive precisely because it 'ministered to the whole child in all aspects of his being.'[171] It is abundantly clear that he conflated the notion of 'the whole child' with study of the liberal arts. He understood the liberal arts, character education, and good citizenship to be the constituent elements of culture, and he crusaded on their behalf throughout his career. However, the fine arts had little enough cultural import for Massey at this stage that he was quite prepared to marginalize and even sever them from the Methodist school curriculum. Nevertheless, as culture supplanted conversion in the Methodist faith, so Vincent Massey by 1921 had become a passionate advocate for the cause of culture.

2

A National Platform for Education, 1920–1926

By the late 1910s, the education gospel had reached climactic proportions. Despite being a provincial responsibility under the British North America Act, 1867, education became increasingly intertwined with notions of Canadian citizenship.[1] For some, the education gospel promised to be nothing short of Canada's salvation as a nation. One of the formations to which this conviction gave rise was the National Council of Education (NCE), a private body launched in Winnipeg in late 1919 to foster citizenship through education. Massey was a senior officer between 1920 and 1926 and, as such, was well positioned to steer a variety of educational initiatives – lectures, publications, conferences – as well as further develop his views on the role of culture in Canadian citizenship.

In 1920, as the council was taking shape, Massey was advancing his education agenda on several fronts, from his involvement in the newly opened Hart House, through his plunge into reform of Methodist secondary schools and colleges (both examined in chapter 1), to an abortive foray into renewal of public primary and secondary schools. On the last front, he and his brother-in-law William L. Grant, principal of Upper Canada College, Toronto, met Premier E.C. Drury in January 1920 to propose a survey of public schools throughout Ontario. In a letter to Drury on 14 February, Massey wrote: 'I think I am right in saying that there has been no such 'stock-taking' of our educational system since the time of Egerton Ryerson.' Determined to make his mark on Canadian life in education reform,[2] Massey may have fancied himself a successor to Ryerson. He added that, if the provincial government established its own commission, he would withdraw his proposal, which he made on behalf of the Massey Foundation. He put forward a complete roster of commis-

sioners' names, including his own, and undertook that the foundation would assume all expenses.[3]

After tentatively accepting the proposal, however, the government turned it down. Massey attributed this failure to the 'forces of darkness,' to unspecified resistance within the Department of Education, and to suspicions about private interest. He took some satisfaction none the less from having drawn attention to education reform and having anticipated 'a public inquiry into our educational system.' He was also heartened by having established 'in the public mind, that the [Massey] Foundation definitely exists for public service.'[4]

The Winnipeg Conference and the NCE

In 1920, another educational project meanwhile appeared on the horizon, attracting Massey's considerable vision, energy, and resources – the National Council of Education (NCE). In a field where the federal government was conspicuously absent, this organization undertook the monumental task of creating a national forum on education. An expression of the desperate need to rebuild and renew society in the wake of the 'moral disaster' of the First World War, the council blamed 'the disruption of civilisation' on the 'lack of character education among the nations.'[5] According to W.J. Bulman, one of the originators, the organization was founded in the belief that 'the character of this country could be modelled in the public schools of this country.'[6]

The NCE's interest in fostering good citizenship served a host of agendas. Alf Chaiton has situated its origins within the social unrest surrounding labour relations in the west in the late 1910s and a fear of socialism. Certainly, the council's initial support was rooted in a business agenda, as is suggested by its early backing from the Rotary Club. It became a forum, however, for educators, theologians, and lay people of various political and ideological stripes. Its steadfast commitment to a liberal arts education runs counter to Chaiton's assertion that it promoted vocational and technical training in schools in order to augment the ranks of skilled factory workers.[7] Its creation was in fact driven by various fears of disruption – the threatening postwar collapse of democracy, the effects of immigration, the rise of socialism, and growing Americanization.

Character education, the leitmotif of the NCE, not only emphasized developing the 'whole' person but promoted an organic, cohesive society. In the words of Lieutenant-Governor Sir James Aikins, an early

sponsor of the council: 'No democratic nation can make headway or attain greatness which permits its people to grow apart from each other by being divided into classes distinct and mutually exclusive. No such nation can succeed and allow itself to be dominated by a class of wealth, a group of labour, a union of farmers, an assembly of athletes, a society of intellectuals, or a body of religionists.'[8] The hope was that character education would overcome fragmentation of various sorts, from over-specialization to social and regional division – in essence, to restore balance. To some people, it was undoubtedly a tool for blunting dissent, for deflecting workers' discontent and quieting sectionalism. For others, it promised to foster understanding and tolerance and thereby strengthen democracy and a sense of community. For Massey, character education entailed both moral responsibility and intellectual empowerment. A liberal arts education, he believed, cultivated not only moral substance but also critical thinking and a breadth of vision. He would steer the council towards a view of education as enablement, not submissiveness, trusting that the individual was capable of free thought and of applying it disinterestedly. Character education, in his view, was the source of a genuinely cohesive society.

The NCE was a direct outcome of the National Conference on Character Education in Relation to Canadian Citizenship, held in Winnipeg from 20 to 22 October 1919. Drawing its membership from some forty cities and towns across Canada, the conference boasted over fifteen hundred delegates, while audience attendance rose to five thousand at one session. According to the accompanying report, the conference attested to 'the large body of opinion favourable to the stressing of what may be called the National and Spiritual aspects of Canadian Education.'[9] The council later claimed: 'That meeting displayed on a scale never before equalled in this country, the passionate desire felt by the people of Canada for Ideality in Education.'[10]

A centrepiece of the conference's first day was an address, 'The Education of National Character,' delivered by the president of the University of Toronto, Sir Robert Falconer. An ordained Presbyterian minister, he was an active organizer of the early NCE and a close associate of Vincent Massey's.[11] He began unequivocally: 'The doctrine that the State is a non-moral institution is dead. That was the theory of the Prussian professors. The war has killed it ... Men were found in our midst bold enough to argue that the State stands by itself in a position in which the distinctions of right and wrong do not apply; that expediency alone is to be

taken into account ... But that is not the principle of Democracy ... It is a mischievous fiction that men can be unselfish in the home and honest in business, but when they vote or act for the State they may be dishonest or grasping.'[12]

Falconer asked, given the diversity of moral standards, religions, and points of view within a citizenry, 'is it possible that in such a state there should be common moral action?' He believed that it was, reverting to the argument that '[Anglo-Saxon Canadians] are a matter-of-fact people who work out our fortunes in an experimental way ... ; what we are is the result of a long process of education of the will rather than of the intellect.'[13] Falconer's bias in favour of northerners has been noted elsewhere.[14]

While insisting that he was not recommending that 'language or science ... be taught primarily so as to inculcate morals,' he stressed the character of the teacher in the formation of the student. He also argued that 'men and women who think for themselves make the best members of our democracies, for they may be trusted to act according to our national character, and they will adopt a reasonable attitude towards life.' The phrase 'trusted to act' conveyed the underlying fear of extremes and instability. But the passage connected critical thought and reasonableness – always a touchstone for Massey.

The notion of independent thought must, of course, be qualified. For Falconer, it meant not being vulnerable to the inculcation of undesirable views, such as those emanating from the Soviet Union, which he specifically mentioned, or from American consumer society. He was not merely a mouthpiece, however, for the status quo. He stressed the need for social justice, greater labour influence in industry, and better wages. He acknowledged that there was no one moral law to follow; codes of behaviour were being 'constantly defined and clarified by the hard experience of humanity.' None the less, he maintained, 'the moral law that has fashioned our national character is embodied in our literature, history and political institutions, and the education of our children is not complete unless they have some comprehension of our heritage.'[15]

Falconer's address set the stage for the conference and the council to which it gave birth. Various speakers from Canada, the United States, and Britain enlarged on its central theme. The titles of their addresses convey some of the flavour: 'Moral and Spiritual Lessons of the War for Canadian Education' (Major the Rev. C.W. Gordon); 'The School and the Development of Moral Purpose' (Dr Theodore Soares, University of

Chicago); 'The Function of the Public School in Character Formation' (J.F. White, principal, Normal School, Ottawa); 'The Right of the State to Concern Itself with Character Education' (Dr Milton Fairchild, National Institution for Moral Instruction, Washington, DC); and 'The School and Newer Citizens of Canada' (Dr J.T.M. Anderson, director of education among new Canadians, Regina). One speaker stated baldly: 'The School should serve the Nation' and urged that Canada's schools be nationalized. An educator from the Ontario Board of Education, Dr Helen MacMurchy, struck a rather isolated note, arguing that 'the natural culture of many children is some form of artistic or creative work,' just as for others it is science or literature.[16]

The conference concluded with a resolution to form the National Council of Education. Although Massey did not attend the conference,[17] by January 1920 he was well apprised of its goals and had agreed to become a member.[18] As early as 17 March 1920, on letterhead that still read 'National Conference on Moral Education in the Schools in Relation to Canadian Citizenship,' W.J. Bulman wrote to Massey about the absence of a person effectively in charge of the organization.[19] Massey was soon chosen one of three vice-presidents[20] and by November 1921 was chair of the Conference Committee organizing the council's next major event, the Toronto conference in 1923.

Vice-President, 1920–1923

The first initiative to which Massey turned was creation of a national clearing-house for information about education – a 'National Bureau of Education.' In May 1921, Massey wrote optimistically to Major F.J. Ney, the council's general secretary: 'As to the National Bureau. I think this will probably be our most striking achievement ... To get Government officials in Canada, to meet together is in itself an achievement, but to bring the various Provincial officials to the point of financial support of an agency for the co-ordination of their own efforts, is a truly remarkable performance.'[21]

The subject was tabled at the Canadian Conference of Ministers of Education, held 30 October–1 November 1922 in Toronto. Four members of the National Council of Education were present: Vice-President Vincent Massey, Sir Robert Falconer, Rev. Canon Cody, and Major F.J. Ney. Massey spoke: 'There is no question that education, as a subject, important as it always has been, is pressing itself on public attention

more strongly than ever before.' He referred to the increasing 'dissolution of society' and observed: 'It is almost overwhelming to conjecture what would happen if a nation's electorate could be brought, through the perfectly possible processes of education, to adopt a critical attitude towards what they see in print.'[22]

Massey expressed the opinion that until recently education had lost its way, but there was now 'a ferment of experimentation in every field.' As the report of the Massey Foundation Commission had stated, there was a new concern with character education; merely disseminating information was no longer adequate. He also acknowledged, in one of his earliest remarks of its kind, a concern for 'the relation of art and the drama to education.' The growth and complexity in education, he argued, called urgently for co-operation and exchange among the provinces. An interprovincial bureau of education would strengthen the national spirit of the country.

Massey situated the task in the context of deflecting excessive American influence: 'We have a next-door neighbour twelve times as powerful as we. There is much we can learn from her, and I hope much we can teach her, but the danger is that we should unthinkingly and unquestioningly assimilate ourselves to her ideas, forgetting that we have our own traditions, which I am arrogant enough to think are just a little superior.' He concluded: 'On the Continent of Europe, nationality is kept alive by armies and tariffs. In Canada, we can win our nationality by the use of a greater and more enduring weapon – education.'[23]

Massey and Falconer put forward a resolution that the provinces create a national bureau of education, representing both languages; it would collect and publish reports on educational problems and developments in the provinces, the Dominion, and the British Empire.[24] The ministers agreed to give the matter consideration but made no commitment.

The NCE continued to lobby for a national clearing-house. A council bulletin declared: 'Canada's problem of citizenship is a peculiar one, for her leaders are anxious that in its evolution she may be successful in those very aspects in which her neighbour to the South has failed. If her Citizenship is to be safeguarded against superficiality, then she must develop a standard of living and life which must make its appeal to all those who come to her from other lands, of first and foremost importance. Here must be no bludgeoning or dragooning – the citizenship now being built must stand upon its own merits. ... In the

development of this Citizenship, the Educational Ideal stands out as of vital importance.'[25]

The bulletin mentioned thirty years of efforts to set up a national bureau of education similar to one in Washington. But because the BNA Act assigned education to the provinces, the effort had failed. Canada did not have a federal department concerned with education, nor even a national educational journal. The council reported with chagrin Canada's reliance on the American bureau (established 1867). Meanwhile, it noted, interest in international educational exchange was mounting. For three years, the Institute of International Education had been operating in the United States. Australia was in favour of a Commonwealth clearing-house for education.

Nevertheless, in 1926, at Canada's Third Triennial Conference of Education and Citizenship in Montreal, Massey, by then outgoing president of the NCE, conceded defeat on this score.[26] In his memoirs, *What's Past Is Prologue,* he reiterated his conviction that it had been feasible to create a bureau 'on a national basis, non-governmental and unofficial ... without an infringement of any provincial prerogatives,' but the effort failed in part 'because of a feeling of apprehension among certain provinces that the field of education might be confronted with federal intervention.'[27]

Wrestling with this impasse gave Massey a deep appreciation of the forces working against a national system of education in Canada, or even national mechanisms in education. It profoundly informed his understanding of the obstacles that stymied national unity and enhanced his grasp of the role of informal education, less clearly a provincial responsibility, in framing Canadian culture. This theme was to resurface in his work – most notably in the royal commission that he chaired 1949–51 (chapter 6).

As the NCE's attempts to form a national bureau of education languished, the council itself assumed some of the duties that it had sought to have adopted by an interprovincial body. It began to provide basic, reliable information on education in response to countless inquiries from provincial boards of education and others. It was asked to recommend history texts and music readers, to provide information on curricula in various disciplines, and to send out copies of reports on education to interested individuals and groups across Canada.[28] Its music department in particular became a major source for data on school music of all sorts.[29]

As vice-president, Massey was also active in organizing the council's next conference, slated for Toronto in 1923. Planning ran into a major stumbling block, however, in the summer of 1922. Massey had assumed that the Rotary Club was underwriting the anticipated costs of $25,000 to $30,000. When this proved not to be the case, he recommended postponing the event indefinitely and concentrating on the 'popularization of education.'[30]

In early July, however, he had a change of heart. He wrote to Rev. E. Leslie Pigeon, honorary treasurer of the council, in Winnipeg: 'The National Council of Education must not be allowed to die, and I for one am willing to do everything in my power to keep it going. The conference may well be essential to the Council's continued existence.'[31] He proposed holding a conference in April 1923, with a more modest budget of $5,000 to $10,000 and 1,000–1,200 delegates.[32] He advised Ney that there would be three speakers – Sir Henry Newbolt, Sir Michael Sadler, and Albert Mansbridge.[33] He had already committed Newbolt. 'This smaller conference,' he added, 'would be quite as impressive as the educational three ring circus we have been planning. Personality, as a matter of fact, counts much more than machinery and these men would be a splendid trio.'[34]

Massey set about placing the conference on a firm foundation. He wrote in October 1922 to R.Y. Eaton of the T. Eaton Co., Ltd, to solicit his support: 'The purpose of the Conference is to awaken a wider interest in education in the fullest sense of the word, to bring the layman into touch with educational problems, and to assist, by the publicity of the Conference, the work of various educational organizations, both governmental and private.'[35] Eaton joined the local organizing committee, which already included, in addition to W.L. Grant, Canon Cody, Professor J.A. Dale, and Sir Robert Falconer, all of the University of Toronto.

In preparation for the conference, the NCE published a series of booklets, intended for a wide audience.[36] A 1922 booklet made the following plea: '"The corporate sense which moved Canada to federation, the spirit which moved her during the war, is now invoked to make her one in education" – not by centralization of authority, nor by uniformity of system but by co-operation of effort towards a common ideal. ... Materially we have progressed but the road along which we have marched forward has taken the Art out of life and made it a gloomy and uninteresting existence.'[37]

Through its publications, the council also began to enunciate what it considered to be first principles of education – that 'education is not a matter of "school" years; it is a process of life'; that 'in the vocation of

teaching, personality must be counted of greater worth than mere access of learning'; and that 'a new humanism must pervade and inform all study and all instruction.'

The council relied on a recent report by the British Board of Education – the Newbolt Report – on the teaching of English. It argued that a renewed commitment to 'an English humanism, including the study of literature, of history and of language ... might go far not only to ennoble the education of the industrial worker, but also to bridge the gulf between industry and culture.'[38]

Fourteen hundred delegates from across and outside Canada attended the Toronto conference,[39] which was held in April 1923 in cooperation with the Ontario Educational Association. Massey ensured that Massey Music Hall (another benefaction of Hart Massey, dating from 1894) was booked for Easter week;[40] it and Hart House were two of the event's main venues. The program included a morning and an afternoon session in French. A committee, chaired by Group of Seven member J.E.H. MacDonald and including artists F.H. Brigden and Arthur Lismer, the latter also an art educator, and J.A. Dale, organized a public exhibition in the University Examination Hall adjoining Convocation Hall, with catalogues apparently available. Copies of council publications, the Newbolt Report, and assorted other books were also distributed.

As chair of the Conference Committee, Massey formally welcomed delegates. He reaffirmed that 'the business of Canadian education is, in spite of geographical barriers and differences in language, to produce good Canadians.' He touched on the familiar theme that education was 'a full preparation for life ... ; boys and girls with well-equipped minds and underdeveloped characters constitute not an asset in the State, but a liability and even a menace.' He maintained that 'education was a spiritual process' and that 'education is everybody's business.'[41]

The conference, shaped by Massey, focused on history, geography, and literature. Gone was the concern with music, art, and cinema planned at an earlier stage probably at the instigation of the council's vigorous secretary, Fred Ney.[42] The Thursday program was devoted to 'the essential place of the language and its literature in Education' and to geography and history, while Friday's was given to the purpose of education as character development.[43]

President, 1923–1926

At the conclusion of the Toronto conference, Massey was elected president of the NCE. His ambitions for the council expanded quickly, and he

set about making organizational and policy changes. Effective January 1924, the council hired J.A. Dale, a professor of social services at Toronto and a former professor of education at McGill University.[44] He was responsible for the council's strictly educational functions, while Ney, whom Massey reduced to part-time employment, handled the more administrative duties, such as arrangements for the lectureship scheme and the next conference.

Massey and his committee also set about putting the NCE on a firmer financial footing, mostly by soliciting private donations, corporate and individual. Prior to 1923, funding came almost entirely from the Rotary Clubs of Manitoba, Saskatchewan, and Alberta.[45] But as the financial difficulties of the 1923 conference demonstrated, other sources were needed. The renewal of a grant from the Ontario government of $2,400 was secured, and Massey worked at persuading Quebec to give the council a similar amount.[46] From 1926 to 1934, the Massey Foundation donated annually to the council ($5,000 in 1927, 1930, and 1931; $3,000 in 1931, 1932, and 1933).[47] According to Chaiton, it was only through Vincent Massey, on behalf of the Massey Foundation, and one other individual that the council managed to survive financially during these years.[48]

Under Massey's presidency, the NCE launched a variety of initiatives – a national lectureship scheme, a report on education, and a series of books, as well as fostering links with the recently revived Canadian Clubs. Fred Ney had tabled the idea for a national lecture series as early as 1921, and Massey endorsed it with enthusiasm.[49] The first speaker, Sir Henry Newbolt, toured Canada from January to April 1923 and was a featured guest at the Toronto conference. Massey was very involved in the council's choice of speakers and their subject matter and was ever mindful of their nationality. He invited John Masefield to speak: 'It is impossible to tell you, in a letter, the significance such a visit as yours would have, not only in the cause of education, in the real sense, but also in its bearing on the spiritual link between Great Britain and Canada. We are sadly out of touch here with the best English thought. ... The only way to offset the influence of American materialism is to keep in personal touch with Great Britain which is still the centre of freedom, and where education still respects the individual.'[50] Massey revealed himself to be preoccupied with both individual and national autonomy, which he so obviously linked. Significantly, while he betrayed his deference to Britain's leadership in resisting advancing consumerism, unlike many of his contemporaries, he framed

issues of identity and sovereignty in a spiritual and cultural-educational context.

Under Massey's presidency, the council also sponsored J.L. Paton, high master of the Grammar School in Manchester, to tour Canada from October 1924 to June 1925 and report on the state of education in Canada. W.L. Grant wrote a letter to Paton introducing Massey as 'one of the few men in Canadian "big business" who has also a very urgent and enlightened sense of public duty.' The sympathy between Grant and Massey's ideas on education is striking. Grant explained to Paton that education was a provincial matter in Canada and that this had 'prevented our educational systems from becoming as great a force for nationality as one could wish.' He continued: 'I do not wish to paint too dark a picture; much has been done; ... if we wished to boast, we could fairly claim to be in many points superior to the United States; but an infinity still remains to do; especially in the way of developing a national spirit, and a spiritual nation.' He said that education in Canada ran the danger of being regarded as a '"side-show," the affair of officials and pedants, while the practical business man goes on to build up our industrial civilization.'[51]

In preparing his 'Report for the National Council of Education,' Paton visited every province and a sampling of secondary schools and universities. He met with both members of business and fellow teachers. In all, he claimed to find few signs of the 'Educational Awakening which has spread like a great tidal movement all over Europe, including Soviet Russia.' While he noted growth in the number of students and some exciting initiatives within the universities, he found the NCE to be one of the few symptoms of educational renewal.[52]

He expressed concern over the itinerancy and lack of training and experience of rural teachers and the dismal, even unhealthy, physical conditions in country schools. In adult education, he painted a bleak picture as well: 'I visited the Y.M.C.A.'s. I had heard that in [the] U.S.A. there were educational activities on a large scale carried out in the Y.M.C.A. The same is true in a few of the largest towns of Canada but only a few. In the ordinary Y.M.C.A. there was Physical Culture, there was some music. But there were no reading circles and practically no books; the spirit of learning was not there.' He praised the Chautauqua movement (see chapter 3) for its educational initiatives and the churches for their high-quality organs and 'excellent work in music in places where there is little cultured or aesthetic life.' He remarked with apparent surprise: 'In Regina I found there were in addition to the Church

Choirs several orchestras and a male voice choir – the Normal School also was doing great work in music. I was not, therefore, surprised to find that a Harp recital by Albert Salvi filled literally every seat in the largest Church in the City, every seat being specially booked beforehand. This growth in the appreciation of music has been immensely assisted by Broadcasting.'[53]

The NCE hosted an abundance of other British visitors and, more infrequently, American speakers. The latter, however, were not received without criticism. Apparently in regard to the 1924 visit of Dr John Finley – an editor of the *New York Times*, a former commissioner of education for New York state, and, in Massey's words, 'one of the most eminent educationists in the United States' – the deputy minister in Saskatchewan wrote disapprovingly: 'Personally I had hoped that the educational contact already established by the Council with English educators would be much further strengthened. The influence of American educationists whose higher training for many years was dominated by the German idea, has not been altogether a good thing for our Canadian educational institutions.'[54] This was a reference to what was perceived as the German and American emphasis on specialization and regimentation. Massey noted with satisfaction that the Canadian university had 'escaped the Teutonic influence which has perverted higher education in the United States.'[55]

By 1933, over eighty men and women 'distinguished in the Arts, in Science, in Education and in Public Affairs' had visited Canada under NCE auspices.[56] In this project, Massey was insistent that the lecture program join forces with the Association of Canadian Clubs, which needed 'poking up.' Partly to bring it closer to the 'geographical centre of the Canadian Club movement,' he relocated the council's headquarters from Winnipeg to Toronto.[57] Although, in this instance, Massey made what appeared to be a highly centralist gesture, he was not insensitive to the need for wider regional representation, particularly as his career matured.

Although the first Canadian Club dated from 1893, the association had been close to moribund during the war and early 1920s and was revived only in 1925 and 1926.[58] Massey reported in an open letter to council membership on 26 March 1924 that, following a resolution made at the Convention of Canadian Clubs in Victoria in 1923, a plan for co-operation between the two organizations was being developed, with Ney designated as the liaison.[59] Massey was persistent on this point. In a letter to Ney, well after his tenure as president was over but while he

still, in a sense, held the purse strings, he continued to press for this plan: 'One point I would bring up ... is the importance of co-ordination with the Canadian Clubs in the arrangement of speakers in Canada. You know my views about this.'[60] Ney was able to report that the reorganization had just been effected; both Graham Spry, hired as the association's national secretary in 1926 and soon to be a key player in the lobby for public broadcasting, and Katherine Evans, assistant secretary, were now members of the NCE's committee on lectures.[61]

In addition to running the lectureship program, the NCE commenced a series of books on educational matters. By hiring J.A. Dale, the council gained a general editor for all its publications. In an open letter to the membership on 26 March 1924, Massey explained that these books were an effort 'to approach the subjects from a Canadian standpoint, and also to reflect, as far as possible, the point of view of the layman.'[62] Massey was ever mindful of the need for wide dissemination of the education gospel, and he consistently resisted tendencies to couch discussions of education and culture in language that smacked of exclusivity.

The first of the council's book projects was *This Canada of Ours: An Introduction to Canadian Civics* (1926), by Charles Norris Cochrane and William Stewart Wallace of the University of Toronto. It followed on the heels of a report for the council by the University of Toronto, *Observations on the Teaching of History and Civics in Primary and Secondary Schools in Canada.*[63] Massey had long been a proponent of history and civics occupying a more central role in the public school curriculum. *This Canada of Ours* was not only a vehicle for disseminating basic information about how government in Canada worked, and about the role of Parliament, the cabinet, and the civil service, it also itemized the attributes of the good citizen. In an 'Introductory Letter' by L.A. DeWolfe, director of rural education for Nova Scotia, the reader (the book was obviously aimed at adolescents) was told that a 'good citizen' was an individual who was 'broad-minded, tolerant, honest, courteous, intelligent, optimistic, thrifty, reliable, helpful, punctual, humane, industrious, and in good health.'[64] While several of these so-called desirable qualities betray an extraordinary presumptuousness, tolerance occupies pride of place. While DeWolfe made it clear that he was concerned with inculcating good, non-disruptive behaviour in students, he argued, like Massey, on behalf of active citizenship, neither shy about voicing dissent nor indifferent to involvement in the political process. He also invoked the new League of Nations in his call 'to respect the rights of our neighbours the world over.'

Cochrane and Wallace expanded on these themes in a concluding chapter devoted to 'the good Canadian.' The individual's greatest sin, they maintained, was lack of political engagement; each person must develop 'an intelligent and active interest in the government of his country.' They advocated subscribing to at least two newspapers in an effort to arrive at an independent, non-partisan view of issues. They denigrated 'the arm-chair critic' and argued that each citizen must play an active role in public affairs, becoming 'perhaps a town councillor, or a member of Parliament, or perhaps a Cabinet Minister.' They added: 'It is always open to a young Canadian to aim even at the Prime Ministership of Canada.' They pointed to the existence of 'virtually universal suffrage' and 'the almost religious duty' of each man and woman to vote at every election.[65] They wrote of the possibility of reform as long as it was backed by the will of the majority and realized in accordance with the rule of law. They also urged involvement between elections in any of the vast array of benevolent societies, clubs, and other organizations that made life better for the greater community.

Finally, they reaffirmed the virtue of tolerance. 'The good Canadian can never be narrow-minded. In a country so vast and broken as ours, a country which has been settled by so many waves of immigration from so many different lands, we can unite in a common loyalty only if we are willing to recognize and respect our mutual differences.' Their next statement, however, chose only northern ethnic groups as examples: 'Celt and Saxon, French and British are separated by the gulfs of race, religion, and culture, and the records of their warfare with one another are visible all over the globe.' None the less, they valorized in principle a respect for difference. They wrote of the 'joint monument to Wolfe and Montcalm [that] stands as a symbol of reconciliation.' Cochrane and Wallace also articulated an argument that became a recurrent refrain for Massey: 'our very differences may prove to be an advantage, because we shall be for ever free from the danger and folly of trying to manufacture citizens of a single monotonous and standardized type, differing no more than if they had all been poured out of the same mould.'[66] Contrasting diversity and conformity became a theme of Canadian nationalism of the 1920s.

It was the aim of Massey and the NCE that schools use *This Canada of Ours* as an aid to teaching citizenship.[67] It was followed by a series of other council publications also intended for a wide audience: *The School Theatre*, by theatre director Roy Mitchell; *A Canadian Song Book* (1928), by Sir Ernest MacMillan, conductor, composer, and principal of the To-

ronto Conservatory of Music; and *Canadian Folk Songs (Old and New)* (1927), selected and translated by J. Murray Gibbon, publicity manager for the Canadian Pacific Railway (CPR) and noted folk art enthusiast.[68] All were launched under Massey's tenure as president; the three latter were a product of Massey's growing commitment to the promotion of Canadian arts – a subject examined in some detail in chapters 3 and 4.

The NCE's last major initiative involving Massey directly was the third triennial conference in Montreal 5–10 April 1926. Massey had strongly favoured that city as the site and had lobbied to secure greater representation from French-speaking Canada on the council. He invited Mgr C.N. Gariépy of the Université Laval, for example, to join the council and help it foster closer relations between anglophone and francophone Canada.[69]

In his presidential address to the Montreal National Conference on Education and Citizenship, Massey adopted diversity as his main theme. Pleased by the strong delegation from the west, he credited the prairies as 'the cradle of this movement,' noting that one of the great achievements of the 1919 conference had been the bringing together of representatives from east and west. He welcomed French-Canadian delegates in French and pointed out with obvious pride that the NCE was the first body to organize a fully bilingual conference on a national scale.[70]

He proceeded to speak with a certain eloquence on the subject of Canada's diversity:

We regard the two languages of this country, not as constituting a barrier between the peoples they represent, but rather as the enrichment of a common heritage. Canada is a diversified country possessing different races, religions, social cultures. One hears this diversity often spoken of as a regrettable fact. Could anything be more fundamentally wrong? Let us thank heaven for the diversities which save this country from a devastating uniformity, and in welcoming diversity let us remember that after all a nation is civilised in proportion to the sympathetic understanding with which it welcomes just such distinctions in language, customs, manners, frames of mind, that makes French and English-speaking Canada as different one from the other in one sense, as I believe they are united in fundamental things. The greatest peril in North America today is the menace of deadly uniformity and standardized common-placeness. I rejoice to think that there is one part of the continent which is proof against these dangers.

The diversified colours of the pattern running through the national fabric have a splendid meaning if we choose to discover it, and I like to

think ... that the National Council of Education, through such gatherings as this, helps us to acquire a true understanding and tolerant respect for these precious contrasts in colours and differences in form with which our Dominion is endowed.[71]

While Massey's idea of diversity had its limitations – mention of the First Nations' role in the Canadian community was conspicuously absent, for example – his conviction on the subject was apparent. His phrase 'the menace of deadly uniformity and standardized commonplaceness' was especially telling. This was a stock refrain among those who saw the rise of democracy as the rise of mediocrity, but Massey was arguing vigorously for a democracy that accommodated difference. He maintained that Canada's French–English polarity was a significant counterbalance to the threat of homogenization emanating from the United States. Massey was not alone in linking these two ideas in the mid-1920s; but he displayed a certain leadership in promoting pluralism, by giving an 'absolutely equal place to the two national languages.' Certainly by mid-decade he was a highly vocal advocate of French–English bilingualism for Canada.[72] And while he sought to find unity within Canada's sectionalism, he clearly viewed its ethnic and regional diversity as assets in the articulation of national character. Passivity and submissiveness contrasted with diversity and a vigorous sense of independence.

While the Montreal conference reaffirmed the council's traditional preoccupation with citizenship, it also signalled some new directions. Massey had set out some of his preliminary ideas for the conference in a letter to Fred Ney in June 1925: 'There are several big subjects which should provide the threads on which the whole conference can be strung. These, to my mind, are: (a) The relation of character to Canadian education. (b) the teaching of Canadian citizenship. (c) the drama as an educational force. (d) music as education. (e) the cinema as an educational force. (f) the teaching of geography.'[73] He considered (c), (d), and (f) three 'neglected or misused subjects of Canadian education' and (e) 'a great and pressing social problem.' In his address to the delegates, he ventured to ask: 'is it not possible that the moving picture theatre under wrong direction may be undoing much of what the school is striving to accomplish in the development of character?'[74] To the traditional triumvirate of 'educational forces' – school, church, and family – he now added film.

Massey's recognition of the role of the arts in the educational arsenal was a departure for him. He had long had an interest in the fine arts, but

not until the mid-1920s did he begin to regard their cultural significance as comparable to that of the liberal arts. This happened for a host of reasons, not least his awakening to the role of art in the service of character development, citizenship, and nationalism. It also resulted from his acute and hard-earned knowledge at the helm of the NCE about the resistance to formal education as a national forum. Increasingly Massey would pin his hopes on informal adult education, in which the fine arts were less reluctantly admitted.

NCE Postscript

At the 1926 conference, Massey took his leave as president of the NCE. There were many changes in his life at this time. He had resigned in October 1925 as president of the Massey-Harris farm-equipment business – a position that he had held since December 1921. He served briefly in the federal Liberal cabinet in the mid-twenties. The death of his father, Chester Massey, in 1926, had led to the upheaval of disposing of his estate. The same year, Massey was named Canada's first minister to the United States – a post that he held until 1930. He and Alice decided to relinquish their Toronto home at 71 Queen's Park Crescent, and in 1927 they resolved to establish a permanent base on a property near Port Hope, known as Batterwood, which they had owned since 1918.[75]

Massey continued to follow the NCE's activities, corresponding with Ney regularly from Washington and sustaining the Massey Foundation's financial support. In 1929, the council held a fourth triennial conference, in Victoria and Vancouver, attended by 2,900 delegates and 30,000 visitors. Ney wrote excitedly to Massey: 'it is being talked about as far afield as Berlin, Heidelberg and Geneva.'[76]

Among other themes, the conference of 1929 addressed the 'great and pressing social problem' of film and its relation to education and leisure. Massey wrote supportively about the conference's program to the NCE's new president, Henry Cockshutt.[77] The conference focused concern on a variety of issues, including the need for limits on the freedom of children to attend commercial moving pictures and film's virtual monopoly of adult education. Alarm was also expressed over foreign – that is, American – control of film distribution outside the United States, which arose and came into sharp focus during the 1920s. In this, Canada was joined by many other countries, some of which (not Canada) moved quickly to restrict exhibition of U.S. films.

In a statement that would have had Massey's wholehearted agreement,

and displayed striking prescience, Ney wrote: 'It may be urged that the world is moving rapidly towards internationalism ... but there is a world of difference between internationalism and the aggressive influence of any one nation. ... With over 20,000 theatres in that country [the United States] and 37,000 in foreign countries under this huge monopoly, it can and does ignore public sentiment and sets itself above all moral, intellectual and artistic standards.'[78] Among the outcomes of the conference were a council pamphlet written by Ney – *Canada and the Foreign Film* – and introduction of a 'Film Week' program to provide venues for 'pictures of international interest and artistic worth' and to stimulate public 'demand for a greater measure of [Canadian] control in this field of public education and entertainment.'[79]

While Massey did not attend the Victoria–Vancouver conference, he continued to support the council until early 1934,[80] when criticisms were received that it was supporting Fascist speakers through its 'Film Week' on German and Italian films.[81] The Massey Foundation withdrew its financial support also in 1934. Informing Ney of his resignation, Massey wrote: 'I still feel the National Council of Education has it in its power to make an important contribution to the life of Canada. Perhaps some of the activities which we discussed long ago, and which were abandoned, may one day be assumed [resumed?].'[82] The council, in the hands of Ney and subsequent presidents, had become more a booking agency for movies and theatrical events. Massey may still have been harking back to the days when the council had been a clear voice for national character and issues of citizenship.

Beyond the NCE: Education as a Crusade

Massey continued to promulgate his educational gospel throughout his career, to which his numerous addresses on the subject attest. His earliest public statement on education dates from 1922,[83] and was followed by a number of closely related speeches on the university and college.[84] Invariably he railed against the university churning out professionals with little regard for the person as a whole: 'Mass production is highly desirable in factories but it plays havoc with education.' He criticized an American university that offered courses in 'Buying for Home Furnishing,' 'Motion Picture Production,' and 'Wrestling.'[85] Such subjects devalued and diverted the central goal of the university – to provide a liberal arts education.

The model that most fostered a humanistic education at the university

level, in his view, was a system of colleges federated into a larger whole: 'I should like to make a plea for the small collegiate residential unit, (either as a separate college or not) where men living in intimacy can learn from each other as well as from books.'[86] As he explained to the Association of American Colleges in 1929, such a model existed in Canada. Something that began as the jealously guarded denominational school grew, unforeseen by its authors, into a federated university system in Toronto, Winnipeg, and most recently Halifax.[87] He commended such a system for giving 'the undergraduate the intimacy of a smaller academic community ... [and] participation in a tradition local enough to be realizable and natural. On the other hand,' he noted, 'the student is privileged to enjoy in full measure the life and facilities of a great university – its libraries, its laboratories, its festivities, and sports.'[88]

He valued the federated university for the same reason that he prized Canada's federal system of government and the Commonwealth; each respected local units within a larger context. As he wrote about 1950: 'We must recognize the fact that centralization is undemocratic, that it is contrary to the ancient Anglo-Saxon tradition of local government.'[89] Yet in the same text he asserted: 'Our education must be nationalized. A pedantic interpretation of Section 93 of the British North America Act[90] has given the provincial governments undisturbed possession of the educational sphere. Each province is a watertight compartment in so far as education is concerned. ... Even textbooks are locally produced. There is little correlation of effort between provinces and apparently little interchange of ideas ... In a country as geographically scattered as Canada sectionalism is the greatest danger.'[91] Although, during the 1920s, American influence supplanted sectionalism as, in Massey's view, Canada's 'greatest danger,' he was ever mindful of the tension between the local and the national and their need for mutual expression.

The collegial unit also fostered personal contact between teacher and student and among students. Massey argued that drawing out each child's 'diversified qualities' was accomplished only through the contact of one personality with another: 'In Scotland they had, in education something better than mass production, a system with the old *dominie* as its core, which turned out vigorous personalities possessing individual characteristics, sometimes forgivable eccentricities. We had something like the old Scotch schoolmaster here at one time, but through the years we have lost him; we have done something to *dehumanize* education and *standardize* it and *effeminize* it too, and we have let something go which somehow we must get back.'[92]

Again character was crucial, but in the sense more of individualism than of moral rectitude. He aligned it once more with manliness. The feminine was apparently less vigorously individualistic, more anemic, less able to resist the tyranny of standardization. Massey vested tremendous faith in the individual and feared loss of individuality. And yet he feared excessive individualism, as his concern with collegiality attested. He trusted neither the individual nor the group alone. The collegiate unit protected the individual from excessive self-interest, as well as from the effacement resulting from over-centralization. His uneasiness about feminization seems to have been entangled in this paradox. The collegial school unit was, at its most desirable, not co-educational, but male. As such, collegiality was animated, or countered, by virility.

In Massey's view, the Canadian university went a long way towards fostering the humanism that he championed. Among its distinguishing features, all of which compared favourably with the American university, were its thoroughness and greater degree of academic freedom. 'We have, I think, to thank the Scottish tradition for much of the relative vigour and thoroughness of the Canadian university, and the English colleges for the art of living and the humane attitude towards learning which they have transmitted.'[93]

The university was especially significant for Canadian nationalism because of its tolerance of difference: 'The university, with its tradition of forebearance and tolerance, with its detached, dispassionate search for truth, its disregard of external differences, should provide a forum where east and west, French and English, Labour and Capital, town and country, can meet, on a common and neutral ground, and exchange ideas there and learn mutual toleration.'[94] Central to Massey's belief was the possibility of fostering some degree of impartiality and thereby achieving concordance among diverse parts.

The holism of collegiate life and the humanism that it nurtured, be it at the secondary or at the university level, continued for Massey to have as its final goal the cultivation of character and citizenship. In a speech entitled 'Education and Nationality' from the mid-1920s, Massey stated plainly: 'Education when one gets down to the bottom of it is a very simple thing, and its primary job is to make human beings responsible, sensitive and intelligent members of society. In other words good citizens. Education is training for *citizenship*.' He added: 'But it is well to remember that the principle of *citizenship* cannot be taught boys and girls by the addition of a subject called *civics* to an already over-crowded curriculum. The notion of citizenship must be in the very warp and woof

of the school fabric; it must lie behind the teaching; it must permeate the curriculum and it must influence even the school sports.'[95] Again, in an address in 1929, he stated: 'Education, we all agree, must concern itself with the training of character ... There is no subject more fascinating than the subtle relation existing between school years and the citizenship which lies beyond.'[96] As late as the 1951 report of the Massey Commission, he reiterated a belief in the fundamental link between education and citizenship.[97]

For Massey, the notion of citizen spoke to membership both in the Canadian national unit and in a democracy. Democracy, like culture (even if defined only as a collection of codes), is a profoundly humanistic conception that prizes the worth of the individual as a place for creating meaning. But excessive individualism need not be the end product. Indeed, a humanistic education, Massey argued, saved society from just such an outcome, because it helped to vest in each citizen a sense of responsibility for the common good. It purported to foster an awareness of alternatives and moved the sense of the alien closer to the sense of self. The individual and the common were invariably poised as counterweights, as were the local and the national, and the national and the international – unity in diversity in ever-widening circles. Western thought since at least the late eighteenth century had sought meaning and relevance in so-called alien cultures and eras – that is, unity in diversity.[98] Very broadly, it is possible to observe in Massey's thought during the 1920s a growing weighting of the principle of diversity in this equation.

Massey commented frequently during this period on education and democracy. He took pride in the Canadian university as a democratic institution and as an agent in Canadian nationalism. Arguing that the universities were Canada's 'most peculiarly Canadian possessions,' because of their predominantly native faculty and student population, he pointed with satisfaction to their egalitarian make-up: 'Again, our universities are broadly Canadian in that their students represent the average native intelligence of the community. They are not necessarily picked men ... The universities of Canada represent no class because the Dominion has no classes ... The university therefore can but be representative of the nation as a whole, for the Canadian university is in a real sense the microcosm of the state.'[99]

Whether one accepts his view of Canadian society as classless, he makes his point in relation to, for example, the entrenched classism of England. He argued strenuously that education was everybody's busi-

ness and in this sense a truly democratic enterprise: 'Our education is one Government activity which touches every individual in Canada and what is more creates the Canada that is to be. We may say that our future is on the knees of the Gods – it lies in our schools.'[100]

In a later text, Massey elaborated his thoughts on education as a broadly democratic concern. He criticized Canadian education for not taking account of the 'special education of the prospective farmer or workingman' and for making no accommodation for the adult worker; he complained that 'High School education is not even free.'[101] There was 'no room in a new Canada for the employer who rejected the plan for tutorial classes for his workmen because it would make them discontented.'[102] He supported the widening of the educational web to include university extension programs.[103] He praised, for example, the Worker's Educational Association (WEA), founded in Britain in 1903 and active in Canada from 1918. Under Sir Robert Falconer's presidency of the University of Toronto, the WEA offered a selection of university courses modified and shortened to suit the labourer.[104] In the mid-1930s, the Massey Foundation sponsored a modest survey of adult education chaired by Vincent Massey and conducted by the WEA, of which Falconer was honorary president.[105]

Conversely, there were aspects of the university that Massey saw as antidemocratic, which criticism might seem prophetic today: 'Our universities are undemocratic in their control. The Boards are too often composed of "prominent citizens," pious benefactors, people of unquestioned respectability, whose very success in life unaided leads them to question the real value of education.' He asked: 'Can the universities be acquitted of the charge that they are placing too limited a construction on their duties? ... Its responsibilities do not end with an annual crop of B.A.'s, embryo professional men and Doctors of Philosophy. If democracy means anything it means that the stores of learning and of inspiration which the universities have in their gift must be carried far and wide. We must not be afraid of the bogy of popularizing learning.'[106]

In short, his education gospel embraced elementary and secondary schooling, public and private, the university, as well as informal and adult education. Education was pervasive, infiltrating every walk of life. Canada was at a cross-roads educationally and nationally, he believed, and must 'agree to a large devolution of authority ... The people must be trusted.'[107] Massey has frequently been accused of elitism, but at least in his views on the role of education in the life of the community and the nation, this is patently inaccurate. Quite justifiably, he could be labelled a populist.

Epilogue: Education and Canadian Sovereignty

The goal of Massey's broadly democratic enterprise was, as he stated in 1923, that 'our education and our nationality should have an intimate relationship.'[108] Education held both the promise of Canadian unity, in the face of regionalism and ethnic diversity, and the promise of Canadian sovereignty, in the face of internationalism and American pre-eminence in the world. As early as 1924, he tackled squarely the cultural domination threatened by the United States – a subject that was to be increasingly central to his thought:

> Sometimes people look on our relation to our neighbour as a rather hopeless one, leading as it does to the infiltration through very many media, of ideas, which would almost seem to be more than we could resist. Our magazines, those of the greatest circulation, come from the United States, as we all know. Our moving pictures are created in California. Our theatres are supplied from New York. And now, to add to the list of those vehicles of ideas other than our own, we have the radio, and our population is listening nightly to political speeches in capitals that are not ours, and to patriotic music from another land. It will be only a very robust kind of Canadianism that can withstand this influence, and it can be resisted only by such a revived consciousness as I am trying to suggest. Censorship will not work – that is a mechanical way, and the wrong way in which to conserve our institutions. Our national characteristics must be protected by our own aroused consciousness, by public opinion, and if public opinion cannot be moved, then the battle is not worth fighting.[109]

The fear of Canadian effacement is palpable here. Culture, understood as education, was the primary route to awakening the consciousness necessary to affirming Canada's unique system of values. In Massey's scheme, despite its lacunae, especially concerning gender, it was a system of values that was mindful of both the individual and the collective, that prized tolerance and diversity, that was predicated on the viability of non-partisanship, and that was broadly democratizing and empowering. In education, specifically a cultural education, where the humanities were the centrepiece and character development and good citizenship were the goals, lay the hope of a robust national identity. Massey stated: 'A Dominion-wide effort to nationalize our Education, to concentrate this potential force in one great purpose would give us the means to produce men and women who in the fullest sense of the word are Canadians.'[110]

During his term as president of the National Council of Education, and sounding like the Methodist that he had been raised, Massey referred to 'education as a crusade';[111] he might have described 'Canadian nationalism as a crusade.' For him, the two were inseparable.

PART TWO
Arts of Resistance

3

Becoming 'Art-Minded,' 1902–1930

In a 1930 speech, Vincent Massey commented: 'We [Canadians] are becoming more "art-minded."'[1] He was referring as much to himself as to others. Until the late 1920s, the arts played a modest, even minimal part in his understanding of culture. This was not unusual – recognition of fine art in Canada has been slow, ambiguous, even tortuous. Its validation has drawn strength from various sources, often ones that simultaneously and viscerally sought its repression.

The role of Protestantism's many denominations in this process is complex and begs to be sorted out. In Massey's case, Methodism was a seminal influence on his early views towards the arts. By the turn of the twentieth century, music and, to a lesser degree, painting had secured some measure of acceptance in Methodist thought. They were enlisted to the educational cause and were understood to serve a moral purpose.[2] Massey was indebted to both these principles; however, he came to draw a pivotal distinction between moral and moralizing art. He decided that art need not be propagandistic to serve society and that aesthetic discernment could improve and unite a community. It was his growing conviction that in art it was possible and desirable to transcend partisanship. It might be argued that he adopted a modified doctrine of 'art for art's sake,' which valued art for its typification of the absence of bias and its so-called universalism. The fine arts illuminated for him a path to excellence and, in excellence, both non-conformity and unity. By the late 1920s, he was dedicated to full recognition of the fine arts, lobbying for their inclusion in university degree programs and their integration into vocationalism and everyday life.

In his early years, Massey was actually 'barred' from the theatre.[3] He could itemize the few occasions when his father was persuaded to attend

the theatre: once to visit the opera; 'once to hear *Parsifal*, because it was a drama with a religious theme; once to the London Hippodrome, because it was not called a theatre ... ; and once to see one of Shakespeare's plays, which were acceptable as classics.'[4] Massey was well into his teens before he was allowed to set foot in a theatre, even though his younger brother Raymond went on to become a very successful stage and television actor, and Vincent, purportedly, an accomplished amateur one. At best, theatre was countenanced in a domestic and amateur context. His father, despite censuring professional theatre, was reputed to be masterful at charades.[5] The Massey home had a stage on the top floor, equipped with lights, a curtain, and dressing-rooms.[6] Dancing, however, ranked as an unmitigated vice. As Massey recalled, 'our family recognized no place in life for dancing, playing cards, tobacco, or alcohol in any form. Sunday was a day of unbroken austerity.'[7] These were the proscriptions of Methodism.

Methodist attitudes towards the arts were conflicted. A Primitive Methodist recounted that in the 1830s 'novel reading was a sin, and a fiddle was a terribly wicked thing. It was the devil's instrument to snare the young into dance; but the bass viol was not in the same category because consecrated to the service of God. Father never allowed us to sing songs, he considered them wicked.'[8] Conversely, the founders of Methodism were notably appreciative of music, and John Wesley's brother, Charles, was a distinguished hymn writer. In the late eighteenth century the established (Anglican) church in England had to contend with the loss of many members who were ostensibly drawn away by Methodist musical practice, which was novel for its secularity.[9]

In Canada, early Methodists had serious misgivings about singing in church. Nevertheless, they soon accepted choral music, which became a mainstay of their services and camp meetings, rivalling preaching in importance.[10] Unlike the Presbyterians, who long considered the organ 'a carnal instrument,' Canadian Methodists welcomed it as an accompaniment to choral music. Beginning in the mid-nineteenth century, Methodist churches eagerly sought to acquire pipe organs.[11] The role of instrumental music was also boosted by the advances of Salvation Army bands in Ontario.[12] In response, the Methodists formed bands to help with their own evangelistic campaigns. Conversion rates were high at revivals assisted by band music.[13]

Methodism's ambivalent embrace of the arts at some point became intertwined with its educational mission. As the report of the Massey

Foundation Commission in early 1921 revealed, the fine arts occupied a role in the Methodist school system sufficient to alarm Massey and his colleagues (chapter 1). Between 1884 and 1925, if we judge by the annual reports of the Methodist church's Educational Society, the growth of art education at its schools was startling. Obviously attitudes were changing. Moreover, Methodism encompassed an assortment of viewpoints and degrees of acceptance of the fine arts. Certainly among the most mystifying areas of Massey's thought were his attitudes towards the fine arts. While advocating the removal or reduction of music and art programs at Methodist schools and colleges in 1921, he simultaneously ensured that the fine arts occupied a secure place in his progeny, Hart House. For Massey, Methodist attitudes towards the arts were both a source of guidance and validation, and a heritage to overcome.

The Masseys, Chautauqua, and the Fine Arts

The Massey family ventured into the realm of the fine arts along various paths invariably with Methodism as its mentor. Vincent Massey's mother, Anna Vincent (1859–1903), an American by birth, was sent in 1880 to the Methodist school Centenary Collegiate Institute in Hackett's Town, New Jersey, where 'for two years she devoted herself to special courses in literature and music.' In later life, according to a memorial prepared by Nathanael Burwash, president of Victoria College, she was distinguished for 'the rich beauty and the harmony and good taste of all that had grown up under her hand in her delightful home.'[14]

Anna Vincent's half-brother, Bishop John Heyl Vincent, who became a close friend of the Massey family, enthusiastically sanctioned a Methodist embrace of the arts. General agent for the Methodist Episcopal Sunday School Union in the United States and editor 1865–88 of the *Sunday School Journal*, Vincent co-founded Chautauqua with fellow Methodist Lewis Miller in 1874.[15] Located on Lake Chautauqua in western New York State on the site of a former Methodist camp meeting ground, it was about a six-hour trip from Toronto at the turn of the century. Begun as a two-week summer school for Sunday school teachers, it soon became a leading force in adult education. Bishop Vincent sought to move beyond old-style revivalism and focused on educating the church community. He favoured culture over conversion, and culture very much included the fine arts, if only within clearly circumscribed boundaries.

Though a Methodist conception, from its earliest days Chautauqua boasted an all-denominational mandate. Chester Massey called Chautauqua 'the most international, and the most interdenominational thing in the world.'[16] It had a broad, populist vision of education and recognized 'the wide relations of biblical and Sunday-school work to general culture.'[17] The expansive mission of the movement was expressed in various statements by Bishop Vincent, notably in *The Chautauqua Movement* (1881). 'The whole of life is a school,' he declared. In a passage echoed frequently by his son George Vincent and his nephew Vincent Massey, he wrote: 'Education, once the peculiar privilege of the few, must in our best earthly estate become the valued possession of the many ... Chautauqua has therefore a message and a mission for the times. It exalts education, – the mental, social, moral, and religious culture ... of all, everywhere, without exception.'[18]

Underlying the commitment to education and the impetus to embrace all facets of life was the belief that leisure time must not be idle. As a visitor to Chautauqua observed: 'It has been the struggle of the world to get more leisure, but it was left for Chautauqua to show how to use it.'[19] Its founders and supporters firmly believed that life was not divisible into sacred and secular domains; all could be transformed to serve the sacred.

Bishop Vincent included aesthetic culture in his vision of education: 'So general a scheme of education must increase the refining and ennobling influence of home life ... giving the whole house an air of refinement; touching with artistic skill floors, walls, and windows; finding the right place and the right light for the right picture; putting the right book on shelf and table; furnishing a wider range of topics for home conversation; crowding out frivolity and gossip; removing sources of unrest and discontent at home.'[20] One shudders to think how 'right' was defined, but Vincent was progressive, relative to then-current Canadian attitudes towards the arts.

The arts flourished at Chautauqua. A music school was established in 1879. The Chautauqua Society for Fine Arts, set up in 1885, organized instruction in painting, sculpture, decorative arts and crafts, and, by 1907, the history of art; it also held art exhibitions. While theatre was long avoided, recitations and readings paved the way to the full staging of plays in the years before the First World War.[21]

The Massey family was involved with the New York Chautauqua from its inception.[22] As an early (perhaps founding) trustee, Hart Massey was intimately acquainted with its development, making periodic visits both

in his capacity as board member and with his family to the summer school. The family owned a cottage at Chautauqua, and it was at Chautauqua that Vincent Massey's parents met.[23] On Hart Massey's death in 1896, Chester became a Chautauqua trustee.[24]

Bishop Vincent looked to the Masseys as primary financial backers of the Hall of Christ, intended as the architectural centrepiece of the Chautauqua site. As he wrote to Hart Massey in 1895: 'It is to have a department devoted to all the pictures, engravings, photographs, which art now represents to the world setting forth the possible appearance and the works of Christ ... It is to be a place for an occasional, rare, rich, reverent, beautiful service of worship to the Christ.'[25] The Masseys contributed to the Hall of Christ and made other gifts of varying size, among them the Massey Memorial Organ and $1,000 for the Margaret P. Massey Scholarship in honour of Vincent Massey's stepmother.

As early as 1902, Vincent Massey, aged fifteen, referred to the family's visiting Chautuaqua in what was probably an annual event. His cousin and close friend Ruth Massey, daughter of his uncle Walter and Aunt Susan, was also present. He recorded seeing Bishop Vincent and cousin George Vincent, and attending sermons, lectures, a dramatic reading, Sunday school, and a Young People's Service conducted by his uncle.[26]

Raymond, Vincent Massey's brother, born in 1896 and younger by nine years, wrote in his memoirs that Chautauqua was the place 'where I got my first taste of the theatre when I was about nine.'[27] He credited Bishop Vincent with introducing him to the stage and described him as 'the first Methodist minister to approve of the theatre.' Raymond recalled how on the family's trip to Europe in 1903 – the fateful journey that brought his mother's death from appendicitis – they rendezvoused with Bishop Vincent in Switzerland. Anna Massey was eager to attend the theatre when they arrived in London. Bishop Vincent encouraged Chester Massey to relent and attend the opera: 'After all, Chester, you have all the great opera stars singing at Massey [Music] Hall. The only difference is that at Covent Garden they have scenery and costumes. You should see some Shakespeare in London, too.'[28] Bishop Vincent vowed that there would be professional performances of Shakespeare at Chautauqua. This happened in 1905, according to Raymond Massey, who recalled being 'one of a dozen youngsters who helped decorate the platform of the amphitheatre for the performances [there being no scenery].'[29]

In 1910 Chester Massey resigned his position as Chautauqua trustee because of his limited physical strength, and in June 1911 Vincent Massey replaced him.[30] In the wake of his new appointment, Massey

visited the Chautauqua summer school in 1911 with his father, step-
mother, brother Raymond, and aunts Lillian Massey Treble and Susan
Massey (Walter's wife). His first two days were taken up with board
work.[31] As a recent university graduate and now twenty-three, he brought
a discerning eye to the Chautauqua experience. 'I can't quite make up
my mind in regard to Chautauqua. In some ways it incorporates all the
faults of the U.S.A.: superficiality, Puritanism, misguided zeal, and a
general vulgarity ... So much of the culture lying about Chautauqua is of
such a piffling variety.' Around this time, he began to develop his cri-
tique of Puritanism, which became a significant theme of his writing and
addresses especially in the 1920s. He came to despise the use of art as
moral propaganda. His sexism also reared its head. He wrote with deri-
sion of the 'meek subdued males' in the audience.

The fact remained that Massey approved of Chautauqua's expansive
vision of education. 'It may have the seeds of greatness within it,' he
observed, praising its summer schools especially. He also found George
Vincent's presence 'an assuring sign.'[32] His cousin was president 1901–
11 of the Chautauqua Institution and subsequently honorary president.[33]
George Vincent went on to become president of the Rockefeller Foun-
dation (1917–29). Like his father, he had a popularizing approach to
education, which included a relative open-mindedness about the role of
the fine arts. The cousins George Vincent and Vincent Massey, each
versed in the Chautauqua model of education, later ran cultural founda-
tions – the Rockefeller Foundation and the Massey Foundation, respec-
tively. Both organizations were heavily mandated to work in the education
sector and, to varying degrees, supported the fine arts.[34] Massey relied
well into the late 1920s on his cousin's counsel in various educational
contexts.

His family's involvement in Chautauqua was symptomatic of its rela-
tively broad cultural stance, expressed in both the Massey workplace and
in public life in Toronto. Charles Massey, one of Hart and Elizabeth
Massey's six children,[35] played a leading role in promoting literature and
music at the Massey Manufacturing Company. He took over manage-
ment of the firm in 1871, when his father went into semi-retirement
because of ill-health. In 1875, the company launched a firm newspaper,
the *Massey Pictorial*, later *Massey's Illustrated*, which reached a circulation
of 70,000.[36] In 1896, as *Massey's Magazine*, it featured articles on agricul-
ture, sports, and the literary and fine arts, including such regular columns
as 'The Literary Kingdom' and 'The World of Art.' Poems and works of
fiction appeared, and Canadian content was featured.[37]

Another publishing initiative to which the company gave rise was the *Trip Hammer*, a monthly magazine that appeared from February 1885 to February 1886 before being absorbed into *Massey's Illustrated*.[38] A 'trip hammer,' it explained, striking an appropriately moralistic tone, was an instrument of precision and power intended to smash 'a thousand and one ['rampant'] evils.'[39] It claimed to 'quarrel with no man's religion. Desiring full liberty for ourselves in this particular, we accord to every man a like freedom.' But it warned, 'towards those who make their religion a cloak for selfish ends ... , we shall have no mercy.'[40]

The *Trip Hammer* was distinguished by the fact that it was produced by the company's employees. It claimed to be the first literary magazine in North America to be published by the employees of a business enterprise. Hart Massey's son Walter was none the less listed as its business manager. It does appear to have been financially independent of the company, covering its expenses through subscriptions, advertising, and the sale of woodcuts. It purported to be an experiment in enhancing the relationship between 'labour and knowledge' and sought to 'crush' the obstacles that beset 'the pathway of labor.' 'Knowledge' was used in the sense of a general education, including the literary arts, history, and music. There was some discussion of current social and political issues and, in one instance, a report on a particulary distasteful debate at the firm's Workman's Library Association on the subject of the character of Chinese people. The magazine remained impartial on the debate's resolution that Chinese immigration was 'detrimental to the interest of this country.'[41] On another occasion, towards the end of the journal's run, the Massey Manufacturing Company experienced its first labour strike. Ostensibly without taking sides, the magazine's editors dared to advance the cause of labour solidarity and the right to strike, as long as the strikers remained peaceful and the union conducted itself as an open shop.

The *Trip Hammer*'s primary focus, however, was promoting reading by encouraging subscribers to find time each day to sample from the rich legacies of fiction, poetry, and history. The magazine had a strong Christian bent, boasting articles by leading theologians including J.M. Buckley, prominent editor of the Methodist *Christian Advocate* (New York) and John Heyl Vincent, chancellor of Chautauqua University.[42] It also chronicled and encouraged the diverse company-fostered cultural activities of its employees. It announced the commencement of a night school for Massey employees, launched with the help of a local public school inspector and two teachers hired by the firm.[43] The journal

informed its readers that an adult Bible class was being started under the company's auspices.[44] It reported on the early organization and progress of the Workman's Library Association, for which the firm provided a comfortable and spacious reading room and library of books and periodicals, also available for circulation. The association aimed to surround its members 'with refining and inspiring influences to draw forth the good in their natures and lead them to overcome and suppress the evil.'[45] It was soon opened to adult family members of the workers and sponsored a variety of entertainments, including performances by the Glee Club and Orchestra, as well as piano, violin, flute and vocal solos, duets and quartets, recitations, readings, tableaux, and a charade in four acts representing the word 'incarcerate'(!).[46] Above all, the magazine was concerned with impressing on its constituents the virtues of 'uplift' – moral and intellectual – and the worth of time spent in its pursuit.

With the encouragement of Charles Massey,[47] the company also launched the Massey Cornet Band in 1881. By the mid-1880s, it had twenty-one members and boasted an expanding popular and classical repertoire. Concerts were held in either of two halls built for the purpose – one that seated 300 guests, the other, the Massey Memorial Hall, 800. The magazines, the musical groups, the Workman's Library Association, and other initiatives were all infused with the same optimistic conviction that invigorated Chautauqua: that education was at once elevating and democratizing.

But what texts were favoured by the company's library, the Workmen's Library Association, the Bible class, the night school, and the musical groups? How critical was their choice and to what extent did they admit dissenting opinion? Unquestionably the Company's stance and its cultural initiatives were, to a significant degree, patriarchal and racist, moralizing and often sanctimonious. Yet there was a partial commitment to ecumenism and a strong endorsement of education as classless. Modestly following Chautauqua's lead, Massey Manufacturing conceded that music and recitation had a role in this democritizing and ennobling process. Indeed, the firm's cultural activities placed it in the vanguard of the adult education movement that Chautauqua helped launch.

In 1894, Hart Massey carried the commitment to music beyond the family firm by giving to the city of Toronto the Massey Music Hall (later Massey Hall), a memorial to his son Charles (who died in 1884 aged 36) and a tribute to his love of music. Vincent Massey, age six, laid the foundation stone on 21 September 1893, and he attended the opening on 14 June 1894.[48] The hall seated over 3,000 people and was equipped

with a large, powerful organ and a spacious stage for orchestral and choral purposes.[49] It boasted state-of-the-art acoustics, ventilation, and sanitary facilities. Nothing like it existed in Toronto. During its first year, more than 350,000 people attended events in this new cultural centre.[50]

A brochure published on the occasion of the hall's opening indicated its perhaps unsurprising marriage of purpose: 'musical entertainments, evangelical, temperance and benevolent work, and such other uses as may be acceptable to the Trustees.'[51] Among the religious gatherings, the *Methodist Magazine and Review* singled out for comment 'the Moody evangelistic services, by which it was crowded twice a day for week after week,' and which were of particular interest to Hart Massey.[52] The deed of trust provided further that the space be used in the 'cultivation of good citizenship and patriotism.'[53] An echo of the authority of Chautauqua may also be found here. Vincent Massey's enterprising uncle Walter, so active in the cultural life of Massey Manufacturing, was closely involved in the planning, building, and finishing of Massey Music Hall and even in its early programming. He wrote to his brother Chester on 4 July 1894 at Chautauqua: 'I wish you would look into a few of the best lectures in Chautauqua while you are there to see how they would suit for the Popular Course I am mapping out [at Massey Music Hall] ... Possibly Bishop Vincent would be a good one for an opening lecture.' Walter Massey wrote with excitement about a dizzying range of possible speakers whom he was considering, from a Bishop Warren on astronomy, to Marian Holland, who conducted cooking experiments on stage, to lecturers on chemistry and electricity.[54] While he did not mention the fine arts, his zeal for enlightenment was sweeping.

Massey Hall by no means neglected its mandate for music, although theatre was pointedly absent and no provision was made for a curtain. The hall was launched with a three-day music festival, opening with a performance of the *Messiah* attended by the governor general, the Earl of Aberdeen. Among the organizations that applied to give concerts in the hall in its first year was the Toronto School of Music, Limited, which was affiliated with the University of Toronto. The author of the request complimented Hart Massey on his deep interest in music, 'educationally.'[55] Later, Massey Hall provided a home for the Toronto Conservatory Symphony Orchestra, founded in 1906,[56] and the Toronto Symphony Orchestra, founded in 1922, both supported by the Massey family. Vincent Massey would become president of the symphony in 1932.[57] The family's support of music also prompted its donation of organs to a

number of Methodist churches in Toronto and a carillon to Metropolitan Methodist Church.[58]

In many ways, Vincent Massey's 'fabulous uncle,' Walter Massey, played a more demonstrative role in his nephew's childhood than did his own father, who was limited by frail health.[59] His father, however, provided a model in at least one area of the fine arts, as a collector of paintings. 'The nearest approach to a hobby which he made was the collection of pictures,' Vincent Massey stated in a family chronicle, 'and his favourite haunt was the room he built to house them.'[60]

As early as 1903, Vincent recorded the Masseys' proclivity for visiting art galleries and dealers. On the occasion of their trip to Britain and the continent that year, he noted their rounds of galleries and museums. On 6 August, they went to the Mauritshuis Picture Gallery in The Hague in the morning, and his parents went to Scheveningen in the afternoon to visit the painter Jozef Israëls (1824–1911), leader of The Hague School of art.[61]

It is not clear how Chester Massey acquired his taste for painting or what role his wife Anna Vincent played in this regard. The family's collecting of paintings from The Hague School certainly antedated her death in 1903. Canadian collectors during the 1890s through the 1910s generally preferred foreign art. Scottish Protestants, prominent among the industrialists who had acquired wealth in the wake of Canada's transcontinental railway project, had infused a taste for The Hague School throughout much of the small but newly affluent collecting community. The historical and geographical affinities between Scotland and Holland were highly resonant during this period.[62] Chester Massey, though not of Scottish heritage, followed suit.

After his remarriage in 1907, Chester Massey and his second wife, Margaret, renovated their home at 519 Jarvis Street and created a spacious, skylit gallery–sitting room. A painted frieze by Gustav Hahn, dating from 1908, surmounted the rich fabric-covered walls. It was there that Chester Massey spent much time in the company of his collection of pictures; 'worshipping in comfort' was the phrase used by a *Toronto Saturday Night* reviewer in 1910.[63]

The collection was dominated by art from the Dutch School (Bernard Johannes Blommers, Jozef Israëls, Jacob Maris, Willem Maris, Albert Neuhuys, Willem Bastiaan Tholen, and Johannes Hendrik Weissenbruch), followed by the Barbizon School of French painters (Eugène Boudin, Camille Corot, Henri Harpignies, and Constant Troyon) and a few English works.[64] All three groups of pictures were invariably tame land-

scapes or domestic interiors. Among the figurative pieces were titles such as 'Children's Lunch,' 'Happy Hours,' and 'The Mother's Return,' genre works with a sentimental and moralizing tone. Finally, there were a very few Canadian works, notably by Frederic Bell-Smith, Lucius O'Brien, and Homer Watson. In short, Chester Massey's collection was very much the sort of 'brown,' foreign, domesticated assortment of paintings that the Group of Seven would rail against during the 1910s and 1920s in its quest for support from local collectors.

Chester Massey also commissioned various family portraits, among them one of Walter Massey for Victoria College and another of Elizabeth Massey, his mother, for the women's residence, Annesley Hall.[65] He also commissioned Robert Harris, best known for *The Fathers of Confederation* (1883–4), destroyed in the 1916 fire in the Parliament Buildings, to paint a portrait of his first wife, Anna Vincent.[66] In addition, Chester Massey put a small sum at Bishop Vincent's disposal to acquire prints, photographs, and reproductions of the life of Christ for the Hall of Christ at Chautauqua.[67] In 1908, he financially supported one William E. Dyer, visiting lecturer and 'general manager for Canada' of the American Tissot Society, who presented a lantern-slide lecture (perhaps at the Metropolitan Methodist Church) on J. James Tissot's Bible paintings before an audience made up heavily of pastors, associate pastors, and editors of church newspapers. The lecture, given in conjunction with an organ recital also sponsored by Chester Massey, was one in a series of similar events held during what Dyer refers to as 'Exhibition Week.'[68]

Chester Massey's interest in painting also led him to a role in the fledging Art Museum of Toronto. As early as 1898, *Massey's Magazine* had decried the lack of a public art gallery and museum in Toronto. It argued that commercial interests had too long prevailed and had received huge subsidies, while art and architecture had been allowed to languish.[69] In 1900, Massey was among those who helped to redress the situation as a founder of the Art Museum of Toronto (later the Art Gallery of Toronto and now the Art Gallery of Ontario).[70] He was a member of the Provisional Council of the Museum and on 18 May 1910, in recognition of his role as a founder, was elected a member of its permanent council.[71] Another founder and the first president was Byron E. Walker (Sir Edmund Walker as of 1910), who played a decisive role in the early development of the Art Museum of Toronto, the Royal Ontario Museum in Toronto, and the National Gallery of Canada in Ottawa and became a towering figure in the advancement of the arts in Canada in the first quarter of the century.[72] Chester Massey apparently relied on

Walker in some of his art purchases, and there are parallels between their collections.[73]

Lillian Treble, Vincent Massey's aunt, joined in her brother's penchant for collecting paintings. After her death in 1915, Chester Massey gave six of her works, including a Hague School piece by Willem Bastiaan Tholen, *The Arcade at The Hague*, and a work attributed to John Constable to the Art Museum of Toronto.[74]

The Massey family was also involved in the early development of the Royal Ontario Museum. The museum was intially conceived by Nathanael Burwash, president of Victoria College, and by Dr Charles Trick Currelly,[75] as a repository for the collection of artefacts amassed by missionaries trained at the college.[76] Currelly (a first cousin of Lillian Massey's husband, John M. Treble) was a graduate of Victoria College and a member of its Board of Regents and was encouraged by Burwash to pursue a career in biblical archaeology.[77] He became what fellow Victoria graduate Northrop Frye called a 'cultural missionary.'[78] By the time of Currelly's return from Egypt in 1905, he had concluded that the museum should be part of the University of Toronto as a whole. With the support of university board member Byron Walker,[79] he was authorized to make acquisitions on behalf of the planned museum. He was made first director (1914–46) of what became the Royal Ontario Museum of Archeology.[80]

Working closely with Currelly, the Massey family made a number of gifts to the early museum. During a visit to the Holy Land in 1888, Walter Massey acquired a collection of clay items in Jerusalem, which he subsequently donated. As well, Chester, as executor of the Hart Massey Estate, established, in co-operation with Currelly, a fund for the Walter Massey Biblical Collection. Middle Eastern artefacts that Currelly had been acquiring since 1907 entered the museum as the Walter Massey Collection.[81] Lillian Treble, her acquisitions guided by Currelly, donated approximately 180 items to the museum between 1908 and her death in 1916, notably a selection of Middle Eastern textiles.[82]

Thus various Masseys ventured into supporting the fine arts, but invariably within carefully circumscribed boundaries. They continued to regard drama and dance with suspicion, even outright hostility, but, consistent with their Methodist heritage, they esteemed music, especially choral and organ. When they collected pictures, it was usually with a didactic, moralizing, or religious purpose. It is probably significant that the artefacts donated by Walter and Lillian Massey to the Royal Ontario Museum came from the Christian Holy Land.

Under the influence of Chautauqua, its deep preoccupation with the constructive use of leisure, and the awareness that leisure was becoming a reality for greater numbers of people, the family tended to place its involvement in the arts in an educational context that verged on proselytizing. The public nature of its support of the fine arts was striking. Certainly Chester Massey relied on his collection of Dutch paintings to provide a personal haven for his delicate temperament, but equally characteristically the family's commitment to music and painting extended into the workplace and the community beyond. In so far as its members endorsed the fine arts, they viewed them as a source of moral edification and instruction, rather than of overt pleasure and entertainment. Of particular importance was their predilection, indebted to Methodism, to democratize access to the arts. While Vincent Massey long preserved a hierarchical view of the fine arts, placing them well below the liberal arts in cultural significance, there were foretastes here of an alternative view, which, as we see in the next section, evolved and underwent significant transformation during his university studies and through his involvement with the Arts and Letters Club, Toronto. This new view found expression in Hart House as we see later in this chapter, and culminated by the late 1920s in his deepened appreciation of the social, moral, and cultural implications of the fine arts.

Wider Horizons (1906–1913)

Vincent Massey's social and intellectual orbit expanded appreciably beyond his family circle with his enrolment at the University of Toronto in the autumn of 1906, although he continued to live in two rooms at the rear of his parents' home on Jarvis Street.[83] Biographical writing about Massey has stressed his interest in history. His history studies at the University of Toronto brought him under the tutelage of George Wrong, who 'had firmly established Canadian history as a major field of scholarship' by this time.[84] History was also Massey's chosen field as a master of arts candidate at Balliol College, Oxford, where he studied between 1911 and 1913. Massey was a lecturer in history 1913–15 at the University of Toronto.

Perhaps less recognized is the fact that Massey's undergraduate program in Toronto was a double major – an honours course in 'English and History with a modern option.'[85] The English honours program included the texts of cultural critic Matthew Arnold. By 1906–7, Arnold's *Culture and Anarchy* was listed as part of the university curriculum,[86] and

by 1909–10 the fourth-year English program also prescribed Arnold's essays 'Democracy,' 'Equality,' 'The Function of Criticism,' and 'The Study of Poetry.'[87] All are among Massey's collection of books, preserved at the Robertson Davies Library, Massey College, including two editions of *Culture and Anarchy*.[88]

Massey marked and occasionally annotated passages in his copies of Arnold's texts.[89] He singled out for approval many of Arnold's key points: that culture had a social function expressed in a 'love of our neighbour' and 'the noble aspiration to leave the world better and happier than we found it'; that culture was 'a study of perfection;' and that this perfection 'is a harmonious expansion of *all* the powers which make the beauty and worth of human nature, and is not consistent with the over-development of any one power at the expense of the rest.'

Arnold was unequivocal about the significance of culture. In *Culture and Anarchy*, he had set about inquiring into 'what culture really is, what good it can do ... [and] to find some plain grounds on which a faith in culture – both my own faith in it and the faith of others, – may rest securely.'[90] Arnold was uneasy about the English emphasis on morality to the exclusion of the intellectual and aesthetic functions and proposed a realignment of the moral basis of culture. While he recognized in Puritanism 'the strength and prominence of the moral fibre, which ... knits ... the genius and history of us English, and our American descendants across the Atlantic, to the genius and the history of the Hebrew people,' he sought to balance what he termed Hebraism and Hellenism. Hebraism represented moral verve, and Hellenism, beauty and knowledge. He blamed Puritanism (Hebraism) for the English devaluation of 'sweetness and light' (beauty and knowledge), in favour of moral rectitude and the useful. Too often, a narrowness that Arnold called philistinism governed: 'how generally, with how many of us, are the main concerns of life limited to these two: the concern for making money, and the concern for saving our souls!' What he prized about Hellenism was its essential 'impulse to the development of the whole man, to connecting and harmonising all parts of him, perfecting all, leaving none to their chance.'[91] For Arnold, the 'whole' person referred not only to the moral and intellectual capacities, but also to the aesthetic.

Through this book and, to a lesser degree, other of his writings, Arnold had a three-fold impact on the relationship between culture and the moral. First, he affirmed culture's moral purpose. Second, he moderated its moral purpose, by arguing for the greater validation of the intellectual and aesthetic. Third, he helped to redefine the moral as the

tireless pursuit of perfection. The disinterest that was required of an inquiring, exacting mind, one that maintained 'its independence of the practical spirit' and did not 'hurry on to the goal because of its practical importance,' did not sacrifice caring and concern. Rather such disinterestedness absented itself from self-interest in order to engage with the greater good.

Arnold's emphasis on culture as the cultivation of all faculties sounds not unlike Methodist language about educating the whole person. The extent to which Arnold's thought affected late-nineteenth- and early-twentieth-century Canadian Methodism, itself with a progressive undercurrent, remains to be explored.[92] None the less, Arnold placed far more emphasis on the aesthetic function than did traditional Methodism, integrating it more fully into his conception of the whole person. This point and his transformation of the idea of the moral function as a pursuit of excellence made a strong imprint on the young undergraduate. It was at this time that Massey began his own critique of Puritanism, which he equated with Methodism. Certainly, he concurred with Arnold that culture, in its ministering to the intellectual, moral, and aesthetic capacities, 'goes beyond religion, as religion is generally conceived by us.'[93]

As his markings of Arnold's text indicate, Massey also took an early interest in the role of the state in culture (still conceived primarily as education), although his own ideas on this subject did not take mature form until the 1940s. In his essay 'Democracy,' Arnold warned that if the middle classes 'will not seek the alliance of the State for their own elevation, if they go on exaggerating their spirit of individualism ... they will certainly *Americanise* it. They will rule it by their energy, but they will deteriorate it by their low ideas and want of culture.'[94] Massey singled out the latter part of this passage. He also found persuasive Arnold's defence of the French diffusion of culture throughout society, where 'the people, as distinguished from a wealthy refined class, most lives what we call a humane life, the life of civilised man.'[95]

Like Arnold, Massey sought to democratize culture, in the sense of making it widely available, and he was interested in how the state might further this end. Arnold, however, assumed that only a select few had the developed knowledge and taste to be the real arbiters of that culture. Arnold might be described as an elitist with regard to the agency of culture and a populist with regard to its recipiency. While Massey was indebted to Arnold's thought, and subscribed to the view that certain groups, particularly intellectuals and later artists, were best positioned as

agents of culture, his idea of culture grew to admit a much broader, more diverse base.

Massey's study of Arnold extended into his extracurricular activities. A reading club, the Seekers, or the Seven Seekers, formed during the 1908–9 school year, with friends Murray Wrong (son of Professor George Wrong) and Harold Tovell, was a forum for his expanding literary interests. There he read the poetry of Matthew Arnold.[96] He also joined the Letters Club, composed of about fifteen members, who met 'for the purpose of studying literature in an informal way.'[97] According to Arnold, literature was the high road to culture. In the study of literature, especially poetry, and especially poetry that is 'the best that has been written,' one honed one's critical and aesthetic skills. While the aesthetic function was gaining credibility for Massey because of Arnold's arguments, the fine arts remained, for now, peripheral to Massey's interest in literature.

In 1910 Massey conceived of a literary monthly magazine run by undergraduates at the University of Toronto.[98] The outcome was the *Arbor*, edited by Massey and five other students.[99] Inviting articles, correspondence, and opinions from every faculty and college, it viewed itself as a badly-needed 'unifying force' within the University.[100] Its first issue, in February 1910, led with an article contributed by Massey's cousin George E. Vincent entitled 'Culture and the College.' Sounding like his father, Bishop Vincent, and invoking aspects of the Chautauquan ideal, he warned: 'Unless liberal culture is conceived in a new spirit, it will survive merely as a means of aristocratic distinction for the sons and daughters of the rich and well-to-do ... Liberal culture is fast becoming a luxury rather than a necessity.' He added: 'Most unfortunate of all is the too prevalent belief that scholarship and culture are inconsistent with deep concern for the community, that they withdraw their possessors from the common life ... Liberal culture cannot exist in any true sense apart from physical science, vocation, the immediate present, the emotional side of life, devotion to the "common ideal."'[101] He urged a new merging of culture with the 'common life,' by which he meant not only social responsibility and vocationalism but specifically a wider, non-elite community.

Massey himself contributed a short piece entitled 'On Thinking and Its Suppression.' While his prevailing concerns continued to be literary, he ventured into the fine arts. As an illustration of the lack of independent thinking among students and society at large, he cited repressive attitudes towards the arts: 'we also have the habit of raising our eye-brows in well-bred disapproval when a man makes a fervent defence of a

favourite poet, or explains his theories on art.' Sounding appropriately Arnoldian, he added: 'This attitude is that of the Philistine and is eminently improper.'[102] One can only speculate as to the theories on art that Massey attempted to espouse at this stage in his life, but he once more couched the discussion in terms of virility. This lack of critical thinking, instead of being consistent with 'the virility of our young nation,' was more symptomatic of 'the decadence of old age.'[103]

In the following issue, Massey again dealt with art criticism. He complained of the lack of informed, discriminating commentary on the arts, describing it as 'a pitiable business.' A book-review was 'still largely influenced by the business-manager's blue pencil, and ... consequently reduced to a "very nice" notice or a synopsis of the book. Dramatic and musical comment seems also to be dominated by the box-office. Most things artistic are reduced to a dead level of uniformity.'[104] He clearly contrasted uniformity with excellence. One suspects that he also linked excellence with virility.

Another essay, 'A Note on Music,' whose authorship remains unidentified may well have been by Massey. The writer tackled the definition of culture, acknowledging the musical character of the Toronto community, but asking rhetorically whether 'the status of music in a community [is] a criterion of its culture? Surely, not," the reviewer replied; 'few will deny that in North America music is patronized to the neglect of the sister arts.' He bemoaned the widespread ignorance of painting and the 'feeble representation' of dramatic art. Describing music as a 'showy' and 'not inexpensive' art, he argued that 'modern artistic reproductions and the cheap editions of to-day have removed any excuse for our ignorance of pictures and books.' The author continued: 'Of course there is another rather obvious error regarding music. This art is vaguely understood to mean culture (we should perhaps spell it "culcher" in this sense) and it seems to be thought sometimes that the purchase of a piano will guide a family into a pleasant cultured path ... But music alone does not give us culture. Newman[105] has said something to the effect that stuffing birds and playing stringed instruments may be delightful amusements, but they do not constitute a liberal education.'[106] Here Massey (or one of his colleagues) was already displaying a determination to centre culture on the liberal arts; otherwise, it was mere pretence. But the author was also arguing for an expansion of the appreciation of the fine arts beyond Methodism's traditional preference for music and for wide accessibility to the visual arts.

During his college years, Massey also experienced wider travel, a broadening circle of associates, and greater exposure to the visual arts. During the summer of 1907, he travelled to Europe with Harold Tovell, son of a Methodist minister and future husband of cousin Ruth Massey (Walter's daughter).[107] Harold and Ruth Tovell, who met through Massey, and with whom Massey maintained a close friendship well into the 1920s,[108] became keen supporters of the fine arts as well.[109] Again in the summer of 1908, Massey made the pilgrimage to Europe, this time with school friend Douglas Mason. They made the rounds of art historic landmarks in Naples, Rome, Pompeii, Tivoli, and Venice. Massey described lying in the grass in the Borghese Gardens in Rome, reading English art critic John Ruskin for the afternoon.[110] On 24 July in Venice he noted: 'Am reading Ruskin assiduously – he is very good on Venice.'[111] This was probably *The Stones of Venice*, a sort of art travel book in three volumes.[112]

Ruskin had revolutionized the English-speaking appreciation of the visual function: seeing, or grasping exactingly with sight, was for him, the superior means of knowing and understanding the world.[113] He not only played a crucial role in the validation of visual art, he insisted that art was at base a moral and social enterprise. He was disgusted by increasingly mechanical systems of production and use of cheap materials and valued Gothic art for its communal and handcrafted character. Arguing that art was not the concern only of artists and connoisseurs, Ruskin stressed its public nature.[114] He adamantly opposed the growing 'art-for-art's sake' movement in England in the later nineteenth century, claiming that art had an urgent social mission – to deter a descent into atheism and utilitarianism. Whatever the specifics of his interest in Ruskin's thought, Massey's commitment to the fine arts would be premised increasingly on a belief that art had a high social and moral mission, though, unlike Ruskin's, not a didactic one.

By the time of his summer trips to Europe, Massey had an easy familiarity with the names and best-known achievements of the art of the Renaissance and later periods, although there is little evidence that he studied art formally.[115] He carried on the family habit of visiting artists' studios. In early August of 1908, he paid a visit to the London home of G.F. Watts, perhaps the most remarkable of England's High Victorian artists, and was entertained at tea by the artist's widow. He described the visit as 'the most important thing I did all summer ... The house breathes of Watts and his work and every pallette [*sic*] and brush are as he left them ... The walls [are] covered with pictures by the master himself.'[116]

He toured the National Gallery, renewing his acquaintance with works by Gainsborough, Reynolds, and Turner.[117]

Massey travelled to Europe again during the summer of 1909. In his diary in August, he noted: 'Charlie Currelly took me to tea at the house of Sir Lawrence Alma-Tadema [in London presumably]. It is quite the most remarkable place I have seen. Exquisite treasures of all kinds grouped together in perfect taste in a beautiful house built to the purpose.'[118] Currelly was a friend of Alma-Tadema, a High Victorian artist who specialized in paintings of archaeologically researched ancient Roman and Middle Eastern domestic interiors. Byron Walker also visited Alma-Tadema's residence in August that year, probably through Currelly.[119] Currelly was also close to Holman Hunt, one of the original Pre-Raphaelite Brotherhood of English painters, whom John Ruskin befriended and promoted.[120] By 1909, Currelly was well-connected in the London art and museum world and was in a position to help initiate the young Massey.

Back home, perhaps having made or renewed an acquaintance with Walker in London, Massey was introduced to his collection. 'What pictures he has!,' Massey wrote; 'everything in the house from the mantel pieces to the smallest vase show the most exquisite taste. Would that all business men were such connoisseurs.'[121] About this time, Massey also started his own art collection. In the summer of 1910, while an official delegate at the World Missionary Conference in Edinburgh, he went to London and 'invested rather heavily' in some etchings by James Abbott McNeill Whistler, among others, noting that he preferred etching to painting, because it had more feeling.[122]

In early January 1911, Massey made his first visit to what was becoming a focal point in the gathering art community of Toronto, the Arts and Letters Club. Founded in 1908 as a men's club for artists and others interested in the arts, it brought painters, writers, musicians, and architects together with members of the business community. Massey visited the club with Ralph Eden Smith, one of its founding members. He 'met many weird geniuses' but found it 'refreshing after the complacent Philistinism of most Toronto drawing-rooms.'[123] Later in the month he dined at the club with member Henry Sproatt, a partner in the architectural firm commissioned to design Burwash Hall and Hart House. They had 'a gloriously bohemian evening';[124] Massey decided to join the club and was admitted in February.[125]

The Arts and Letters Club, a breeding ground for the Toronto Symphony, the Mendelssohn Choir, the little theatre movement, and the

Group of Seven,[126] was seminal in Massey's expanding view of the arts. He met there many of the artists whose work he and Alice later collected, venturing to comment: '[if] it had not been for their association with this Club, the Group of Seven would probably never have emerged.'[127] It was through his association with the club that Massey's interest in theatre developed into a lively hobby during the 1910s.[128] Massey's friend Eden Smith was among those who were active in Toronto little theatre and belonged to the Arts and Letters Players; Massey was involved in at least one of its productions in 1917.[129] Under the leadership of Roy Mitchell, also a charter member of the club, the troupe became 'the foremost group in Toronto's amateur theatre' during the 1910s.[130] Future Group of Seven member Lawren Harris, another founder, and Arthur Lismer, who had been with the Sheffield Little Theatre in England, were both active in the club's dramatic efforts. The club confined itself to performing plays that had not previously been produced in Canada and, in many respects, leaned towards the experimental, especially in set design.[131]

In 1911–12, planning began for an adequate theatre space for the Arts and Letters Players, which hitherto had used 150 movable boxes as a stage in the club's quarters in the Old Assize Court House on Adelaide Street, Toronto. Eden Smith, an architect, designed 'a most ingenious little theatre and art gallery combined,' which incorporated an innovative system of lighting whereby the audience was lit 'in sympathy with the mood and atmosphere of the play.'[132] The project was 'well on its way,' according to Merrill Denison, when it had to be abandoned in 1914 with the outbreak of war.[133] It was eventually resuscitated with the club's removal to St George's Hall on Elm Street, by which time Massey was club president (1921). There a small stage was included, designed by architect Henry Sproatt. Denison maintained, however, that the activities of the Arts and Letters Players were largely absorbed by Hart House at the end of the 1910s.[134] Roy Mitchell became Hart House Theatre's first director, and Harris and Lismer worked there side by side with Massey. Certainly the many relationships that Massey forged at the club paved the way for the central role that the fine arts – music, theatre, and the visual arts – were to play at Hart House.

Hart House and the Fine Arts

Originally, there was little provision for the arts at Hart House, although, from the outset Massey viewed the building's architecture as crucial. As we saw in chapter 1, the Hart Massey Estate hired the Toronto firm

Sproatt and Rolph, specialists in the Collegiate Gothic idiom, to design both the male residence at Victoria College – Burwash Hall – and Hart House. As far back as 1895, Hart Massey had indicated his preference for Gothic architecture, encouraging John Heyl Vincent to adopt the style for his Chautauqua Hall of Christ.[135] Chester Massey in turn appears to have favoured a Gothic style and to have been a reader of Ruskin.[136] On Burwash Hall, Vincent Massey wrote in his diary in 1910: 'The building is going to be charming – Gothic in its very essence ... Sproatt and Rolph are geniuses at this style of work.'[137]

Gothic Revival architecture, and specifically Collegiate Gothic, had been employed in Canada since the mid-nineteenth century, valued for its associations with Christianity, England, morality, spirituality, and a pre-machine age. Sproatt himself, around the time of Hart House's opening, was asked by art critic Augustus Bridle how he was able to make the building's athletic functions conform with what Bridle called 'college Gothic mixed up with Tudor.' Sproatt replied: 'The whole building is a conformity. The essence of Gothic is to conform. All true Gothic grows out of necessity. We wanted to carry on tradition, at the same time to make it serve a Canadian purpose. The style grows out of need. The decoration conforms to the style. There's not a cubic foot of waste space in this House.'[138] Sproatt obviously prized Gothic for its highly organic or, as Paul Gary Russell has described it, 'mutable' character. Russell has emphasized the architect's debt to English social reformer and designer William Morris, referring to Hart House as 'the key monument ... of the Arts and Crafts aesthetic in Canada.'[139]

The extent to which Vincent Massey's own knowledge of Gothic architecture or his reading of Ruskin or Morris affected the style of the two university buildings is mere conjecture. Nonetheless, Russell argues plausibly that as a social conception, Hart House was indebted to the milieu of the Arts and Letters Club, itself 'in the Morrisian social mould.' Undoubtedly the moral and social import of Neo-Gothic art, not to mention the political implications of its association with England, escaped neither Massey nor his father.[140]

Massey commented tellingly about the interior design and decoration of Hart House. Acknowledging his wife's role in its furnishing, he stated: 'Both she and I felt very strongly that although every effort should be made to give the building beauty and distinction, this did not imply an atmosphere of luxury. The latter is too often confused in the public mind with the former. Luxury is an enervating thing, beauty ennobling and invigorating ... Most of the club rooms of Hart House are austere in

character.'[141] A commentator has described them as 'spartan' and 'monastic.'[142] The distinction that Massey drew between beauty and luxury surely echoes his concern with virility and moral uprightness. He referred further to the 'noble proportions' of the dining hall – , the 'Great Hall' – as a means to counteract 'sordid habits.' He once contrasted the behaviour of a group of schoolboys in 'some unlovely basement dining-room' with the same students 'in a dignified, well-proportioned hall – with lofty timbered roof and mullioned windows.' In the latter setting, 'their manners will improve and with their manners, the point of view of which manners are a natural expression.' In his words, 'physical environment is part of the equipment of education.'[143]

The development of the role of the fine arts in Hart House, meanwhile, is somewhat unclear. The first extant, very preliminary plan of the structure, published in the *Varsity* in March 1910, about two weeks after Chester Massey formally offered the gift to the university, allocated space only for athletics, the YMCA, a banquet hall, and a 'Gothic auditorium.' But as the conception of Hart House evolved and its actual construction took shape, it was modified to accommodate the fine arts.

Massey claimed that only a music room was planned originally.[144] Extracurricular musical activity at the university prior to the opening of Hart House, in fact, remains to be charted. In 1910 the *Varsity* commented that music had played a lively role early in the university's history but had since suffered a decline. It reported that only recently had the Glee Club been revived and in 1908 a University Orchestra finally established. It is perhaps not suprising that music found a ready home at Hart House, in keeping with the Massey's traditional support in this area. When a YMCA meeting in the music room called for a piano, the Massey Foundation purchased a concert grand on the condition that it would, if well used, become a permanent gift.[145] This initiative marked the beginning of a musical club, which held weekly recital/meetings on Wednesdays (later they were moved to Fridays). At its second meeting, the club resolved that 'all music of the kind known as "ragtime" be excluded from the piano.'[146]

Best known of the musical ventures associated with Hart House was the internationally renowned Hart House String Quartet, celebrated especially in the years between 1924 and 1934. Vincent and Alice Massey had a pivotal role in its formation and subsequent success, the Massey Foundation guaranteeing the four musicians' salaries.[147] But there were many other facets to the House's musical life, and invariably an educational agenda informed the programming, from the Sunday Concerts in

the Great Hall to Friday recitals in the second-floor music room. As Warden Burgon Bickersteth recounted: 'We avoided the word "educational" but the fact remains that these particular events did provide an opportunity to instruct the undergraduate informally in musical construction and history. I think of the brilliant recital Sir Ernest MacMillan gave on the architecture of music, playing Bach fugues and a Mozart sonata to illustrate his points.'[148]

The music room was also used on alternate Sundays for what became known as 'songsters' – informal choral evenings – led by oratorio singer Campbell McInnes.[149] These, too, became an educational opportunity. McInnes divided the hundred or more participants into two groups antiphonally. Two pianos – the Steinway and the upright – stood between them. The sheet music was projected onto two screens, and McInnes directed the signing, interspersing remarks about the music's history and composer. As Bickersteth wrote: 'it is not difficult to see what an immense influence this must have had on the undergraduates ...'[150] In support of its various musical endeavours, Hart House also built up a substantial reference collection of songbooks and slides.

Drama, too, became a vigorous branch of the Hart House cultural milieu, although the evidence concerning the origins of Hart House Theatre is somewhat contradictory. Massey stated unequivocally and frequently that, because construction of the building slowed due to the war, it became possible to incorporate certain 'afterthoughts.' He maintained, in a letter to a Warden Burgon Bickersteth years later, that only once the roof was on and the building enclosed did he and Alice decide to include 'the theatre and its adjoining equipment, the faculty union, the chapel and the sketch-room.'[151] In *What's Past Is Prologue*, he told an anecdote, often repeated since, about how the theatre came to exist. He and Alice were making one of their many visits to the Hart House site under construction. In the basement, beneath the quadrangle, was a huge, excavated, but unallocated space. 'The roof rested on well-proportioned arches, and at one end, the flanking supports and beams joining them resembled the proscenium of a theatre. We said to each other in almost one breath, could this be a theatre?'[152] In 1929, Massey elaborated: 'The architects were brought into consultation on the subject [of incorporating a theatre] and by a certain amount of readustment in existing quarters and further excavation, the theatre and its accessory quarters were made possible.'[153]

Even the architect, Henry Sproatt, in an interview published around the time that Hart House opened in 1919, perpetuated this version of

the story. Art critic Augustus Bridle having toured the new building with Sproatt and having arrived at the underground theatre, asked about the origins of its conception, commenting: 'Yes, I might have known there would be something half sinful to counteract the chapelette. But whereabouts on the ground plan is it?' Sproatt replied: 'It is – not. The theatre, like the chapel, was an after-thought to give scope to the Players' Club [a university dramatic group] ...'[154] The idea that the theatre was an afterthought was disseminated throughout the press coverage on the building's opening.

It is true that a theatre was not part of the original written proposal to the university, nor did it make an appearance in a preliminary plan published in March 1910. It was also not included in a detailed listing of the building's projected facilities in the 10 January 1911 issue of the *Varsity*. But as Martin Friedland has noted in his recent history of the University of Toronto, a theatre was included in the plans for Hart House before construction began.[155] It made its first appearance in a set of plans published in the July 1911 issue of the *University Monthly*. Here the theatre is situated in the building's basement, with an entrance from the south façade. By October 1911, the firm of Sproatt and Rolph had produced a set of detailed plans and working drawings that included a theatre spanning two floors – that is, the sub-basement and basement – with seating for 830 and with two entrances on the south, much as they were subsequently built – one became the theatre entrance, the other the stage entrance. It is true that the final theatre displays some later modifications. Seating was reduced to about 500 to accommodate a foyer, men's and women's cloakrooms and lavatories at the west end, and a forestage at the east end. A more complex network of seven dressing rooms behind the stage was also incorporated. Nevertheless, in approximate overall size and in its placement within the building, the theatre had been planned by late 1911.

Why Massey and Sproatt insisted on saying that the theatre was not conceived until after the building was erected and war had slowed the progress of its interior construction remains a puzzle. It is possible that the idea for a theatre was temporarily shelved or that both men's memories were faulty. It does appear none the less that Massey went out of his way to downplay the theatre's significance in the early conception of the facility. Was its subterranean location, while ingenious, also suggestive of something slightly clandestine? At the least, it bespoke a secondary importance. It was also symptomatic of the scarcity of theatres in Canada

at the time – there were few prototypes and little common practice to guide situating such a creation.

It is probably not coincidental that the plan for a theatre in Hart House took shape not long after Massey joined the Arts and Letters Club in early 1911 and that discussions and plans for the Arts and Letters Players theatre intensified at this time. The ferment on the subject of theatre building was undoubtedly felt by Sproatt, also a member, and Massey. Merrill Denison, writing about Hart House Theatre in 1923, viewed it as a product of Massey's determination that the little theatre movement in Toronto 'not be allowed to die' after the club's theatre-building plans collapsed about 1914.[156] That Hart House Theatre had its own entrances directly from outside the building may point to the intention from the outset that it function, to some degree, as a community playhouse.

Hart House Theatre was not only an outgrowth of activities at the Arts and Letters Club, however; it was a response to campus dramatics at the University of Toronto. Theatrical activity at the university dated from as early as the 1880s. In the period between 1910 and 1940, there were over a dozen different drama groups. Women, despite their smaller numbers, were especially active. Harold Averill has called the Women's Dramatic Club of University College the dominant amateur theatrical group on campus before and during the First World War.[157]

Until the 1920s, theatrical activity at the university tended to be divided into male and female groups. The need for a committed men's theatrical group gave rise in 1913 to the Players' Club, to which Massey belonged. Perhaps not coincidentally, the club mounted two productions in the dining-room of Victoria College's Burwash Hall. According to one source, the Players' Club began as the Victoria College Players Club.[158] Despite Massey's assertion that 'Victoria was steeped in the Puritan tradition,' the club's origins date to the beginning of his tenure as dean of residence at Victoria College.[159] One of the two Players' Club productions performed in Burwash Hall was *The Pigeon* by John Galsworthy, directed and produced by Massey in early 1915, while he was club president.[160] His brother, Raymond, by then an undergraduate at Victoria College, played the character Ferrard.

The Players' Club moved into Hart House on its completion in late 1919 and ran the theatre briefly, under the supervision of Roy Mitchell, who was both the theatre's first director and the club's director at the time. None the less, as an announcement in the *Varsity* made clear, 'the

encouragment of every dramatic club, whether of men or women, and the rendering of any assistance that such organizations may desire while reserving full freedom of action for themselves, is an integral part of the whole plan of fostering dramatic art at Toronto ... [and] the reason for the inclusion of a model theatre in the scheme of Hart House.'[161]

With help from Roy Mitchell, who had gone to New York to study set design but returned to Canada in 1918 to become director of motion pictures for the federal wartime Department of Information, Hart House Theatre went on to become one of the best-equipped theatres on the continent. The lighting system was especially sophisticated,[162] and the facility included all the equipment necessary to make its own scenery, properties, and costumes.[163]

In 1921, management of the theatre was removed from the Players' Club and taken over by a House managing committee, known as the Board of Syndics, administratively separate from the House's Board of Stewards. Massey became chair, a post that he kept until 1935,[164] and Alice Massey was one of the other three members. Sustained with assistance from the Massey Foundation, it was run as an independent repertory theatre. Aside from a professional director, several one-time professional actors, and one or two technicians, it was operated by amateurs, many but not all from university ranks. Campus drama groups were still able to book time in the theatre for their plays but, due to demand, often had to look for other venues. Among the more prominent University groups that mounted plays at Hart House, between the regularly subscribed shows, were the Dramatic Club of St Michael's College, the Player's Club of University College, the Trinity Dramatic Society, and the Victoria College Dramatic Society. Later in its history, the theatre became a wholly university enterprise.[165]

Like Hart House's musical programming, the theatre was conducted with a view to its educational potential. When the theatre launched its first program, each play was preceded by a lecture and talks on the nature and practice of drama.[166] Beginning in 1923, the theatre also conducted a summer school for individuals interested in learning about directing amateur theatre.[167]

Added to these initiatives in music and theatre was Hart House's growing support of the visual arts. In 1917 a call to form a visual arts organization at the university appeared in the *Varsity*. While applauding its creation, the student newspaper expressed bafflement that no such initiative had surfaced before. Massey responded by proposing that such a club have a place in Hart House.[168] This was the beginning of the

University of Toronto Sketch Club, later the Hart House Sketch Club. In 1921, it became a standing committee of the house and was renamed the Sketch Committee.[169] Each house committee was made up of both faculty members and elected students, the latter in the majority, and reported to the governing body of the house, the Board of Stewards. With an administrative structure conceived by Massey, Hart House was the first institution at the university with substantial student representation.[170]

Only in 1938 did the Sketch Committee become the Art Committee.[171] As Massey later explained: 'The word "art" ... was carefully avoided at first ... The fear that they might seem to be taking themselves too seriously led the beginners to use the modest term "sketch," and the "Sketch Committee" for years flourished under this title until the importance of its work brought about the adoption of a more precise, if challenging, word and the 'Art Committtee' emerged.'[172]

A moving force of the Sketch Committee was renowned Goethe scholar and portraitist Barker Fairley, its first chair and an enthusiast of Canadian art. The committee carried on the series of modest exhibitions begun by the Sketch Club and offered informal art classes by C.W. Jefferys, Fred Brigden, and others.[173] But it added a variety of other activities. Most significantly perhaps, in 1922, it began to purchase works of art, always Canadian, at the rate of usually two to four a year, and it built up one of the premier collections of Canadian art in the country. Massey, Bickersteth, and Fairley steered the early art collecting of the committee.[174]

In 1925, the house developed a formal policy on collections, assisted by a group of advisers that included Bickersteth, Fairley, Lawren Harris, Massey, B. Richardson, and Professor H. Wasteneys (Sketch Committee chair). They recommended that Hart House collect Canadian art, that the pictures be representative of the best work available, and that an advisory committee of three artists be formed to assist a subcommittee of the Sketch Committee in its purchases.[175] Funds from the Massey Foundation made early acquisitions possible, but other sources were needed for the longer term.[176] In 1927, Massey's friends the Wrongs, keen supporters of the arts,[177] established an endowment for the purchase of art.

The committee also mounted increasingly ambitious exhibitions. During the 1923–4 academic year, it held solo shows of work by the late Tom Thomson, lent by Dr James MacCallum[178] and Lawren Harris. Meanwhile the sketch room, 'intended as a studio from the first,' hosted an art course for the first time. Group of Seven member Fred Varley taught

every Monday night for two hours.[179] The classes were successful imme-
diately. Bickersteth referred to the sketch room as 'the only place in the
university where a novice in sketching and painting could begin opera-
tion.'[180] Massey reiterated this point in the late 1920s: 'Until Hart House
was built there had been practically no organised interest in the arts and
certainly no activity in this sphere [the visual arts] of the informal nature
which is often the most lasting in its effect.'[181]

The group of advisers who met in May 1925, Massey among them, also
decided that 'the holding of short lectures leading to a discussion on
pictures, architecture, old silver, old jewelry, handicrafts in general, and
heraldry, was an experiment worth trying.' They planned to begin such a
series before Christmas and, if it was successful, carry it on in the new
year. Suggested speakers on the subject of 'pictures' included Eric Brown,
director of the National Gallery; Lawren Harris; J.E.H. MacDonald, an-
other of the Group of Seven; and Massey, now listed as a member of the
Board of the National Gallery of Canada. The group also discussed the
viability of Hart House publishing monographs on Canadian artists.[182]

Moreover, in January 1926, the Sketch Committee decided to create a
fund to purchase reproductions to illustrate the history of art. It ac-
quired several hundred reproductions and each month mounted an
exhibition in the print room – a small space off the sketch room. Accord-
ing to Bickersteth, over three or four years the shows covered the whole
history of art from 'the primitives' to the Barbizon school. In his view,
'this plan was of great educational value, though I hesitate to use that
word. The one thing we tried to avoid Hart House ever becoming, in the
strict sense, was educational. Of course the House was educational in the
broadest sense, but only as a *side* issue.'[183] 'Culture,' 'art,' and 'educa-
tion' seem to have constituted a triumvirate of forbidden words.

Massey himself, while increasingly supportive of the fine arts, long
appeared ambivalent about his penchant for theatre and painting. In
1930, he remarked: 'A grand assize would reveal each year more lawyers
and bankers and doctors and manufacturers who would confess to the
secret vice of painting, or, under the pressure of a search warrant, would
reluctantly surrender a sonnet or a play composed in stealth.'[184] Despite
the gentle sarcasm, his remarks indicate that his support of the fine arts
continued to place him on the defensive. Admitting in his memoirs that
Hart House Theatre had been his chief hobby in early adulthood, he
referred to amateur acting as 'an unusual recreation for a serious busi-
ness man' and defended it as no 'more frivolous or unbecoming than
golf or shooting or yachting.'[185]

Yet, as we noted in chapter 1, as chair of the Massey Foundation Commission between 1919 and 1921, Massey attempted to curtail, if not eradicate, the fine arts at Methodist secondary schools and colleges, while he strengthened their role at various male organizations. At the the very moment that he chaired the commission, he was president of the male-only Arts and Letters Club of Toronto and oversaw the club's relocation to new quarters and its incorporation of a long-awaited theatre. This was also the precise moment when Massey's brain-child Hart House, for male undergraduates only, opened with a theatre, gallery, and music room – a North American innovator quickly and widely recognized for its experimental agenda.

What then was the impact of Hart House on the women of the University of Toronto? A few authors have addressed the question briefly,[186] but it remains to give an account of women's experience specifically with reference to the fine arts. A thorough assessment must await a broad study of the fine arts at the University of Toronto before Hart House opened. Among the questions that need to be answered are: How active were men and women, jointly or otherwise, in organizing art activity? What groups were most active, and what facilities and resources did they garner? What happened to this activity with the opening of Hart House – was it truncated, redirected, intensified? For now, it is important to assume neither that the fine arts were non-existent at the University of Toronto before 1919 nor that Hart House was less than a major conduit of campus art activity after it opened.

As noted above, drama had a lengthy, if fragmentary, history at the University of Toronto prior to the opening of Hart House, and women were leaders in this area. But a male group, The Player's Club, was assigned responsibility for managing Hart House Theatre during the first two years of its existence. Despite this, drama became the one area in which Hart House was relatively co-educational from the outset. Aside from the fact that the Players' Club had control of the physical equipment of the theatre and was allotted a clubroom in the House, men and women participated as audience and players, both within student groups on campus and among those outside the university who performed as part of the repertory theatre. The fact that the theatre welcomed both women and men from the university and the larger community was immensely important for the invigoration of amateur theatre in Toronto and indeed in Canada more widely. The development of theatre at Hart House appears to have concided with the university's general abandonment of male- and female-only drama clubs.[187]

This openness did not extend, however, to music and the visual arts. While extracurricular musical activity at the university before 1919 remains to be clearly delineated, it is evident that both instrumental and vocal music received an immense boost with the opening of Hart House. The impact of this for women was highly problematic. Women were excluded from the Sunday evening Songsters and could attend the Sunday Concerts only as guests of a male. In early 1920, the *Varsity* reported that Hart House was open to women once a month, and then, only if accompanied by a male. Similarly, the Sketch Club served the university's male population: committee members were all male, and art classes were open only to males. However, presumably, women could visit the art exhibitions in the company of a man once a month. They were also allowed entrance for four or five major university functions a year – namely, dances and balls in the gymnasium.

As early as 17 October 1919, under the heading 'A Co-educational Social Centre,' the *Varsity* pleaded the case of women's entry into Hart House: 'It is with longing eyes that the women of the University gaze on the towering grandeur of Hart House, and sigh in vain for an "Open Sesame" to those sacred portals which guard their fabulous treasures from the feminine view.'[188] The article argued for a facility that would offer women 'the great service which Hart House is rendering to the men of the University.' It also pointed out that the absence of co-educational social and cultural spaces drove students off campus and diffused college spirit. While the women of University College acquired a student union in the early 1920s (plays were performed in the auditorium), adequate funds for a union building for all university women were never raised. And despite recurrent appeals for women's equal admittance to Hart House, Massey never relented. Not until the early 1970s, several years after his death, did the House become co-educational. This stands in marked contrast with testimonials to the House's tradition of genuine religious and racial tolerance.[189]

One might hypothesize an almost sinister, purposeful effort on Massey's part to disassociate the fine arts from the feminine sphere by eliminating them or discounting their value at Methodist ladies' colleges and by withholding from women much of the programming and facilities for the fine arts at Hart House. Even allowing for the widespread division of male and female athletic, social, and cultural activity when Hart House was conceived and built, it seems unconscionable today that Massey could avail male students of these 'fabulous treasures,' while steadfastly

ignoring the needs of women for artistic, not to mention social and athletic, opportunities.

Overlaid on this disjuncture was Massey's only partial endorsement of the fine arts. The role that the fine arts might occupy in character development and good citizenship remained tentative for Massey well into the 1920s. It seems ironic that while many Canadians might have disdained the fine arts in a male context, preferring to relegate them to the female domain, Massey appears to have been insensitive to their place in the female sphere and helped secure them a larger role in male-only contexts. All the while, of course, he wrestled with the taint of emasculation. As vice-president and later president of the National Council of Education (chapter 2), a less overtly gendered forum, he continued to ensure that the liberal arts were the focus and purposefully excluded the fine arts from the council's education agenda until at least the mid-1920s. In short, it seems that he was able to countenance the fine arts in a primarily informal, amateur context at first and only during the later 1920s recognized their value in formal education and national citizenship training.

In the early years of Hart House, Canadian universities accorded little recognition to the fine arts generally, formally or informally. Perhaps the earliest curricular interest in the visual arts at the University of Toronto were the summer session courses in 'Art (Elementary and Advanced)' offered by the Faculty of Education (formed 1906) dating from at least 1909.[190] By the time that Hart House opened, Victoria College had art appreciation study groups, and by the early 1920s the Extension Department of the university was giving some lectures in art history and art appreciation.[191] But as late as 1947, art critic Robert Ayre, in *The Humanities in Canada*, observed that the place of fine art (which he defined as visual art) in the university, while 'perplexing educationists and artists in the United States,' had 'not greatly disturbed Canada.'[192] While 'Canadian Universities recognize music as an essential subject of education,' for many, even this was a recent development.[193]

Much of the impetus to foster the fine arts at the University of Toronto sprang from developments at Hart House, with the encouragement of Massey and his associates. As early as 1922, Massey had suggested including dramatics in the curriculum of the university,[194] but attention focused initially on music. In the 1920s, the university had a Faculty of Music consisting of a dean and four part-time lecturers, three cross-appointed to the Toronto Conservatory of Music, which had come un-

der the university's jurisdiction in 1919.[195] The faculty, itself only recently created, did very little teaching and in general appears to have been singularly inactive.

In May 1926, in a bid for financial support from the Carnegie Corporation of New York for developing the university's musical life, Massey wrote: 'We are most anxious to make an appointment to the University ... [of] a Director of Music, who could co-ordinate and develop the various musical activities among the undergraduate body, particularly the Glee Club.' A beginning had been made at Hart House, and he believed that, if the right person could be found, 'the results on music in this country would be very important.' However, because of economic conditions, the university was unable to pay for the appointment. He added: 'Music, as you know, is too often regarded, by the powers that be, as a frill.'[196]

The fine arts met with resistance in the university setting for various reasons. For those who assigned cultural pursuits little weight, the fine arts were especially dubious. Others, not unlike the Massey Foundation commissioners in 1921, considered the arts too technical to have much cultural value. But by 1926 Massey had largely overcome his prejudice against the fine arts in a formal setting, provided that they were taught as part of a general arts program. He was pleased to report to Carnegie that Sir Robert Falconer, president of the university, and Dr A.S. Vogt, principal of the conservatory, also strongly supported appointment of a specialist in music.[197]

In a subsequent letter to the Carnegie Corporation, Massey argued the case for the creation of a full professorship of music at the university and wrote that Dr Ernest MacMillan was the 'right choice' for the position.[198] MacMillan, who became one of Canada's most distinguished conductors and musical figures, had composed and conducted music for productions at the Hart House Theatre.[199] However, it does not appear that the position was created at this time.[200]

The enhancement of musical life at the university continued to be a subject of discussion at Hart House. In the spring of 1928, the warden, noting that the musical programs of the house had 'encouraged the belief that students were attracted by good music,' still identified severe shortcomings. There was no university orchestra, the Glee Club had died, and 'little or nothing was being done in music among the women students.'[201]

On Massey's suggestion, Bickersteth proposed a series of Hart House fellowships. A young specialist in music, for example, would be appointed

to guide and develop the university's musical life. On behalf of his family's foundation, Massey wrote confidentially to MacMillan in 1928 and offered to pay $2,500 for three years for a director of music at Hart House, though recognizing that this was not an adequate salary for a well-qualified individual. He continued: 'If the University is not sufficiently interested to pay $1,000 or $1,500 towards such an object, I am afraid the only conclusion to be derived is that the interest in such work is not great enough to warrant its success when established.' He added, 'I greatly hope that something can be done, if not this year, in 1929 at the latest.'[202] It was suggested further that a fellow in art be appointed – Group of Seven member Arthur Lismer was named as a prospective candidate.[203] The creation of other fellowships in the arts was also envisioned. It is unclear what implications such fellowships, based in a male-only preserve, would have had for women on campus.

The proposal was greeted, however, with reservations; one member of the Board of Stewards thought that 'the appointment of Fellows of Hart House might emperil [sic] ... the voluntary and spontaneous co-operation among members of the University of all ranks: the name "Fellow" carried with it certain purely academic associations and suggested a positive educational role.' While acknowledging that there was great interest in 'the various experiments being carried on in music, art, religion, debating and other activities' at Hart House, other board members were also reluctant to venture into a more formal relationship between staff and the House; the proposal appears to have been indefinitely postponed.[204]

Meanwhile, Massey was active in plans to create a chair of fine art at the University of Toronto. The idea seems to have dated from 1928, a time when visual art was very modestly making its way onto the agenda of a few other Canadian universities.[205] Walter Abell, with financial assistance from the Carnegie Corporation and other sources, established a lecture course in art history at Acadia University in 1928[206] – art was already being taught at the women's seminary affiliated with Acadia.[207] Similarly, Regina College and Mount Allison University, both Methodist, had taught art for decades.[208]

In 1928, Massey wrote to F.P. Keppel, president of the Carnegie Corporation, about support for the visual arts in Toronto. He explained that there was now an art school adjacent to the Art Gallery of Toronto,[209] and that the School of Architecture at the university had 'in the last few years emerged from the domination of Engineering.' Along with the

Royal Ontario Museum and the Art Gallery of Toronto, these constituted 'a very powerful engine in a responsive community for the promotion of the arts, both as regards achievement and popular interest.' A chair of fine arts at the university would help galvanize the cause of the arts, he argued, but lack of funds had to date precluded its creation.[210]

Subsequent correspondence reveals that the search was on for a suitable candidate. In 1931, W.G. Constable of the National Gallery, London, replied to Massey's inquiries, in the negative, saying, 'When the Courtauld Institute [of Art, London,] gets going I hope we shall be able to offer a better choice.'[211] The matter dragged on. Eric Brown corresponded with Massey about the position, which he regarded as crucial to art in Canada.[212] In 1933, Constable reported in confidence that 'a first-rate man seems likely to be available'; this proved to be Herbert Read, rapidly becoming one of Britain's most eminent art critics and theorists.[213] Vincent Massey had to write back and report that the position was still in limbo.[214]

Finally, in 1934 a chair of fine arts was created with assistance from the Carnegie Corporation, and occupied first by arts scholar and well-known minor poet John Alford. Bickersteth recounted that Alford spent the first couple of weeks in Toronto living at Hart House and soon commenced a series of informal five-o'clock talks on art in its sketch room.[215] Two years later, enrolment in a four-year honours bachelor of arts in fine art became possible.[216] Art education, which had made informal inroads first, now became a formal pursuit, Hart House, a conduit for both.

It became Massey's life-long view that education gained informally was the most lasting, and the inclusion of the arts at Hart House was very much a product of this outlook. As he stated in 1927: 'A liberal education should give us the knowledge of how to live – in leisure and in work. I think that the use of leisure is after all the most searching test of the educated man or woman.'[217] By the later 1920s, however, he had also become fully supportive of the integration of music and visual art into formal study at the highest levels of academe, as demonstrated by his vigorous lobby to secure a chair in these two disciplines. In 1929 he was able to state: 'The appreciation of art in all its forms, abstract and applied, is worthy of the attention of the university mind.'[218]

The Moral and Social Functions of Art

Massey's growing endorsement of the fine arts was facilitated not only by their alignment with education, but by a transformation in his under-

standing of their moral function. This he elaborated on in several statements during the 1920s. Increasingly he remarked on the inadequacy of the Puritan view. In a 1922 essay he warned, with some humour, against using the theatre for didactic or propagandistic ends:

> We are familiar with the morally elevating play that our fathers thought safe[:] ... plays to teach children the value of soap and fresh air; plays to teach farmers the importance of consolidated schools and the evils of scrub bulbs; and there are plays to aid home missions, or to stop cigarette smoking, to stimulate patriotism, and to do a number of things, in the interests of health or morals, for which the drama was not intended. Perhaps from our double foundation of Puritanism – drawn from Scotland and New England and a strength in most respects – we have derived a certain weakness for preaching. But the drama may be elevating without a trace of 'uplift.' A play must not point a moral and the plays which really give us the 'uplift' – in the original sense of this degraded word – are the plays which 'nourish the imagination.' The *Beggar's Opera*, as its prologue says, contains not an honourable man nor an honest woman, yet with its sheer beauty of colour and music, and the clean wit of its satire its influence is incomparably finer than the most moral Sunday School pageant, in which a set of allegorical abstractions, called 'social service' and 'foreign missions' or what you will, ultimately overcome another set of allegorical abstractions labelled perhaps the 'drink traffic' or 'heathen religion.'[219]

Here Massey illuminates the transformation of Puritanism's moralism into post-Puritan 'uplift.' He had come to view Puritanism as the main enemy of the arts; it either ignored them altogether or subverted them with moralistic pronouncements. In 1929, he referred to the Puritan's 'half-confessed idea that ugliness is on the side of the angels.'[220]

This theme preoccupied him again in a 1930 address when he spoke about North America's puritan forebears' and their suspicion of beauty. However, 'the Puritan, in the first blush of the reforming movement did not set his face against the beautiful. Cromwell's men may have broken painted glass and sculptured saint in their zeal, but Cromwell himself, as we know, loved music.' He added: 'A Puritan atmosphere lingered longer in North America than in Europe. A simpler life, relative poverty, and other causes kept our physical surroundings, for instance, comparatively austere. The 18th century, which to Europe meant elegance and urbanity, not without a touch of cynicism, brushed this continent but lightly.'[221]

Despite his view of Puritanism as the primary culprit in the suppres-

sion of beauty and art, he was still Puritanism's heir in his emphasis on 'uplift.' His distinction between moralizing and so-called true uplift resulted from various interventions. One was his endorsement of the role of criticism, for which he was indebted to Arnold. He often argued for the 'intellectual detachment' that empowered one to make distinctions between good and bad art.[222] He came to disdain moralizing art as sentimental and uncritical. What was truly ennobling about art was not only its beauty (art as beauty still had some currency in the 1920s), but the opportunity that it gave to exercise one's powers of discrimination, to discern excellence, to transcend self-interest, and thereby to serve the greater community.

In a speech dating from 1929 he argued that 'our equipment for life' should include 'an aesthetic conscience' – a balance between the intellect and the emotions. If one relies solely on intellect, he stated, one tends to 'over-intellectualize"; if solely on emotion, 'the result is worse – the sin of sentimentality ... The appeal of the arts must be jointly to mind and senses.'[223] The intellect provided a presumed impartiality, while the emotions and senses provided authenticity, a connection with life.

As Massey worked his way towards a moral foundation for art, which, he came to understand, lay in the principle of disinterest, he, perhaps paradoxically, strongly opposed divorcing art from life. Though now valuing fine art, like the liberal arts, for their non-utilitarian and therefore disinterested nature, he also sought to wed art to the useful. He adamantly disagreed with those who viewed art as belonging to a rarefied sphere or as existing for art's sake alone. While he saw the intellectual, and subsequently the artist, as a source of special insight and came to call the artist 'the interpreter,'[224] he resisted the separation of the artist from the greater community.

Massey spoke repeatedly in favour of a reunification of art and utility – too long, in his view, divorced. In a college address in 1929, he stated:

Art is too often thought of only in relation to sonnets, symphonies and old masters, but the same principles are to be found in the streets and rooms we have to see hourly and in the tools of our everyday life. The concepts underlying a treatise on aesthetics are afterall, no different from those governing the design of a lampshade. The restriction of our sense of criticism to an occasional concert or art exhibition and the fleeting hour we grudgingly give to real literature, may well remind us of that kind of religion which is reserved for Sunday alone. Most human beings must find their aesthetic stimulus chiefly on the hoardings and in the newspaper or

on the walls of whatever may be their home. We are influenced, after all, by what we see oftenest. This suggests to the trained aesthetic conscience its opportunity and its appropriate task. In a famous passage Milton says: 'I cannot praise a fugitive and cloistered virtue unexercised and unbreathed, that never sallies out and seeks her adversary.' ... This was written, or course, in terms of a moral issue. If we apply it to the world of art – the fine arts and the applied arts as well – it teaches its own lesson. If the university mind, sensitive to beauty and as discerning as sensitive, and above all possessed of a public spirit, which rejects the seclusion of cloistered beauty and sallies out to seek the adversaries of Philistinism and ugliness and sentimentality still to be found about us, there is no telling what victories it might still achieve.[225]

The subject of art in relation to community was gaining topicality in the late 1920s. 'Art in Everyday Life' was the title of a lecture series proposed by the National Council of Education about 1930.[226] According to Arthur Lismer, the idea that the artist 'decorates life – is the colourful mouthpiece of the upper classes – has passed. He is nosing into all kinds of things ... Town planning, educational schemes, printing, advertising, craftsmanship, architecture, office decoration, modern interior decoration of the home, industrial design, wherever the aesthetic question of choice of form and colour rises for solution.'[227] Lismer, like others in the public gallery and museum field, saw the art gallery 'becoming a community idea in Canada, serving the public as a library, or a hospital, serves.'[228] Such sentiments are reminiscent of George Vincent's condemnation of the rarefication of culture and his plea for its unification with vocational training and even recall the role of literature and music at the Massey Manufacturing Company.[229]

In an address to the American Federation of Arts on 16 May 1930, Massey spoke of 'reconciliation' and 'a re-marriage between the useful and the beautiful.' He stated, sounding again like the Vincents (uncle and cousin): 'It is an accepted axiom that the time is past when art can be regarded as a luxury of the few – it must now be regarded as the necessity of the many.'[230] In a speech of 22 May 1930 to the Royal Society of Canada, he challenged the propensity to relegate art to the sidelines: 'we commonly think of it [art] as a commodity – as something external – as representing one side of life – a hobby to be played with – a subject for examination – a superficial embellishment – a sort of sociological cosmetic.'[231] He described the art of the recent past as emasculated by the divorce between art and utility (this emasculation he characterized as 'a

group of anaemic and angular maidens'). 'Art had a place in Canada,' he argued, 'despite its population of "practical people" and this "a practical age."' He compared the artist and the engineer, who shared a sense of poetry and the need for a 'disciplined intelligence'; both discern the 'unseen harmonies.'[232]

Beyond Massey's emphasis on integrating art into the larger community lay his awareness that art was a source of community. He seemed to understand this unity to reside in part in the principle of excellence. He trusted the search for quality as a means of transcending partisanship and divisiveness, at the same time as it ameliorated conformism. In its eloquent capacity to unite, it shared a sacred mission. As artist Bertram Brooker wrote in 1929, art was first about exalting 'the *wholeness* and the *oneness* of life' and as such was akin to the religious experience.[233] 'Human beings are separated by material things and united by the spiritual,' Massey stated in 1930. 'Art, after all, is a kingdom in itself, a unifying, not a dividing thing.'[234] For Massey to accord such stature to art testified to the significant transformation in his thought during the 1920s. Through its alignment with a liberal arts education and through the rearticulation of its intellectual, moral, social, and even spiritual functions, fine art had become a worthy ally in the cultural quest.

4

Nationalizing the Arts, 1922–1935

'The swift development of Canadian painting is not only a story interesting to ourselves but it also has ... [a] bearing on the large question of the relation between art and nationality,' wrote Vincent Massey in 1948.[1] By the later 1920s, he no longer considered art a 'superficial embellishment' or a 'sociological cosmetic.' He was awakening to the role that the arts might play in forging a sense of national community[2] and became a zealous advocate for the development of national forums in the visual arts, drama, and broadcasting – each the topic of a section in this chapter.

His association with the Group of Seven, especially Lawren Harris, was instrumental in persuading him of the national and spiritual vocation of art. 'A people only live when they create,' Harris stated; 'it is spiritual suicide to import designs and works in lieu of creating them ourselves.'[3] Harris believed that 'the stimulus of ... a particular place, people and time' was essential to creativity and that creativity was the link between diversity and the universal. In the late 1920s and early 1930s, Harris and Massey spoke and wrote almost in unison, defending a national context for art and arguing that internationalism need not efface the multiplicity of local and national experience. Diversity, in Harris's scheme, was the lifeblood of creativity, in turn the lifeblood of sovereignty (both personal and national) – a belief that parallelled and invigorated Massey's war against uniformity and his commitment to a pluralistic nationalism.

In 1926, the newly elected Liberal government named Vincent Massey the first Canadian minister in Washington, a post that he occupied from 1927 to 1930. While Massey frequently applauded the rise of internationalism and acted as a spokesperson for the enhancement of mutual understanding among foreign powers, his stint in Washington height-

ened his appreciation of the vulnerability of Canadian culture to the growing sphere of American influence. His Canadian nationalism deepened visibly in this period, and during the late 1920s and early 1930s he became intensely involved in a wide range of projects, national in scope, aimed at constructing a support system for the arts and at expressing Canadian identity.

Massey's Canadian nationalism drew on various sources, not least his Methodist heritage – a hotbed of nationalist sentiment. His nationalistic views were shared by his wife, Alice Parkin Massey, daughter of Imperial Federation advocate Sir George Parkin. Massey, like so many others of his generation, had served in the First World War, which, historians tend to agree, was the single most significant event in bolstering a sense of Canadian self-confidence and common identity. Added to this was the national self-awareness Massey gained in Washington. In his memoirs, he wrote: 'From the United States where we had lived for three years and more, the character of Canada was easier to know, and with our knowledge grew our pride.'[4]

While Massey's activities were centred on Toronto during his youth and early maturity, his perspective had widened as chair of the nationwide Methodist commission on schools between 1919 and 1921 and at the helm of the National Council of Education during the early and mid-1920s. At this stage, as I argued above, he was thoroughly convinced that culture, defined as a liberal arts education, was the primary route to good citizenship and national character (or what we now might call national identity). However, his notion of culture was soon to broaden.

Massey first tackled the confluence of nation and art in print in 1922. In an essay about drama in Canada, he expressed his deep concern about foreign domination of the Canadian stage. 'In the theatrical world we are – as I am afraid in some other things – a province of New York.'[5] Moreover, he was unhappy with the 'Trans-Canada Theatre' scheme, which brought English theatre companies to tour in Canada. 'This plan,' he commented, 'seems not unconnected with an all-British propaganda. I am not quarrelling with such propaganda, but propaganda and art do not harmonize. Little good will come of the substitution of one form of mediocrity for another.'[6] Thus began Massey's post-colonial discourse, which grew to be a dominant theme in his writing and speech-making from the 1930s to the end of his career. Usually he chose to view Britain as an ally, rather than as an oppressor, and took aim at U.S. cultural imperialism. But, as his critique of the drama situation in Canada illustrates, he was capable of recognizing Britain's less benign influences. Even there, however, he displays a certain ambivalence. On one hand, he

was critical of foreign domination of the Canadian stage. On the other, he backtracked, maintaining that it was not foreign propagandizing but mediocrity that offended him.

Massey claimed that only twelve to fifteen Canadian plays had yet been produced, but he held out hope for the 'little theatre' movement of amateur experimental drama, noting that there were now several well-organized community theatres in Canada. He singled out for particular praise the Orchard Players of the Okanagan Valley in British Columbia.[7] In 1922, Hart House Theatre, also amateur, was beginning its own climb to renown. Of course, the obstacles that stood in the way of Canadian professional theatre, ideological and economic, would not begin to be overcome until after the Second World War.[8]

In the same essay, Massey wrestled with the notion of what makes drama Canadian. 'Must the plays be by a Canadian? Must they be about Canada?' He acknowledged that Canadianism could not be prescribed – 'no standard set of virtues can be made to personify Canada.' He wrote of 'several Canadas' and noted that 'there is little in common between the atmosphere of Maria Chapdelaine and Moose Jaw – between a peasant farm in Northern Saskatchewan and commercial Montreal, between a Hudson Bay Post and an Ontario city. ... The forces of geography are too strong for the growth of a national drama in the strict sense.' But he reflected that 'it would be comforting, of course, to feel that whatever the diversities of material, a characteristic feeling, manner or style, was possible that could be called Canadian.' He claimed that the country's dramatists need only be 'both good Canadians and good artists' for their plays to have in them 'the essence of Canada.'[9] Presumably 'good Canadians' were those who were products of a liberal arts education. He cited the 'Algoma School' of painters (the Group of Seven) as having 'something, almost indefinable, which can be called Canadian' and added, 'a similar quality equally subtle will be characteristic of the Canadian drama.'[10] The Group of Seven, which developed a landscape idiom based on Canada's identity as a northland, became a touchstone for Massey in his nationalizing agenda for the arts. As a result of its achievement, he believed that painting, of all the arts, pointed the way to something discernibly Canadian.

Massey, Harris, and Nationalism: Diversity, Creativity, and the North

The Group of Seven, which took its name and held its first exhibition in 1920 at the Art Gallery of Toronto, was self-consciously nationalistic. While the First World War had temporarily dissipated the prospective

group's gathering momentum, it had at the same time fuelled national-ism. Writing in 1918, future member J.E.H. MacDonald linked support of the arts with patriotic duty: 'the aim of patriotism is a full expression of the beneficent spirit of a particular people, and this expression is stunted without a native Art.'[11] MacDonald championed the artists who had participated in the Canadian War Memorials, created in late 1916 by Lord Beaverbrook to record the war effort, arguing that the war had increased 'the emotional interest of Canadians in their homeland.'[12] Approximately 440 of the War Memorial works were exhibited in 1919 and 1920 at the Canadian National Exhibition's Fine Art Gallery in Toronto and at the Art Association of Montreal and in 1923 and 1924 at the National Gallery of Canada.[13] Sir Edmund Walker exclaimed: 'Apart from the war itself [the Memorial project was] ... one of the greatest events in Canadian history.'[14]

Art's relevance for Canadian nationalism was central to the Group of Seven's mission, as Lawren Harris's catalogue foreword for its 1920 exhibition emphasized: 'Art ... interprets the spirit of a nation's growth,' he wrote; 'an Art must grow and flower in the land before the Country will be a real home for its people.'[15] The group's theorist, Harris was unequivocal about the high mission of art and its importance for national well-being. A.Y. Jackson wrote of his first acquaintance with Harris just before the war: 'To Lawren Harris art was almost a mission. He believed that a country that ignored the arts left no record of itself worth preserving. He deplored our neglect of the artist in Canada and believed that we, a young vigorous people, who had pioneered in so many ways, should put the same spirit of adventure into our cultivation of the arts. With MacDonald, Lismer, Varley and others, whose acquaint-ance he had recently made, he believed that art in Canada should assume a more aggressive role, and he had exalted ideas about the place of the artist in the community. After the apathy of Montreal it was exciting to meet such a man.'[16]

Massey's close friendship with Harris, arguably the Group of Seven's leader, was influential in shaping Massey's embrace of the fine arts. Harris (1885–1970) was about a year and a half older than Massey and outlived him by two years. Their lives ran parallel in many respects. Like Massey, Harris owed his financial independence to the Massey-Harris Company. Both came from fervently religious backgrounds. Harris's family had ties with various Protestant denominations and counted sev-eral clergymen in its ranks. Harris shared Massey's Christian ecumenism,

writing disapprovingly in 1924 of early Ontario as 'divided and blinded and sustained by sectarian views.'[17] Like Massey, Harris came to find traditional religion lacking: 'Art alone points the way to a new day. Religion has failed us.'[18]

The friendship of the two men has been perhaps underestimated. Claude Bissell, Massey's biographer, remarked on some of the parallels in their careers but did not dwell on the relationship.[19] Art dealer Blair Laing claimed that they were little more than acquaintances, whose social circumstances were coincidentally similar.[20] Their friendship in fact dated from 1906, when the two were students at the University of Toronto.[21] Beginning that summer, Massey socialized frequently with the 'Harris boys' – Lawren and Harold – playing tennis, boating, and swimming.[22] On 2 October, Massey noted in his diary that he went to see Harris off on his journey to Berlin to study art.[23] Massey and Harris renewed their friendship at the Arts and Letters Club, where Harris, a founding member, was an important link between his fellow artists and the business community.[24]

During the First World War, Lieutenant Harris, based at Hart House, an army headquarters, reported to Lieutenant-Colonel Massey. The future theatre there was used as a rifle range, its backdrop a mock Belgian village in ruin designed by Harris.[25] Massey and Harris were closely associated in the theatre's early years, the latter designing sets; they also worked together on the Hart House Sketch Committee.

Both were good friends of Ruth (Massey) and Harold Tovell, at whose home in Dentonia Park they socialized.[26] On one such occasion in 1925, Arthur Lismer sketched Massey and Harris among those gathered (illus.), and Harris did a rare portrait sketch of Massey (Private Collection). Over the following three decades, the two men frequently enlisted each other's assistance. Massey relied on Harris's counsel in making purchases of Canadian art; Harris in turn called on Alice and Vincent Massey's growing collection of Canadian paintings for loan exhibitions. As late as 1948, Massey, then chair of the National Gallery of Canada's board, was responsible for Harris's appointment as a gallery trustee, the first artist to be so appointed since the Wembley controversy of the early 1920s. Given their sustained and close working relationship, it is hardly surprising that Massey and Harris's views on art and nationalism found concordance.

Harris's views on art, spirituality, and nationalism reached considerable resolution in a variety of published statements during the 1920s. His

writings were often quite esoteric, a quality that Massey's middlebrow
tastes would have shunned. Certainly Massey's remarks disclose no inter-
est in Harris's theosophical views, which became increasingly dominant
during the 1920s.[27] Nevertheless, Massey found many features of Harris's
thought persuasive. Indeed, the writings and speeches of the two men
exhibit close parallels during the later 1920s and early 1930s. Harris
published, for example, 'Revelation of Art in Canada' in the *Canadian
Theosophist* (1926) and 'Creative Art and Canada' in Bertram Brookers'
Yearbook of the Arts in Canada (1929), while Massey delivered a speech to
the American Academy of Arts and Letters on 23 April 1929 entitled
'The Arts and Nationality' and one to the Royal Society of Canada on 16
May 1930 on 'Art and Nationality in Canada.' It is no coincidence that
the two men tackled the subject of art and nationality in public, at
length, and virtually in tandem.

Both were quick to qualify their concern with nationalism. They read-
ily conceded the abuses that had been perpetuated in the name of
nationalism. Harris suggested that another word be substituted 'with no
combative or competitive implications.'[28] Massey stated: 'Nationality has
been the excuse for deeds of violence and selfishness since nations were
known.'[29] In the 1920s 'national' was commonly understood to mean
'local.' Harris defined 'nationality' simply as the result of the interplay of
a particular time and place.[30]

Massey and Harris also wrestled with the apparent incompatibility of
nationalism and internationalism. Harris spoke of 'the seemingly oppos-
ing statements that "there is no such thing as a national art" and on the
other hand that all manifestations in art are of time, place and people.'
He stated: 'Both are true, for a paradox is not a contradiction.'[31] In his
turn, Massey wrote:

There are those ... who say that art has no concern with nationality; that the
only aim of the artist should be to produce good art. It can be argued that,
as the international point of view gains strength in the world, as we hope
and believe it will, it is less and less appropriate that the work of artists
should emphasize national colour and this is a plausible thesis. But it surely
requires little argument to refute that cosmopolitanism which regards na-
tionality as an evil, and to demonstrate that the world has never suffered
from this principle, but rather from its abuse. Nationality rightly under-
stood surely provides the very pillars on which a sound internationalism can
rest. Nations form the very framework of a coherent and integrated world.[32]

Ultimately, although Massey always professed to hate 'self-conscious' nationalizing, he and Harris were vigorously defending Canadian nationalism. They did so, however, at a time when art theory tended to promote internationalism by conflating it with abstraction and the quest for a universal language. Those who viewed art as an expression of local or national character were placed on the defensive. At one level, Massey and Harris gravitated towards theories and practices predicated on a belief in an underlying, universal unity. Their texts frequently betrayed their idealism, assuming the existence of universal truths that merely awaited discernment. Harris spoke often of ascending to a greater truth and of an intensification and rarefication of experience such as is reminiscent of the ecstasy described by religious adherents in their journey towards godliness.[33] He referred disparagingly to 'the confusing, multifarious facts of existence' and sought an increasingly severe distillation of nature in his paintings – by the mid-1930s, his art was fully abstract, divested of the so-called non-essential in order to reveal an underlying unity.

Citing W.M. Tomlinson, Harris wrote: 'the power of art, as of religion, is to bring communion of the spirit.'[34] Massey, as we have seen, also spoke frequently of union and communion. Without the common life, existence was mundane, even sordid. A cornerstone of Massey's quest for unity was the principle of excellence – a means by which to 'disregard external differences,' to transcend partisanship and ethnic and religious distinctions.[35]

But despite the impetus to locate unity and transcend difference, Massey and Harris both highly prized the particular and the principle of diversity. Neither assumed that difference only divides. Massey wrote: 'There can be *unity* without *uniformity*.'[36] Harris argued vehemently that diversity was as important as unity: 'Interdependence ... does not rely on sameness, or even on similarity. It relies on differences and is not only fortified by those differences but derives significance and value because of those differences. It is no virtue for two individuals who think alike to agree. It is virtuous and valuable if two individuals think differently yet live in concord. This presupposes non-aggressiveness and sufficient goodwill to transcend disagreements.'[37]

Harris stated also: 'In a democracy the arts serve many purposes – ... expression is immensely varied. ... For life in a democracy exists on many levels. It varies in different parts of the country. And if the stream of intelligence is to flow ... then it must flow on all levels and in all

regions.'[38] In an essay entitled 'Sectarianism in Art,' he compared religion and art: 'No one sect of religion or art will serve all mankind. It needs all of them and it can be said that to fasten to one of them and deny the rest is to inhibit the freedom of communion and the freedom of the life of the spirit.'[39]

For Harris, the concept that most vitalized his idea of diversity was creativity. He championed the creative function. He viewed it as spiritual and as crucial to Canada's survival. He promulgated a withering view of those who relied on borrowed traditions, which he called European 'hand-me-downs': creativity and true art were not about copying. As the artist broke free to creative expression, so Canada must create itself. We 'must create our own background,' he wrote elsewhere.[40] Harris regarded the absence of creativity as decay. For him, it was not education, but 'an unconquerable faith in the presence of the creative spirit,' that was his source of hope for national sovereignty.[41]

Diversity and creativity were inseparable for Harris. He wrote: 'A symphony is composed of many individual themes ... and it is the interplay ... that gives not only unity to the work but richness of experience. A play is composed of many definite characters, each striving for its own realization, and it is the interplay of the essential life of each of these characters ... that makes ... a work of art.'[42]

While Harris prized creativity and privileged the creative individual, he did not see the artist as the sole source of creativity. 'Masterpieces in art are not single and solitary births. They are the outcome of many years of thinking in common, of thinking by the body of the people, so that the experience of the mass is behind the single voice.'[43] Above all, Harris argued for 'continual replenishment' and renewal. 'We must ever create anew, for the creative spirit illumines no two races, no two nations, no two ages, no two individuals in precisely the same way. Were it otherwise life would be meaningless.'[44] Here then was a bedrock belief for Harris: without uniqueness, life was meaningless. And without the particular, creativity was unsustainable. 'We have thus the seeming paradox that it needs the stimulus of earth resonance and of a particular place, people and time to evoke into activity a faculty [creativity] that is universal and timeless.'[45]

Like Massey, Harris was rivetted by the spectre of conformism. He spoke of the 'age of conformity' and complained that earthly existence was 'a goose-step in all pursuits and activities.' He championed 'every creative individual whether in art, govt, science or religion ... [as] a heretic, and in the exact degree in which he manifests creative capac-

ity.'[46] Certainly the fear of conformism was in part a response to fascism, as the expression 'goose-step' would seem to suggest. Harris was also critical of communism and the Soviet Union's efforts to control its artists.[47]

But the fear of totalitarianism was compounded by another anxiety about conformism, one that would become a dominant theme in Massey's writings and speeches from 1930 onwards. This was Canada's colonial dependence, first, in relation to Britain, and, second, increasingly vis-à-vis the United States. Harris commented frequently on Canada's colonialism. He remarked on one occasion that 'we would seem to be awakening from our long and not unpleasant subservience.'[48] In a talk on the Group of Seven at the Vancouver Art Gallery, he stated: 'Artistically as in other ways we were an entirely subservient people/living in the inferiority and dependence of the colonial attitude.'[49] In the same address, he challenged the assumption of metropolitanism – that meaning and civilization come from large urban centres and that a nation remote in relation to those centres was therefore unimportant.

He also commented on the phenomenon of colonialization more broadly. 'The wholesale colonization of materially backward peoples of the world by a few powerful European nations has inevitably evoked in these peoples the consciousness of their own genius and the right to give it expression.'[50] Harris viewed Canada as desperately needing to break free from Europe: 'Europe is enclosure, Canada expansion.'[51] He sought to end deference to European models in art and viewed Europe as a repository of archaic and repressive values, systems, and practices. He was very critical of the Paris School of art and its 'camp followers' and 'sophisticated cosmopolites' and of the 'essential sterility' and 'arid sophistocation' of the European art scene.

An adherence to 'the international method,' he claimed, 'means in reality the modern French method.' Moreover, Harris argued that 'what is called internationalism becomes merely standardization.'[52] 'Creative individuals only create where they give themselves fully to the immediate experience.' He insisted: 'Internationalism in art results in complete sterility, in a lifeless standardization devoid entirely of that inner life that makes the arts of prime importance as a means of communication.'

Massey's own preoccupation with the decolonialization of Canada appears to have coalesced in the late 1920s, deeply reinforced by the nativistic views of Lawren Harris and his colleagues. While Massey would depart from Harris in believing that Canada had moved beyond its colonial dependence on Britain to full partnership, he was deeply con-

cerned about what he later referred to as a 'new colonialism' – that is, excessive reliance on the United States.

Massey and Harris were united, then, in their fear of conformism. The threat of standardization emanated from various sources: from the formations of consumerism and mass production, from the rising tide of internationalism or early globalism, from totalitarianism, and from British and American imperialism. In Harris's view, it was the artist or creative individual who rescued society from standardization. Quoting from an unnamed Canadian critic, he stated: 'Many things can be mass produced but art never.'[53] Massey conversely had long trusted the fight against standardization to a liberal arts education with its goal of character development. But he now had reason to admit the fine arts into the cultural pantheon that stood guard over Canadian citizenship. In Harris's system, wherein creativity was understood as a life force that drew sustenance from local diversity, art was crucial to the war against standardization. Indeed, Massey might have defined culture as the battle against conformity; in this context, art had a pivotal role to play.

Massey must have found another feature of the Group of Seven's aesthetic reassuring: the language of 'virility' that laced contemporary assessments of their art. The notion of virility, in this context, pertained to the group's celebration, even deification, of Canada as a northland. Harris wrote: 'We live on the fringe of the great North ... and its spiritual flow, its clarity, its replenishing power passes through us to the teeming people south of us.' Indebted to various sources, including theosophy, he glorified the north as 'everything that is spontaneous or free or creative.'[54] The mythology of the north also spoke of ruggedness, remoteness, vigour, healthfulness, character, and manliness.

As we saw in the discussion of the Massey Foundation Commission on Methodist Schools (chapter 1), Massey was keenly sensitive to the charge of effeminacy. 'Effeminacy' and 'virility' appear to have been endlessly resonant words in Canada during the 1910s and 1920s. Accusations of effeminacy could be hurled at various targets – women, those from southern climates, and the so-called worn-out societes of Europe. In the mid-1920s, in an essay on education, Massey equated dehumanization, standardization, and effeminacy.[55] In Harris's scheme, those who did not honour the local as the source of their art demonstrated a passivity, a submissiveness, that rendered them prey to manipulation and conformism. They displayed a 'sickness of the soul' resulting from overreliance on science, trade, economics, and politics. Alternatively, those who made 'a thorough acquaintance' with all the forms of nature, with

'the almost endless diversity of individual presences of lakes, rivers, valleys, forests, rocklands, and habitations' were empowered and virile.[56] An intense scrutiny of nature in all its diversity placed one in proximity to a source of vitality that countered the age of mass production and the machine. 'Virility' and 'vitality' became virtual synonyms for 'character' or 'identity' and were consistently contrasted with 'passivity,' 'subservience,' 'effeminacy,' and 'conformism.' The language of virility must surely have eased some of Massey's qualms about art as an effete, female, and trivial pursuit.

Massey was certainly touched by the rhetoric of the north. In his speech 'Art and Nationality in Canada' in 1930, to an audience that included many scientists and engineers, he reflected on the north from both a practical and an artistic perspective. 'Our northern wilderness is ... the scene of this poetry of action with its great treasure hunt conducted from the sky, its railways nosing their way through the forest to northern oceans, the harness which is being thrown on rapid and water-fall.' In addition, 'its legend and mystery ... inform our literature and art with a spirit of its own.' 'These northern wilds,' he enthused, 'have cast the same spell over us as has the sea upon the life of England.'[57]

Yet he departed in at least a couple of key respects from Harris. While he shared his friend's reverence for the north, his views on diversity were framed less in environmental than in ethnic and regional terms. And where Harris seemed to entirely discount Canada's debt to the past, Massey sought to honour historical connections, including those with Europe. He invoked Renan's[58] definition of nation: 'Avoir fait des grandes choses ensemble, vouloir en faire encore, voilà la condition essentielle pour être un peuple.' Massey observed: 'The formula involves a recognition of the past and its influences. Of this, surely there can be no question.'[59]

On the role of the past, he took issue, for example, with the writings of Walt Whitman, a major source for Harris and others of the group and their circle.[60] He qualified Whitman's statement that 'the direct trial of him who would be the greatest poet is today. If he does not flood himself with the immediate age ... let him merge in the general run.'[61] Massey argued that to look forward only and not back was to rob the Canadian artist of a major source of inspiration. He accused his fellow citizens of 'lethargy' and 'indifference' in relation to their past and claimed that they were 'in little peril of an over-grown historical sense.' 'The safe path to a national art lies, of course, through the increased consciousness of our environment – of our geography as well as of our history.'[62] In short,

his was a less radical view than Harris's, which sought to sweep away a
repressive heritage viewed as heavily indebted to Europe. Massey instead
summoned renewal through a deep imbibing of present and past.

Massey never adopted the strident environmentalism of Harris and
always valued history as much as or more than geography as a source of
national identity. Nevertheless, Harris's spirited defence of diversity, his
determined resistance to conformity, and his belief that creativity and
the fine arts were essential to this project must have been deeply reso-
nant for Massey as his commitment to Canadian pluralistic nationalism
deepened.

Massey also defended the fostering of Canadian arts and letters against
those who argued that they were of little interest beyond the nation's
borders: 'Our contribution to the world, whatever it is to be, will be true
to ourselves and welcomed by others in direct proportion to its Canad-
ianism. As we grow more conscious of our own past and our surround-
ings, we will produce ... art which will be increasingly significant.' He
cited the 'vast quarry in the folk-songs and chansons of French-Canada,'
the Native music that was being (re)discovered, and the distinguished
composers in Canada's midst. 'There ... is an audience for them, not
only in Canada but beyond her boundaries, interested in proportion to
the Canadian atmosphere which they have infused into their work.' He
spoke of art as a contribution to 'our diversified national achievement'
and of the role of artists in lending 'increasing richness to the orchestra-
tion of our life.'[63]

While Massey and Harris were both engaged in legitimizing the princi-
ple of diversity, did their actions correspond with their rhetoric? Despite
some validity to charges that the Group of Seven resisted art that did not
conform to its wilderness aesthetic, its members were not immune to the
hyperconsciousness surrounding the subject of community in Canada as
complex, shifting, fragile, and multi-focal. By the 1920s, there was al-
ready considerable debate about diversity, whether artistic, historical,
ideological, regional, or ethnic. Tensions about immigration, for exam-
ple, had generated both repressive legislation and progressive social
activism.[64]

Harris has sometimes been suspected of racism because he commonly
referred to 'a new race' forming in northern North America, but he
seems to have simply used 'race' interchangeably with 'people.'[65] In
practice, he was fiercely egalitarian, championing a break with Europe
precisely to be free of old hierarchies of class and ethnicity. For Harris,

focusing on the environment was a means of transcending (perhaps denying) ethnic difference.

Massey has been accused of racism, too, notably by Irving Abella and Harold Troper in *None Is Too Many: Canada and the Jews of Europe, 1933–1948*. As Canada's high commissioner in London during the Second World War, Massey was in a position to influence Canadian policy in favour of European Jewish refugees, but he chose not to. Massey's biographer, Claude Bissell, has argued that it would have taken someone 'incautious and heroic' to challenge Canada's committed anti-Jewish immigration policy before and during the war.[66] But there is no question that Massey subscribed to racial stereotypes. As late as 1948, Massey characterized Canada as a nation of northern races and attributed the Canadian propensity for stability and moderation to its racial (and climatic) make-up.[67] Elsewhere, he blamed what he called 'Teutonic' influences for an anti-humanist orientation in North American education. Yet from the time he was a young adult, he had been a vocal advocate for French–English bilingualism and biculturalism, admittedly premised again on a common northern ancestry. None the less, this dualism established a model of coexistence that he invoked frequently in his eloquent, even passionate defence of Canada's ethnic diversity. This included, for example, his outspoken opposition to Canada's racist policies towards Chinese people during the early 1930s.[68]

Massey appears to have belonged to Harold Palmer's third of three views of ethnic assimilation/integration in twentieth-century Canada.[69] This model, which Palmer states began to manifest itself in the 1930s, was cultural pluralism. As opposed to the 'melting pot' model, which saw immigrant and settled communities as merging into a new Canadian type, or 'race,' cultural pluralism valued retention of some measure of diversity within the new mix as crucial to the sustainability of Canadians as a community. I argue that despite the profoundly troubling limitations on his notion of what we now call multiculturalism, Massey was influential in articulating and advancing the cause of ethnic diversity in Canada.

Beginning to Collect Canadian Art

As Vincent Massey's ideas evolved about the role that art might play in the cause of national unity and identity, he became increasingly active as a patron of the fine arts and an advocate and cultural diplomat for their

cause. During the early 1930s, he and his wife, Alice, became among the few serious collectors of contemporary Canadian painting. Collectors in Canada in the early part of the century had preferred imported art, particularly The Hague and Barbizon schools,[70] favourites of Chester Massey. Despite the National Gallery's concerted efforts to support Canadian art during the 1920s, early private support for the Group of Seven came from a tiny circle of patrons and was confined to small works and sketches. Not until the mid-1920s did its major canvases begin to find a market.[71] Dealers in Canadian art continued to be virtually nonexistent. Though not alone, Alice and Vincent Massey would be instrumental in turning the collecting tide.[72]

Late in life, Massey claimed that pictures had always been 'an obsession,' and he acknowledged his wife's 'keen instinct for paintings and a highly developed aesthetic sense.'[73] Their first Canadian acquisitions were fourteen sketches by Tom Thomson, bought for $25 each, in 1918.[74] 'Alice and I were captivated by what was happening in the world of art in Canada,' Massey wrote in his memoirs. 'I think our original inoculation, so to speak, took place when we had the privilege of choosing a number of Tom Thomson's sketches, shortly after his death. We spent nearly a day looking at the brilliant little panels that had been painted in the open, not as studies for larger paintings but as finished works in themselves. So began our collection of Canadian pictures.'[75]

Tom Thomson, closely associated with the Group of Seven, but never a member himself because of his premature death, drowned in Canoe Lake, Algonquin Park, in July 1917. Dr James MacCallum, a major supporter of Thomson and his colleagues, and then president of the Arts and Letters Club, hung a selection of paintings from Thomson's estate in December 1917 at the club[76] and subsequently at the Studio Building, where they were stored while being sold off.[77] Massey saw the Thomson works probably at the club.

A second foray into collecting contemporary Canadian art occurred in 1920, when, through the efforts of Professor Barker Fairley, Group member Fred Varley was commissioned to paint a portrait of Massey for Hart House (illus.).[78] In the words of Fred Housser, who wrote the first monograph on the group, the picture 'was considered at the time it was done, the most modern piece of portraiture in the Dominion.'[79] The commission led to three other Massey portraits by Varley: of Chester Massey, dating from 1920 and also in Hart House; of Sir George Parkin, Alice Massey's father, 1921 (National Gallery of Canada); and of Alice,

magnificantly attired in a green shawl, dating from 1924–5 (illus.). Varley
was none too pleased, however, with his treatment from the Masseys
senior. Hungry and poor, he recounted how on his last day of painting at
their home, Chester Massey came and asked him to join them, not for
something to eat, but for prayers![80]

The Masseys received many requests for loans from their collection
over the years and were generous lenders. Perhaps the earliest occasion
was a Thomson exhibition in February 1925 at Hart House, borrowed
from several collectors, including Lawren Harris, to which the Masseys
lent all fourteen sketches.[81] The Masseys were always keenly aware of the
public role that their collection might play and were active in the canoni-
zation of the Group of Seven and other artists of its generation – includ-
ing, as we see in this section, A.Y. Jackson, Lillias Torrance Newton, and,
most problematically, David Milne.[82]

Even while Canadian minister in Washington, at some remove from
the art scene at home, Massey managed to promote the cause of Cana-
dian art. He had taken up the appointment as Canada's first minister to
Washington in early 1927. After arranging for the purchase of a house
for the legation on Massachusetts Avenue (not without controversy over
the price),[83] he set about securing art for its walls. He wrote to A.G.
Doughty, Dominion archivist, on 18 March 1927, inquiring about the
loan of some prints of Canada from the Public Archives. He explained
that he had been presented with some engravings of Quebec by the
Belgian ambassador 'and should hate to feel that the Belgian Embassy
could out-do our own Archives in supplying a Canadian atmosphere to
our Legation here.'[84] He also appealed to the archives for the loan of
one of its prizes, a portrait c. 1776 of Mohawk chief Joseph Brant by
English artist George Romney, which the National Gallery had acquired
in 1918 on the initiative of Lord Beaverbrook, but which was then in the
custody of the Public Archives.[85] He recruited the assistance of Eric
Brown, director of the National Gallery, on whose board he now sat.
Soon afterwards Brown sent to Washington fifteen or so works, which
included the Brant portrait.[86] Also in the shipment were a number of
Group of Seven works owned by the gallery or still in the hands of the
artists and one or two owned by the Masseys.[87]

Massey also inquired about obtaining a reproduction of the 'famous
picture by Robert Harris of the Fathers of Confederation' and a portrait
of John A. Macdonald. He corresponded with Sir Robert Borden about
his portrait for the same grouping. He apologized to McCurry, the

National Gallery's assistant director, for giving 'so much trouble with regard to the decoration of the walls of this building, but the subject is not without its importance to Canada as I know you understand.'[88]

The collection attracted considerable attention. In response to an inquiry from Emma H. Little of the *New York Times*, Massey explained that the pictures were practically all Canadian landscapes, some belonging to him and some to the National Gallery. He told her that he was 'very much interested in the development of Canadian painting' and offered to show her the pictures and send any material that might be helpful.[89] The pictures also attracted the attention of the *Washington Post* in June 1929. While its article misled the reader into thinking that the entire group of works belonged to Vincent Massey (one suspects that Massey was not immune to self-aggrandizement), it provided some insights into the nature of the collection. Those owned by the Masseys included portraits by R.S. Hewton of the couple's sons, Hart and Lionel, and of Alice. By this time, they had also acquired one or more works by Group of Seven member A.Y. Jackson, who was represented at the legation by several paintings – 'mostly Quebec villages and scenes in Alaska' that drew 'inspiration from the untrodden fields of the far North,' according to columnist Ada Rainey, who waded rather clumsily into the language of northern myth-making.[90] The Masseys were to become good friends of Jackson's, acquire a number of his works, and rely on his counsel in putting together their collection.[91]

The *Washington Post* also mentioned and reproduced a major canvas by Lawren Harris, *Afternoon Sun, Lake Superior*. Massey had written to the artist asking for some of his work for the legation, since the Masseys then owned only one small sketch.[92] Harris lent them a canvas for Washington, which they hung prominently and subsequently bought.[93] Massey wrote to Harris: 'You will be amused to hear that the more conservative picture-lovers, who look with misgiving on the work of Jackson, Lismer and Varley, look on your canvas with relief and pleasure because it has no "new-fangled nonsense" about it.'[94] Massey was obviously pleased with the collection's effect, informing Harris that 'the Canadian pictures here have been a great success and have attracted much attention.'[95]

Massey's tenure in Washington also introduced him to the world of international cultural exchange. 'Music and pictures and sculpture and all which they represent can provide an international language more expressive and more profound than any manufactured Esperanto,'[96] he

stated. He applauded the sending of art exhibitions abroad, a practice still in its infancy, and praised American collector and benefactor Duncan Phillips for his recent comments promoting the role of native art in the foreign mission.[97] 'An internationalized embassy is, after all, a contradiction in terms,' Massey asserted. 'We can accept the artist as a true ambassador, and his product, whatever it may be, as a diplomatic language which can both express nationality and help to unite nations. ... Paradoxically enough, competition in such things as music and painting and sculpture and architecture means co-operation and collaboration too.'[98]

Massey believed that if Canada were to assume its nationhood, it must participate fully as a member of the international community. After his stay in Washington, Massey became very active in the Canadian Institute of International Affairs (CIIA), which was founded in 1928 to promote educational concerns. It was one of a host of bodies that sprang up between the world wars in an effort to foster peaceful international exchange. It served its membership (drawn from business, universities, journalism, members of Parliament, and trade union officials)[99] primarily by hosting speakers and publishing papers.[100] It acted as a national unit of the Institute of Pacific Relations, founded in 1925, electing delegates to the parent organization's biennial conferences. It also liaised with the Royal Institute of International Affairs in London, created shortly after the First World War. In the early 1930s, Massey became a major supporter of the CIIA, funding it through the Massey Foundation[101] and assuming the presidency in 1934.[102]

As a delegate for the CIIA, Massey attended the Institute of Pacific Relations conference in 1931 in Shanghai, where he emphasized the role of culture in international affairs:

Is it too fantastic to suggest that we are under some obligation to know something of the civilization, the culture of these people in the Orient with whom we want to trade[?] We shall not be less effective as traders if we learn to respect their contribution to the world in all its aspects and earn their respect in return. It happens that the first men of business in China and Japan, as many here are of course aware, are generally interested in literature and the arts as well as in trade returns. They do not indulge in a love of pictures or porcelain or poetry as something to be ashamed of but as a natural part of every day life and the better we are able to meet them in their widespread interests, the better we shall get along with them.[103]

As the Masseys' stay in Washington drew to a close in 1930, their commitment to collecting Canadian art intensified. Besides periodic visits home during the late 1920s, which had helped them stay in touch with developments in the visual arts, both Lawren Harris and A.Y. Jackson had kept them posted about exhibitions of contemporary Canadian art. The Masseys had relinquished their house on Queen's Park Crescent in Toronto on their departure for Washington and now decided to transform their country place, Batterwood, outside Port Hope, Ontario, into their primary residence. Meanwhile, Chester Massey's collection of art, so heavily weighted towards the modern Dutch and Barbizon fields, was disposed of by auction in 1928, with the blessing of Vincent and brother Raymond.[104] On their return to Canada in the summer of 1930, the Masseys settled into Batterwood, and over the next five years they built up the largest private collection of Canadian art in the country.

Massey immediately commissioned Jackson to make an oil sketch of a view from Batterwood as a birthday present for Alice. He invited Jackson to spend a few days with them, adding: 'What we should like most is to have the chance of some good long talks with you about pictures and other things in general.'[105] Two Jackson oil-on-wood panels survive from this visit – *Valley at Batterwood* and *Massey Gardens at Port Hope* (illus.), both at the National Gallery of Canada.

Henceforth Jackson and the Masseys were in frequent contact. The nationalistic sentiments that they shared are evident in their correspondence about Jackson's Arctic journey of 1930. Shortly after his stay at Batterwood, Jackson left on his second trip to the Arctic on the *Beothic*, a ship of the Department of the Interior that supplied northern RCMP posts established to secure Canada's territorial claim to the Arctic.[106] Jackson wrote to Massey about the upcoming trip: 'I think we can put the Canadian Arctic on the map pretty definitely. We might even hold an exhibition in New York. It would be a very artistic way of letting the Americans know it is ours.'[107] He asked Massey if he could do anything to facilitate Lawren Harris's accommodation on the ship. Massey contacted Charles Stewart, minister of the interior, suggesting 'our north can be made better known ... by the work of painters who will use its scenery as their subjects.'[108] Harris made the journey and returned, according to Jackson, with 'enough sketches to keep himself busy painting canvases for the next two years.'[109]

Jackson was a tremendous organizer, like Harris, and seemed to have his finger on the pulse of virtually any art exhibition, on show or in the

making. He kept the Masseys thoroughly posted. In early 1932, in reporting on the current Royal Canadian Academy of Arts exhibition in Ottawa, he singled out a Kathleen Morris entitled *St. Sauveur*, priced at $150, as 'about the best thing in the Academy ... I thought it about the liveliest interpretation of a Quebec village I have seen.' He noted that 'there is also a Jim [J.E.H.] MacDonald which I thought was sold years ago, a brook with leaves floating on it, about the size of the Algoma canvas.'[110]

For a 1932 exhibition at the Roerich Gallery, New York, Jackson wrote to borrow from the Masseys' growing collection, requesting *Ludivine* (illus.) by Edwin Holgate, a recently joined member of the Group of Seven.[111] The Masseys obliged. For the first exhibition of the Canadian Group of Painters – the Group of Seven's successor – in November 1933 at the Art Gallery of Toronto, Jackson appealed to the Masseys for a loan of one of his own canvases, *Frieze of Spruce*, which had never been exhibited because they had bought it right off the easel.[112] After the show, Jackson told them that he was dissatisfied with the work and asked if he could replace it: 'I like to think of your collection as being only the outstanding works by Canadian artists.'[113]

Jackson also introduced the Masseys to the art scene in Montreal, where, he reported, artists were 'perhaps more sure of their social position ... while in Toronto I feel sometimes that art is only being used as a means of gaining social prestige.' He observed that, whereas the Group of Seven was all male, now women were doing some of the most exciting work: 'There was a remarkable example of it in our group show ... Arthur Lismer and I thought it [Isabel McLaughlin's *Grey Ghosts of Algonquin*] the most significant thing in the show. I wished it had gone to your collection ... There is a kind of celestial feeling about Sarah Robertson's work, just sheer beauty. Prudence Heward is better equipped technically than the others. Less imagination, but a deep sincerity and a fine intelligence.'[114]

Alice Massey wrote back that 'Vincent and I will be infinitely grateful if you will let us know from time to time when there is a picture that you think we ought to add to our gallery.'[115] Jackson reacted quickly. Within the week, he reported that he had arranged to have 'a little silvery autumn canvas by Isabel McLaughlin' reserved at Scotts.[116] Jackson also arranged to assemble a number of possible additions at the Art Gallery of Toronto – several Harris pictures, including three Arctic works, which Jackson marked first, second, and third choice, and a work entitled *Ontario, Hill Town*, that Harris considered 'one of his finest works' but

had always 'hedged' about selling.[117] Anne Savage's *The Plough* and Jackson's *Quebec Farm* were also in the selection.

Massey wrote to Jackson about the resulting acquisitions: '*The Plough* has arrived and looks splendid on our wall ... We have decided that the [Harris] canvas we like best is an early one, called *House in the Slums*, painted I think in 1920. It is a charming study of a rough cast house in pinks and greys.' Massey added: 'We like the *Quebec Farm* more and more and more.'[118]

Later, in 1935, in the wake of the break-up of Lawren Harris's first marriage to Trixie (Beatrice Phillips) and his departure from Canada with Bess (Larkin) Housser, Jackson wrote pessimistically of his 'feeling that the great days are over.' He concluded: 'We hear that Lawren and Bess are not coming back, and I have a feeling that I will be returning to Quebec before very long. The movement here is over. The ending has little of the glamour of the beginning.'[119]

Meanwhile, the Masseys developed friendships with several other Canadian artists. Around the new year 1934, they bought a controversial picture by the Montreal artist Lilias Torrance Newton, of a female nude wearing green slippers, that no one in Montreal would exhibit. How they knew about the picture is unclear, but the artist, discouraged by the ban and in 'a state of almost hopeless despair,' was thrilled.[120] To the Masseys, she wrote: 'to have it all so splendidly vindicated is wonderful.'[121] She believed that their interest in her work significantly improved her fortunes, and she looked forward to teaching at the Art Association of Montreal's reopened school the following autumn. The Masseys subsequently commissioned Newton, primarily a portraitist, to paint their likenesses and invited her to Batterwood during the summer of 1934. She wrote to thank them for the 'happy summer': 'I feel enormously refreshed in mind and spirit. Please remember what loving interest will always follow you and the boys.'[122] Other artists who spent time there during the summers of 1933 and 1934 in what has been called 'the little art colony'[123] were Pegi Nicol (after 1937, McLeod), who also designed sets for Hart House Theatre,[124] and Will Ogilvie, whom the Masseys commissioned in 1935 to design and execute murals for Hart House chapel.[125] Guests included as well violinist Harry Adaskin, soprano Frances James, and National Gallery of Canada director Eric Brown and his wife, Maud, who wrote of their 'refreshing' stays, often in the company of a small group of artists.[126]

The artist with whom the Masseys had the most ambitious and problematic relationship was David Milne. Their efforts during the 1930s to

promote his work in the name of bettering Canadian art went terribly awry.[127] Massey dated their introduction to Milne's work to 1930 or 1931, shortly after their return from Washington. He recalled in his memoirs first seeing a painting by Milne with Alice in a show at 'an art dealer's shop in Toronto.' 'Its subject was simple enough: a bunch of white flowers – trilliums, I think, – placed in some sort of jug on a window-sill, overlooking the roofs of a small town – purple, green, the off-white of the trilliums, and throughout the canvas – it was an oil – masses of grey and even black strikingly and effectively employed.'[128] Alice Massey recalled their first encounter with Milne's work somewhat differently, as is indicated in a letter to Milne of 28 March 1932: 'We have never met but my husband and I had the delight of discovering at the National Exhibition[129] one of your pictures, and now it hangs in an honoured place in our dining-room. I cannot tell you what a delight it gives us – it is full of a subtle charm that fascinated us from the moment we saw it.' Enclosing a cheque for $175, she continued: 'I hope some day that we may have the pleasure of meeting you.'[130] The picture was *The Window* (illus.), now in the National Gallery of Canada, and its acquisition marked the couple's immediate and sustained interest in the artist's work.

Milne subsequently approached them with a novel plan. In 1934, in dire financial straits, he wrote the Masseys a twenty-nine-page letter, one of the most illuminating and lively documents in Canadian art history, outlining his development as an artist and his artistic concerns. He proposed that they acquire his entire unsold (it was mostly unsold) artistic output to date: 'I have put a price of five dollars each on them, good or bad, as they come, possibly five thousand in all. This is purely arbitrary. It isn't large enough to have made their painting a profitable, or even possible, enterprise; yet it is enough to ensure years of continuous, undisturbed painting for the artist of simple tastes.'[131] It was arranged that Milne would send the Masseys the works then in his possession (a large number were still in New York, where Milne had lived during his early maturity). Lilias Torrance Newton was present at Batterwood when a trunkful of Milne's paintings arrived in September 1934, 'packed like tablenapkins.'[132] Alice Massey wrote to Milne to tell him what a 'thrill' the works had given her husband and her. 'How they ought to be dealt with we do not as yet know – in some ways it is a difficult thing. We are thinking much about it. It was your idea that they should be bought en masse.'[133]

David Silcox has emphasized the value that Milne placed on keeping his works together.[134] Milne approached his works in a serial manner,

exploring and developing an 'aesthetic theme' through a dozen or more paintings or etchings.[135] The idea of keeping them together, while a wonderful conception, was probably feasible only within a large public collection. The Masseys sought the advice of H.O. McCurry, assistant director of the National Gallery. The works could have been subdivided by series perhaps, and only one or two series purchased for a domestic collection. But it was an incredibly ambitious undertaking for a private collector to assume responsibility for such a large and complex group of works. In the end, the Masseys agreed to take approximately 300 pieces, for which they paid $1,500.[136]

Probably several factors were at play in the Masseys' decision: they were sincerely trying to accommodate Milne's wish to divest himself of a large number of works; they knew that the remarkably advantageous price was dependent on their sale en masse; and they recognized that, as custodians of such a large body of exceptional work by a hitherto largely unknown artist, they were in a position to recover some or all of their original outlay for the works while at the same time furthering Canadian art.

From the outset, as they made clear to Milne, they had no intention of keeping the works together. Enclosing the first of two payments of $750, Alice Massey explained that, after selecting some works for their collection and donating a few to public galleries, they proposed to arrange exhibitions in Toronto and Montreal: 'Our intention is that as the pictures sell, whatever surplus there is over and above the original purchase price of the group we are buying from you (together with selling costs, framing, etc.) will be used to buy further examples of Canadian Art. It is of course right that you should have some share in the appreciated value of the canvases, and this I hope you will let us arrange.'[137] She also asked that they be given right of first refusal on future works.

Initially Milne found the exhibition proposal 'startling,' fearing that it would 'demolish' his 'pet theory of the interrelation of the pictures.' On reflection, he changed his mind:

Now that I think it over, it doesn't, or needn't, at least for the period of the exhibition. Anyway the adventure sounds thrilling. The whole thing is surely a unique experiment in art patronage. You speak of my having a share in any appreciated value of the canvases. It was kind of you to think of it, but it isn't possible. It would be unfair to the enterprise, besides I am being fully and generously paid for the pictures, and that closes the transac-

tion. If the pictures can be used to give other Canadian painters a chance it will be an additional pleasure to me ...

With thanks, and best wishes for the further success of the enterprise in aid of Canadian painting.[138]

The Masseys' correspondence with Milne makes it clear that they were very much enthralled with advancing not only Milne's career but Canadian art. Massey wrote: 'Both my wife and I are very glad that you approve of the plan which we have for the pictures. The exhibition of your canvases, I have no doubt at all, will greatly increase the existing interest in Canadian art.' He introduced Milne to Donald Buchanan, recently of the staff of *Saturday Night* and the recipient of a scholarship from the Carnegie Corporation for studying painting and gallery and museum operations, who had 'a real flair' for writing about art. While acknowledging Milne's dislike of fanfare, Massey argued that 'some dignified publicity' was an essential accompaniment to the Toronto and Montreal exhibitions and that 'in the general cause of Canadian art' it would be beneficial for Buchanan to write about Milne's work. He added: 'I feel sure that there will be a widespread interest in your painting when the public has a chance to see it.'[139]

Buchanan visited Milne at Six Mile Lake in the Muskoka area, where the artist had recently moved. Living humbly in a small cabin, he introduced Buchanan to 'roughing it'; they canoed and slept on a bed of moss in the open air. Milne was delighted with his new acquaintance, the first of many that developed out of the Masseys' support: 'I think I said I found Mr. Buchanan interesting. That is too mild. He has the makings of what Canada should pray for, if it is to have any widespread culture – an appreciator and critic with an aesthetic point of view – and that is of more value than a score of artists.'[140] Buchanan wrote a brochure essay in preparation for the exhibitions and an article on Milne for *Saturday Night* and *Canadian Forum*.[141] He also told Alice Massey that Milne could afford little reading material; this deficit she determined to remedy by sending him material selected from 'the great many books and papers' that came into their home owing to her husband's work.[142]

Alice Massey kept Milne apprised of plans for exhibitions, the first of which was slated for 20 November to 8 December 1934 at Mellors Fine Arts Limited, a private gallery in Toronto. Sending Milne a copy of Buchanan's pamphlet, she promised to respect as much as possible Milne's suggestions for the pictures' hanging.[143] Once it had opened, she wrote excitedly: 'You cannot think how exceedingly well the show is

going. I will send you some clippings. The effect of it all, I am perfectly sure, will be cumulative, and it is only the beginning. There were 100 or more people on the first day in at Mellors.'[144] Milne wrote to affirm his endorsement of the project: 'From my point of view it is all fine. I hope it will be a success, at least that it will produce something to launch the second half of the unusual plan you have in mind, that there will be something toward the purchase of pictures by other Canadian painters.'[145]

After the exhibition, the Masseys placed 135 Milne works on consignment with Mellors, who was to be 'exclusive agency for David B. Milne's pictures until May 31st, 1935.' Mellors set out several conditions that were very favourable to his gallery; he was to deduct the costs for framing, stretchers, insurance, transportation, commissions to other than members of the firm, advertising, and incidentals and then to split the remaining proceeds evenly with the Masseys.[146] From subsequent accounting, it appears that this arrangement was followed, and it was renewed in a letter of 10 September 1936.[147]

Meanwhile, in early 1935, Massey wrote to H.S. (Harry) Southam, chair of the board of the National Gallery of Canada, with the plan to donate some Milnes to the gallery, which he noted had 'a very fine collection of Milne's watercolours done under the War Records scheme, but nothing as yet illustrating his work in oil.'[148] The Masseys gave three Milnes to the gallery at this time.[149]

They also turned their attention to extending their association with the artist. Alice Massey wrote again in March 1935: 'I have been thinking a lot in connection with any future work you may do. I think our arrangement was that we should have the opportunity of seeing anything that you turn out. The organizing of the Exhibitions has been quite a problem, but I cannot tell you how happy we are that people are beginning to know you. It strikes me that it would be better for you for us to have a clear understanding as to what we should plan for the future. Will you think out some sort of business arrangment that we can make for a year or so[?]'[150]

No such arrangement emerged, however, and the parties waded into what became an almost insoluble muddle. It appears that the Massey–Mellors agreement extended beyond the Masseys' Milnes to include new works that they did not own, but in which they assumed a proprietorial interest. The Mellors Gallery did indeed lump the two groups of paintings together.[151] Milne was not a signatory to any arrangement with Mellors and apparently remained in the dark for some considerable time about the exact nature of the Massey–Mellors relationship. Mean-

while Mellors and the Masseys arranged exhibitions of his work; Mellors sent small sums from the proceeds of sales to the Masseys, much of it applied against the original purchase price of $1,500; and Alice sent modest sums to Milne, referred to alternatively as advances by Milne and payments by Alice.

As remarkable as the Masseys and Mellors treating the two groups of paintings as one – a seeming mixture of gross presumption and ineptitude – is the fact that Milne sent new works to Mellors for exhibition, despite the absence of a contract, apparently trusting that the benevolent patronage of the Masseys would ensure payment. In the wake of a visit with the Masseys in 1935, Milne did partially endorse the arrangement, on a temporary basis at least, when he wrote to Alice before the Masseys moved to London: 'Your information about sales and exhibitions and finances was a little bit of a shock. I have always clung to the idea that sometime the pictures would have a market value, but it never occurred to me that they might sell without producing a surplus. It was disappointing to learn that after all the time and thought and enthusiasm the Masseys have given, the picture fund was still a minus quantity ... Of course to continue the price arrangement we made for the accumulation [i.e,. $5 a piece] and apply it to current painting could be no more than an emergency plan to get the fund on its feet; it would soon produce a crash in Six Mile Lake.'[152]

In other words, Milne acknowledges, if only in the short term, the involvement of his new pictures in the Masseys' fund to buy other art. In a later letter to Alice, he wrote: 'I suggested that these pictures be used to try to get the fund on its feet, but I never did understand very clearly about the fund – I was just tagging along. At first I thought it was a very ambitious plan for the encouragement of Canadian art in general – by purchases and sales from an ever renewing fund. Later, something either Mr. [or] ... Mrs. Massey said made me think it was concerned only with my pictures ... Anyway, I was dropping that year's work into the pot hoping to make it boil over to the great delight of all of us and to some profit for myself.'[153] Increasingly, however, as he realized how little this arrangement was yielding him financially, he became desperate. After all, his entire output of new paintings was going to Mellors, and this was his only source of income. And, as he wrote to Alice Massey in early 1938, he turned fifty-six that January.

Vincent Massey claimed afterwards that Milne was apprised of the arrangements with Mellors.[154] Whether or not this was so, the question remains: why would Milne have conceded management of his new pictures to the Masseys when they had not bought them?[155] The fund to

which Milne referred, initially envisaged by the Masseys to be an accumu-
lation of revenue from the resale of the original 300 works, made no
sense applied to new, unpaid-for works. Why would Milne agree to have
his new pictures sold to support a fund to buy other artists' work,
especially when he was so close to being broke himself? How either the
Masseys or Milne thought this a viable plan is hard to fathom, and yet it
would seem that they all played a role in its making.

The matter climaxed in 1938. In January, while attending an exhibi-
tion of his works at Mellors, Milne apparently twigged to the financial
arrangement between Mellors and the Masseys. As he put it in a letter to
Alice: 'If Mellors are guaranteed [expenses] ... and then a commission,
they would be taking no chance at all and, unless there were phenom-
enal sales, there wouldn't be anything much for the painter.' In short,
'Mellors appears to be profiting too much from the arrangement.'[156]
Alice wrote to Mellors and attempted to get the matter sorted out, but
without success.

Meanwhile Milne was reaching a state of extreme distress. On 28
August 1938, he wrote:

> Occasionally the cabin has failed me and I have felt a strong desire to walk
> out on it, to leave the clock ticking, the kettle [brewing?] on the stove, the
> pails full of water, the pictures lying in their usual place, everything just as it
> is, not to close the door – not to look back, or ever think of it again, or
> remember anything connected with it. Simply to go, to make an end. With
> no feeling except relief. Clean, free and new, as a snake may feel when it
> crawls out of its own skin.
>
> I have something of that feeling about the Mellors picture situation, no
> particular ill-will or criticism, not much feeling of any kind. Just a strong
> desire to end the complicated situation, to ask no more about it, to think no
> more about [it], to abandon the unsold pictures and to look for nothing
> from those sold, to call the last few years a dead loss so far as any material
> return for the by-products of painting is concerned, and to start over with
> nothing, but with no entanglements from the past.[157]

Not until Milne put the matter in the hands of a lawyer, Miss V.
Parsons, was ownership of the various pictures finally resolved. In the
autumn of 1938, Milne received restitution from the Masseys for the
sales revenue that he was owed – a grand total of $354.67.

Despite this unfortunate, indeed painful, turn of events, there is evi-
dence of considerable good intention on both sides. The Masseys had

taken a sizeable risk on an unknown artist with their initial purchase of his work. As Vincent stated, it was their aim 'to popularise the work of an artist in whom we believe,'[158] and they did much to this end. Alice expended significant time and effort in aid of exhibitions of Milne's work, in Toronto, Ottawa, and Montreal, especially before she and her husband left for England in late 1935. There was also a Milne exhibition installed in the foyer of Massey Hall in early 1938, which Milne reported to Alice had 'been of interest to a good many people.'[159] In London, where they hung Milnes throughout their home in Hyde Park Gardens,[160] along with works by other Canadian artists, Alice Massey was also intent on organizing an exhibition of his work. She reported on 'how very keen people who have come to the house are about the pictures. Mr. Constable, the head of the Courtauld Institute, was most enthusiastic about them, and many other casual visitors. Today I have one of the art dealers coming to see our whole collection, and will let you know at some later time his reaction to yours.' While fielding the idea of a London exhibition, she sought to reassure him: 'My feeling is, don't become obsessed by what you call "exhibition pressure"; just paint with no exhibition in mind and then let us, who love your work, get exhibition-minded if we want to.'[161] Later she wrote from London to report on sales and exhibition plans and wondered: 'How we are going to get this whole thing going on a good business basis I don't know – the suggestions must really come from you. I do feel that I am a help in getting them across and I want to continue to be.'[162]

The Masseys' encouragement must have meant a good deal to Milne. Time and again they expressed their esteem for his work and their desire to promote it. David Milne and Alice Massey, in particular, shared what appears to have been a genuine affection. Alice wrote with concern in April 1936: 'I wonder if you refused to show with the group in Toronto? If they didn't ask you I am furious – still it doesn't matter. We know where you stand and what your pictures mean.'[163] Milne wrote to her on a variety of subjects, not only about his art, but his immediate environment: 'Last night I woke up several times hearing the rattling of ice in the hard court. This is one of the nice Canadian sounds – we have a lot of nice sounds and sights and smells, not much art or literature or music or creative effort of any kind but lots of geography and weather.'[164]

Alice Massey obviously treasured his letters, and from London in late 1937 she wrote: 'You little know how I miss the letters you used to write ... I really long for a touch of your woods in the midst of our black fogs and our very exacting life here. They always bring me a breath of fresh air from the country I love and from an atmosphere in which my heart is.'[165]

'Do write as often as you can,' she urged him, 'and continue to take care of yourself, and paint, paint, paint[;] there are few people like you.'[166]

The Masseys' enthusiastic efforts certainly widened Milne's circle of support. In late 1935, he visited Hart House and was introduced to art activities and various art-minded individuals at the university; his work began to be exhibited there in 1936. By January 1936 his works had been purchased by such collectors as W.C. Laidlaw, Gerald Larkin, J.S. McLean, Alan Plaunt, and the Canadian legation in Paris, among a host of others. J.S. McLean, founder and president of Canada Packers, credited Vincent Massey's example with his own commitment to collecting Canadian art, which would ultimately cover the walls of his company's offices.[167] At an exhibition at Mellors in January 1938, Milne had a parade of visitors: *Globe and Mail* columnist Pearl McCarthy, Arthur Lismer (a first meeting), a Miss Proctor from the *Varsity*, Barker Fairley, A.Y. Jackson (whom he had met many years earlier), Bob Hunter, assistant to the curator of the Art Gallery of Toronto, and Douglas Duncan and Alan Jarvis, of the Picture Loan Society, founded in 1936.

Without doubt the Masseys helped Milne to forge important future relationships in aid of his art. They recognized that they were in a position to activate the market for his work, through exhibitions, introductions, publicity, and documentation of his art (Alice Massey referred to a clippings file that she was keeping as well as a list of purchasers of Milne's work). But most of all they sought to 'aid the enterprise of Canadian art,' which ambition coloured even their relationship with Mellors. Alice wrote to Robert Mellors: 'Have you seen Mr. Eric Brown or Mr. McCurry? Both were interested in my suggestion that you should become an agent for Canadian work.'[168] As early as 1932, Vincent Massey had been one of those interested in establishing a commercial gallery of Canadian art in Toronto specializing in the work of the Group of Seven and its circle.[169]

The Massey–Milne experiment in art patronage, hare-brained as it may have been, and to some downright abusive in its lack of sensitivity to Milne's financial realities, makes some sense as part of a grand scheme by the Masseys to promote Canadian art. Earlier successes in art patronage had emboldened them. Even Milne's unfathomable 'tagging along' with the plan was in part driven by the prospect of participating in this benevolent fund to further Canadian art. Yet while the fund worked to recover the Masseys' initial investment, it did little to further Milne's financial well-being. And it nowhere approached being of aid to other

artists. In short, it was a dismal failure. The whole affair may speak as much to the pitiful, often desperate, state of artists' finances (then and now) in Canada. Even the members of the Group of Seven, who by the 1930s had become Canada's most acclaimed artists, could not survive on income from painting, except for A.Y. Jackson, a frugal bachelor.[170] Lawren Harris was financially independent; the others had to rely on teaching or commercial art.

Milne also came to be critical of the very emphasis that the Masseys placed on exhibiting his work, again perhaps unwilling to accept economic reality. In his correspondence with Alice Massey in the late summer of 1938, he lamented the fact that he was no longer as free to work in a trial-and-error fashion. Because he now had to assume that each picture was intended for exhibition, and he was afraid that early trial works would diminish the value of more resolved pieces, he tended to work and rework the same composition. As he clearly seemed to realize at this stage, his preferred method of working in series made his art most at home in a museum setting.[171]

Despite its shortcomings, this unique experiment ended amicably enough. Vincent Massey became eager to right matters (once they were in the hands of lawyers!). In receipt of an accounting of Mellors's Milne transactions, Massey wrote to W.M. O'Connor of the National Trust Company: 'This statement makes quite clear that pictures belonging to Milne have been treated in the same way as have pictures belonging to my wife and myself. He should, of course, have received all the proceeds of such sales, and the statement confirms my fear that this had not been done.'[172] Milne also took exception to the expenses that Mellors had charged against his pictures and alleged that Mellors had sold them at disadvantageously low prices, in accord with the deflated prices of the Massey acquisition. Massey took full responsibility for recompensing Milne for any charges that the artist considered unjust. To O'Connor, Massey added: 'I may say that Milne is a very fine character. My wife and I are fond of him personally. He is the soul of fairness and honour ... We are very anxious to maintain his friendship and deal with the matter generously and constructively.'[173]

Milne, in 1939, wrote a conciliatory letter to the Masseys: 'Among my few good qualities I do claim a capacity for forgetting, for blotting out what has been unpleasant. I hope the same applies to the Masseys.' He nevertheless remained guarded in response to their proposal to exhibit his work at the Leicester Galleries in London that year. In his view there were not enough new oils to warrant a London show. Careful to distance

himself, he added that, should they wish to pursue the idea, they could contact Douglas Duncan, who now managed his pictures.[174]

The Masseys' mounting support of Canadian painting, which played no small part in its recognition, climaxed in an exhibition of their collection at the Art Gallery of Toronto at the end of 1934. Alice Massey wrote excitedly that the pictures were leaving for the Grange (part of the gallery) on 29 November.[175] To Milne, she added: 'The show of this little collection of ours will, I think, give an impetus to Canadian Art.'[176] Approximately 135 works were on display in three galleries for December.[177] Except for a painting by Cornelius Krieghoff and some early French-Canadian carvings, all dated from the twentieth century.

In addition to the Masseys' fourteen Thomson sketches, which one reviewer called 'the most important group of Tom Thomsons outside of art galleries,'[178] there were four works by Lawren Harris, including two Lake Superior pieces and one of his Toronto 'Ward' pictures on panel and close to a dozen by A.Y. Jackson, as well as works by other founding Group of Seven members J.E.H. MacDonald, Fred Varley (including his profile portrait of Alice Massey), Arthur Lismer, and Frank Johnston, and later members Lionel Lemoine Fitzgerald and Edwin Holgate. Milne was represented by nine oils and three watercolours. Marc-Auréle Fortin, James Wilson Morrice, and Albert Robinson, from Quebec, were also represented, as was British Columbian Emily Carr. In addition, a host of works by a new generation of Canadian painters reflected the greater presence of women among professional artists: three pieces by Lilias Torrance Newton, including her portraits of Vincent and Alice Massey; close to a dozen by Pegi Nicol; and single works by Mabel Lockerby, Isabel McLaughlin, Mabel May, and Kathleen Morris, Sarah Robertson, Anne Savage, and Ethel Seath.

The exhibition generated considerable enthusiasm. A review in *Canadian Homes and Gardens* opened by bemoaning the continued preference among Canadian collectors for foreign rather than local art 'in spite of the fact that in the past twenty-five years Canadian art has become lusty, articulate, confident, that it has had something to say and a particularized method of saying it.' But circumstances were changing, it acknowledged, pointing to the Masseys' leadership: 'There isn't a dull or uncovetable picture in the whole collection, and they are all Canadian.'[179]

Pearl McCarthy wrote in the *Mail and Empire*: 'The thrilling thing about his [Vincent Massey's] collection – and thrilling is not too strong – is the astuteness of the buying.'[180] Augustus Bridle commented in the *Toronto Daily Star*: 'There are citizens in Toronto who have spent more on

J.E.H. MacDonald, *Vincent Massey with Fellow Members of the Arts & Letters Club, Toronto,* 1927. Pen and ink on paper, 15.1 × 13.5 cm. From a volume presented to Massey on his appointment as Canada's first minister to the United States; Massey is seated at the extreme lower left. Thomas Fisher Rare Book Library, University of Toronto; reproduced by permission of the Arts and Letters Club, Toronto.

Arthur Lismer, *Caricature of Polya, Harris, Varley, Jackson, MacDonald, Vincent Massey Seated*, 1925. Graphite and conté on paper, 19.1 × 25.4 cm. Art Gallery of Ontario, Gift of Mrs. Ruth M. Tovell, 1953.

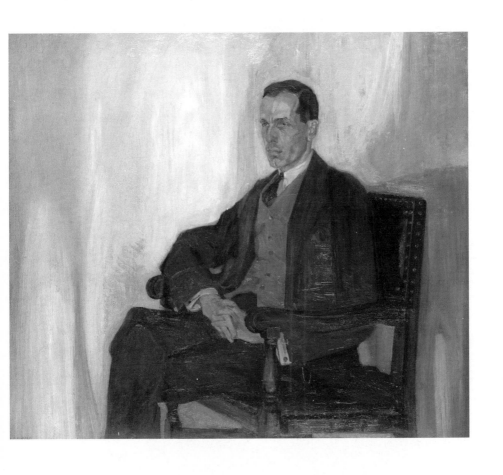

F.H. Varley, *Vincent Massey*, 1920. Oil on canvas, 120.7 × 141 cm. Hart House
Permanent Collection, University of Toronto.

A.Y. Jackson, *Massey Gardens at Port Hope*, 1930. Oil on wood, 26.7 × 34.4 cm. National Gallery of Canada, Vincent Massey Bequest, 1968.

Study, Batterwood; F.H. Varley's portrait of Alice Massey hangs over the fireplace. From *Canadian Art* 21, no. 90, 1964.

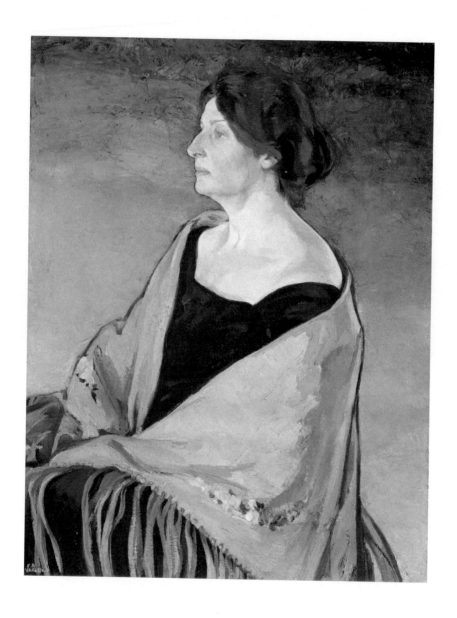

F.H. Varley, *Alice Massey*, c. 1924–5. Oil on canvas, 82.0 × 61.7 cm. National Gallery of Canada, Vincent Massey Bequest, 1968.

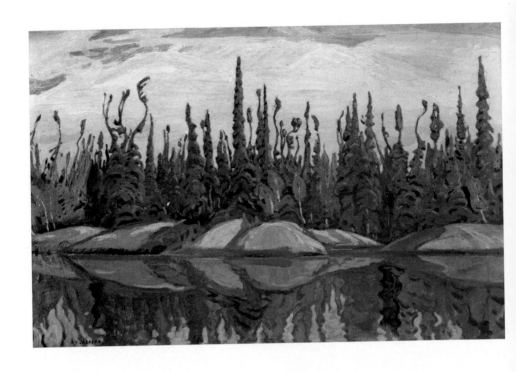

A.Y. Jackson, *Northern Lake*, 1928. Oil on canvas, 82.3 × 127.7 cm. National
Gallery of Canada, Vincent Massey Bequest, 1968.

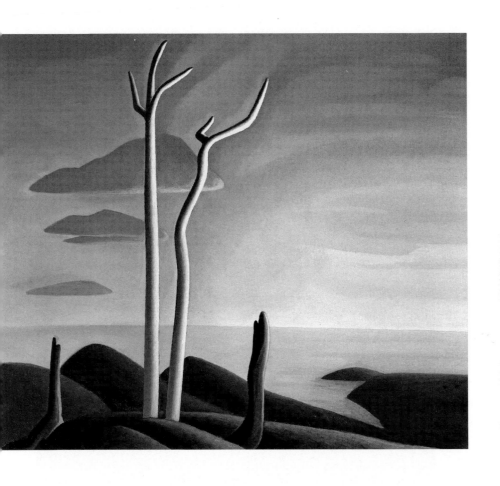

Lawren Harris, *Lake Superior*, c. 1928. Oil on canvas, 86.1 × 102.2 cm. National Gallery of Canada, Vincent Massey Bequest, 1968.

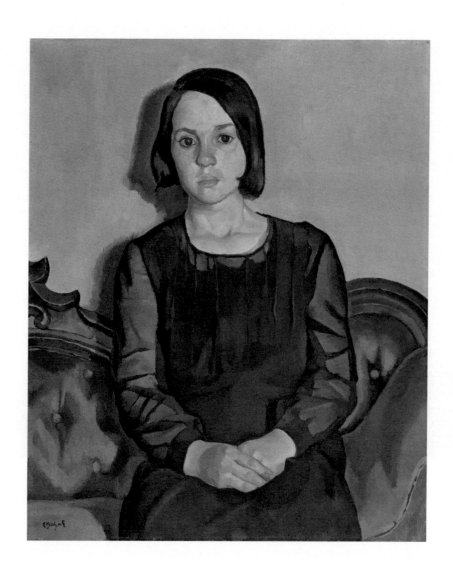

Edwin Holgate, *Ludivine*, 1930. Oil on canvas, 76.3 × 63.9 cm. National Gallery of Canada, Vincent Massey Bequest, 1968.

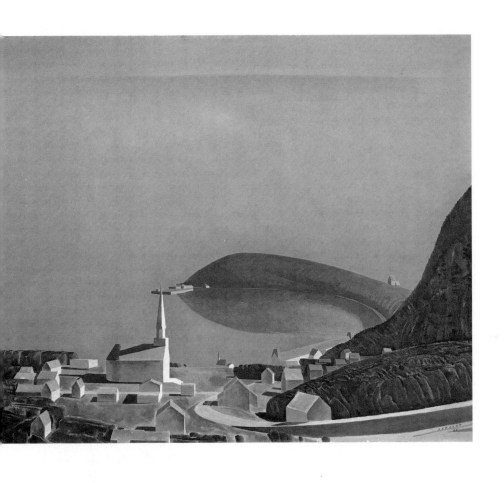

Charles Comfort, *Tadoussac*, 1935. Oil on canvas, 76.1 × 91.4 cm. National
Gallery of Canada, Vincent Massey Bequest, 1968.

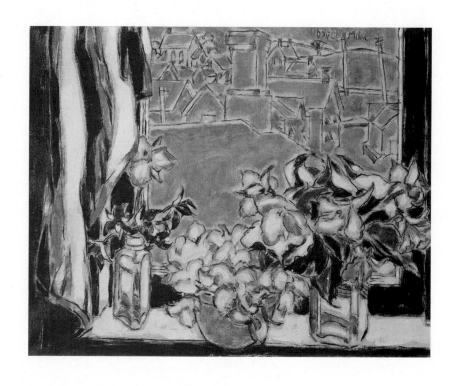

David Milne, *The Window,* 1930. Oil on canvas, 56.2 × 71.9 cm. National Gallery of Canada, Vincent Massey Bequest, 1968.

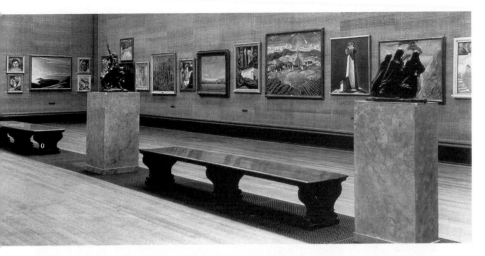

A *Century of Canadian Art*, Tate Gallery, installation photograph, 1938;
Emily Carr's *Indian Hut* from the Masseys' collection hangs thirteenth from the
left. Photo: National Gallery of Canada.

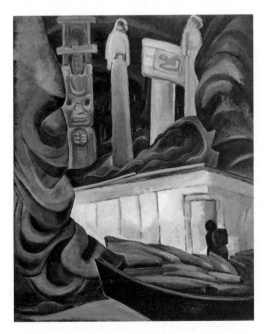

Emily Carr, *Indian Hut, Queen Charlotte Islands*, c. 1930. Oil on canvas, 101.6
× 82.6 cm. National Gallery of Canada, Vincent Massey Bequest, 1968.

Paul Nash, *Chestnut Waters*, 1923–8. Oil on canvas, 102.9 × 128.3 cm. National
Gallery of Canada, Gift of the Massey Foundation, 1946.

Henry Moore, *Family Group*, 1948. Gouache on paper, 55.9 × 60.9 cm.
National Gallery of Canada, Gift of the Massey Foundation, 1948; reproduced
by permission of the Henry Moore Foundation.

a few old masters than the Masseys did on their whole show. But in all Canada there is no other home with so many Canadian pictures and so few foreign ones as at Batterwood House near Port Hope.' He claimed that Massey viewed painting as Canada's 'most indigenous creation,' while also being supportive of architecture, plays, and music.[181]

Reviewers did not tend to mention an apparent anomaly among so many modern works – several nineteenth-century French-Canadian carvings, including *Oval Panel with Angel's Head* by François and Thomas Baillairgé, an altarpiece of the Last Supper by Jean-Baptiste Côté, and an anonymous tabernacle door. The inclusion of these works points to one of the primary historicizing initiatives of Canadian nationalism of the 1920s. In acquiring early Quebec sculpture, the Masseys relied on anthropologist Dr Marius Barbeau, who was documenting French-Canadian sculpture and folk music on behalf of the Geological Survey of Canada. Barbeau was a moving force in the organization of a series of major folklore festivals;[182] with the stock market crash of 1929, international sentiment would lose ground to localism and interest in regional and folk art would gain momentum.

Massey and Barbeau may have first made contact in connection with a celebration of Canada's Diamond Jubilee, a 'Canadian Week' held in New York in October 1927, under the patronage of Governor General Lord Willingdon and Massey, as minister to the United States. Films were shown that gave 'a few glimpses' of the French-Canadian Folk Song Festival at Quebec in May 1927, of the 'Highland Gathering and Scotch Music Festival at Banff' in September, and of the 'Indians of the Totem Pole land,' organized under the auspices of the Canadian government.[183]

Massey and Barbeau subsequently corresponded in early 1928, when Massey required information about Canadian folksongs for a public address,[184] and Barbeau sought Massey's support for 'A Concert of Canadian Music' held in Ottawa in April 1929. Massey also encouraged Barbeau's liaison with Graham Spry and the Association of Canadian Clubs.[185]

In late December 1928, in response to an inquiry from H.O. McCurry of the National Gallery of Canada on the Masseys' behalf, Barbeau wrote that there were several carvings and statues by Quebec artists that might be of interest to them. Their acquisitions appear to date from this time. The Masseys in turn became lenders to the *Exhibition of Traditional Arts of French Canada*, which opened 4 January 1935 at the Art Gallery of Toronto, organized by Barbeau with assistance from the National Gallery.[186] According to the Art Gallery of Toronto's curator Martin

Baldwin, the show was 'a revelation to the people of Toronto of the historical background of French Canada.'[187]

The exhibition of the Masseys' Canadian collection at the Art Gallery of Toronto in December 1934 took place in conjunction with *Contemporary Paintings by Artists of the United States*. The U.S. exhibition was a result of a collaboration between the National Gallery's trustees (including Massey) and the Carnegie Corporation of New York, with which Massey made connections while in Washington.[188] The organizers claimed that Canadians were not well enough acquainted with 'the trends and accomplishments of the art of its nearest neighbours.'[189] The project reflects growing ties between the two countries generally in the interwar years and their joint isolation from Europe.[190] Among the leading American artists represented were Thomas Hart Benton, Charles Burchfield, Stuart Davies, Charles Demuth, William Glackens, Marsden Hartley, Edward Hopper, Rockwell Kent, and Canadian-born Ernest Lawson.

The Masseys had seen the American show in Ottawa, where it opened, and in Alice's opinion there was 'no comparison between what the Americans are doing and the really lovely work of Canadians.'[191] In a letter to Alice, David Milne also recorded his reactions to the two exhibitions. He considered the American show strong technically but complained: 'These are not composers, they are musicians ... Cezanne is God and we are his prophets, and no one could ask [for] more appreciative and enthusiastic disciples. I don't see much sign here of any one hammering at things for himself, trying, failing, once in a while seeing just a glimmer of something no one else had ever seen. Perhaps the selecting committee left those things out, the uniformity of the show suggests it ... A mellow, competent, delightful show. I remember no better exhibition of American art. But the one great thing – creative courage – if it is here, I missed it.'

He too considered the difference between the two nations' shows 'startling':

> The Canadian is more difficult and you will get lots of fighting. Do you like that? I'll admit low tastes – once in a while I get tired of harmony and enjoy an out and out dog fight in art ... The little green Morrice, done when he forgot about everything except the thrill of the thing. The little Jackson with the road to the village ... Here rythm [*sic*] wasn't a formula, it was pure joy. Harris at his most aggressive, the woman from B.C. [Emily Carr] ...

Perhaps the most exciting moment for me was when I saw the watercolors – my own. I had skated through the American section in joy and harmony, but when I came to these – even though they were familiar enough – I was stopped dead – someone had sanded the ice ... I am not sure that they don't give the key to the collection – drive for one thing and overlook everything else to get it.

I hope this splendid exhibition may be seen outside of Toronto; nothing could be more stimulating to art appreciation in Canada.[192]

The Masseys continued to collect Canadian art for another couple of years, but with their departure for England in 1935 their new acquisitions dwindled to a few works.[193] While they remained active promoters of Canadian art, their collecting turned increasingly towards modern British painting. None the less, especially during the early 1930s, their collecting had significantly advanced Canadian art. Whatever the personal satisfaction and/or prestige that this activity brought them – and the prestige must have been limited, given the uphill struggle that Canadian art faced – it is clear that they were caught up in the spirit of Canadian nationalism and that supporting Canadian art was central to this cause.

Vincent Massey now appreciated art as a valuable component in the project of defining Canadian identity. Like Lawren Harris, he was acutely concerned with the spectre of conformism and colonialism and was determined that Canada would elude the homogenizing forces that plagued modern society. The question remains to what extent his nationalism remained sensitive to diversity in art. There is no doubt that Vincent and Alice Massey heavily endorsed the art of the Group of Seven and subscribed to the identification of Canada as a northland. Their taste today would be considered middle-of-the-road, eschewing, for example, all abstract art. Nevertheless, they collected figure paintings as well as landscapes, despite the wilderness aesthetic of the Group of Seven. They demonstrated a considerable responsiveness to emerging artists, including many of the young women who were struggling to establish themselves professionally during the Depression years. While they have been accused of exploiting David Milne, conversely, they intervened in a timely and favourable fashion on behalf of Lilias Torrance Newton and Pegi Nicol McLeod. It is true, however, that they collected primarily anglophones, particularly from the Toronto and Montreal areas.

By the mid-1930s, Vincent Massey trusted art to a degree that would

have been unfathomable fifteen years earlier. In his modified scheme, artists joined the well-educated, as beacons of Canadian character and identity. Massey always professed a mistrust of what he called 'self-conscious' nationalism – by which he meant propagandizing or moralizing. Instead, he came to rely on artistic creativity as a touchstone of national identity and remained confident that he was not prescribing Canadian character but fostering its expression.

The National Gallery of Canada: Struggle for Autonomy

Massey's growing faith in art also manifested itself in his activities as an art museum trustee. His relationship with the Art Gallery of Toronto, where his father had a lengthy affiliation, actually dated from 1913.[194] But it was not until the mid-1920s that his involvement there deepened. By 1924 he was chair of its building committee at a time when plans were being made for a major expansion.[195] On 26 May 1925, Massey spoke at the laying of the new building's cornerstone. Thanking the city of Toronto and private benefactors for their contributions in excess of $282,000 at a time of 'commercial depression,' he made a favourite point: 'we have come to realise that it is under the rigours of hard times when we most need the inspiration which can be derived from intangible things such as painting and the sister arts.' He suggested that 'in painting, perhaps first of the arts, Canada is finding herself.'[196]

On commencement of his appointment to Washington in 1927, Massey attempted to resign his position on the building committee, but he was persuaded to serve during 1927 and then accepted the title of honorary president. Intermittently he acted in various capacities for the gallery, especially while high commissioner in London from 1935 to 1946 (chapter 5).

The main focus of his activities as art museum trustee in Canada, however, was the National Gallery of Canada. Mackenzie King's government appointed him a trustee in 1925, and he served until 1952, when he became governor general of Canada.[197] He worked closely with Eric Brown, who had been appointed the gallery's first curator in 1910 and director in 1912 and who remained in that position until his death in 1939. Brown had very definite views on the role of art in relation to nationality. In the gallery's first annual report in 1921, he stated grandly: 'there never was a great nation that had not a great art ... Art is one of the most spontaneous forms of individual or national idealism which exists. Money spent wisely on it returns a thousandfold in the education of public taste

and elevation of national character.'[198] Brown viewed the hard economic times in 1933 as an 'extremely opportune, if not unique [occasion] ... for presenting this gospel with vigour and power.'[199]

Brown and Massey sustained a close association, professionally and personally, until Brown's death, each undoubtedly strengthening the other's zealous support of Canadian art. However, their emphases differed somewhat. Rarely did Massey talk about the 'elevation' of national character – more commonly, it was the revelation of national character; nor did he rely on the rhetoric of national glory. Massey invariably framed the development of national character as resisting the uniformity of cosmopolitanism.

Taking up his appointment as trustee in 1925, Vincent Massey fell heir to the controversy that surrounded the gallery's role in the British Empire Exhibition in 1924 at Wembley, near London.[200] Opinion was strongly divided on which artists should represent Canada, and how the selection was to be made. Basically it boiled down to a rivalry between a more conservative group under the auspices of the Royal Canadian Academy of Arts and the 'moderns,' primarily the Group of Seven. The exhibition gave ample representation to both but vindicated the latter, who won dramatic acclaim in the British press. More than any other single event, this exhibition established their reputation. As trustee, Massey joined forces with Brown and H.S. Southam, who became chair in 1929, to protect the director from sustained attempts at his removal, to assert the gallery's autonomy in the face of interference from outside bodies, chiefly the Royal Academy, and to affirm the gallery's freedom to collect and exhibit progressive art.

Massey hotly defended the gallery in 1927 to the minister of public works, into whose jurisdiction the gallery fell, claiming that statistics showed 'no preference or favouritism ... in gallery exhibits at home or abroad for any one group of Canadian painters.' He argued against artists' being appointed to the board (for which the academy forces were lobbying) because they tended to perpetuate rivalries.[201] The matter dragged on, escalating again in 1931 after the change in government – indeed the continuing assault on Brown, which took place behind closed doors, in the media, and in Parliament, was nothing less than relentless and mean-spirited. As late as 1934, Massey, working with Southam to formulate a response to the latest round of attacks, warned against 'too many concessions with regard to the alleged shortcomings of the Director.' While hastening to assure artists and public that the gallery would strive for the most cordial possible relations, he argued that Brown's

continuation as director must not be conditional on changes in gallery policy or structure.[202]

The gallery had long struggled for an adequate measure of autonomy. Founded in 1880 by the Marquis of Lorne, the same year as the Royal Canadian Academy of Arts, its early development was closely intertwined with the academy. Further, it had little protection from direct political and governmental whim. Even with its incorporation by an act of Parliament in 1913, its personnel were still employees of the Department of Public Works, whose functions were entirely dissimilar. Massey was keenly committed to securing the gallery's arm's-length relationship from government and directed much of his energy as trustee before and after his departure for England in 1935 to this end (chapter 5).[203]

Massey was quite prepared to defend the gallery's actions, even when it displeased its supporters. A.Y. Jackson, for one, was not happy when the gallery spent funds on European historical art. Jackson wrote to Massey: 'The "group," much to its disgust finds itself in accord with the Academy in regard to Eric [Brown]'s old master hunting ... [,] one thing that needs no assistance from the government of Canada.' Jackson specifically blamed Brown's reliance on art adviser Charles Ricketts, whom he considered as welcome 'as a shark at a bathing beach.'[204] Massey, however, clearly held a dissenting view. Citing Brown's 'skill and initiative' in collecting European historical art as well as his influence in promoting the development of Canadian art, he recommended Brown for an honorary degree from the University of Toronto in 1929, as a means of recognizing 'the place which the plastic arts should take in our national life.'[205]

The rivalry between the so-called moderns and the more academically minded artists and their supporters affected a host of activities, as well as pointing up the consequences of Canadian default in the cultural sector. In 1929, an exhibition of Canadian art was proposed for travel in the United States under the auspices of the American Federation of Arts (AFA),[206] with funding from the Carnegie Corporation.

Massey's correspondence illuminates the ludicrous situation in which the National Gallery now found itself. None other than Prime Minister King entered the fray. In receipt of a letter from Massey that broached the exhibition proposed by Carnegie Corporation President F.P. Keppel, King replied: 'I agree with you as to the compliment to Canadian art which the invitation implies. I can see, however, wherein its acceptance may lead to considerable differences of view and many heart-burnings, unless the greatest possible care is taken in the selection of the paintings to be exhibited.' He continued: 'Personally, I should rather see no

exhibition at all than one which would favour a few Canadian artists at the expense of others, and which would seek to put forward any particular group as being distinctively Canadian ... I am, as you know, particularly anxious to avoid all possibility of controversy, especially where it is linked up, in the public mind, with the attitude of the United States towards Canada, and vice versa.'[207] King's remarks might have had some credibility if his own interest in the arts had been more than marginal and highly partisan.[208] Moreover, his efforts to prevent the sending of an exhibition of Canadian art sanctioned by the National Gallery highlights the difficult course that the gallery was obliged to tread.

Massey pressed the matter with the skills of a professional diplomat: 'I entirely share your feelings as to the importance of keeping any exhibition of Canadian pictures in a foreign country, out of the realm of controversy. It should be possible, however, for the pictures to be selected in such a way as to relieve the trustees of the National Gallery and, *a fortiori*, the Government, from any responsibility.' He continued: 'a well-chosen exhibition of Canadian pictures in this country would be of such value to the development of art in Canada that, unless there is one insuperable objection, the trustees of the gallery should very discreetly and circumspectly offer their cooperation.' He added a postscript: 'My own idea of an exhibition would be one showing the historical development of Canadian painting commencing with Kreighoff and running through Homer Watson, Horatio Walker, Clarence Gagnon etc., with a very carefully selected group from Tom Thomson and his school and no extreme canvases at all.'[209] It was characteristic of Massey to favour a historical survey. He placed store in the authority of tradition and believed that a greater sense of historical continuity would strengthen Canadians, but he also seems to have viewed a survey as a means of diffusing accusations of partisanship. Moreover, he invariably hastened to avoid extremes.

Massey also heard from A.Y. Jackson, who explained that he and Harris had carefully considered the proposed exhibition and had concluded that only a show of modern work would attract attention in New York. They believed that an academy show, representing its overall membership, would constitute 'the dull average of Canadian art' and excite no interest. Jackson warned that involving the National Gallery would risk triggering 'another campaign in the press and elsewhere to oust Eric Brown' and proposed that he himself, Harris, Edwin Holgate, or Arthur Lismer arrange the show and liaise directly with the AFA.[210]

Massey arranged with Carnegie and the AFA that the organizing should not directly involve the National Gallery.[211] Harris and Jackson,

along with an AFA representative, selected the works – all 'moderns.'[212] They showed at the Corcoran Gallery in Washington in March 1930, at the Grand Central Art Galleries in New York in June, at the Minneapolis Institute of Arts in July, and at the City Art Museum of St Louis in August.[213] Thus an exhibition of contemporary Canadian art was mounted for travel in the United States without institutional involvement from Canada or the expenditure of Canadian funds.

Following on the heels of Massey's recent stint in Washington, the AFA show was greeted favourably in that city. The *Art Digest* remarked that it was the first time that Americans had had an opportunity to view on such a comprehensive scale the art of the Dominion and quoted Ada Rainey of the *Washington Post*: 'The Canadian paintings are among the most original seen in the gallery for years.' Soaring to mythological heights, she stated: 'These men of the North sing a saga of their land which has a strain of cosmic forces untainted with the sterility of a false civilization.' Quoting Leila Mechlin of the AFA in the *Washington Star*, the article added: 'Obviously, nature in the Northland is rugged and severe. Strength and endurance are its dominant characteristics, and it is these that one finds reflected in the art of these Canadian painters ... In many of these pictures one comes face to face with the immutable and realizes the littleness of man as measured by the eternal.'[214] Despite government neglect and prime ministerial resistance, Massey's skilful intervention had garnered at least modest foreign recognition for Canadian art. Whether he deserves to be held accountable for this essentialization of Canada as a nation of hardy northerners remains a moot point.

In a postscript to Massey's dealings with the AFA, president Frederic Allen Whiting inquired about the possibility of developing its Canadian membership and even invited Massey to head a Canadian chapter. Massey replied with pointed clarity: 'Under present conditions a Canadian chapter or a Canadian individual loses all national identity in a body which belongs to another country.' He made a counter-proposal – a Canadian Federation of Arts, with which the AFA might then cooperate. But, as he readily acknowledged, such an organization was not likely in the immediate future, given economic circumstances.[215] Whiting replied that if the plan went forward, the AFA would cooperate in every way. For the time being, it would recruit whatever Canadian members it could.[216] Massey must have been less than pleased.

Meanwhile, Massey and his colleagues at the National Gallery of Canada accepted guidance and financial assistance from the Carnegie Corpora-

tion, which had been supporting the arts in Canada since the mid-1920s.[217] Even earlier, Carnegie had funded libraries and the acquisition of church organs in Canada. In 1931 the corporation commissioned Sir Henry Miers, scientist, scholar, and president of the Museums Association (London, England), and Sidney F. Markham, British Labour member of Parliament and secretary of the same organization, to survey museums in Canada.[218] Among those they interviewed was Vincent Massey.[219]

While 'astonished at the standard of museums and galleries' in Canada 'considering the infancy of the movement,' Miers and Markham lamented their lack of cooperation. With few exceptions, curators were completely ignorant of each other's activities, even within their immediate areas. Generally in favour of decentralization, Miers and Markham nevertheless recommended a network of provincial museums loosely affiliated with a central body.

They were also critical of the lack of effort to interest the general public in Canada's museums: 'Paralytic modesty is a common museum disease from Calgary to Halifax.' Not least, they expressed dismay at the 'steady drain of some of the best full-time curators in the Canadian museums to museums in the United States.' They estimated that if all sixty of the inadequately curated museums were to seek curators, 'it is doubtful whether more than two or three persons could be found in the whole Dominion qualified to fill these posts.'[220]

The report led to the formation of the Carnegie Corporation's Canadian Committee in 1933. Miers recommended specifically to Frederick Keppel, president of the corporation, that 'there be set up in Canada a small group of informed persons who would discuss informally Canadian museum problems and proposals with a view to advising the Corporation as to significant opportunities for service.'[221] The corporation's substantial resources included $10 million earmarked for the Commonwealth outside the United Kingdom, which had yielded an accumulation of $2 million or $3 million.[222]

The National Gallery of Canada convened a committee on behalf of the Carnegie Corporation consisting of Eric Brown; E.L. Judah of McGill University; F. Kermode of Victoria, British Columbia; H.O. McCurry; and Dr Clarence J. Webster of Shediac, New Brunswick.[223] Massey accepted an invitation to join[224] but was unable to attend the first meeting. Propelled by a belief that museums were rapidly becoming among the most active of cultural agencies and as essential to the education of children and adults as the public library, the committee resolved to

create a Canadian Museums Association to organize a circulating exhibition system beyond but in harmony with the National Gallery's and to implement a system of scholarships for museum training.[225] Massey was selected to sit on the three-member executive committee (with Brown) and on a subcommittee on galleries (with Brown and Webster).

Massey wrote to Keppel after attending his first meeting on 29 May 1934: 'I am most enthusiastic about [the] possibilities ... arising out of the establishment of the Committee on Canadian Museums. The meeting of the 29th was a revelation to me of what can be done in educational effort under this head.' However, he questioned the exclusion from the committee of a representative from the Royal Ontario Museum, specifically C.T. Currelly, arguing that 'the Royal Ontario is the only museum which can perform a national duty in such activities as the loan of materials and numerous other services.'[226] Keppel advised him to take the matter up with the rest of the committee, explaining that it was 'of the first importance that the initiative for enterprises in the Dominions should come from the Dominions themselves.' Keppel added that at the present time he was 'engaged in teaching a lesson upon this point to the British Association, the active representative of which, Mr. Markham, would be very glad indeed to have the initiative lie in London instead of Canada or Australia. For this reason, we have endeavored to be particularly correct in our relations with the Canadian Committee, though our informal relations are wholly friendly and comfortable.'[227] While the Carnegie Corporation may have made an admirable effort at devolution, and its profile in Canada warrants closer study, Keppel's choice of words 'teaching a lesson' rather betrays the problem of one country's funding the cultural activities of another.[228] The latitude given the Canadian committee remains unclear. In September 1934, Keppel wrote: 'In a general way I think the practice which has so far been followed by the Canadian Committee of informal consultation with this office in the case of grants of importance is a sound one.'[229]

More alarming for Canadian cultural sovereignty was a turn of events in the gallery's funding in early 1934. Faced with a dramatic decrease in its parliamentary appropriations during the early 1930s to a mere $25,000 for the 1934-5 fiscal year,[230] the gallery contested the matter with the minister of public works and meanwhile looked elsewhere. Massey reported to Harry Southam that he had visited Keppel in New York to propose that the latter underwrite the gallery's 'requirements for the year 1935 ... if for any reason the Government decided against increasing our grant for this year to $100,000.' Massey continued: 'A few days

after my return home I received a letter from Mr. Keppel's secretary saying that ... it was found they could make us a straight grant of $7,500 from some unexpected fund which they asked the National Gallery to accept as a token of their appreciation of the work we are doing, and for our helpful co-operation with the Carnegie Corporation, especially in connection with the recent exhibition of paintings by contemporary American artists' at the Art Gallery of Toronto.[231] Remarkably, the gallery accepted this donation,[232] a telling commentary on its financial vulnerability. It also represented an ironic concession from Massey – in so many respects a consummate nationalist – and offers an insight into the fruits of cooperating in the showing of American art in Canada.

The gallery's meager appropriation was matched by an equally inadequate physical plant. As chair of the Massey Foundation, Massey made several offers to fund the building of a concert hall and art gallery in Ottawa.[233] Writing to Mackenzie King in 1937, he proposed that the foundation finance the building if land were provided. As he noted in his memoirs, however: 'This aroused no interest, let alone enthusiasm, and the proposal died a natural death.'[234] Federal disinterest on this occasion approached almost perverse neglect. However, Massey would return to the subject of a building for the gallery with renewed vigour after his return from England in 1946.

The Dominion Drama Festival

Massey's nationalizing agenda was also shaping his involvement in Canadian drama. At Hart House Theatre, he was insistent on inclusion of a Canadian bill of fare – usually two plays a season.[235] Seventeen of these were published in 1926–7 in *Canadian Plays from Hart House Theatre* in two volumes edited by Massey. The Masseys also arranged for a $500 annual prize for a full-length play in French or English written by a Canadian (or a British subject living in Canada) that dealt with some aspect of Canadian life. The Syndics of Hart House Theatre agreed to give the winning play a public production during the 1926–7 season.[236] During and after their stay in Washington, the Masseys remained involved in Hart House Theatre, choosing its directors, including the first woman, Nancy Pyper, a former professional from Winnipeg, in 1935.[237]

But the theatre project that distinguished Massey's career after his return to Canada in 1930 and was most symptomatic of his national agenda was the Dominion Drama Festival. Amateur theatre had gained ground in Canada, invigorated by developments in the late 1920s and

early 1930s. The 1929 crash and the arrival of 'talking' pictures killed
professional theatre, which was dominated by foreign touring compa-
nies, especially out of New York. Failing international money markets
helped to validate local initiative, including amateur theatre. By then,
theatre had also acquired a certain respectability among the church-
going population, in the service of the social gospel movement.[238]

As early as November 1931, Lord Bessborough, governor general from
1931 to 1935 and a devotee of amateur theatre in Britain, floated the
idea of a national drama league and festival in an address to the Ottawa
Little Theatre. The talk exalted drama both artistically and education-
ally. In his view, universities were the primary 'sources of culture,' but
artists too could enhance a nation's reputation.[239] His emphasis on
national prestige contrasted quite sharply with Massey's defence of na-
tionalism as a protection of diversity. None the less, both men hoped for
a national infrastructure for amateur theatrical activity.

Bessborough sent Massey a proposal for an ambitious national ama-
teur drama competition, and despite initial reservations, Massey re-
sponded with alacrity.[240] He recommended two competitions – one for
'declamation' and one for 'drama.' Declamation, he argued, would
incur little expense and be more attractive to the public and educational
authorities, who did not yet accept drama 'officially as a factor in educa-
tion.' Massey noted 'certain misgivings' about theatre in Canada because
of a 'lingering Puritan tradition.' Thus he advised 'that the dramatic
competitions ... be conducted the first year on a very conservative and
limited basis, while the contest in declamation might be carried consid-
erably further.'

Massey also stressed the need for support from all provincial govern-
ments. 'The subject of education ... is strictly provincial and the prov-
inces are very jealous of their prerogatives in this matter.' He rejected
Bessborough's suggestion of limiting the dramatic competition in the
first year to certain large centres: 'The plan must, for obvious reasons, be
a national plan and it would be unfortunate if even in the first year
participation was confined to the eastern cities or even the cities as
distinguished from the country districts.'[241]

Bessborough invited Massey to be chair of the general and executive
committees of the festival, and on 29 October 1932, at a meeting at
Government House in Ottawa, the Dominion Drama Festival was inau-
gurated. Bessborough relied heavily on Massey, who was intimately
involved from the beginning with the festival's organization and

arrangements, in everything, even down to the wording of diplomas.[242] As with his support for other ventures, Massey's role here qualified as what he called 'active' rather than 'passive patronage.'[243]

For the purposes of the festival, the country had twelve regions, with each of the nine provinces deemed a region, except Ontario (three regions) and Quebec (two). The winners of the regional competitions were to compete in national finals in Ottawa. For the first festival there were 110 entries. As chair, Massey welcomed the 168 contestants: actors, directors, and technicians, who converged on Ottawa in April 1933 for the first finals. He noted with satisfaction that eight provinces were represented: 'The number of individuals who will take part have become a rather formidable army. If the festival was held in Europe, teams would have to come together from as far apart as Constantinople, Warsaw and Algiers. That gives you an idea of the geographic dimensions of this Dominion Drama Festival.'[244]

The success of the first national competition was the result, in significant measure, not only of Massey's counsel, but of the financial support that he steered its way. The Massey Foundation made an initial $2,500 donation; the balance of the projected $6,000 needed for the first year's expenses was solicited from a few other private donors, although it was hoped in the long run that the festival would be self-sustaining.[245] The Massey Foundation continued to be a benefactor, giving $1,000 in 1933 and in 1934.[246]

From the first, there was a consensus that original Canadian plays were to be encouraged.[247] Looking over the proposed list of plays that contestants could choose to perform for the first festival, Massey suggested inclusion of one or two one-act plays from the two-volume Hart House collection. However, the number of Canadian plays performed was consistently disappointing. Little theatre companies were timid about untried material, despite a prize – the Barry Jackson Challenge Trophy (dating from 1934) – to encourage domestic material. Moreover, plays by Canadian authors were still in limited supply; not until 1967 did the festival dare to hold an 'all-Canadian play' final.[248]

Massey's affiliation with the festival continued, albeit in a less active manner, after his departure for London in 1935. He held the title of president until 1950, except for a brief period as vice-president in 1937. As governor general from 1952 to 1959, he was also an active supporter.[249] While most intimately involved with Canadian theatre during the 1920s and early 1930s, he held throughout his career strong hopes

for the development of a national theatre. He became a keen supporter of the Stratford Shakespearean Festival in 1953, with the Massey Foundation[250] and Massey[251] himself making timely donations.

Central to his involvement with theatre was Massey's healthy respect for the well-spring of theatrical activity across the country and its local character. The creation of a national system was a means of fostering communication and excellence and was by no means an initiative aimed at dominating or suppressing local diversity. His activities in connection with both Hart House and the Dominion Drama Festival testify to his keen appreciation of the richness of Canadian artistic effort.[252] He increasingly believed, however, that the amateur and local nature of theatre was not sufficicent; it must be aligned with national structures in the arts in order to protect Canadian sovereignty and the very principle of diversity.

Broadcasting

By the late 1920s a new threat to Canadian cultural sovereignty and diversity had reached alarming proportions – the growing domination of the airwaves by U.S. private broadcasting interests. The orbit of American influence in Canada expanded appreciably after the First World War as both countries sought to distance themselves from any future European conflict. By 1926, with North American isolationism on the rise, American investment in Canada for the first time exceeded British.[253] Meanwhile, a massive influx of American cultural fare entered Canada via radio, driven by commerical concerns and virtually unhampered by the American and Canadian governments.

Massey's deepening nationalism awakened in him an acute appreciation of public radio as a means of fostering a sense of community. Those who have accused him of ignoring or minimizing the role of the mass media as purveyors of culture need to take account of his place in the battle for public broadcasting in Canada during the late 1920s and early 1930s. While not a major player, he intervened in a timely manner on several occasions. In Washington, Massey served as part of an international body involved in assigning radio frequencies and appreciated fully the expansionist aspirations of private American radio interests.[254] In December 1928, the Canadian government established the Royal Commission on Radio Broadcasting, chaired by Sir John Aird, president of the Canadian Bank of Commerce. Massey apparently suggested Aird's name, along with that of one of the other two commissioners, Charles

Bowman, editor of the Ottawa *Citizen*,[255] who was the most active of the three members and already committed to public broadcasting. Massey kept up a lively correspondence with Bowman from Washington during the commission's proceedings.

Bowman warned him in December 1928 'that United States organizers of commercial airways' were 'planning to treat North America as one common field of enterprise.'[256] Bowman also bemoaned the contradictions of those who lobbied against public broadcasting and pointed to models in Britain and Germany that Canada might consider emulating. Massey sent Bowman and Aird a copy of the annual report of the U.S. Federal Radio Commission[257] and a copy of an editorial in the *Washington Post* (2 January 1930) that was critical of the American system of broadcasting.[258]

In the face of opposition to the Aird Commission's report (tabled in September 1929) in favour of public broadcasting, Massey launched his own lobbying campaign. He wrote to Bowman 'that in addition to the organization of a nation-wide body which will represent the point of view in favour of nationalization, it will be essential to find a number of outstanding citizens who will be prepared to appear before the Committee' (the parliamentary committee considering the report's recommendations). He suggested Colonel Henry Cockshutt, Canon Cody, Sir Arthur Currie, Sir Robert Falconer, and 'other men with intelligence and influence in various cities.' He argued that if such individuals spoke in favour of government ownership of broadcasting, it would help counter 'the organized effect of propaganda which is certain to be brought to bear upon the question by people who are commercially interested in maintaining the status quo.' He added: 'Your editorial suggests the most appropriate line for such persons to follow, that of advocating nationalization in the interests of Canadian nationality.'[259]

In turn, Bowman wrote Aird: 'The necessity of safeguarding Canada's place in the radio realm for educational broadcasting must surely appeal to leading citizens like Sir Robert Falconer, Canon Cody, and your banking associates, particularly Sir Joseph Flavelle and Sir Thomas White.' To the list, he added Toronto patron of music F.R. MacKelcan (National Trust Company) and Ernest MacMillan, pointing out that several of these people might be willing to appear before the committee in support of the commission's report.[260]

Bowman also wrote to Fred MacKelcan to solicit his support, emphasizing the campaign's importance for the arts in Canada. 'Within a few years it will be possible to bring by radio some of the finest music from

Great Britain and the cities of Europe ... It does seem desirable under the circumstances that no effort should be spared to retain Canadian radio independence on this continent, by establishing Canadian broadcasting on a secure national basis. Otherwise, the present tendency would seem to indicate that private stations will become more and more dependent upon United States sources of supply for radio entertainment.'[261]

Massey meanwhile suggested to Bowman that Ernest MacMillan, head of the Toronto Conservatory of Music, appear before the committee.[262] Massey also recruited the members of the Hart House String Quartet.[263] Moreover, he authorized MacKelcan to make a submission on behalf of Massey Hall; MacKelcan was able to marshal statistics on attendance there that countered unsupported statements in the media about the lack of musical talent in Canada and showed 'a large majority of Canadian performances as compared to outside ones.' MacKelcan and Massey were keenly in favour of public radio, not only in order to support the arts in Canada, but as a means of moving the focus of broadcasting beyond Toronto, where it had been heavily weighted by commercial broadcasting.[264]

In March, Massey wrote to O.D. Skelton, under-secretary of state at External Affairs, enclosing two copies of an article in the *United States Daily* on the report of an advisory committee on education by radio; set up by the U.S. secretary of the interior, Ray Wilbur, the committee gave 'little hope of commercialized broadcasting being able to perform educational services.'[265] Meanwhile, Massey was also in contact with BBC executive Gladstone Murray (a Canadian) in London, who was following the struggle with keen interest.

Rather auspiciously, in February 1930 Massey speculated to Bowman on the virtue of attempting to enlist the support of 'any existing bodies such as Canadian Clubs, or Rotary and the other 'service' clubs which might be induced to give a corporate support to the Radio Commission's report.'[266] In October 1930, Graham Spry, the energetic and enterprising national secretary of the Association of Canadian Clubs, and Spry's new friend Alan Plaunt created the Canadian Radio League. Together, they would conduct what has been called 'a classic study on the art of lobbying'[267] and 'one of the most remarkable accomplishments ever to take place in our country.'[268] As chairman and secretary of the league, respectively, they galvanized support for national public broadcasting, which led to formation first of the Canadian Radio Broadcasting Commission in 1932 and in turn of the Canadian Broadcasting Corporation in 1936.

Speaking on behalf of the league in 1932 to the parliamentary committee convened to study the matter of radio, Spry stated: 'Radio broadcasting is not to be considered or dismissed as a business only. It is no more a business than the public school system, the religious organizations, or the varied literary, musical, and scientific endeavors of the Canadian people. It is a public service. It is a national service. As a public and national service it should be controlled.'[269]

As the lobbying effort climaxed, Plaunt reported to Massey that 'the radio issue has reached a decisive juncture and the League will require substantial financial assistance if it is effectively to complete its work.' In March 1932, he summarized its efforts: 'During the past fourteen months the League has organized and focussed a vast body of public support for a rationally organized Canadian broadcasting system. That support now includes the leading national, labour, farm, women's and listeners' organizations, the heads of, and the principal religious bodies; 16 presidents of Canadian universities; a large number of business, industrial, banking and professional leaders throughout the country, and 75 principal daily newspapers.'[270]

Plaunt followed with a telegram on 21 March 1932, impressing on Massey the urgency of the situation: 'Would appreciate your financial assistance to bring Gladstone Murray Canadian sub director BBC London appear before Parliamentary Committee on Radio. Would require five hundred dollars for this purpose stop his testimony would be invaluable at this time stop ... time most important as committee sits only one week after Easter recess.'[271] Massey stood the cost, and, enclosing his cheque (for $400), he wrote to Spry to commend the league on its efforts: 'All of us who believe in radio as a national service owe you [Spry and Plaunt] a debt of profound gratitude for the self-sacrificing and skilful work you have done in the last few years.'[272] Plaunt wrote back to thank Massey for making Murray's appearance possible: 'his testimony may well have been the decisive factor in convincing the committee and the Prime Minister of the feasibility of a public monopoly.'

Plaunt's correspondance with Massey is also revealing for his view on the nature of a public monopoly. As he explained to Massey, the league had always opposed paid commissioners and envisioned instead 'a voluntary board of directors who would simply be a guarantee to the public that the broadcasting organization was being operated independently of partisan politics and generally in the public interests. Then there would be the operating corporation or commission headed by a high salaried expert such as Gladstone Murray.'[273] Massey himself would reflect deeply

over the next decade on the nature and mechanisms of non-partisan governmental support for culture.

In May 1934 the league and Massey were in contact again. The compromises that had shaped the CRBC's creation had proven of limited success. Plaunt wrote to Massey 'that the present set-up imperils the principle of a public system' and sent him a copy of a memorandum that the league had prepared on the present situation for the parliamentary committee.[274] The league had particular concern over, for example, the future make-up of the commission's governing board (qualifications of members, their numbers, tenure of office) and its relation to Parliament, so that its structure and administration would be non-partisan and business-like. The league was strongly of the view that the board, not the government, should appoint a 'director-general' of the reorganized corporation. Again Massey was supportive and encouraged the league to renew its efforts.

In October the government changed hands, and Massey was active in promoting the league's position with C.D. Howe, with others of King's government, and with King himself, as well as advising the league on strategy. With the successful reincarnation of the CRBC as the Canadian Broadcasting Corporation (CBC) in 1936, Gladstone Murray was put forward as its possible head. Plaunt wrote Massey to solicit his support of Murray's candidacy. The league feared the appointment of R.M. Brophy, a Canadian then employed by the U.S. National Broadcasting Company (NBC), whom it viewed as a supporter of commercial broadcasting. Murray was chosen and in his new capacity wrote to Alice and Vincent Massey, now in England. He reported that he had just completed a tour of western Canada, where he had had meetings in communities from Nanaimo to Fort William. 'It was strenuous,' he reported, 'the temperature varying from 40 above on the Island to 40 below at Regina. But enormously useful. No one so far had taken the trouble to examine radio problems on the spot. This is the only basis on which to found policies of lasting value.' He closed: 'Thank you again for your critical part in opening this opportunity. It is a great challenge. Pray God I can stand up to it until the new organisation is in being.'[275]

In 1938, Massey sought to intervene again in Canadian broadcasting. In a letter to C.D. Howe from London, he tackled the subject of short-wave radio transmission from Canada to Britain and the rest of Europe. He pointed out that broadcasts from Canada travelled to Britain through either American transmission services or the very expensive 'beam telephone.' Massey strongly supported the CBC's ambition of

erecting a short wave transmitter in Canada for broadcasts overseas. He solicited the support of the BBC's new director general, F.W. Ogilvie, who welcomed more Canadian material 'from both the broadcasting and the imperial points of view.' Massey also pointed out that one of his duties in London was 'to secure the fullest possible publicity in Great Britain for Canada and Canadian services. Broadcasting is an increasingly important medium for this purpose and without direct broadcasts from Canada through a short wave transmitter we will never secure the volume of wireless publicity which is so desirable.'[276] From the 1930s on, the value of the media in promoting Canada abroad by no means escaped his attention.

Through his activities in the arts in the late 1920s and early 1930s – as a spirited, thoughtful, and sometimes even visionary speaker, as a patron of the visual arts, as a trustee of the National Gallery, and as first chair of the Dominion Drama Festival – Massey displayed an accelerating and increasingly public commitment to the arts. The fine arts now ranked for him with the liberal arts in cultural import, having aquired value in direct relation to their capacity to serve national identity. As a lobbyist on behalf of Canadian public broadcasting, Massey also recognized the enormous potential of the mass media in defining Canada.

The transformation in Massey's view of the fine arts was indebted to various sources. Lawren Harris, in particular, made perceptive and persuasive arguments in defence of art. His passionate determination to resist the artistic subservience of colonialism helped Massey to understand art as an important battleground in the fight for national independence. Harris also provided a theoretical basis for elevating the status of art, one that defended art as an enterprise profoundly indebted to local inspiration and diversity. Massey now had more planks in his platform for Canadian sovereignty; in addition to character education and excellence, he was able to place his faith in artistic creativity and diversity. By the time Massey was posted to Britain in 1935, his ideas about the role of the fine arts in culture and nationality had achieved a new degree of intellectual complexity and moral resolution: the fine arts undeniably intermingled with, in his words, 'the spiritual forces which nationality creates.'[277]

PART THREE
Forging a New Framework

5

The State and the Arts: British Models, 1935–1946

In late 1935, Vincent Massey arrived in London as high commissioner for Canada. He had long favoured close relations between the two countries, and, with the approach of war, he was now at the vanguard of resurgent Canadian–British cooperation. For Massey, this realignment was an affirmation of the humanism that he believed to be central to Canadian democracy and that distinguished it from a more purely capitalistic model. Humanism – which signified for him such key features as moral agency, a highly developed critical sense, a commitment to excellence, tolerance engendered by exposure to diverse perspectives, and a sense of duty to the broad collective – was central to the project of resisting cultural homogenization (or in today's terminology perhaps 'globalization'). A renewed bid for alliances with Europe, especially Britain, counterbalanced the threat of colonial dependence on Canada's powerful neighbour to the south and helped deflect the spectre of cultural effacement. Massey's stance belongs within Canada's now familiar commitment to multilateralism in moderating superpower control, be it British or American.

Assuming that intellectual and cultural life lies at the root of identity and sovereignty, Massey became committed to revitalizing the Canadian–British cultural heritage. In a world where the idea of military and economic alliances had common currency, the notion of a postcolonial cultural alliance was more novel. And despite Massey's conviction that enhanced relations with Britain would indirectly serve Canadian independence, this in no way replaced or diminished his resolve that government in Canada needed to be strengthened. Part of Britain's attraction to him was as a model of a particular type of state intervention.

Canada has been the recipient of vast British cultural export, long as a

colony. A mixed legacy, which in the artistic field awaits a thorough assessment, it has generated both loyalty and resentment. Massey was one of those who firmly believed that the British colonizing presence in Canada was a thing of the past. Of course, discerning the precise line between cultural dependence and cultural partnership remains problematic. In turn, some colonializing structures that Canada inherited from Britain and perpetuated survive today – for example, in the treatment of Native North Americans. But in view of Britain's declining economic clout in Canada and internationally in the immediate post-war era, the contours of its cultural interaction with Canada have perhaps become more readily apparent. Certainly Massey claimed no patience with Canadian international subservience and was committed to transforming any lingering dependence into a partnership of reciprocal exchange with Britain. He advanced the cause on both fronts – the dissemination of Canadian culture abroad and the projection of Britain in Canada.

The endeavours on which he embarked to strengthen the alliance were various. He promoted Canadian art in Britain; helped launch and administer the Canadian program of war art, which brought together Canadian and British artists; served on the boards of the Tate Gallery and the National Gallery, London; and headed a commission on their relations. As chair of the Massey Foundation, he assembled, with help from his family, a collection of modern British art for Canada; he also encouraged the British Council's activities in Canada. Furthermore, Massey was profoundly impressed by the nationalizing role of the arts in Britain's war effort and its emergent model of state-supported art. He viewed this as an extremely promising resolution of Canada's need for state involvement in the cultural sector without placing the arts at the service of political sloganism and cronyism and without suppressing local initiative.

Massey's affinity for the Anglo–Canadian alliance dated from his earliest career. During the 1910s, along with Edward Kylie, Sir Edmund Walker, George Wrong, and others, he had been involved in the Round Table movement.[1] Founded about 1909, it studied and promoted international, and especially British imperial, relations. Massey and other Canadian members opposed any legal or constitutional union but sought to foster cultural relations among the dominions.

It is difficult to assess whether Massey's interest in British connections waned during the 1920s and then accelerated during the 1930s or remained steady throughout. As chair of the Massey Foundation, he

launched a lecture series in 1932 apparently aimed at resuscitating the flow of British intellectual currency in Canada. The Massey Lectures brought prominent speakers from Britain once a year to deliver addresses at a Canadian university in areas such as education, letters, philosophy, and public affairs. The first lecture was broadcast on national radio only two months before the Canadian Radio Broadcasting Act was passed in May 1932. When proposing the series, Massey noted that distinguished Americans often visited Canada, but distance and current economic circumstances made British guests more scarce.[2] He was undoubtedly attempting to stem the tide in Canadian–American relations, which escalated so markedly in the interwar years. In introducing the opening lecture, he stated his bias clearly: 'the more faithful we are to those British ideas of which we are heirs, the better Canadians we shall be.' He particularly praised certain 'traditional qualities of English public life' – namely, 'the natural willingness to serve the state, the contact with the humanities which tempers the judgment and enriches the mind, [and] the broad and balanced view.'[3]

He was also interested in modern Britain. His inaugural speech as high commissioner in 1935 was critical of the 'thatched cottage and ivy-mantled tower' view of England. He looked forward to familiarizing himself with Britain's 'impressive plans ... of economic and social reorganisation' and stated: 'it is my belief that England presents today ... attributes associated more with youth than with age – the qualities of enterprise, of vision and energy.' This dovetailed neatly with the image that British foreign policy was seeking to project.[4]

'Old Masters' for Canadian Museums

Massey's tenure in London from 1935 to 1946 opened up various opportunities for the visual arts in Canada, which Massey, the National Gallery of Canada, and the Art Gallery of Toronto soon capitalized on. As early as 1930, when it first appeared that Massey would be appointed high commissioner,[5] the National Gallery's director, Eric Brown, and board (on which Massey sat) sent a resolution to the prime minister and the minister of public works supporting Massey's continuation as trustee. Brown also wrote to the governor general to commend Massey's potential assistance with international exhibition exchange, the encouragement of gifts and bequests, and – 'as an enthusiast of Canadian art' – promotion abroad of the gallery's work.[6] Assistant Director H.O. McCurry added: 'A Trustee resident in London would be of simply incalculable

value to the National Gallery in view of the fact that practically all the best things turn up there and ... the rapidly growing sentiment in favor of interchange of art exhibitions in the Empire.'[7] Massey was more than pleased to carry on as trustee: 'The work of the Gallery, I need not say, is very close to my heart.'[8]

Both the National Gallery and the Art Gallery of Toronto looked to Britain for the acquisition of Old Masters. Since the death in 1931 of Charles Ricketts, who had acted as a London adviser to the Gallery, the institution had been without an overseas scout. With Massey's arrival in 1935, the gallery acquired an active advocate abroad.[9] One of his first tasks was to approach Paul Oppé, a London art collector and connoisseur, about acting for the gallery in the purchase of drawings.[10] Brown also sent Massey a list of those whom he considered to be the most reliable picture dealers in London and suggested that Massey foster the acquaintance of W.G. Constable, director of the Courtauld Institute of Art: 'If ever you have a spare afternoon and cared to ask Constable for lunch, he would take you on a "dealer crawl" and visit some of the most interesting people.'[11] In February, Brown cabled Massey about an auction at Sotheby's of a picture by Hyacinth Rigaud[12] – Massey was pleased to guide the transaction to a successful completion.[13] In November 1937, Massey wrote to Kenneth Clark, the youthful and energetic director of the National Gallery in London about the possible acquisition of a work attributed to Anthony Van Dyck. Massey ventured to suggest that they had 'many interests in common' and looked forward to meeting.[14] The two men became friends and relied heavily on each other's advice in assorted art-related matters; Clark helped to secure Massey's position in the London art museum establishment, and Massey lent his support to various projects with which Clark was affiliated.

The Art Gallery of Toronto also enlisted Massey's services, taking him up on his offer to watch for possible acquisitions.[15] He went to see an El Greco at the Spanish Gallery and recruited Clark for an opinion; the latter viewed it as only a fair example of the artist's work, and overpriced. Martin Baldwin, the gallery's curator, later thanked Massey for his and Clark's assistance in navigating in this 'very interesting though somewhat dangerous field.'[16]

A Century of Canadian Art

Massey also promoted Canadian art in Britain. He and his wife arranged to have virtually their entire collection of 132 works displayed on the walls of their London home.[17] According to Massey, they looked 'extraordinarily

well' and created 'a good deal of interest.'[18] They showed innumerable visitors through the collection, Canadian and British, including the young BC artist Jack Shadbolt.[19] In 1938, the collection garnered an illustrated story in the *Sunday Times*.[20] As early as 1936, Massey received an inquiry from the City and County of Bristol Museum, whose director saw the works and asked to organize a small loan exhibition.[21] Massey declined, on the grounds that he and his wife hoped to display the entire collection at a future occasion; he probably also envisioned a more auspicious venue.[22]

In the summer of 1937, Eric Brown wrote to Massey that he was seriously thinking about 'a really bang-up Canadian show at the Burlington Galleries or somewhere equally good for 1938–39,' possibly in the autumn (Massey had suggested the timing). 'We could call it A Century of Canadian Art and include a few of the best of the old things, Kane, Krieghoff and others with possibly some Quebec carving. I believe it would be a great success.'[23] A month later, *A Century of Canadian Art* was tentatively booked at the Tate Gallery in London for the autumn of 1938. H.O. McCurry anticipated that 'if properly and tactfully done it should make for peace in Canadian art circles [between the 'moderns' and more academic artists] and form the basis for some constructive Canadian propaganda in London, and possibly result in adding some worthy Canadian pictures to the Tate collection.'[24]

A leitmotif running throughout planning for the Tate show was a concern to stall an American exhibition, *Three Centuries of American Art*, from New York's Museum of Modern Art (MOMA), then on show in Paris. McCurry wrote to Massey: 'If we act now the American exhibition will be allowed to wait.' Massey approached Tate director John Rothenstein about the U.S. show and reported to Brown: 'Rothenstein appreciates the importance of doing nothing which would take the edge off our Exhibition and I am sure will act in accordance with this view.'[25] Rothenstein in turn wrote to the MOMA, behind the veneer of impartiality, to decline the show on the grounds that the Tate could not at present do justice to an exhibition of its size.[26]

In December 1937, Massey continued to press the Tate's commitment to the Canadian show, urging that it take place in the upcoming year. He argued that 'it would mean much to the fortunes of contemporary painting in Canada' and 'be widely appreciated ... as a friendly act' from one of Britain's major museums.[27] In January 1938, Massey reported to McCurry that arrangements had been confirmed. Enthusing that 'this will be a tremendously important event,' Massey offered to lend 'anything off our own walls' and to do anything personally to assist in its success.[28] The National Gallery of Canada, with the help of an advisory

committee, selected about 250 pieces for the show.[29] Massey sent Brown a list of his Canadian works, indicating those that he considered the most representative, but added: 'It would not be a good thing to have too many pictures from our collection – not that Alice and I mind – but it might give the exhibition too personal a character.'[30] Massey was acutely sensitive to the appearance of bias.

Massey had strong views about the timing of the exhibition. While Brown considered it advantageous that it commence in September while Canadian visitors to the Empire Exhibition in Glasgow were still in Britain, Massey preferred a later date. Arguing that visitors stayed away from London until well into the autumn,[31] Massey prevailed, and the opening date was 14 October. Brown left publicity to Massey, who was determined to have a 'well-staged formal opening' and if possible, 'the presence of one of the Royal Family.[32]' He arranged for the Duke of Kent to open the show.[33]

As high commissioner, Massey addressed the guests at the opening of A Century of Canadian Art. He pointed out that this was the most comprehensive exhibition of Canadian art yet held. It may have been the first attempt at a significant historical overview of Canada's visual arts in a gallery setting.[34] Certainly the other overseas displays of Canadian art – the two at Wembley in 1924 and 1925 and one at the Musée du Jeu de Paume in Paris in 1927 – had featured contemporary material. But as Massey stated in the exhibition's catalogue: 'The history of Canadian art is a longer one than many people imagine. By the middle of the 17th century a flourishing school of ecclesiastical craftsmanship had been established in the St. Lawrence valley which brought artists from France to design and decorate with pictures and carvings the churches and seminaries of the Province of Quebec.'[35]

While weighted heavily towards the twentieth century, the show featured five wood carvings from early Quebec and six west coast Native works of art, including three Haida totem poles in argillite and two Chilkat ceremonial robes. It is noteworthy that these pieces were included in an aesthetic context rather than in the then-more-usual anthropological setting, but authorship of the native pieces was not given, beyond tribal origin.

Symptomatic of the rudimentary state of Canadian art history generally, the catalogue had no essay on the history of Canadian art, beyond Massey's foreword of four short paragraphs. Yet it was generously illustrated and included a brief biography of each of the approximately 120 artists in the show, of whom about one-fifth were women.

At the exhibition opening, Massey touched on some of his favourite themes – that Canada was developing 'outside the purely material sphere'; that 'the great and growing popular interest in the arts' was attributable to modern education; that 'if a community attempts to speak in the language of art it must use its own vernacular'; and that the work displayed 'a healthy diversity,' which ranged from 'an emphasis on tradition' to the 'more experimental.'[36] He closed by commending cultural exchange between 'our two British countries.'[37]

About 1,200 people attended the opening reception, and press reaction was 'very favourable.'[38] During the first two weeks of the exhibition, 22,000 people visited, apparently far in excess of normal attendance. Massey was gratified and praised Eric Brown for this 'very impressive demonstration of the work you have been doing on behalf of Canadian art for the last twenty-five years.'[39] Brown in turn hoped that the show would lead to a reciprocal exhibition from the Tate the following year, possibly in November, when John Rothenstein was planning a visit to Ottawa.[40] According to Brown, Rothenstein's interest in Canadian art was very much indebted to his acquaintance with the Masseys' personal collection.[41]

Massey also wrote about the show to his son Lionel, offering some insight into his own artistic preferences:

'It is very useful to see Canadian pictures in a setting abroad. In the tranquil atmosphere of the Tate the colours and design of some of the canvases from Canada are pretty strong. Occasionally I think too strong. A number of people have said that our own pictures, those from 12 H.P.G. [Hyde Park Gardens], are to be preferred to many of the others. I think this is true. We never bought extreme ones and there is a considerable contrast between ourselves and some of the more ultra vigorous paintings from elsewhere. However, by and large, the Show is a great achievement for Canadian painting and whatever the public here may think of it – and for the most part it has been received extremely warmly – it represents a definitely Canadian movement. The pictures could not have been painted anywhere else.'[42]

The Masseys, who had lent approximately twenty works to the Tate show, continued to promote Canadian art in Britain, often by lending from their collection. In early 1939 they sent twenty-five pictures to the Oxford Art Club, where Massey also gave an address.[43] The Masseys lent some David Milnes to the City of Gloucester Municipal School of Art and

Crafts for an exhibition of Canadian drawings, which Massey opened.[44] He took the opportunity to speak about Canadian art to the Royal Scottish Society of Painters in Water-Colours at its annual exhibition in February 1938 and to the concurrent showing of a selection of Canadian watercolours in Edinburgh.[45]

In a more personal vein, and illustrative of his deep affection for Canadian art, he wrote excitedly to Lionel (by now a prisoner of war) about a new National Gallery of Canada initiative in the promotion of Canadian art. In early 1942, the gallery completed its first film on art, about A.Y. Jackson, in co-operation with John Grierson of the National Film Board of Canada.[46] Massey, who thought it 'a fascinating film with some very lovely pictures of Canadian landscape and of Jackson's own paintings,' showed it as part of the family's Christmas celebrations in 1942.[47] The Masseys repeated the experiment the following Christmas with 'a colour film about Tom Thomson. Some lovely pictures of the North country with reproductions of his own canvases. It gave the Canadians a touch of homesickness.'[48]

Studying State Support

Massey was well-positioned in London not only to promote Canadian art, but to study the dramatic expansion in British support of the arts. Nationalism in Britain was on the rise before and during the Second World War and expressed itself in a variety of cultural and artistic projects. Topographical and architectural landmarks were documented, and new histories of British art emphasized the continuity and distinctiveness of the English heritage.[49] As tensions in Europe mounted and culminated in war, fears intensified about the threat to the British way of life, its values, and its cultural expressions, and the nationalizing agenda strengthened.

Britain, like Canada, was slow to throw state support behind the arts. Unlike France, Germany, Italy, and other European countries, whose governments sponsored cultural initiatives before the turn of the previous century,[50] Britain had confined its involvement largely to the creation of the British Broadcasting Corporation (BBC) in 1927[51] and a quota system for domestic films to protect them against Hollywood's assault on foreign markets during the 1920s. Reluctantly, in 1934, the government also established the British Council to counter the mounting anti-British rhetoric emanating from Fascist Germany and Italy.[52]

With the outbreak of war, British inhibitions about state-supported art

faded measurably. The fine arts were drafted to the task of raising citizens' morale. In the early months of the war, the Council for the Encouragement of Music and the Arts (CEMA) was created; in 1946, it would become the Arts Council of Great Britain.[53] From ten regional offices in England and with the advice of committees for Scotland and Wales and panels of experts on art, drama, and music, the council undertook an ambitious program of travelling exhibitions, touring concerts, and plays for civilians, endeavouring to respond to local initiatives in the arts. It supported professional artists and emphasized quality under the slogan 'The Best for the Most.' The effect on the demand for symphony and other music, ballet, and touring theatre throughout Britain was dramatic.[54] The council's efforts were added to that other artery of state-supported art – entertainment for the troops – which the Entertainments National Service Association (ENSA) actively developed. By late 1943, ENSA was sponsoring about 3,000 performances per week to military personnel throughout Britain.[55]

Despite the dire circumstances of war, the expenditure of public funds on the arts was not begrudging. In the words of one cultural historian, 'a long tradition of state neglect was finally broken,' and suspicions about state interference evaporated. Through creation of an agency that was 'nonpolitical in policies and personnel, but dependent on Treasury grants,' cultural activity 'flourished with far greater diversity' than before the war.[56]

Massey studied closely British initiatives in the arts during the war. His friendship with Kenneth Clark helped. Clark was a founding member of CEMA, and, as director of the National Gallery, he supported the introduction of music into the gallery in the form of daily concerts during the war, which drew up to 1,000 people at a time. While the rest of the national art collection was secreted away in a Welsh slate mine, he arranged to bring a single treasured work of art to London each month. Massey was impressed by 'the long stream of people who came daily to see "the picture of the month" [which] gave the corner where it was displayed more the atmosphere of a religious shrine than that of a picture gallery' and by the audiences that listened to chamber music during air raids.[57]

With renewed conviction, Massey returned to the theme that 'art is not merely the pursuit of the dilettante or the high-brow, but has a normal place in the life of the many.' In public addresses, he spoke about the new 'appetite for pictures and plays and music' throughout England. He championed the role of museums 'as positive instruments

of education ... where scholarship and showmanship can properly walk hand in hand' and lauded the travelling exhibition as a means of extending access to art. He noted the war's energizing effect on art galleries. 'Morale is a word which applies not only to a regiment or a ship but to such places as museums as well, and it is good to realize that wartime difficulties have so often, far from depressing the spirit of art galleries, actually stimulated their energies.'[58]

On the invitation of Jane Clark (Kenneth's wife), Massey also participated in a British experiment to popularize art in 1943. The British Institute of Adult Education and the 'Art for the People' Exhibitions commissioned artist John Piper to decorate a suburban London restaurant.[59] Massey described the result as 'a very good example of how a commonplace building can be made interesting, even exciting, by the introduction of first class mural painting.'[60] At the opening, Massey, pointing out that over the previous year Canada had sent Britain two-thirds of its total production of cheese and three-quarters of its bacon and pork, as well as its entire 1942 catch of salmon and herring, turned to 'another form of refreshment.' 'Many people spend much of their time in railway stations, hotels and restaurants. There is no reason why these places, so drab and depressing, should not be a setting for the work of the artist. I hope that when the war is over we shall not have forgotten the lesson which we can learn from what British artists have done to give distinction to the British Restaurants.'[61]

Canadian War Art

Massey was eager to enlist the arts in support of the Canadian war effort. As early as 1939, he contacted Clark, who had been made chair of a new British government initiative, the War Artists' Advisory Committee, created to employ artists to record the war.[62] Massey hoped for a comparable plan for Canada, noting with pride the similar venture during the First World War – the Canadian War Memorials, the largest war art program ever undertaken.[63]

The British program of war art quickly proved its worth, yielding among its achievements Henry Moore's absorbing drawings of Londoners sheltering from air raids in the underground (subway), and Graham Sutherland's studies of twisted and collapsed buildings. Canadian newspapers began to herald a large exhibition, *Britain at War*, which opened at the MOMA in New York on 22 May 1941 and toured the United States and Canada.[64] Curated by Kenneth Clark, it comprised approximately

110 pictures from the British program and about 200 photographs depicting the war effort, both civilian and military. It attracted more publicity than any previous show at the MOMA.[65] H.O. McCurry, Eric Brown's successor as director of the National Gallery of Canada since 1939, wrote to A.Y. Jackson: 'I am planning the "Britain at War" exhibition in such a way as to explode a bomb under the Government on the question of war records. Maybe it will work.'[66]

Massey, equally determined that a Canadian scheme for war art be established, investigated possible Massey Foundation funding.[67] However, legal counsel dissuaded him from this course. He approached David Milne to see if he would be willing to paint war pictures in Britain by private arrangement with the Masseys, but to no avail.[68] McCurry meanwhile wrote to Massey in July 1941 to say that he was still struggling to activate the plan at his end. The situation for Canada's museums was generally bleak – the National Gallery had been unable to make any purchases for two years, and the government had closed the National Museum. None the less, McCurry's policy was 'no retreat on the cultural front.'[69] Despite lack of interest, from cabinet and government, McCurry remained upbeat. Acknowledging that a federal minister of education was out of the question and that public opinion would not support a minister of fine art, he argued: 'What we need is a Department of Public Information under a minister of vision and energy to get the war job done and afterwards to remain as a virtual Minister of Education and cultural affairs ... My nomination would not be hard to guess!'[70]

In September 1941, Will Ogilvie, a private in a Montreal unit then stationed in London, visited Massey and showed him 'a few first class sketches.'[71] Massey was instrumental in Ogilvie's being seconded for painting duties.[72] A year later, however, in August 1942, Massey was still at a standstill in securing government commitment to a full-fledged war art program: 'I have not yet given up hope of getting some war artists over here. It will be tough going but the case is such a good one that I am going to return to the charge shortly.'[73]

The military itself had long recognized the importance of fostering morale through music in the form of marching bands and tattoos, and through theatricals, but not until November 1942 was a Canadian plan for war art finally in place. Two committees were formed, composed of artists and representatives of the armed forces – one under McCurry in Ottawa, the other under Massey in London.

Even with the approval to proceed, the program was not without its problems. As Alice Massey put it, some of the artists 'are all over the

shop.' Massey met with Canadian war artists Charles Comfort and Carl Schaefer to discuss the project, seeking to enlist in particular Comfort's 'organising, business-like mind.'[74] Artists who were already in the military were selected first. In total, the program commissioned about thirty artists including Molly Lamb Bobak, Alex Colville, Lawren P. Harris (Lawren's son), Edwin Holgate, E.J. Hughes, Jack Nichols, Will Ogilvie, and Jack Shadbolt.

The Masseys and Clarks saw to it that the artists met their British counterparts, as Alice recounted to son Lionel in December 1943: 'The Canadian artists that are over here doing special work had a little meeting in our room the other morning, with Father and Kenneth, with all their pictures distributed round the room, and Kenneth, Father says, in the most charming way, criticised and told them what he thought of each one. He evidently did it so well that no one was hurt and everyone was pleased. Then, in the afternoon, we had a cocktail party, where the Canadians met those who were doing the same kind of work amongst the English artists. Kenneth and Jane came, and it was a great success.'[75]

Jane Clark also arranged for a group of Canadian war artists to attend the Churchill Club, established in the summer of 1943 to provide Canadian and U.S. military personnel with opportunities to experience British art, music, and literature. In December 1943, the Canadians were invited to attend an evening in which 'a brain's trust' of artists Henry Moore, Paul Nash, John Piper, and Graham Sutherland, with Clark in the chair, spoke about modern English painting.[76]

An exhibition of Canadian war art, chosen by Massey and Clark, took place at the National Gallery in London in early 1944.[77] Massey arranged that it be opened by the Duchess of Kent. The gallery also kept one room in its War Art Exhibition space for the long-term display of Canadian pictures. Exhibitions followed in Canada. In the catalogue foreword to a 1946 show organized by the National Gallery of Canada and circulated across the country,[78] Massey explained some of the history of the enterprise. While he was unhappy about the project's delayed beginnings, the first three years of the Canadian war effort were not entirely unrecorded: the War Artists' Advisory Committee in Britain had presented to Canada 74 pictures by British artists working alongside Canadian troops abroad.[79]

The 1946 exhibition in London included sketches done in the field, but also larger, finished pictures – partly the result of Massey's intervention. He had written to Mackenzie King in November 1945 that, unless some provision was made for the war artists to complete their assignment, they would leave the military without working up large-scale can-

vases for the national collections. The government provided for the artists to complete the war record as civilians briefly under the National Gallery's supervision.[80]

Massey was involved with at least one other war-related project in support of Canadian art – the distribution of a large number of silkscreen prints to military personnel overseas. In partnership with the Toronto printing firm Sampson-Matthews Ltd, the National Gallery of Canada oversaw wartime production of a vast supply of reproductions of Canadian art. The high commission delivered two thousand to the War Office in London for distribution to the British army.[81] By the end of 1944, McCurry had received a request for prints for all the Royal Air Force stations from Gibraltar to India and asked Massey to function as the liaison in their delivery.[82] McCurry estimated that some 35,000 prints were distributed to Canadian and British military personnel in the course of the war.[83]

London Museum Trustee and a Massey Report

Massey was assuming meanwhile an increasingly strategic position in the London art scene. In May 1941, he was appointed to the board of the National Gallery – in Kenneth Clark's opinion, 'a brilliant appointment, the best that has been made for years.'[84] Massey was 'thrilled,' while Alice speculated that it was the first time that a Canadian had held the position.[85] In 1943, his fellow board members selected him to be chair of the National Gallery. As he told Harry Southam, he felt that he could not refuse such an opportunity to 'be a link between Canadian and British activities in this particular sphere.'[86]

The war greatly circumscribed the National Gallery's activities, and the trustees met only a couple of times a year. With its collection in safekeeping in Wales, the gallery was essentially without its lifeblood, although it did host temporary exhibitions – notably the 'picture of the month.' In April 1942 and the summer of 1945, it also displayed the wartime acquisitions of the Tate Gallery, which had been bombed in September 1940 and remained closed till 1945. Although his duties as chair were correspondingly limited, Massey spoke on both occasions.

He also performed other minor services, including deflecting a 're-newed attempt to have an exhibition of modern American painting in the gallery.'[87] The Royal Academy had rejected the suggestion outright. Clark wrote: 'I think that we can get out of it by saying ... that immediately the war ends, it is our first duty to get as many as possible of our

pictures back on the walls of the gallery, and that we should feel bound to cancel any engagements in favour of this over-riding consideration. Apparently the Wallace Collection said this to the Americans and it has choked them off.'[88] Massey concurred and pointed out that the gallery had already adopted a policy to reject 'national exhibitions under official patronage' as being 'invariably unadventuresome.'[89] While this was an entirely valid point, it veiled the obvious British and Canadian hostility to American art. Massey obviously drew a distinction between 'national' exhibitions in general and *A Century of Canadian Art*, which, while promoting the art of Canada, was, it is true, far from a government-organized show.

In March 1942 Massey was also made a trustee of the Tate Gallery. The National Gallery and the Tate were closely affiliated; indeed, the Tate's mandate and autonomy vis-à-vis the National Gallery were subjects of ongoing debate. In April 1944, the chancellor of the exchequer and the President of the Board of Education named him to chair a committee on the functions of three national art collections – the Tate and National galleries and, with reference to paintings, the Victoria and Albert Museum. The other members of the committee were the directors of the three museums, including Kenneth Clark and John Rothenstein.[90] They first met in July 1944, and their final report, dated 29 December 1944, appeared in early 1945.[91]

The committee found that the national art collections were in a state of confusion, with overlapping functions and minimal coordination, the product of great growth and little overall planning. Its report traced the history of the idea of a national collection of British art to as early as 1841 but pointed out that little had yet been done to realize such an entity. In 1897, while the Tate had been designated the national gallery of British art and some paintings were transferred to it from the National Gallery, it remained a collection of contemporary art. So-called masterpieces remained in the National Gallery, which housed art from diverse national schools and periods. The task at hand was to conceive of British art in terms of historical continuity, and the committee recommended that the Tate become a truly 'National Gallery of British Art of all periods.'[92] This historicizing impulse must have been of great interest to Massey.

The Massey Report pointed out damningly that the Tate had not received 'one penny directly from public funds towards the purchase of works of art.'[93] 'The absence of any assistance by the State in this country in the public acquisition of examples either of British art or of modern

art is a fact which would appear to reflect, however unfairly, upon the national attitude towards the study, enjoyment and encouragement of the arts as a whole. Comparisons with the Government's policy in this matter and that of other nations are extremely unflattering.' By now, Massey was becoming better versed in the role of art and culture outside the English-speaking world and used this argument to counter their neglect. The committee recommended a yearly expenditure of £5,000 for the Tate – roughly the equivalent of the National Gallery's annual grant for acquisitions.

The Massey Report also took up the issue of loans from the national collections. It praised the 'striking process of decentralisation' in the arts that was taking place during the war and urged that it continue in peacetime. 'We consider that the national collections should play an essential part in maintaining and spreading the interest thus aroused, and that, by whatever machinery, a liberal and systematic policy of loans should be developed after the war.'[94]

On the subject of foreign loans, the committee noted the great increase in activity since the previous war and anticipated its continuation in peace. 'Art exhibitions are now an established feature of international life; by assembling in one place works which could otherwise neither be studied and enjoyed together nor compared, they serve a valuable educational and artistic purpose.' Regardless of the motives for a national government to send art abroad, the committee argued, the art must always be of the highest quality. Such a policy would foster 'a knowledge and appreciation of the finest British achievement in the sphere of art.'[95] Certainly a major theme of British state involvement in the arts – one that would have resonated with Massey – was the emphasis on quality over propaganda, on the assumption that quality itself was a far more persuasive means of engaging an audience.

Massey subsequently answered for the report in person at a meeting of the Parliamentary Standing Commission on Museums and Galleries on 5 December 1945. The document's primary recommendations – recognizing the Tate as a national gallery of British art of all periods and that it function as an independent institution – won resounding endorsement. It was not until 1954, however, that a bill resolving the Tate's status finally passed the House of Lords and received royal assent.[96]

Even though Massey's support of cultural projects was rarely token, it is difficult to determine his role in this instance. At the least, he was acutely sensitive to the role of the museum in nation-building, while

bringing a persona of sympathetic impartiality to the task of adjudicating the claims of the various museums. By now, he also held the concordant belief that, while art must not propagandize, it could play an essential role in affirming national identity. Certainly his experience as chair of this committee acquainted him thoroughly with the complex issues concerning public art in a national context – both its significance and the structuring of its support. It must also have reinforced his already-firm belief in the role of history. While perhaps relatively unquestioning of the choices that may be made in the weaving of a historical narrative, he knew well the weight that such a narrative lent to national consciousness and its legitimization of the national will to survive. The struggle to forge a fully-fledged national gallery of British art was one that Massey could wholly endorse, and it surely served to strengthen his own conviction about the role of memory and art in Canada's bid for self-preservation.

Acquiring Modern British Art for Canada

The Masseys' acquaintance with the London art scene also included a growing familiarity with modern British art. As nationalism mounted in response to war, the visual arts witnessed the rise of a loosely affiliated group of painters labelled the English Neo-Romantics, who traced their lineage back to the early-nineteenth-century Romantic painters and nature poets (notably Constable, Turner, Wordsworth, and Coleridge). The Romantics' reputation had been eclipsed in the early twentieth century by the taste for modern French art (Impressionism, Post-Impressionism, and Cubism) but was now being restored.

A new generation of British artists (Barbara Hepworth, Henry Moore, John Piper, and Graham Sutherland), as well as the older Paul Nash, among others, and critics, notably Herbert Read, would unapologetically dwell on the British landscape and the British experience. With the outbreak of the Second World War, contact with the continent became tenuous, and the self-reflective character of much British art became more pronounced. This unreservedly nationalistic idiom gave further evidence of the viability of local expression despite the hegemony of French or so-called international art.

At what point exactly the Masseys devised a plan to assemble a collection of modern British art for Canada remains unclear. In March 1938, Massey wrote to the National Trust Company in Toronto, which managed Massey Foundation business, explaining that he and Alice wanted

to spend approximately $5,000 a year to buy contemporary English painting for the National Gallery of Canada. Seeking to determine whether such a benefaction fell within the foundation's scope, he pointed out: 'it is possible at the present moment to buy very interesting examples of contemporary work here at very reasonable prices. The National Gallery has to spend its own resources first on Canadian contemporary work, and secondly on old masters, which leaves no funds available for the purpose we have in mind. A few thousand dollars a year for a few years would give the gallery a very interesting collection of work which would appreciate rapidly in value. The fact that I am a trustee of the National Gallery makes it possible to arrange the matter very simply.'[97] The National Trust confirmed that the gift would qualify as a legitimate charitable donation, and by May the Masseys were drawing on the Foundation's account to purchase modern British art for the gallery; the resulting collection showed in London, Canada, Australia, New Zealand, and the United States after the war, before settling in its permanent home in Ottawa. This was one of two projects funded by the Massey Foundation during the war.[98]

Eric Brown and his successor as National Gallery director, H.O. McCurry, were very enthusiastic about the plan. Brown, English by birth and early training, and still reasonably well-connected with the London art scene, had long been keen on cultivating connections with Britain. He wrote to the Masseys in September 1938 commending their purchases to date and making some suggestions. He guided them to the oeuvre of Philip Wilson Steer, whom he described as 'one of the most outstanding landscape painters of his day,' pointing out that the gallery did not own a single work. They purchased a distinguished example – *The Severn Valley*.[99] The Masseys also relied heavily on the advice of certain dealers, particularly Richard (Dick) Smart and Dudley Tooth at Arthur Tooth and Sons, Ltd. As Alice stated in 1942, 'that firm have the knack of getting the really lovely things, and I always trust them.'[100] As well as guiding many of their purchases, Tooth arranged for Augustus John to paint a portrait of Vincent in June 1938.[101]

The Masseys embarked on their new collecting with obvious relish. As early as 1936, Alice Massey admitted that, while Canadian art compared very favourably with modern British, 'quite frankly, a great deal of the new work here gives a tremendous thrill. The best Duncan Grants are marvellous and there are all sorts of new and younger schools coming to the fore that are intensely interesting.'[102]

Both Alice and Vincent Massey spent much time in the selection

process, acquainting themselves with the art market, consulting private dealers, viewing exhibitions at the Royal Academy, National Gallery, and elsewhere, and visiting artists' studios. An exhibition of Walter Sickert's work at the National Gallery was a revelation to Massey, who remarked on the artist's versatility, the 'lovely pictures of an old music hall in Camden Town, full of warmth and colour, moonlight scenes in Dieppe, numerous studies of cottage life ... This exhibition is a perfect joy.' The couple also studied and accumulated catalogues and consulted with those knowledgable in the field.

They frequently wrote to their son Lionel in Germany with excitement about their purchases. They were pleased with an early Augustus John for both its 'historical-biographical value' and its aesthetic properties.[103] They bought a Matthew Smith nude, which they were persuaded was 'one of the very best.'[104] For Lionel, they conducted a sustained search for a Sickert and found, with Dick Smart's help, 'the Sickert of all Sickerts' – *The Rialto, Venice*. According to Alice, her husband was ecstatic about the purchase, and he described it in loving detail to his son.[105]

While the vast majority of their acquisitions were for the Massey Foundation gift, they bought the occasional work for themselves and quite a number for Lionel, who had decided to use his accumulating army pay for the purchase of art and his enforced inaction as a prisoner of war to study art history.[106] By letter, he instructed his parents and brother, Hart, on his acquisition and book preferences. Alice recruited assistance from Kenneth Clark, John Rothenstein, Dick Smart, Dudley Tooth, and Ben Nicholson, a leading British abstract artist, in drawing up a list of books and in obtaining leads on where to find them.[107]

Massey encouraged his son's plan to employ his time studying art history and reiterated the virtues of a liberal arts education: 'Reading as you do, making notes and keeping a commonplace book and thinking about what you read, turns reading into a very important form of education. Forgive all this preaching. It must sound very boring, but I am so anxious that you should not feel that you are losing time. A liberal education is derived from two sources – the men you meet and the books you read. Your present existence offers you men and books and little else, and I know you are taking full advantage of both.'[108]

The Masseys prided themselves on the care with which they selected works for their family and for the foundation. When Massey wrote to inform Harry Southam of the plan to assemble 'the Massey Collection of Contemporary British Painting' for the National Gallery of Canada, he added: 'I need not say that this little idea of ours has given both Alice

and me great pleasure and we are selecting the pictures with all possible care.'[109] Elsewhere, he stated: 'There is no doubt that it is never worth while to buy anything for any collection which is not first-rate.'[110] They adopted the policy of acquiring only works that they both agreed on, and, 'when in doubt, don't'[111].

Their early choices were by older, twentieth-century British artists, like J.D. Innes, Augustus John, Paul Nash, Walter Sickert, Matthew Smith, Philip Wilson Steer, and Christopher Wood, all well established by the time of the Masseys' arrival in England.[112] Massey's interest in war art manifested itself as well, especially while he was still struggling to interest the Canadian government in sponsoring such work.[113] They bought 'a very interesting documentary picture by Eurich of the evacuation of Dunkirk'; Clark, who had an option on it for the War Artists Exhibition, 'gave way' for the Masseys.[114] They purchased 'two amazing Johns' – including one of T.E. Lawrence (of Arabia) as an airman[115] – and 'two lovely Paul Nashes, one called "Night Fighter" and the other "Day Fighter."'[116] With Dick Smart's assistance, they also acquired in 1941 a large charcoal drawing dating from the First World War by Augustus John – a cartoon for a mural, *The Canadians opposite Lens* (12 feet by 40 feet), for a projected Canadian war art building (neither the edifice nor the mural was ever realized).[117]

As the collection developed, the Masseys became somewhat more venturesome, partly under the influence of Kenneth Clark. Clark was a strong advocate of modern British art, particularly of the Neo-Romantics and the Euston Road School (William Coldstream, Lawrence Gowing, Victor Pasmore, Claude Rogers, and others), a realist school with some socialist overtones.[118] As early as November 1938, the Masseys and Clarks dined and chatted about modern British art.[119] Jane Clark followed up the evening with a note: 'the artists we told you about are Victor Passmore [*sic*], William Coldstream, Lawrence Gowring [*sic*] & more modern Graham Sutherland. Kenneth thinks all four very good. You could see Graham's things in our house, as he lives in Kent, & if you lunched with us we could take you round to the others' studios which are in Fitzroy St. behind our home.' She added: 'I sent you a card of Graham Suther-land's china exhibition ... which opened yesterday. The things are lovely & very cheap, & keep him going when he can't sell pictures.'[120] Kenneth Clark wrote with prices for the works that interested the Masseys – two Coldstreams (one of Bolton and a portrait head of Miss Anreg), as well as two small Sutherlands.[121] The Masseys acquired all four, thanking Clark for the introduction.[122]

Alice Massey was, perhaps, the more daring of the two. When Kenneth Clark praised a Modigliani at the Leicester Galleries, she became keen to purchase it for themselves, but Vincent would not budge: 'I cannot help thinking that there is nothing very permanent about his work.'[123] It was Alice who sought to add a Gwen John to the Massey Foundation's collection. She reported in July 1943 that Dudley Tooth had found one that he wanted them to see. 'I have always longed for the Collection to have one of hers. Nobody knows where most of them are.'[124] It would not be until the late 1940s that the Masseys would manage to secure one for the National Gallery of Canada.

Despite his emphasis on quality and his support of modern art, there remained a decided conservatism about Vincent Massey's taste. This is suggested, for example, by his attitude towards the work of one of the leading British sculptors of the period, Henry Moore. While inspired by natural forms, his pieces were generally abstract. Massey got to know Moore on the Tate's board and observed: 'He does not look like the sort of man who would produce what he produces – in other words he looks quite sane.'[125] Massey expressed some of his own views on the practice of collecting in a letter of January 1944. The Leicester Galleries had exhibited the distinguished collection of Michael Sadler, generating considerable interest. Massey reported: 'Much of the work was bought when the artists were very young and entirely unknown. It took a good deal of courage on Sadler's part to make these purchases, but, on the other hand, the expenditure was in most cases trifling compared to what some of the works are fetching to-day. It shows what a discerning collector can do if he is prepared to trust his own instincts and willing to make a mistake now and then.'[126]

By the end of their stay in London, while the Massey Foundation collection was about half by well-established early British moderns and half by the younger generation – Coldstream, Hillier, Hitchens, Moore, Pasmore, Piper, and Sutherland – it continued to be fairly narrowly circumscribed by the Masseys' middle-of-the-road taste. The examples that Massey and his wife chose were often very fine, but certain artists, Augustus John and Paul Nash, in particular, were disproportionately represented. And there were some notable omissions; they stayed away from abstract artists and 'ultra-moderns,' such as Barbara Hepworth and Ben Nicholson, and avoided the intensely spiritual figure pieces by Stanley Spencer, the highly realist work of Lucien Freud, and the disturbing figurative work of Francis Bacon (whose reputation gained a real footing only in the later 1940s). These choices reflected partly the Masseys' personal preferences and partly their desire to appeal to a wide audi-

ence. Writing to H.S. Southam, Massey stated: 'we have tried to build up the collection on broad lines so that it will appeal to various tastes, but we have rather emphasised certain painters, such as John, Steer, Sickert, who have a wide appeal.'[127]

John Rothenstein had written to the Masseys as early as May 1939 asking to make an exhibition of their British art.[128] Massey replied in the negative for the time being but expressed hope for a show when the accumulation of works was more developed.[129] The Tate eventually hosted the collection in 1946, to mark the gallery's reopening on April 10, after partial completion of repairs to bomb damage. The works, some stored in Toronto, others at Garnons, were assembled and totalled seventy-one pieces.

English art critic Eric Newton wrote a press release for the United Kingdom Information Office in Ottawa in April 1946, remarking on the unusual nature of the collection – 'neither a national collection nor a specially planned exhibition gathered together from many different sources,' but rather the effort of one family intent on assembling a survey of modern British art.[130] Rothenstein, who lamented the departure from Britain of a number of masterworks, observed that Canada was 'the only dominion where modern English painting can be properly studied and enjoyed on the spot.'[131]

The gift was a noteworthy, even curious project. While actively enjoying the works that they collected, the Masseys clearly envisioned the gift as an act of cultural propagandizing. But was it a deferential and colonial tribute to a parent country? Or was it an effort to use art to promote closer relations between the two countries, to evoke a common set of values, and, less directly, to affirm the project of nationalism? Massey would undoubtedly have argued that it was the latter. He would also have considered it significant that the works were contemporary. Not only had this made them more affordable, they testified to Massey's efforts to forge connections with modern Britain.

In March 1946, Massey had announced the gift to Prime Minister Mackenzie King. He explained that there were seventy-odd canvases by thirty-five artists, only six then represented in the National Gallery. He hastened to add: 'Although they are all from the field of contemporary painting, few, if any, of the canvases are modern in the extreme sense. They have been purchased with a view to giving pleasure to the general picture-loving public.' King, whose relationship with Massey had gone from enthusiastic to civil to hostile over the years, privately belittled the gift as 'self-glorification.'[132] Formally, he thanked the Masseys.[133] McCurry

reported that the prime minister had spoken of the Masseys' 'magnificent gift to the National Gallery' and was 'extremely pleased.'[134]

On 1 October 1946, the Board of Trustees of the National Gallery of Canada formally accepted its largest gift to date – the seventy-five pictures to be known as the Massey Collection of English Painting. It rendered the institution probably the largest holder of modern British art outside the United Kingdom. John Rothenstein's catalogue essay emphasized the paintings' native character: 'The salient characteristics of recent English painting [are typified by] ... artists such as Sutherland, Moore, Piper and David Jones who have freed themselves most completely from the ideals of independent French art at the beginning of the century as interpreted by Roger Fry, [and] display an imaginative tendency that can be conveniently described as neo-romantic.'[135] Rothenstein assumed that Romanticism was peculiar to the British Isles. H.S. Southam, in the catalogue's foreword declared that the English model displayed 'a confidence in, and a sympathetic understanding of the land and people of their native country.'[136] Press material described contemporary British painting as 'one of the most interesting schools of today' and also dwelt on its resistance to international dogma.[137]

The contract between the Massey Foundation and the National Gallery specified that the collection be exhibited extensively across Canada. Massey had told King that he wanted as many Canadians as possible to see the works and that an extensive tour could circumvent the National Gallery's lack of permanent quarters.[138] He added: 'There is great expansion in this country [England] in the loan of pictures from the national collections in London to provincial galleries and such a development would seem even more advisable in a country with such a dispersed population as ours.'[139] The collection began its Canadian tour at the National Gallery, at a gala opening on 30 October 1946, attended by the governor general and a host of dignitaries. In the Ottawa *Evening Citizen* the next day, Dr R.H. Hubbard struck the central theme: 'The Massey Collection bears out the importance of a national school of painting even during a period when the world prefers to think of its art as international.'[140]

The works travelled across Canada – to Montreal in January 1947 and then to Toronto, Edmonton, Vancouver, Regina, London, Winnipeg, Windsor, Sackville, Kingston, and Port Hope – not returning to Ottawa until early 1949. It consistently received favourable, even enthusiastic press notices and attendance figures. The longevity of its tour is suggestive of its demand. From Vancouver, Bess Harris wrote to Alice Massey:

'We visited the British Paintings in the Art Gallery again and again – they are wonderful.'[141] Critic Graham McInnes observed: 'The importance of the gift is enormous'; he singled out Graham Sutherland, for his 'brooding' evocation of the 'nightmare ... in which we live,' and John Piper, for his 'brilliant and terrifying use of bold color and the abstract forms suggested by burnt buildings.' He contrasted the 'joyous, protesting and extrovert' character of Canadian art with the 'sober' and introspective nature of British painting.[142]

In early 1949, the Masseys added eleven works to the collection, acquired on their visit to London the previous autumn. They chose the pieces – which included two works by Henry Moore, a Gwen John, another Wilson Steer, and two pieces by William Scott[143] – to fill in some of the collection's gaps. With the financial assistance of the Carnegie Corporation, the eighty-six works travelled to Australia and New Zealand (1949–50) and stopped in Honolulu and San Francisco before returning to Vancouver for a second stay. Lawren Harris, then chair of the Vancouver Art Gallery's exhibition committee, arranged for them to visit both his institution and the University of British Columbia.[144] In short, their exposure was enormous.

The British Council in Canada

The Massey Foundation gift and its tour added presence and momentum to the showing of modern British art in Canada, which was by now entering the country from a second source, the British Council. Here, too, Massey played a part. In the visual arts, the collecting and exhibiting of British work had had a sporadic but not inconsiderable history in Canada. Early on, art museums not uncommonly made the collecting of British art a top priority.[145] Until the Second World War, two-thirds of the art displayed at the Canadian National Exhibition in Toronto was foreign, mostly British. The two primary sources of British art exhibitions until 1939 were the Royal British Colonial Society of Artists[146] and the Art Exhibitions Bureau in London. Neither, typically, was distinguished by its curatorial choices.

The National Gallery of Canada began in the mid-1920s to bring large loan exhibitions to Canada from abroad. In the aftermath of the British Empire Exhibition at Wembley in 1924, at which the Group of Seven received such acclaim, Eric Brown mounted the gallery's first major show of foreign art. Having borrowed heavily from the British section of the Wembley exhibition and corresponded directly with the artists, Brown

wrote in his catalogue that the exhibition was part of the gallery's policy to do 'everything possible to promote the interchange of the art of the British Empire.'[147] It included a few prominent moderns, along with a host of more conservative British painters.

More modest showings, both in size and quality, punctuated the gallery's offerings during the late 1920s and the 1930s, the most ambitious being in 1935. Brown wrote to W.G. Constable at the Courtauld Institute: 'The whole future of British contemporary shows out here rather stands or fails by this one, and it is a thing rather near my heart to establish a close and continuous art connection [with Britain] by a series of such shows.'[148] Brown relied heavily on London art dealers to assemble the show; in some instances, artists sent paintings of their own choosing, which caused Brown concern but over which he had limited control – symptomatic of his still highly colonialized position.

Brown's effort to strengthen the association with Britain was sustained and augmented through the offices of Vincent Massey, whose London connections placed him in proximity to the recently constituted British Council. At close hand, he could observe and to a degree steer British outreach in Canada. Already long committed to the ambassadorial function of the arts, Massey studied with immense sympathy the council's early workings as it struggled to resolve its administrative and constitutional make-up and assert itself as a serious force in Britain's external affairs.

With the launching of the British Committee for Relations with Other Countries in 1934 (known from 1936 on simply as the British Council), the United Kingdom belatedly joined other leading European countries in actively projecting its culture abroad. France had led the way in cultural diplomacy, with French-language schools in the Middle East and the Far East dating from before the turn of the twentieth century. The Alliance française, a private society for the promotion of the French language abroad, operated with government support and had begun in 1880.[149] As early as 1883 it had established operations in Ottawa–Hull. Germany and Italy had comparable societies – the Goethe Institute and the Dante Alighieri Society, respectively – dating from before 1900; between the two world wars, both enormously augmented their sponsorship of cultural propaganda. The Soviet Union founded the All Union Society for Cultural Relations with Foreign Countries (VOKS) in 1925.

The British Council aimed its cultural initiatives at countries that figured prominently in its overall foreign policy.[150] Favourable cultural exposure led to mutual understanding, it was argued, and paved the way

for economic and political rewards. The council is remarkable, however, for the pains that it took to mute the political import of its mission – *Britain Today*, for example, its most widely distributed publication, always hid its council connection.[151]

The British Foreign Office had always preferred to propagandize through private and semi-official vehicles in order to maintain credibility.[152] The experience of the First World War, wherein Britain had engaged in negative and less than accurate propagandizing against its enemies using photography and film, had backfired.[153] The bitter aftertaste that lingered through the 1920s and 1930s delayed government support of cultural projection.[154] There was also diminishing tolerance in Western democracies for a small coterie of diplomats and politicians determining foreign policy behind closed doors. Universal suffrage and the growth in importance of public opinion (and swaying it) had come to count formidably. To enhance credibility, the British Council resolved to confine its efforts to promoting its own nation's arts, language, and values, rather than denigrating those of others.[155]

Parallelling its intention to disassociate itself from overt and negative propagandizating, the council sought to remove itself from direct government management. At the outset, it was created as a semi-official body drawing funds from both the private and the public sectors.[156] This situation gave the council some autonomy, making it an early example of a cultural branch of government operating modestly at arm's length. It later became an agency fully funded by the government but retained some vestiges of autonomy structurally by, for example, relying on advisory panels of outside experts. While Massey claimed that it operated free of political interference, the extent to which this was true remains unclear.

Certainly the overt content of its various cultural initiatives, whether an art exhibition or a concert, was chosen ostensibly on the basis of quality, as opposed to political slogan or affiliation. Of course, there are both uses and abuses of excellence. Quality, and the impartiality that it purports to embody, may camouflage many agendas. Excellence should go hand in hand with transparency; but, at this early stage, in an effort to distance itself from propagandizing, the British Council may have conveniently conflated secrecy and impartiality. Nevertheless, its Fine Arts Committee relied heavily in its early years on the membership of art historians and critics such as Kenneth Clark, Philip Hendy, Herbert Read, and John Rothenstein, who earnestly steered the art exhibition program away from pure political exigency in the name of excellence[157] –

a moral imperative that Massey knew well and strongly endorsed. He was to study the mechanisms of the British Council's support of the arts with intense interest.

The earliest documented contact between the council and Canada dates from 1938 and was initiated by the high commissioner in London. Under Vincent Massey, a member of the commission's staff inquired if the British Council might circulate some of the pictures from the Tate show *A Century of Canadian Art* to foreign countries.[158] While the council declined the proposal, the request stimulated vigorous internal debate. One member of council staff wrote: 'Surely Canadian Art *is* British art & surely we want the closest possible cultural collaboration with the dominion.' The same author conveyed something of the pressure emanating from Canada House: 'the High Commission would like anything possible to be done.'[159] The Fine Arts Committee meeting on 27 March 1939 concluded, however, that only in exceptional cases would works of art from the dominions be accepted in council exhibitions and that the practice could not be recommended in principle.[160] Those within the council who supported circulating the show did so from a colonial mentality. In the absence of a viable Canadian state mechanism for cultural projection, the high commission concealed any qualms that it might have had about depending on British resources for this purpose. Similar to his reliance on the Carnegie Corporation, Massey was quite prepared to turn to foreign financial sources to fill the vacuum at home. He was ready to trade exposure of Canadian art for an admission that Canada did not support its own culture abroad. One can only imagine how he rationalized this dependence. He knew well that until Canadians took their culture seriously, the nation would remain vulnerable to the very forces of colonialization that he felt obliged to exploit.

During the summer of 1939, the British Council turned its attention to starting operations in Canada. Massey was supportive but expressed the view that the council would have to operate indirectly, in view of the Canadian government's sensitivity about British interference in its affairs and the appearance that Britain was planning new inroads. Lord Lloyd, the council's chair, reported to its executive committee that Ottawa was anxious about the council's prospective work in Canada, particularly that it be carried out under the auspices of an already established organization.[161] While Massey himself could not be associated officially with the council, he 'promised that behind the scenes he would give it every possible support.'[162] Massey suggested recruiting Major F.J. (Fred) Ney, general secretary of Canada's National Council of Education and a

member of the Overseas Education League, to act on the council's behalf in Canada.[163] But Lloyd was reluctant to allow any infringement on council control, and the suggestion apparently went nowhere. Also, rivalries within the British government pitted the council against the Dominions Office and the wartime Ministry of Information, each with a stake in relations with the dominions.

Although a British Council office did not open in Canada until 1959, the agency was active as early as 1939 as a source of modern British art exhibitions for Canadian galleries. The show that commenced the council's visual arts activities in North America was organized for the New York World's Fair of 1939 – the council's first large-scale effort on the continent. Outright propagandizing by a foreign government was virtually impossible in the United States. The U.S. Senate had recently passed a law requiring all foreign propaganda organizations operating in the country to register with the federal government.[164] The only vehicle for disseminating state information from Britain in the United States was the British Library of Information. With branches in a number of American cities, it functioned in a low-key manner as a reference library, whose holdings were largely copies of official British government papers.[165] The World's Fair exhibition thus provided a rare and very timely opportunity to promote British art and Britain on American soil. Asked to loan Augustus John's *Summer Noon*, Massey warmly endorsed the project.[166] The British Pavilion at the fair was hugely successful and, it has been argued, may have vitally influenced American sympathies towards the British war effort.[167]

The outbreak of war and fears about the safety of the approximately 300 works of art returning across the Atlantic led to hurried arrangements to show the exhibition in Canada. A.A. Longden of the British Council's Fine Arts Committee Exhibitions Office had a flurried exchange of correspondence with Vincent Massey and H.O. McCurry. Longden referred to 'my friend Vincent Massey strongly approving of Lord Lloyd's proposal.'[168]

The exhibition opened in Ottawa at the end of November 1939. The reception was attended by over 600 guests, among them the governor general, Lord Tweedsmuir, as well as John Rothenstein.[169] From Ottawa, the works travelled to Toronto, Montreal, and Vancouver between January and March 1940. The Vancouver Art Gallery extended its hours to accommodate demand. The Canadian press was enthusiastic. In England, at the British Council's offices, it was reported that the show had 'made a very fine impression in both the United States of

America and Canada and, [in John Rothenstein's opinion] the cultural propaganda in connection therewith was of far reaching importance.'[170] The World's Fair exhibition was the first in a parade of British Council shows to visit Canada during the 1940s and 1950s and later, and helped establish the council as the primary link between modern British art and the Canadian art museum community.

Invariably Massey's name crops up in the dealings between the council and Canada. When one of the sculptures lent by the council to the MOMA in New York – Eric Gill's *Mankind* – suffered from exposure in the open air, Massey suggested loaning it to the Art Gallery of Toronto (it was).[171] When McCurry wrote in 1944 to ask for an exhibition of modern British art, Massey offered to sit on the selection committee.[172]

In 1941, a sum of £10,000 was donated to the British Council for the promotion of Anglo–Canadian relations.[173] Massey and Sir Malcolm Robertson (council chair, 1941–5) were trustees of the fund. About this time Robertson suggested that a council representative visit Canada, and in 1942 Michael Huxley toured the country on its behalf. He was greeted with 'a mixture of sympathy and suspicion.'[174] Among his recommendations was the creation of the Canada Action Group – later the Canadian Committee – to promote knowledge of the country among air force personnel from Canada, Australia, New Zealand and Britain training in stations across Canada under the British Commonwealth Air Training Plan. Vincent Massey and Stanley Bruce, the Australian high commissioner, had tabled the idea for a vast air force training program based in Canada at a meeting of the high commissioners in London in September 1939, and it had been agreed on in December.[175]

With Massey's strong endorsement and Prime Minister King's approval, the Canadian Committee was launched in November 1942. Despite hopes that it would develop into an organization similar to the British Council, they were in no way formally connected.[176] John Grierson, founder of the National Film Board of Canada, was a member of the committee and one of its projects was to establish a circuit of films for Royal Air Force stations in Canada. The plan was to include a British film for every three Canadian films shown by working with the British Council. It also drew on an army of volunteers in an effort to fulfil the demand among the troops for cultural services. It created more than a hundred small libraries each consisting of about 150 books on Canadian history, geography, poetry, art, music, and so on. Specialists visited the many clubs organized by the troops and spoke on topics such as bird-watching,

film, painting, classical music, and woodcarving.[177] In a reciprocal gesture, the British Council supplied libraries on the transport ships of the Royal Canadian Air Force.

By 1944, on the advice of the Canadian Committee, the British Council was distributing – through the United Kingdom High Commission Office in Ottawa – news releases, feature articles, and illustrations to the Canadian daily and periodical press, as well as printing and distributing Canadian editions of *Britain Today* in French and English.[178] Added to these initiatives were the exhibitions so enthusiastically received by Canadian art museums. Gradually the council, which initially made all arrangements pertaining to the visual arts with the National Gallery of Canada, worked directly with other Canadian galleries in planning shows.

After returning to Canada in 1946, Massey continued to encourage the British Council's activity in Canada. In 1947 he wrote to Sir Shuldham Redfern, who, as director of its Commonwealth Department, was to tour Canada in the autumn of 1948: 'I am one of those people who feel that the British Council should operate in Canada – not, of course in any way suggesting Empire propaganda, but as an organization existing to keep the Canadian public in touch with the "cultural" (how I hate the word, but there is no alternative) life in Britain. I gather that there is no official objection to this in Ottawa, and I would hope that before long a representative of the BC might be established there. He could do a most useful job in restoring and strengthening contacts between this country and Great Britain in the field of music and the arts, and the intellectual sphere generally.'[179]

Redfern also conversed with Prime Minister King on the subject in the autumn of 1947 in London. King, according to Redfern, had no objection to extending the council's activities in Canada: 'He welcomed the idea of my going to Canada on a visit to discuss with interested parties an interchange of views on cultural matters and said that such people as Vincent Massey would be most helpful.' King made it clear, however, that the federal government must in no way be associated with the initiative, because of the 'delicate relationship' with the provinces and because 'any sort of Govt control over a body like the British Council meant red tape, bureaucracy, & stifling initiative & a waste of public funds.' Redfern also commented: 'He had absolutely set his face against the Government having anything to do with the Canada Foundation, but admitted that the Canada Foundation had almost collapsed for lack of funds.'[180]

The British Council's presence in Canada continued to be ambiguous. The Massey Report of 1951 would rebuke the government's resistance to

its operations in Canada and proposed the appointment of a resident British Council representative.[181] Even more pressing, however, as the British Council's example made patent, was the absence of a companion organization in Canada. Nevertheless, in concert with bodies such as Canada House in London, the National Gallery of Canada, and the Canadian Committee, the British Council was able, and indeed encouraged, to make significant, if somewhat surreptitious, cultural inroads into Canada.

Other British Art for Canada

There were other legacies of Massey's British sojourn. The Massey Foundation gave a small selection of modern British works to the Art Gallery of Toronto. As early as 1937, Massey proposed to curator Martin Baldwin that the gallery buy the occasional modern British painting. He enclosed a catalogue from a current exhibition at Tooth's in London and pointed out the modest prices for works by well-known artists.[182] The gallery subsequently authorized him to make art purchases on its behalf while he was in London; instead, under the auspices of the Massey Foundation, he arranged for a small group of works to be gifted.[183]

He also acted for the Art Gallery of Toronto in connection with gifts from Britain's Contemporary Art Society (CAS). The CAS had been founded in 1910 to support British artists by acquiring their works and then distributing them to public art galleries, which paid a nominal subscription fee. The Art Gallery of Toronto had become a CAS subscriber during the war.[184] Other Canadian art galleries followed suit. In early 1946, Martin Baldwin wrote to Massey, who by now was on the CAS's board,[185] asking him to act on the Toronto gallery's behalf in selecting a painting from the CAS's current pool of works. Massey chose a Sickert, *St. Jacques, Dieppe,* which was accessioned shortly thereafter.[186]

Massey also put the gallery's executive in touch with English art historian Anthony Blunt – later notorious for his activities as a Soviet spy – who acted as a London agent in acquiring Old Masters and modern works of art. Blunt had been keeper of the king's pictures and in 1947 became director of London's Courtauld Institute of Art. The Art Gallery of Toronto employed him to curate the British section of a large exhibition, *Contemporary Paintings from Great Britain, the United States and France with Sculpture from the United States,* organized to celebrate the gallery's fiftieth anniversary in 1950. He also counselled it to acquire modern British pieces by artists such as Henry Moore and Ben Nicholson.

With the assistance and funding of its Women's Committee, the gallery went on to do precisely that.[187] Blunt acted as well for the National Gallery of Canada.[188]

Massey was also instrumental in bringing a major postwar exhibition of eighteenth- and nineteenth-century British art to Canada. As chair of the National Gallery in London, Massey explained to the Art Gallery of Toronto in April 1946 that he and his fellow trustees had decided to authorize a loan exhibition of works by Hogarth, Constable, and Turner, mostly from the National Gallery's collection, for travel to Chicago and New York. Describing it as 'an exhibition of the very greatest importance,' he claimed that the board was eager for the show to go to Canada and added, 'you may assume that I have not been backward in expressing the same desire.' Massey had recommended that it be offered to the Art Gallery of Toronto as 'having the best-equipped, most modern facility.' He emphasized that he was 'most anxious to have the pictures go to Toronto' and impressed on Martin Baldwin the need to settle the matter before he left London in a month.[189] The exhibition showed at the gallery during April and May 1947, along with *British Contemporary Painters* from the Albright Art Gallery in Buffalo (later the Albright–Knox Art Gallery). The Old Master exhibition was promoted with the Massey Collection of modern British art in Ottawa: 'Taken together, the two shows provide a survey of the best expression in English art of the past two hundred years.'[190]

These exhibitions in turn stimulated Canadian collecting of modern British work. The Art Gallery of Toronto acquired a string of works in this category beginning in 1949. Building on the Massey gift, the National Gallery followed suit with purchases during the 1950s, and the Vancouver Art Gallery renewed its commitment to this collecting area with its creation in 1949 of a Contemporary British Picture Purchase Fund.[191] As *Canadian Art* magazine reported (winter 1951–2), the Toronto and Vancouver galleries seemed to be vying with each other in updating their holdings in this field.[192] Among the other Canadian galleries that joined the trend, the most ambitious was the Beaverbrook Art Gallery in Fredericton (opened 1959). Private collectors also participated.[193]

Massey alone did not precipitate this wellspring of interest in modern British art, but his initiatives were a significant factor, in concert with the British Council, Canada's museum community, and the Canadian War Art program, which brought some of the country's most noteworthy artists in contact with their British counterparts. In turn, modern British

art found concordances in Canadian visual expression. According to McCurry, Canadian artists in particular expressed their appreciation of the Massey gift.[194] Some found the technical experiments instructive – Michael Forster, for example, sent overseas as a war artist, emulated the richly evocative wax resist surfaces of Piper and Sutherland. Others responded to the eloquent renderings of organic fragments by Sutherland and Paul Nash – clusters of thorns, twisted roots, and tree stumps. Stand-ins for the battered human psyche, they conveyed both the life force of nature and the brutalization of the modern world, especially resonant in the wake of war. Canadian artists as diverse as Oscar Cahén, Jack Shadbolt, Gordon Smith, and Harold Town engaged with this landscape aesthetic, sharing in its anxiety about the loss of personal autonomy and encroaching societal fragmentation.

On his departure from London in 1946, Massey was eager to keep alive the contacts that he had made and urged H.O. McCurry to visit London.[195] Certainly the war experience renewed and forged a broad base of connections between Canada and Britain that would survive well into the postwar era. Large-scale British immigration, peaking in 1957, brought to Canada many individuals who took up leading cultural positions, from Celia Franca at the National Ballet and Betty Oliphant at the National Ballet School to Tyrone Guthrie and Tanya Moiseiwitsch at the Stratford Festival. Others, Canadian-born but with British credentials, also played a decisive role, from Alan Jarvis at the National Gallery of Canada to George Woodcock, prolific author and founder of the magazine *Canadian Literature* in 1959.[196] The 1950s became the golden era (if there was one) of the Commonwealth.[197]

In the raft of initiatives on which Massey embarked, aimed at re-energizing relations between Canada and Britain, there was undeniably the taint of lingering colonial deference, despite his assertions to the contrary. As well, Massey displayed an almost unapologetic Eurocentricity. None the less, there was much evidence of exchange with Britain as well. Undoubtedly, in the ebb and flow of the two nations' association, the relationship underwent a sort of renaissance during the 1940s and 1950s, characterized not only by renewal but also by a transition to greater equality.

Meanwhile, fears of American domination, economic and cultural, mounted. Massey was far from alone in his belief that Britain's relevance for Canada lay in its shared honouring of a humanistic tradition fostering tolerance, stability, and public service. Britain experienced considerable success marketing itself as a source of stability and vitality in a world

shaken by war and in need of innovative solutions. With reference to the arts, the Canadian painter Charles Comfort contrasted the 'fluctuating environment of the United States' with 'the British School [which] provides a model of stability ... a rational modernity.'[198] Massey himself used the argument of stability to support the alliance. When the Canadian Citizenship Act came into effect in January 1947 – 'the first nationality statute in Canada to define its people as Canadians'[199] – Massey hastened to refute conclusions drawn by the American press:

> This was interpreted by some newspapers to the south as a step which would weaken our ties with Great Britain. They overlooked the fact that this legislation states quite clearly that a Canadian citizen is still a British subject. That duality, of course, is the key to so much that has happened over the last century ... Indeed, in working out our own destiny we have quite unconsciously been the laboratory in which the principles of the modern British Commonwealth were discovered and successfully applied ... in these days when so much seems to be in dissolution, a story of orderly democratic development has something refreshing about it and the British Commonwealth, we believe, is a highly constructive achievement in a world which needs all the stability it can find.[200]

Moreover, as Britain embraced the welfare state and its public sector became more dominant, the United States perceptibly moved away from the state intervention that had characterized Franklin Roosevelt's administration and the New Deal policies of the Depression era. It was the British example that Canada favoured, including the arts council model of state-supported culture. State intervention in the cultural sector, Massey believed, was now urgent in the battle for Canadian sovereignty.

6

Arm's Length: Culture, the State, and Canadian Sovereignty, 1946–1951

Massey returned from England in 1946, his diplomatic posting having served to harden his convictions about the cultural perils that Canada faced and the sources from which it drew strength. He was utterly convinced that Canada must assume responsibility for its culture or remain prey to mounting American imperialism. His early concern for overcoming Canada's sectionalism and for locating a sense of community and unity within its ethnic and geographical diversity was now overshadowed by what he perceived to be the external forces that threatened national sovereignty.

At the end of the war, he asked what he considered to be a central question: was a relationship between art and the state viable and desirable in peacetime?[1] His answer was clear. He had observed how an alliance between culture and the state had served wartime Britain, and he sought to harness similar energy and commitment for Canada. He launched a personal campaign to enlist broad-based, cohesive government support to the cultural cause, through speaking engagements, through his book *On Being Canadian*, and, ultimately, through the Royal Commission on National Development in the Arts, Letters, and Sciences (1949–51).

Museum Advocate

Immediately on his return to Canada, while the Massey Foundation gift of modern British art was still in circulation, Massey set out on an ambitious lecture tour. As Alice Massey noted: 'Vincent conceived the idea – and he was perfectly right – that he and I must get to know our own country again.'[2] The couple travelled some 9,000 miles, and Massey gave

approximately thirty addresses. According to Alice, they received 'a most wonderful reception everywhere.' Many of the people they met were former military personnel, whom they had encountered in the Canadian service clubs in London, where Alice had volunteered tirelessly.[3]

As much as reacquainting themselves with Canada, the Masseys were goodwill ambassadors for Britain. As Alice wrote of the lecture tour: 'It is so important in this country now to tell them all about England and to reiterate all her qualities when so much of the American press exaggerates in its headlines the breakup of England.'[4] Her remarks evoke the intense British–American rivalry at the end of the war. It is quite likely that the Masseys' views of the United States had been sharpened by British anti-Americanism. By the close of their trip, they were heartened by the sense of unity that they observed: 'although the provinces are very self-determining ... there is far less talk of isolation.'[5] They attributed this sense of community to the experience of war and renewed contact with Britain.

After the tour, 'restless' and eager 'to get into active life again,'[6] Massey continued to give numerous addresses. Among them was – on the invitation of David Finley, director of the National Gallery of Art in Washington (opened 1941) – a speech to the American Association of Museums in Quebec City in May 1947. Massey's comments were intimately informed by his experience on the boards of the National Gallery of Canada and the National Gallery and the Tate Gallery in London. He laid out clearly his views on the museum's role as an agent in the transmission of culture, deserving of an enhanced role in an enlarging public sector.

Referring to the museum as 'a spiritual institution,' he emphasized the trend towards greater accessibility, claiming that the day was over of the 'crowded and forbidding depository of objects of value where the necessary notice, "Please do not touch" seemed to imply "Please do not enjoy." ... Museums are happily no longer merely passive in their functions; they have become positive, living instruments of education.'[7] Moreover, he found fault with the growing move to scholarship, which, in an effort to produce 'exact scientists,' was losing touch with the humanities and 'reduced the study of previous cultures to exhaustive classifications of empty vessels.' 'In museums,' he stated, 'we shall always have to tread a careful path between the Scylla of pedantry and a popularizing Charybdis.' Museums, he suggested, were 'the product of a marriage between scholarship and showmanship.'[8] Such a statement was quintessentially Massey.

While acknowledging that 'a museum can, of course, quite properly be a monument to national pride,' his concern was less with patriotic glory than with the museum's cultural – that is, educative – role in fostering understanding and tolerance within the world community. 'The great function of museums is surely to give us a sense of oneness; to make us think, not nationally nor hemispherically, but spherically. It helps us to gain a correct perspective when we can see the pattern of civilization presented as a whole. It gives us, too, a salutary sense of humility. No one, for instance, who visits a great Chinese collection like that at the museum in Toronto, could retain too cock-sure a complacency about our streamlined Western civilization of today. ... It can project the world as a whole more directly than even the university or the library, because its records are original ones and can be most easily comprehended.'[9] The speech both affirmed the museum's educative role in fostering tolerance and understanding among nations, and stressed wide access to cultural artefacts.

It also displayed Massey's characteristically hybrid thought, which tried to reconcile assimilationist liberalism with a sincere respect for cultural difference. Since the 1930s, at least, critics had attacked liberalism for its many contradictions, from its promise of economic utopia yet seeming inability to address huge social inequity to its advocacy of freedom of belief yet its behemothic assimilationism. While Massey was deeply resistant to liberalism's propensity to monolithism, he never abandoned his profound trust in individual human agency. But increasingly he sought to moderate the excesses of individualism by privileging collective and public venues. He enthusiastically endorsed the modern museum as a site of cultural formation and exchange and as a buttresss of Canadian distinctiveness, while he wrestled with its problematic nature as an agent of nationalism and internationalism.

As a museum trustee in London, Massey had become well versed on art exchanges between nations and state-supported art's fostering of international dialogue. Quoting from the Massey Report on the British national art collections, he argued that artistic exchange among nations could eschew propagandizing: 'there should ... be only one dominating purpose underlying any display of art, and that is the presentation to the public of fine works.' He maintained: 'If that principle is applied, it seems to me the questionable element of national propaganda can be happily eliminated.'[10] Linking quality and nationalism – a central plank of the Arts Council of Great Britain and the British Council – became a mainstay of Massey's campaign for Canadian self-projection. He

commended two recent international touring shows for their ambassadorial role and level of excellence – the Hogarth, Constable, and Turner exhibition, which, as chair of the National Gallery in London, he had been instrumental in sending to North America,[11] and a collection of the arts of French Canada, which travelled to the United States.[12] Being guided by excellence may camouflage or muzzle a nationalist agenda, of course, but does not eliminate it. None the less, Massey argued that quality can moderate bias, thereby honouring some degree of multiplicity and deflecting the more offensive aspects of propagandizing. Contrary to those who insist that excellence is an inherently elitist notion, Massey would have recognized no conflict between quality and wide accessibility to art.[13] Quite the opposite; aspirations to excellence nudged art and the state away from unbridled partisanship and levelled the playing-field.

The National Gallery of Canada

During the late 1940s, the National Gallery of Canada became a major forum for Massey's campaign for government-supported culture. A gallery trustee since 1925 and appointed its chair in 1948, he was well positioned to translate some of his thought and rhetoric on art museums into practice in Canada. He found himself at the helm of the postwar bid to reformulate gallery policy and to lobby for a proper gallery building.

As Massey had reminded Prime Minister King in November 1945, the gallery's activities and budget during the war had been reduced to an absolute minimum.[14] There had been no board meetings since 1939. Vacancies on the five-member board had gone unfilled for some years, and Massey urged that at least one of the new members be appointed from the west.[15] A variety of other issues left in abeyance were now pressing, especially the urgent need for a new building. Given present quarters and lack of staff, services to the rest of the country, very much in demand, could not be expanded.[16] As well, the gallery was eager to promote wider use of art through establishment of a Design in Industry Council and a museum of industrial art.[17]

Massey was keenly aware that the gallery's well-being, even survival, depended on its capacity to democratize its services. But more important, the museum had a crucial role to play in securing a Canadian value system, central to which, in his view, was a non-partisan public-spiritedness. Establishing a significant degree of gallery autonomy was essential to this task and became in the nature of a crusade. To this end, the

trustees and administration were determined to clarify the gallery's relationship with government. Above all, they sought to have the institution divorced from a government department (Public Works) with unsympathetic functions. This, and a variety of other issues, they would pursue over the next several years, with varying success.[18] The subject of the autonomy of the federal museums would figure prominently in the Massey Report of 1951.

The project that absorbed most of Massey's energies as a trustee during this period was lobbying for a permanent, fireproof building. In 1940, Massey had contemplated lending the Massey Foundation's growing collection of modern British art to the Art Gallery of Toronto until such time as the National Gallery had a fireproof structure. Alice Massey told Lionel in a letter of February 1941 that they had firmly decided to give the foundation's pictures to the gallery only when it had a new, fireproof home. 'We have got to in some small way spur them on in Ottawa to create something really worth all the treasures they possess. Think of the little Botticelli not being in a fire proof room.'[19]

H.O. McCurry reported to Massey in early 1945 that the prime minister had assured him that a building in Ottawa's centre had 'his most cordial support.'[20] King, however, was quite capable of simply 'stirring the pot.' He commented to McCurry that Lord Beaverbrook had recently implied his willingness to finance the project and that Massey had for unknown reasons lost interest. Massey was quick to discredit Beaverbrook's sincerity and as gallery chair took up the subject with renewed vigour in 1948.

Massey wanted 'a really distinguished structure' in the heart of Ottawa.[21] He wrote with keen interest to King about the 'City of Ottawa Plan' that was being developed.[22] He and his fellow trustees promptly passed a resolution: 'WHEREAS successive governments have recognized the necessity of providing a home for the National Gallery which could serve as a centre of art activity for all Canada and a worthy monument to the high position of the arts in this country ... THEREFORE be it resolved that ... immediate steps to study the whole problem of a new building in all its aspects [be taken], and that specially qualified architects be employed to assist in this study.'[23] In June 1948, Alphonse Fournier, minister of public works, acknowledged that the development of the national capital must accommodate a new national gallery. He authorized gallery officials to develop plans and offered the services of department architects.[24]

Massey approached Fournier once more: 'in view of the highly specialized nature of the building required,' he suggested a $25,000 parliamen-

tary appropriation to prepare thorough preliminary studies of the site, size, and style of the prospective building. He added that the gallery's Design Industry Section needed exhibition and office space so urgently that a temporary pavilion might be necessary near the present gallery.[25] Fournier replied curtly that 'the selection of a site and the erection of a new building for the National Gallery is a matter of government policy.' As a temporary measure, he disclosed that the gallery would probably be offered space in the Museum building, when the Department of Mines and Resources vacated the space occupied by the Geological Survey of Canada.[26] The campaign for a new National Gallery was in effect on hold.

On Being Canadian

Massey meanwhile addressed the subject of state-supported culture in a book entitled *On Being Canadian* (1948) – a synthesis of his experiences abroad and a prelude to his work as chair of the soon-to-be-convened Massey Commission. 'The sort of thing that has not been done before,' in Alice Massey's words,[27] it was a well-developed argument in defence of cultural sovereignty and itemized the state apparatus required.

Massey had apparently conceived of such a book before the war. His personal papers include a rough synopsis for what he titled 'The Other Canada.'[28] While it considered various artistic disciplines, including film, as well as archives, museums, and pageantry, and addressed themes ranging from the relationship between art and nationalism to Canada's association with Britain and the United States and the projection of Canada abroad, it did not directly allude to state support of culture. It was Massey's engagement with state-supported art in wartime Britain that so shaped his convictions in this area.

On Being Canadian was, above all, a plea for state-supported art. Massey no longer dealt with the arts alone but integrated them into a broader conception of Canadian nationalism – they were indeed its centrepiece. He denigrated the 'disposition to regard painting and music or like pursuits as "frills," ... as something largely "of interest to the ladies."' He invoked a 'rereading' of Matthew Arnold's *Culture and Anarchy*, which he felt had 'lost none of its force.'[29] 'If life in Canada has a pattern of its own, to whom can we look to explain the design?' he asked. His answer was the artist and writer, whom he labelled 'the interpreters.'[30]

Massey also summarized his conclusions about the sources of Canada's cultural strength. The first source was its diversity. He quoted Sir

George-Etienne Cartier (in the legislative assembly of Canada in 1865): 'It was a benefit rather than otherwise that we had a diversity of races,' and Lord Acton in his essay on nationality, 'the co-existence of several nations under the same state is a test, as well as the best security of its freedom. It is also one of the chief instruments of civilization.' Massey addressed specifically the need to understand difference, not only to find common ground: 'About half our people are of British stock; nearly one-third are of French origin. The remainder, about one-fifth, represents a great variety of races – German, Scandinavian and Ukrainian forming the largest groups. There are forty-two Canadian periodicals carrying advertisements in foreign languages of which thirteen are represented. The Bible is distributed in Canada in over fifty languages.'[31]

While his outlook may not be construed as multicultural by today's standards – he patently ignored First Nations' history when he stated that Canada's founding coincided with Champlain's arrival in the early seventeenth century – he strongly promoted the notion that Canada's strength resided in accommodating diversity. Since at least his university days, he had been a committed biculturalist who spoke French well himself and ensured that his children learn the language. He was a leader in including French-speaking representatives in national forums and was generally outspoken about the need for bilingualism and biculturalism. The French–English fact undercut for him the assumptions of racial hegemony that still pervaded so much thought and practice. Of course, Massey, like others of his generation who endorsed biculturalism, tended to do so at least partly on the grounds of a common northern racial heritage.[32] This did not, however, diminish the great store that he placed in Canada's historical protection of the freedom to sustain diversity; he lauded the constitutional protection assigned to the French language and the Roman Catholic faith, the freedoms experienced by the United Empire Loyalists on their arrival, and the freedom implicit in the achievement of early responsible government, making Canada the 'laboratory' for 'that monumental conception which has given the world so great a pattern of political liberty,' the Commonwealth.[33]

The second source of Canada's cultural sovereignty, he argued, was its shared history with Europe, specifically Britain. He adopted a bipolar metaphor: the force of geography versus the force of history. As proof of the role of history, Massey pointed to the fact that 'unlike the twenty-one other nations of the Americas,' Canada did not cut its 'political ties with Europe and the impact of the older world upon Canadian life has been stronger for that reason.' But whereas geography and in turn the relation to the United States were givens, he argued that history and the

European legacy were dependent on nurturing.

He elaborated the geography–history metaphor, equating the north–south 'threads in our national fabric' with things physical and the east–west threads with intangibles.[34] He could not have been more resolute in his view that Canadian culture was strengthened by association with Europe and that this alliance helped bind the country together from coast to coast. Or, put more bluntly, Canadians and Europeans shared common values and traditions, and Canada and the United States clearly less so. Aside from the Eurocentredness that seems so outdated now, his view of the United States went well beyond uneasiness about the extent of its influence – a growing reality – and seemed to deny any commonality at all, other than physical, between the two nations. While an extreme perspective, and not consistent with other statements that he made acknowledging positive American influences, it spoke of his profound belief that Canada must resist U.S.-style values and recognize the crucial role of culture in achieving the sovereignty to do so.

Massey also attempted to disentangle internationalism from colonialism and imperialism. He argued: 'true internationalism comes only from the co-operation of responsible national units. It is far removed from the cloudy cosmopolitanism which denies that national feeling.' Massey traced Canadian nationalism back eighty-plus years and assured his readers that while '"colonialism" died hard, ... it has been long dead. National sentiment killed it.' But he warned of a 'new colonialism' – dependence on the United States.[35] 'If ... we are to keep our Canadian traditions inviolate, we must face another battle, a spiritual battle, for if the obstacle to true Canadianism was "Downing Street" in the nineteenth century, its enemy today is "Main Street" with all that the phrase implies.'[36] He noted Hollywood and New York's domination of Canada's film and commercial theatre, respectively, and gave statistics on the immense Canadian readership of U.S. magazines. He expressed concern about the infiltration of particular American values and practices – specifically racial discrimination against blacks and the use of unsavoury tactics of law enforcement for extracting information from accused persons. A decade before Walter Gordon's plea to support economic nationalism,[37] he pointed out that about one-third of the investment in Canadian industry was now American. Trade unions, he noted, operated under powerful U.S. influence. But, above all, it was the 'cultural reorientation in Canada which demands our thought and attention.'[38]

Finally, he tackled state responsibility for culture. 'No state today can escape some responsibility in the field to which belong the things of the mind.' He pointed to the cultural tactics of totalitarian regimes, arguing

that 'our peoples need to understand the way of life which they are defending in the war of ideas of today so that they can defend it the better. The state indeed has very serious obligations in this field.' But, as he emphasized, 'Canada cannot be said to have accepted this principle. We seem to trail far behind most civilized states in our *governmental* recognition of the arts and letters and the intellectual life of the community.'

He relied on the example of the Arts Council of Great Britain, pointing out that, while it was funded by the British taxpayer, it maintained independence from the civil service: 'We would do well to study such a successful experiment in state-aid.' He firmly rejected the notion of a government department of culture. 'We need public money for the encouragement of our cultural life, but we want it without official control or political interference. That is why a Ministry of Fine Arts or a federal Department of National Culture would be regrettable. The very phrases are chilling. The arts can thrive only in the air of freedom. Official approval of this school of painting, or that group of painters, would sterilize taste and create a false orthodoxy.'

Under the title 'Culture and the Constitution,' he anticipated a key point of the Massey Report – that the biggest stumbling block historically to federal support for the arts was the BNA Act's allocation of education to the provinces. To Massey, accepting this as a given was to sidestep a role that only Ottawa could assume. 'However active provincial governments may be in the cultural field, there are countless things to be undertaken in this sphere which would be of great value to the Canadian community as a whole, and which, if not done by the federal government or on its initiative, cannot be done at all.'

While claiming to support fully the allocation of education to the provinces – it 'protects for all time the rights and privileges of a linguistic and cultural minority' – he argued strenuously that it did not preclude the federal government's involving itself in 'Canadian intellectual life.' He noted exceptions to the constitution – most notably broadcasting, a national responsibility – and pointed to radio's educational mandate as proof of legitimate federal involvement in the cultural sector. He proceeded to itemize the 'missing equipment' in Canada's state support of culture, among them a national library and permanent, fireproof quarters for the National Gallery.[39]

A Climate for Change

Concurrent with the publication of *On Being Canadian*, pressure was mounting within the artistic community for stronger government pres-

ence in the cultural sector. The historic Kingston Conference at Queen's University (1941), funded by the Carnegie Corporation, enabled visual artists from across the country to meet for the first time and share their concerns. In its aftermath, there was a growing effort to enlist government support for the arts. In areas ranging from copyright law through creation of a national library and of a nation-wide network of community art centres to the setting up of a national funding agency for the arts, federal government assistance was sought.

The Federation of Canadian Artists (FCA), a fruit of the 1941 conference, provided a voice for Canada's hitherto desperately isolated visual artists. In May 1944 the FCA joined forces with fifteen other cultural organizations to present a well-argued brief to the House of Commons Special Committee on Reconstruction and Reestablishment (Turgeon Committee). While yielding no immediate results, the appeal joined the growing chorus of demands for the federal government to reckon with its responsibilities in the cultural sphere.

Of course, state-supported culture required broader changes in both the conception and the structure of government. The federal system underwent a sea change between the 1930s and the 1950s.[40] Measured by the number of civil servants, the federal government grew vastly, as did its budget. The civil service changed from a largely stultified repository of hacks and incompetents, animated principally by political patronage, into a fully rationalized, well-equipped, and professionally staffed modern apparatus.[41]

A host of factors fuelled this transformation. One was the new concentration of funds in federal hands. At the beginning of the war, Ottawa had assumed control of personal income tax and corporate taxes for a period of one year beyond the end of the conflict. In 1945, it negotiated with the provinces a continuation of this control of taxes, adding death duties. The latter would prove propitious for the creation of the future Canada Council.

Facilitating this reallocation was the embrace of the philosophy and policies of English economist John Maynard Keynes, whose *General Theory of Employment, Interest and Money* appeared in 1936. In the wake of the Depression, there was a readiness to abandon laissez-faire policies in favour of greater federal intervention in the rhythms of the economic cycle. Canada itself was not entirely without a tradition of government provision of services. In areas where the private sector had clearly fallen short – notably transcontinental railways, long-distance telephone service on the prairies, and broadcasting – the government had taken control.[42] But there would be a dramatic escalation of government

involvement during the 1940s. The birth in 1932 of the Co-operative Commonwealth Federation (CCF), forerunner of the New Democratic Party (NDP), also signalled a growing critique of pure capitalism and a resolve to enlist government to the task of social welfare. During the early 1940s, the CCF made a number of major political gains, becoming in August 1943 the official opposition in Ontario and winning power in 1944 in Saskatchewan – the first socialist government in North America. Ottawa introduced such cornerstones of the welfare system as unemployment insurance (1940) and family allowances (1945).

By the late 1940s, there was thus a significant broadening of the notion of the public sector in Canada and a new readiness to identify it with federal responsibility. The concept of the public good itself was undergoing profound revision, provoking many questions: how broad collective action was to be; what goods and services to embrace; in whom and in what to vest responsibility for collective action; and what guiding principles were likely to be the most reliable guardians of these public goods. Certainly, in Canada at mid-century, the idea of the public good was deeply intertwined with a transformation in government that involved both size and make-up. It entailed finding ways to eliminate or reduce political exigency from public policy-making and to incorporate mechanisms of personal disinterest into public forums.

Massey was involved in both these missions: the broadening of the public sector and the locating of moral authority therein. He was uniquely poised to participate in this project, given his wide knowledge and experience in areas ranging from the university to the museum, from the fine arts to broadcasting and film. In his grasp of the implications and scope of cultural matters, and in the clarity of his resolution on the role that the state might play, he might be viewed as something of a visionary. While there was considerable ferment on the subject of culture in Canada, few people, if any, combined Massey's depth of experience in education and the arts with his credibility in industry and government.

The Massey Commission: Defining Its Terms

The events leading to creation in April 1949 of the Royal Commission on National Development in the Arts, Letters, and Sciences have been chronicled by various authors. The account has varied. On one hand, the commission has been characterized as a response to a groundswell of mounting public support for government intervention in the cultural

sector.[43] On the other hand, it has been described as a small band of intellectuals conspiring to press its agenda on an unwilling public – a case that remains inconclusive and may indeed have done the commission a considerable disservice.[44] It is possible, of course, that there were elements of truth in both. None the less, Massey and his fellow commissioners were deeply fortified by their public hearings and written briefs. Their report received widespread favourable, even enthusiastic, support from all levels of government, from the media, from all manner of volunteer organizations, from the universities, and from numerous other constituencies.[45]

We must be careful, of course, not to conflate the vigorous contributions made by the various commissioners, or to diminish the input of other individuals and groups who contributed. But drawing the line between their roles is as difficult as discerning the exact dimensions of public support. The fact remains there were innumerable continuities between Massey's earlier views on culture and the commission's findings. This may testify less to Massey's or the other commissioners' strong-arming the enterprise, than to consensus among the commissioners and the public. Be that as it may, Massey's purposeful stewardship of the project is clear at every turn.[46]

Massey, named chair in the order-in-council of 8 April 1949 establishing the commission, helped choose its other four members – Father Georges-Henri Lévesque, Norman A.M. (Larry) MacKenzie, Hilda Neatby, and Arthur Surveyer.[47] The commission held public hearings in sixteen cities and in all ten provinces, heard over 1,200 witnesses, and received 462 briefs.[48] It tabled its report – 517 pages, with twelve appendices – in Parliament on 1 June 1951. While it is widely recognized as the single most important document in the history of Canadian cultural policy, its most significant outcome – the creation of the Canada Council – has tended to eclipse the commission's other concerns and recommendations.

The report itself had two parts. Part I, which opened with a couple of general chapters entitled 'The Nature of the Task' and 'The Forces of Geography,' was the product of considerable original research and provided an overview of Canadian cultural endeavour at mid-century. It testified to the impressive richness of the country's cultural fabric and brought a wide range of organizations, hitherto largely obscure, to national attention. Part II (see next section) contained the commission's extensive recommendations with regard to broadcasting, the National Film Board, the National Gallery, national museums, federal libraries, archives, historic sites, aid to universities, the fine arts, Canadian culture

abroad, and creation of a national funding body for the arts, letters, humanities, and social sciences.

In its work, the commissioners wrestled with a number of complex, sometimes ambiguous terms and concepts – culture, education, leisure, citizenship, the public good, diversity, and sovereignty. From the outset of the proceedings, Massey's long-standing discomfort over the word 'culture' was palpable. He later commented on the press conference that he called the day after the commissioners' preliminary organizational meeting: 'The word "culture" floated like a menacing cloud over the occasion. I avoided the use of the term and said that as far as the accounts of our work in English were concerned, it had better be looked on as a naughty word.' He added: 'It is interesting that "culture" in French is a perfectly normal term but in English it suggests everything that is highbrow, self-conscious and esoteric. If our enquiry was known as the "culture probe," it was simply the result of good natured flippancy.'[49] That the word 'culture' engendered such acute discomfort and embarrassment in Massey is suggestive of the still limited acceptance of its role in Canadian society.

As early as the draft terms of reference of the commission, Massey was careful to cross out all uses of the word 'culture.' In a covering letter to external affairs secretary Lester B. Pearson of 20 January 1949, he said that while he liked the term 'National Development' in the commission's title, 'the phrase "in the field of arts and letters" is ... a bit too restricted in view of some of the subjects which must be in the list. Culture is of course a word to be avoided and so is education for obvious reasons.'[50] Despite his early strictures, by the time of the commission's final report, the submission abounded in the use of both words.

In fact, Massey and his colleagues adopted a fairly broad definition of culture. While the fine arts were included and were even elevated to join the liberal arts in forming the centrepiece of the project, the commissioners were careful to encompass a wide spectrum of concerns, including scientific research and the mass media. As Alice Massey (who died before the commission completed its work) summarized it, its mandate was to study the entire 'cultural side of Canadian life and to recommend where the government should step in and help.'[51] The commissioners noted: 'such an inquiry ... is probably unique; it is certainly unprecedented in Canada.'[52]

A quotation from St Augustine's *The City of God* opened the report: 'A nation is an association of reasonable beings united in a peaceful sharing of the things they cherish; therefore to determine the quality of a nation,

you must consider what those things are.' The commission proceeded on the assumption that there was indeed a discernible collectivity of 'cherished things' among Canadians and that to measure its worth as a nation one must look not to its material well-being and physical resources but to these values. What they were called on to consider was 'nothing less than the spiritual foundations of our national life.' The commissioners called them variously 'human assets,' 'spiritual resources,' 'these intangible elements,' 'a common set of beliefs,' and the 'important things in the life of a nation which cannot be weighed or measured.' They wrote: 'Canada became a national entity because of certain habits of mind and convictions which its people shared and would not surrender. Our country was sustained through difficult times by the power of this spiritual legacy. ... It is the intangibles which give a nation not only its essential character but its vitality as well. What may seem unimportant or even irrelevant under the pressure of daily life may well be the thing which endures, which may give a community its power to survive.'[53] The commissioners' idealism, their affirmation of an existence for culture separate from material or economic factors, was unequivocal. In Canada, this approach was ground-breaking, both for the centrality assigned culture and for the insistence that it belonged squarely within the purview of the state.

The phrase 'a community's power to survive' also strongly evoked an underlying sense of threat, a desire for stability, and a determination to maintain (or achieve) sovereignty. Massey's campaign for culture's recognition, and the Massey Report itself, may be understood as a bid for Canadian autonomy, hitherto of questionable existence precisely because of a traditional emphasis on the practical and material and a concomitant neglect of culture. To those who might argue that trying to distinguish culture from economics is naive, one might retort that a denial of culture only clears the path more readily for economic imperialism.

Despite Massey's early reluctance to call culture by its name, the first chapter of the report, 'The Nature of the Task,' conceded the problematic nature of the concept in Canada, especially in its relation to education.[54] 'Although the word culture does not appear in our Terms of Reference [so carefully deleted by Massey], the public with a natural desire to express in some general way the essential character of our inquiry immediately and instinctively called us the "Culture Commission."' The commissioners explained that they had listened to many interesting ideas about the importance of culture, both from those who

welcomed the inquiry and from others who worried about its encroaching on education. Education, the commissioners hastened to acknowledge, was the constitutional purview of the provinces, but they distinguished between formal and informal education and equated culture with the latter. Rather tortuously, they pointed to culture's affiliation with education, in order that it be taken seriously, and then tried to disengage it from education as a provincial responsibility.

The commission's view of education clearly revealed its nineteenth- and early-twentieth-century humanistic lineage, so central to Massey's own upbringing and early education: 'education is the progressive development of the individual in all his faculties, physical and intellectual, aesthetic and moral. As a result of the disciplined growth of the entire personality, the educated man shows a balanced development of his powers; he has fully realized his human possibilities.' To distinguish culture from applied education – that is, from technical and professional training – the commissioners defined it as 'that part of education which enriches the mind and refines the taste. ... This development, of course, occurs in formal education. It is continued and it bears fruit during adult life largely through the instruments of general education; and general or adult education we are called upon to investigate.'[55]

In making the distinction between formal and informal or adult education, the commissioners were guided perhaps and certainly strengthened by the briefs that they received, especially from religious groups. The brief from the Canadian Catholic Conference, for example, which Massey found 'important and helpful,'[56] readily divorced formal from adult education and considered the latter the territory of the Massey Commission's work.

The churches, however, did not hesitate to also employ the term 'culture' to designate the whole non-material realm of human endeavour. The Catholic Conference concerned itself with the 'general principles that ... should inspire our Canadian culture' and, in keeping with the intellectual tradition to which Massey was so indebted, readily equated culture with the humanities. Massey bracketed a passage of the Catholic Conference's brief: 'The poison of materialism has sadly infected our modern world. If Canada has so far been spared its worst ravages, it is due, in large part, to the fact that our *tradition in culture and education* has been solidly based on the conviction that *it is man that matters rather than things*, a conviction which has manifested itself in, and been fostered by, the important place assigned to the humanities in all levels of our

education' (Massey's emphasis).[57] The Church of England in Canada concurred: '*We believe that no field of knowledge or research, however important in itself, should be allowed to become a substitute for a basic training in the humanities*' (Massey's emphasis).[58]

The commissioners invoked another concern that had exercised theologians and educators in Canada since at least the mid-nineteenth century – the constructive use of leisure. The Anglican church noted that, while the amount of relaxation time had increased with industrialization, 'little has yet been done to enable the community to prepare itself for the creative use of leisure.'[59] The commission wrote: 'The work of artists, writers and musicians is now of importance to a far larger number of people than ever before. Most persons today have more leisure than had their parents. ... But leisure is something more than just spare time. Its activities can often bring the inner satisfaction which is denied by dull and routine work.'[60] The Catholic Conference's submission called for humanistic training 'to counteract ... the already alarming intellectual passivity among modern people' – a passage that Massey underlined in his copy of the text.[61] The commissioners weighed the agility of mind and independence of thought that the liberal arts were presumed to cultivate against what they referred to as 'passive entertainment' – 'a tendency to spend increasing leisure in gazing and listening or in aimless motoring.'[62]

Harking back to Massey's days on the executive of the National Council of Education in the 1920s, the report's opening essay also situated its task in the context of citizenship: 'Our concern throughout was with the needs and desires of the citizen in relation to science, literature, art, music, the drama, films, broadcasting,' as well as federal aid to higher education. Implicit in its choice of the nomenclature 'citizen' was concern with fostering not the individual's pursuit of personal happiness (although this was by no means excluded), but service to the community. As the commissioners wrote: 'Education is primarily a personal responsibility ... [:] however, the individual becomes entirely himself only as a member of society.' Elsewhere in the report, they wrote: 'in the realm of culture as distinguished from citizenship, if such a distinction is possible. ...' They continued with a key statement: 'All civilized societies strive for a common good, including not only material but intellectual and moral elements. If the Federal Government is to renounce its right to associate itself with other social groups, public and private, in the general education of Canadian citizens, it denies its intellectual and moral purpose, the complete conception of the common good is lost,

and Canada, as such, becomes a materialistic society.'[63] Here was the idea, so familiar to Massey, that it was the common life that elevated existence above the commonplace and the sordid. 'The common life,' 'the public good,' and 'the public sector' were rapidly becoming intertwined, even inseparable.

While the commissioners were vocal about the collective good, they were equally forceful in their defence of diversity. They devoted a chapter to volunteerism and the volunteer, which they understood to be a major dimension of 'the diversity within our unity.' 'The fine tradition of the voluntary society which performs work of national importance beyond what government can or will do is perhaps rightly regarded by English-speaking Canadians as their special contribution to our common life in Canada. This claim is partly although not entirely justified, since France too has had her tradition of voluntary effort; but in a more fully centralized state the role of the voluntary organization has been inevitably less vigorous.' The contributions by other ethnic groups we are left to surmise. None the less, this statement provides a counterpoint to the report's endorsement of government involvement and reminds us that its authors were far from recommending wholesale centralization. Indeed, they found the 'energy' and even 'fanaticism' with which volunteer groups had mounted their activities throughout Canadian history 'reassuring in a country where circumstances have exaggerated the virtues of the conformist.' They championed the history of 'public service on a voluntary basis' and affirmed that 'there is general agreement on the need to maintain individual initiative and a sense of responsibility.'[64] However, the volunteer, the local, and the amateur were strengthened, in their view, by an alliance within a larger unity. A national infrastructure of support was required for the local not to be threatened with effacement.

As Massey had said on an earlier occasion, '"mass culture" is a contradiction in terms. Culture is primarily an affair of the individual ... [;] its mechanized dissemination may defeat its own end.'[65] While favouring universal access to the arts and education, he was apprehensive that cultural production disseminated *en masse* dulled its recipients, minimized their opportunities to participate, and made them vulnerable to manipulation. Passivity, homogeneity, and manipulation were seen to work hand in glove. Fear of standardization, early in the twentieth-century a refrain of those afraid of democracy and the loss of privilege, became ironically a chorus for those on the fringes of society (or the margins of a superculture), seeking to make alternative voices heard.

The theme of diversity in Canada drew much of its potency from the affirmation of Canadian society in the face of superpower domination; Canada was beginning to prize itself as an alternative voice in a growing single-culture globe. Massey and his fellow commissioners cited and defended biculturalism and bilingualism as evidence of Canada's own respect for diversity internally. In chapter 2, written by Massey,[66] it was clear that they also viewed regionalism as a virtue: 'In our travels we were impressed by differences of region and atmosphere. ... The very existence of these differences contributes vastly to "the variety and richness of Canadian life" and promises a healthy resistance to the standardization which is so great a peril of modern civilization.'[67] They also linked creativity with diversity and – more surprising, perhaps – with government. They rejected the premise that government involvement necessarily stifled creativity and turned it around; they argued that industry, driven by the profit motive and mass production, circumvented creativity and diversity.[68]

While the Massey commissioners positioned culture in opposition to commerce, and by implication Canadians as more 'cultured' than their U.S. neighbours, they also wrote of 'cultural indebtedness' to the United States. They praised cultural exchange in principle. They quoted from a brief of the National Conference of Canadian Universities: 'culturally we have feasted on the bounty of our neighbours.' In acknowledging that cultural debt, they employed 'culture' in a second sense, not only to designate the non-material realm, but to distinguish particular communities, each with its own 'vigorous and distinctive cultural life.'[69] Culture was not only that which was lofty and elevating – it varied from community to community; it could even be loathsome and threatening. The Massey Report, in fact, gave expression to a conception of culture in transition, which admitted an increasing spectrum of belief systems and fields of endeavour.

The document unequivocally sounded the alarm about American cultural penetration into Canada, which advanced in step with business and even military inroads. While the two nations had moved perceptibly closer in the 1920s and 1930s, some of the events that attended the Second World War had aroused Canadian animosity. With U.S. entry into the conflict after the bombing of Pearl Harbor on 7 December 1941, American military personnel arrived in the Canadian northwest and Newfoundland often with the manner of 'occupying forces.'[70] Accompanying this threat to Canada's own defence policy was the escalation of American capital investment and direct ownership of natural

resources and business ventures. While fuelling Canada's postwar prosperity, this economic influence reached proportions that frightened many Canadians. The report commented: 'We know that if some disaster were to cut off our ready access to our neighbours, our whole ecomomic life would be dislocated; but do we realize our lack of self-reliance in other matters?'

The commissioners acknowledged the beneficence of American foundations to Canadian libraries, and their scholarships to Canadian students, but were concerned by the 'vast importations of what might be familiarly called the American cultural output.' 'Few Canadians realize the extent of this dependence; ... our lazy, even abject, imitation of them [American institutions] has caused an uncritical acceptance of ideas and assumptions which are alien to our tradition.'

As an example of the problematic state of Canadian culture, the commissioners cited a brief which reported that in a grade 8 class of thirty-four students, nineteen were able to explain the significance of 4 July, and only seven, 1 July.[71] To the commissioners, this was patent evidence of Canada's neglect of its own history – a theme that has lost none of its relevance a half-century later. Culture could be either a pipeline of American influence or a bulwark against it.

Massey Report: Findings and Recommendations

In its findings and recommendations, the report focused on what it considered to be the primary gathering points for culture: the mass media, specifically broadcasting and film; federal cultural institutions: galleries, museums, libraries, archives, and historic sites; the universities and scholarships; and the fine arts. While its immediate task was to assess and recommend systems of aid to each, broad patterns, invariably centred on nationalization, depoliticization, excellence, and diversity, characterized its vision of state-supported culture for Canada.

With particular urgency, the commission had been asked to review the principles on which to base radio and television broadcasting. Most Canadians, other than those in southern Ontario and British Columbia, who received U.S. transmissions, had not seen television when the commission was established, but its launch was imminent.

Despite reservations about mass-disseminated culture's inducing passivity, the commissioners recognized the central place of mass media in modern society and commended especially the 'pleasure and instruction [they brought] to remote and lonely places in this country.' They

readily referred to radio 'as an instrument of education and culture.' Comparing national public broadcasting in Canada to the building of an all-Canadian railway fifty years earlier, they applauded both projects on the grounds that they defied absorption into an American system.[72]

The commission regarded the functions of the Canadian Broadcasting Corporation (CBC) as three-fold: to foster national unity, to provide quality programming, and to be responsive to diversity. The CBC had met the geographical challenges of the country by straddling six time zones, extensively rebroadcasting national programs, providing special regional services, and maintaining separate networks in French and English, while competing with the American ability to 'spend millions on lavish commercial productions.' The commissioners reported with satisfaction that 'minorities, even small minorities, have not been forgotten.' They lauded, among its public services, 'the *Northern Messenger Service* with its personal messages to Royal Canadian Mounted Police constables, missionaries, trappers and others in the far north.'

They praised the CBC also for its offerings of educational programming, in the form of both school broadcasts and adult education. The latter category included *National Farm Radio Forum, Le Choc des Idées, Citizens' Forum,* and *Les Idées en Marche,* all geared towards an audience organized into listening and discussion groups. The report commended such programs for 'making better citizens of us, in that they awaken our critical faculties.' An American authority cited by the commission praised *National Farm Radio Forum* for bringing into being 'one of the largest listening group projects in the world.' The report continued: 'The joint listening and discussion has led in many rural areas to a high development of community spirit and to useful local projects.'[73]

Finally, while conceding that the CBC paid its writers poorly, the report stressed its instrumental role in the development of Canadian writers, composers, actors, and musicians – one of many areas in which private broadcasting had failed dismally. Private broadcasters, who were the chief critics of the existing system, contested the CBC's function as both broadcaster and regulator and argued for a separate regulatory body. That and their second major aim – to open the door to private broadcasting networks – the commissioners soundly rejected. While acknowledging the private stations for providing local services and acting as affiliates within the national system, the commission was unequivocal that public broadcasting in Canada must not be eroded.

The commissioners situated their argument in the context of a public trust: 'radio, as one of the most powerful means of education, may be

regarded as a social influence too potent and too perilous to be ignored by the state which, in modern times, increasingly has assumed responsibility for the welfare of its citizens. This ... view of radio operation assumes that this medium of communication is a public trust to be used for the benefit of society.' Those who argue that the commissioners repudiated mass culture might bear in mind their profound respect for the mass media and their concomitant determination to harness it for non-commercial interest. And those who argue that their report was elitist may in fact be misunderstanding the commission's populism, which resided in its presumption of the need for broad-based access to the nation's cultural resources (intellectual, spiritual, and artistic) and in its conviction that individual freedom (of, for example, the private broadcasting enterpreneur) must be weighed against collective well-being.

The commissioners were particularly critical of the American system, which treated broadcasting merely as 'a by-product of the advertising business,' although they pointed out that even the United States had accepted 'the general principle that radio frequencies are within the public domain' and had in 1934 created the Federal Communications Commission, appointed by the president and accountable to Congress.[74] They praised France and Britain for placing broadcasting squarely in the public sector, adopting sole government ownership, and not allowing advertising. They obviously would have liked Canada to emulate this model but dared not tamper too radically with the existing mix of private and public.

While seeking to strengthen the CBC's position within Canadian broadcasting, they did not ignore its shortcomings. The commissioners acknowledged the widespread criticism that the national broadcaster was overly centralized. To increase its responsiveness to the country as a whole, they recommended that the CBC's board of governors be enlarged. They proposed that the CBC seriously consider further investment in programming developed outside Toronto and Montreal and that it establish regional advisory councils in order to be more responsive to its listeners' views. They also tackled the inequity in availability of English and French programming and recommended a second French network as well as a French-speaking station to serve the Maritimes. They urged the CBC to consider using existing French-language stations in western Canada for national programs.[75]

Many of their recommendations pertained to quality. In arguing for the CBC's autonomy from political interference, they urged that governors be fully qualified, experienced, and interested in the field. To avoid

the political exigency that attends an annual appropriation 'by the government of the day,' they recommended a statutory grant on a five-year basis to enable the CBC to make long-range plans. They also waded into the specifics of programming policy and practice. They disapproved of the CBC's use of speakers with no qualifications in a particular field to give radio talks – a practice defended with the argument that amateurs had a more popular appeal. They cited by contrast the BBC's policy: 'It is the principle of the B.B.C. that the popular talk should be in quality and authority comparable to the scholarly. In this matter Britain shares the fine tradition of France where even philosophers are expected to make themselves comprehensible to *l'homme moyen raisonnable*.'[76] In this, the commissioners displayed their determination that the public broadcaster not condescend to its listeners; this too may have earned them the label 'elitist' from their critics – unjustly, I argue.

The commissioners' findings in broadcasting established the pattern for the rest of their report, with emphasis on quality, independence from political exigency, and responsiveness to a diverse audience. The very visible successes of CBC radio, which the commission underlined with tremendous satisfaction, buttressed its recommendations for state involvement in other cultural areas. Each of the disciplines examined faced both common and unique difficulties. The commissioners were quick to acknowledge the particularly embattled position of Canadian film in relation to Hollywood and the shocking extent to which the press and periodical literature were American-dominated, pointing out that foreign news was collected and written largely by Americans for Americans. They gestured gently in the direction of tariff protection for paper used by domestic publishers. But they seemed largely resigned to publishing being controlled by commercial, foreign interests.

As for movies, Massey had expressed the view in *On Being Canadian* that the feature film seemed to prosper most in a free-enterprise setting. Yet he had been alarmed since the late 1920s about Hollywood's control in Canada. He and his fellow commissioners lauded the National Film Board of Canada (NFB) for its documentary films and animation and for stimulating the private industry in Canada. In response to pleas from private filmmakers, however, who sought a greater share of government-sponsored work, or argued that the NFB should retire from film production altogether, the commission was adamantly opposed, citing the danger of commercialization. Herein lay its conundrum – fostering a homegrown industry, while none the less harbouring deep suspicions about

commercial interests, especially as a pipeline for American culture. Because of its difficulty in envisioning a support system for producing feature films, in particular, it has been accused of complicity with the commercial interests fuelling the American film industry in Canada.[77]

Should the commissioners have been more demonstrative about restructuring support of film production, distribution, and exhibition? They were surely well aware of the proposal to create a quota system, which would have obliged Hollywood to invest a percentage of its box-office revenues in Canada. This idea had been floated in response to Canada's balance-of-payment difficulties with the United States after the war, but the American film lobby had mounted vigorous opposition, and Canada's political establishment had retreated.[78] Alternatively, the Massey Commission might have recommended tax incentives and protective tariffs for film, not unlike those in manufacturing. Observers have attributed its lack of initiative in this area to two biases – animosity towards commercial control of culture and a rarefied disapproval of the non-educational use of mass media. In other words, the commission was disdainful of popular culture. As proof, critics quote its report's statement that 'the cinema at present is not only the most potent but also the most alien of the influences shaping our Canadian life.' But the word 'alien' was used to refer not to the film medium itself, but to the fact that it was dominated by foreign – that is, Hollywood – control and content. As the commissioners state in their next sentence, 'Nearly all Canadians go to the movies; and most movies come from Hollywood.'[79]

The fact remains that the commissioners addressed virtually all their comments on film making and distribution in Canada to documentaries. They most certainly contrasted Hollywood's commerical films with Canadian documentaries – to the latter's favour. It is truly remarkable that feature films did not command more of their attention. Yet in their terms of reference (admittedly drafted in consultation with Massey), the only component of the film landscape that they were asked to study was the NFB. This task was framed in the context of the commission's examination of all the government agencies that had some cultural mandate. Virtually no such precedent, of course, existed for feature films. The history of feature-film making and distribution in Canada since the 1920s, when Hollywood consolidated its grip on the international market, has been a source of particular frustration for Canadian nationalists and filmmakers. Massey was certainly well apprised of this situation. But the commissioners had to be realistic. They must have found daunting the sheer expense of feature-film production in a coun-

try as regionalized as Canada, particularly at a time when public broadcasting was making the leap from the relatively cheap medium of radio to one ten times more expensive, television. Nationalization of feature-film production was out of the question financially. Moreover, as recent research on the Canadian industry has demonstrated, even recommending indirect forms of support was deeply problematic in the context of Canada's already firmly entrenched position of dependency capitalism.[80]

While the Massey Report was in a sense a cultural wish list, which aimed ultimately at reversing Canadian vulnerability to American inroads, the commission recognized fully that its credibility and the implementation of its recommendations rested on some significant measure of consensus. Certainly Massey was ever the pragmatist, and in this matter the commissioners allowed themselves to be silenced. Their concluding paragraph on film commented limply, even wistfully, 'The documentary film, for all its popularity and increasing use, still represents only a minute fraction of total film consumption in Canada. For general film entertainment, Canadians want commercial features; and in this field there is practically nothing produced in Canada. Promising developments in feature films Canadian in character are taking place in Quebec; but English-speaking audiences are still exposed to strange Hollywood versions of a Canada they never thought or wished to see.'[81]

Turning from the mass media, the commissioners addressed with more optimism the assortment of federal institutions that functioned (or were intended to function) as custodians of Canada's material culture. They started with one that was of particular interest to Massey – the National Gallery of Canada.[82] Their report noted with satisfaction the gallery's energetic outreach work, through travelling exhibitions, art reproductions, radio broadcasts, and films. With reference to its promotion of Canadian art abroad, it commended specifically the *Century of Canadian Art* in 1938 at the Tate Gallery in London, in which Massey had had such a stake. Drawing on some seventy briefs that addressed the gallery's status, the commissioners made a persuasive case for the extension and elaboration of its services across the country. However, only six galleries had the professional staff and physical conditions to host art exhibitions. There were no provincially supported art galleries. The National Gallery of Canada's own funding, facilities, and staffing were drastically inadequate. The commissioners recommended that plans proceed for a new building and urged a significant increase in staffing, in order to accom-

modate the growing education and extension demands being made of the gallery.[83]

They also recommended a realignment of the gallery's relation with government. Noting that its control had been increasingly brought under the Department of Public Works, specifically the deputy minister, who had little knowledge of and little sympathy for its functions, they argued that the gallery's board should report directly to cabinet, as did the Dominion archivist. While remaining accountable to Parliament and having more presence at the top decision-making level, the gallery would gain greater autonomy. In principle, only major issues warranted cabinet attention, and the gallery would be better able to make decisions based on quality and service rather than on political expediency. The commissioners also proposed making the gallery's board more representative of the entire country by increasing its membership from five to nine.[84]

Inadequate physical plant and lack of trained staff were endemic to the national collections. Little had improved in the almost twenty years since the Miers and Markham report on Canadian museums. The Massey commissioners were alarmed by the loss and destruction of irreplaceable museum material every year reported across the country. Moreover, there was a lack of legal protection for material of national historical significance leaving the country. The commission called for separation of the history and natural-history collections and for creation of a Canadian Historical Museum. Like the National Museum (now proposed to be the Canadian Museum of Natural History) and the National Gallery, along with a proposed Canadian Museum of Science, the Canadian Museum of History would be controlled by a non-governmental board reporting directly to cabinet. Its employees and administration would thus be completely separate from the civil service, in recognition of its specialized functions.

The circumstances of the federal libraries were, if possible, even more calamitous. The commissioners reported with shame: 'it has been mentioned that Canada is the only civilized country in the world lacking a national library.' Equally demoralizing was their report's finding that 'good collections of Canadiana are rare in Canada'; the best three were located in the United States. Such facts illuminated the depth of Canada's heavily colonialized cultural status. Commenting on the local public library as a key institution of education and culture, the report pointed to the outside help responsible for the development of regional library systems in Canada. Grants from the Carnegie Corporation in the 1930s

had established such a system in the Fraser Valley of British Columbia. The entire library service in Prince Edward Island was indebted to the same source. Meanwhile, the commissioners estimated that a mere 7 to 10 per cent of rural Canada had library services, compared to 5 per cent a decade earlier. A project to microfilm old and rare Canadian newspapers was proceeding only as a result of a grant from the Rockefeller Foundation.

The commissioners' recommendations were fundamental: 'that a National Library be established without delay; that a librarian be appointed as soon as possible,' and that proper fireproof facilities accommodate the national collections of books. They urged an amendment to the Copyright Act requiring that two copies of any book published in Canada be deposited at the National Library and that the librarian and board be authorized to assemble through purchase and gift a complete collection of the books published in Canada. Further, they recommended that the library add music in all forms to its collection. In order that the collection be accessible, they encouraged the establishment of a microfilm service.[85]

The state of the national archival collection was almost as dismal, and the report was positively damning of its neglect. The recovery and writing of Canada's history were, of course, among Massey's most passionate concerns as a nationalist. The commissioners reported that virtually no improvement had been made in the archives since the Royal Commission on Public Records of 1912, which had found national record-keeping in disarray. The report could not even quantify the extent of the holdings or their condition, neglect was so endemic. While there are many today who are critical of efforts to transform the state into a custodian of national cultural well-being, it is difficult to repudiate government involvement in areas so basic as these to a country's self-preservation.

Systematic preservation and retrieval of records required a professionalized staff. As Massey and his colleagues pointed out, of the more than thirty people then engaged in professional archival work in the federal government, more than half had less than a high school education. The commissioners were equally appalled by the state of public record-keeping in the provinces, where, in several instances, records had no legal protection and could be destroyed indiscriminately. Some provinces, they noted, were more historically minded than others; Nova Scotia, Quebec, Ontario, and British Columbia had provided adequate facilities for the housing of records, while the others had made little or

no systematic provision for the collection and deposit of archival material.

They commented, too, on the range of materials that needed to be preserved, quoting from one of their briefs: 'The historian of today, and his allies in the fields of political science, sociology, economics and anthropology, are interested in the activities of all people, and not merely those of their political and military leaders. In a democratic society this interest can be expected to increase.' Noting 'the very close relationship which exists between standards of historical scholarship and national policy,' the commission considered 'that the public interest is best served by a liberal policy in the matter of access by historians to public records. ... Without unlimited opportunities for research in the country's modern records the historian cannot render our society and our culture the highest service of which he is capable.' The commissioners also permitted themselves to comment on the role of the historian: 'Many people lament the comparative lack of scholarly readable books about our country, its history and its traditions. It has been suggested that Canadian historians, in spite of some recent and welcome publications, have not yet bridged the gap between the area of scholarly research and the ground on which they can meet the common reader.'[86] Such a statement was characteristic of Massey's ongoing effort to demystify education and make learning widely accessible.

Closely related to the commission's concern for documenting Canada's histories through the preservation of written records was the federal government's management of historic sites and monuments, usually consisting of no more than the mounting of a commemorative plaque. The report called for immediate steps to arrest the deterioration of the Halifax Citadel. It singled out Fort Henry at Kingston, Ontario, as one of very few restoration successes. Above all, it argued for greater autonomy for the Historic Sites and Monuments Board, wider representation from across Canada, and professionalization of staffing and board membership. The commissioners urged that historic sites, then under the care of the Department of National Defence, be transferred to the National Parks Service, which followed proper curatorial practice and grasped its budgetary requirements.

Thus with respect to the federal cultural institutions that it surveyed, the commission's recommendations were fundamental: providing adequate physical plant, professionalizing staff, and achieving greater autonomy from the civil service and wider representation on the boards from across Canada. All of this, of course, was aimed at expanding and

strengthening the mandate and presence of these institutions and rendering them more effective. More simply, it was about bringing them into the twentieth century, their neglect was so fundamental and endemic, and about pressing the government of Canada to assume some of its most basic duties of nationhood. As Massey wrote in his memoirs over a decade later: 'We Canadians are in no danger of narrow nationalism; our peril is to be too little conscious of our own identity, too little given to understanding and preserving it.'[87] With respect to the federal museums, library, and archives at least, the accusations of elitism and a propensity for over-centralization that have been levelled at the commission are clearly unwarranted. Its recommendations were more in the nature of beginning to fill a void.

At the outset, the commissioners had committed themselves to addressing informal education alone, but they gradually changed their minds. The only exception to this in their original terms of reference was a mandate to review the system of scholarships awarded to researchers by government departments and agencies – notably the National Research Council. The commissioners soon became convinced, however, that it was impossible to ignore formal education, at least at the university level, if they were to honour their vision of their mandate. As their report neared readiness, Massey wrote on 15 September 1950 to fellow commissioner Larry MacKenzie, who strongly favoured federal aid to the universities: 'You will remember that at our sessions we agreed that it would be difficult to recommend Federal Aid to Universities although we arrived at the conclusion that we could, with propriety, recommend the expenditure of Federal money for all forms of scholarships in higher education, including under-graduate scholarships. Miss Neatby and I have come to the conclusion that we can and should recommend Federal Aid to Universities in the Faculties of Liberal Arts, that is to say, for their work which lies outside the professional schools. To neglect the humanities would be to leave out the key stone of the cultural arch with which we are concerned.'[88]

In view of Massey's deep faith in the humanities as 'the key stone of the cultural arch' (not to minimize the convictions of his colleagues in this regard), it would have been more surprising had the commission not found a means of overcoming the strictures against federal involvement in formal education. While they would undoubtedly have been more than happy to address the role of the humanities at the elementary- and secondary-school level, had provincial jurisdiction allowed it,

they confined themselves to the university, partly because they could make a more convincing plea for its national role.

The commission proceeded to make a thoroughly argued case for the universities place in the nation's cultural life. It pointed to their role in the local community's 'general culture' – that is, in adult education and as a patron of the arts, letters, and sciences. By drawing students from across the country, the universities also functioned as a national communications network. They were as well the nation's major sites of scientific research. Industry in Canada lagged behind in both pure and applied research because, as the commissioners found, so many firms were branches of American and British businesses and primary research took place generally at head office. Finally, universities had recently become significant recruiting territory for the public service, propelling its professionalization. Therefore universities were of central national concern and warranted national attention – in 'probably no civilized country in the world ... [is] dependence on the universities in the cultural field so great as in Canada.'[89]

Of particular interest to the commissioners was 'the plight of the humanities' – their devalued role in relation to engineering, medicine, and science. The report provided statistics demonstrating that the humanities had become 'poor relations' in terms of both faculty salaries and numbers of appointments. Not only were they shrinking in importance with the advance of 'the mechanical and utilitarian tendencies of the past generation or two,' they themselves were changing. As Massey had argued in his speech to the American Association of Museums in Quebec City in May 1947, the classics were being taken over by the philologist, history was becoming a branch of sociology, and philosophy was giving way to psychology.

Of course, 'the plight of the humanities' was only one symptom of the larger problem – lack of financial support for universities. 'Falling revenues and rising costs' threatened to prevent them from being (quoting from a submission) 'nurseries of a truly Canadian civilization and culture.' 'Canada's future cultural development depends primarily upon the availability of higher education for her young people,' the commissioners wrote; 'the more students with ability who receive such education, the wider will be the scope and variety of Canada's cultural possibilities.' This elitist emphasis on the university as the primary conduit of culture obviously had Massey's concurrence as chair, but it was not a sentiment characterisic of his earlier prose. In *On Being Canadian*, for example, he made no special case for universities. Hilda Neatby was

the commissioner who most valued the university's role in Canadian society. Moreover, three of the commissioners – Lévesque, MacKenzie, and Neatby – were academics.

Dwelling on Canada's unfavourable statistics in relation to other countries' financial assistance to university students, the commissioners proceeded to recommend an array of enhanced and enlarged scholarships at the undergraduate, graduate, and postgraduate levels. At the risk of deeply alienating the Quebec government, they also proposed that the federal government provide direct aid to the universities – that is, 'make annual contributions to support the work of the universities on the basis of the population of each of the provinces of Canada.' While this constituted significant federal encroachment, the proposal was generally welcomed for filling a desperate need that no other level of government or the private sector was ready to address.

A chapter running to over sixty pages, the report's longest, dealt with the fine arts. The commissioners had stated in their introduction: 'We were conscious of a prevailing hunger existing throughout the country for a fuller measure of what the writer, the artist and the musician could give.'[90] And while they had made periodic reference to the arts in their intervening chapters, they now addressed squarely the situation facing artists and art in Canada. Of all the commissioners, of course, Massey was by far the best equipped to assess and articulate the interests of the artistic communities in Canada. The Massey Report was a testimonial to the transformation in his valuation of the fine arts since his early career.

The report quoted from the brief of the Canadian Arts Council, an organization formed in 1945 and an extension of the lobbying effort by artists' groups that had banded together to present a brief to the Turgeon Committee (on reconstruction) in May 1944. The council, representing some 10,000 members, was an umbrella group for eighteen arts organizations, including the Dominion Drama Festival, La Société des Écrivains Canadiens, the Royal Canadian Academy of the Arts, the Canadian Society of Landscape Architects and Town Planners, and the Arts and Letters Club of Toronto.

Its brief opened with a dramatic passage that Massey had marked in his own copy and which was quoted in the Massey Report:

No novelist, poet, short story writer, historian, biographer, or other writer of non-technical books can make even a modestly comfortable living by selling his work in Canada.

No composer of music can live at all on what Canada pays him for his compositions.

Apart from radio drama, no playwright, and only a few actors and producers, can live by working in the theatre in Canada.

Few painters and sculptors, outside the fields of commercial art and teaching, can live by the sale of their work in Canada.[91]

The commissioners proceeded to review the status of the various artistic disciplines. They applauded and celebrated the many promising signs of activity in each, while emphasizing the universally dismal level of support. They began their survey with music, the art form with pride of place among Protestant Canadians. They noted the tremendous increase in interest in the previous twenty-five years, including in 'serious music,' which received most of their attention. Symptomatic of this growing interest was the number of music festivals, numbering almost one hundred annually across the country. Yet Canada had no written history of its music, no library of music, only limited opportunity for advanced study in music, and a sad deficiency in appropriate settings for performance. Furthermore, concert stages were dominated by performers sent by influential American concert agencies. The litany of underdeveloped and colonialized artistic supports seemed endless.

The commissioners traced an even more bluntly inadequate situation in theatre: 'In Canada there is nothing comparable, whether in play-production or in writing for the theatre, to what is going in other countries with which we should like to claim intellectual kinship and cultural equality.' While there was no lack of talent, there was little encouragement. Advanced training in theatre was said to be non-existent; and 'except in the few largest centres, professional theatre is moribund in Canada.' The only significant employer in either music or drama was the CBC. The commission tackled the proposal for a national theatre in Canada but warned of 'the dangers inherent in attempting to establish and to operate an agency for the advancement of national culture directly under government control.' Without safeguards, such a theatre would be vulnerable at every election, and high-quality work would be impossible.[92] Theatre was at a critical moment, the commissioners argued, and required careful assessment. As they were soon to emphasize, government support was possible without direct government control.

The commissioners looked briefly at ballet, sculpture, architecture, painting, and crafts. They commended the work of Marius Barbeau and the National Museum in documenting Native, French-Canadian, and

English-Canadian folk songs, stories, dances, and myths, but bemoaned the widespread ignorance of Canadian folklore, which, while regional in nature, was of general interest and a source of national community. In particular, the commissioners pointed to the widespread ignorance of Native artistic traditions among Canadians of non-Native descent and among Native peoples themselves. They did not accept the widespread belief that Native cultures were vanishing and that their arts should be preserved merely as a record of the past. Despite referring to the 'integration' of Native peoples into Canadian society and making other Eurocentric assumptions, they argued strenuously for the encouragement of Native art and craft production. They were critical of the federal Indian Affairs Branch for its lack of support for Native art and maintained that arts and crafts should be understood as an essential part of Native education. They adopted a suggestion from one of their briefs for a Canadian Council of Amerindian Studies and Welfare. They concluded: 'it is no act of patronizing charity to encourage a revival of the activities of those who throughout our history have maintained craftsmanship at the level of an art.'[93] They at least came close to abandoning the placement of Native cultural formations within the hierarchy of craft and art.

On painting, while the commissioners acknowledged the successes of the Group of Seven and of recent work in Quebec, they argued that 'painting in Canada is not yet fully accepted as a necessary part of the general culture of the country.' A concern that deeply informed the commission's recommendations for state support of culture was expressed by the Federation of Canadian Artists: 'The arts must not be dominated, regimented or exploited to serve special or narrow ends; they are an unfolding and evolving expression of the inner consciousness of the individual or society.'[94] This belief in the autonomy of the arts – that an art form, to have integrity, must not be the servant of propaganda – was a notion that Massey had wrestled with since at least the 1920s and accepted, only with significant modification. While against art that preached, he recognized full well the ideological function of art. The challenge was to enlist its support without subjugating it. A belief that this was possible underlay the commission's single most important recommendation: the creation of a funding body, the Canada Council for the Encouragement of the Arts, Letters, Humanities, and Social Sciences.

In the introduction to their report, the Massey commissioners had targeted two of the chief challenges to state participation in culture: 'First, how can government aid be given to projects in the field of the arts

and letters without stifling efforts which must spring from the desires of the peoples themselves? Secondly, how can this aid be given consistently with our federal structure and in harmony with our diversities?' The commissioners were careful not to imply that such a council would stifle or supplant the wellspring of initiative and creative energy that volunteerism had exhibited. For one thing, the taxpayer was not going to be asked to bear the full brunt of this expense. However, as the commission pointed out, only five learned or cultural organizations then received federal subsidies, totalling a mere $21,000 – 'a completely inadequate reflection of public interest in the field of arts and letters.' More bluntly, it stated: 'If we in Canada are to have a more plentiful and better cultural fare, we must pay for it.'

The report pointed out that Alberta and Saskatchewan had already established arts boards, and it looked to models in other countries. In many instances, state support of culture took the form of a ministry of national education or a ministry of cultural affairs. Such a solution was 'constitutionally impossible or undesirable' in Canada, and for this and other reasons the commissioners adamantly opposed creation of a ministry of fine arts and cultural affairs, echoing Massey in *On Being Canadian*. The model that they considered most appropriate, and which they claimed was most consistent with the general desire of those who had made submissions to them, was a modified version of the Arts Council of Great Britain.

They recounted the circumstances of its creation and early history. Massey might have been speaking from personal experience: 'On the outbreak of war in 1939, with blackout conditions and shiftings of the population, the prospects of the arts and of artists were seriously affected. Theatres and art galleries were closed, concerts could not be held, but at the same time there arose a great demand for the stimulus and relaxation which only the arts can give. Those who had known such things felt their loss keenly; others who had never heard fine music or visited a theatre or looked at original paintings became aware of what they had missed.'[95] In response to the demand, the Massey Report continued, the Council for the Encouragement of Music and the Arts (later the Arts Council of Great Britain) was created.

The commissioners quoted a 1945 broadcast by John Maynard Keynes, then chair of the council: 'I do not believe it is yet realized what an important thing has happened. State patronage of the arts has crept in. It has happened in a very English, informal, unostentatious way, half baked if you like.' What he referred to as a 'semi-independent body' had

been set up to support private or local initiatives in the arts. He added: 'The task of an official body is not to teach or to censor, but to give courage, confidence and opportunity.'[96] Here, in quoting such a passage, was evidence of the enormous change in Massey's attitudes towards the fine arts. He too had long subscribed to a non-propagandistic use of the arts, but he had invariably framed it in an educational context. In the Massey Report, by contrast, he seemed resolved that the arts were truly deserving of recognition in their own right. Of course, underpinning this recognition was the belief that the fine arts, like the liberal arts, were of value within the framework of citizenship and national identity.

The Massey commissioners were also interested in Britain's second arts agency, the British Council, founded to project British culture abroad.[97] But rather than proposing two separate bodies for Canada, the Massey Commission recommended one funding agency for both domestic and foreign initiatives in the arts and letters. It stated: 'The encouragement of the arts and letters in this country, we believe, cannot be dissociated from our cultural relationships with countries abroad.' This itself was a telling assumption, but not immediately explained. Elsewhere it added: 'we are convinced that, in our country particularly, encouragement of these studies [the humanities and social sciences] must be carried on to a considerable extent through international exchanges, and through closer contacts with France, Great Britain and with other European countries where traditionally they are held in great respect.' In other words, by advocating that internal and external cultural support be amalgamated, the report betrayed an assumption that Canada was too immature or too vulnerable to American domination to protect its culture alone. Internationalism, still very Eurocentred and grounded in a faith in the humanities, was believed to be an essential buttress to Canadian sovereignty.

The whole business of the 'cultural projection of Canada' was a key concern of the commissioners. Canada's cultural export had been extremely limited and scattered. The new Canada Council would be in a position to spearhead and coordinate a wide range of cultural initiatives and exchanges commensurate with Canada's place as a growing international presence. In the area of cultural projection, too, the commissioners emphasized autonomy, praising the British Council for maintaining a degree of freedom from political interference. They cautioned, for example, the National Film Board, a primary source of exported information about Canada, against sending films that attempted to persuade foreign audiences of the virtues of the Canadian way of life.[98]

Having argued Canada's need for multilateral cultural alliances, the commission turned to the mechanics of constituting an arts council for Canada, such that it would enjoy a measure of autonomy from governmental interference. 'We should ... consider it a misfortune if this Canada Council became in any sense a department of government, but we realize that since this body will be spending public money it must be in an effective manner responsible to the Government and hence to Parliament.' The report recommended that the Canada Council have fifteen members, all appointed by an order-in-council of the federal cabinet. The positions of chair and vice-chair should be full-time appointments, while the other members would receive only reimbursement for travelling expenses and a per diem while engaged in council business. Officers of the federal government should not sit as members, and the council should 'be properly representative of the cultures and of the various regions of Canada.'

The commissioners rejected a suggestion from Canadian artists and writers that such a council be representative of their professional organizations. This they judged to be too partisan. They added: 'This is not to say, however, that a Canadian artist, a Canadian musician, a Canadian writer, or a Canadian scholar should not serve on the Council; if he does, however, he should sit in his capacity as a distinguished and public-spirited Canadian citizen.' They also ruled out a separate council for the humanities and social sciences, modelled on the National Research Council, as had been suggested in some submissions, on the grounds that this would further isolate the liberal arts. Finally, following the example of the use of expert advisory committees by the Arts Council of Great Britain and the British Council, the commissioners recommended: 'For its complex and disparate duties we should imagine that the Canada Council would find it advisable to establish permanent committees on which the members would sit in accordance with their special experience and interests.'[99] This, they argued, would enhance the council's capacity to honour quality and minimize (if not overcome) political partisanship

The agency that they were proposing thus embodied a host of mechanisms now generally grouped together under the rubric of 'the arm's-length principle.'[100] When the Canada Council was finally created in 1957, along the structural and administrative lines that the Massey Report recommended, it would entrench many features of this principle. The council's creation was precipitated by the windfall estate taxes collected by the federal government as a result of the death of two Cana-

dian millionaires. These taxes yielded an endowment for the Canada Council amounting to $50 million, giving it an added measure of early autonomy. Subsequently, as its success grew and it had to rely increasingly on parliamentary appropriations, the council found its independence under constant threat of erosion. Today, of course, government support of culture has become highly vulnerable to partisanship, for cultural issues are managed not by one but by two government departments – Canadian Heritage, which includes among its responsibilities what is now called the Canada Council for the Arts, and Industry Canada. Various government schemes to earmark funds for specific programs and an increasing emphasis on partnerships between the public and the private sector have also drastically reduced the autonomy of artistic support systems. Nevertheless, while in continuing danger from the very forces that Massey and his colleagues sought to thwart, the arm's-length principle remains a touchstone of Canadian cultural policy. It belongs among such planks of liberal democracy as the rule of law, academic and religious freedom, and freedom of the press.

While the arm's-length principle of arts funding has been widely recognized for its restraint of political interference and state sloganism, facets of its construction are worth underscoring. Removing political exigency as the guiding force for choice requires the substitution of other criteria. One of these, for the Massey Report, was the principle of excellence. Excellence was the means by which to transcend partisanship and find unity within difference. Everyone, in theory, could aspire to excellence, regardless of their ethnic or regional background, their gender or class.

In a sense, this is a denial of difference, a seeming unwillingness to admit more than one standard, to endorse a multiplicity of perspectives. Excellence can quickly become its own tyranny. By definition, it presumes a hierarchy of value and a certain exclusivity. Moreover, excellence, behind the pretext of impartiality, hosts all manner of biases.[101] Yet as we have observed in the process of cataloguing the paradoxes of Massey's thought, excellence may also be understood to enable difference. Simply acknowledging a hierarchy of complexity or sophistication in a sense constitutes a denial of mundaneness and a means of preserving variety. When the principle of excellence is allowed to override political expediency, moreover, minorities are conceivably protected from the political majority. If, as Lawren Harris argued, creativity is predicated on diversity, then recognizing excellence may be especially important in the artistic field. Excellence keeps artistic production at one remove

from the effacement of alternative voices that is commonly perpetrated in the name of commercial efficacy. The notion of quality provides at least some protection from the behemothic swagger of unfettered economic will.

While the quest for quality is often equated with exclusivity, in Massey's value system excellence and democratization went hand in glove. By seeking to supplant the political motif with the aesthetic, by attempting to substitute standards of quality for political bias and self-interest, Massey and his fellow commissioners were seeking to affirm and elaborate government as a moral construction that honoured inclusion. Indeed, they helped to entrench a moral imperative that had a complex history in the Canadian mindscape and was gaining momentum in social practice: a moderation of popular – that is, majority – will, in the name of accommodating alternative voices. In keeping with Massey's long-standing resistance to homogenization and standardization, his reliance on excellence in conceptualizing arm's-length government support of the arts put a critical distance between the majority and minorities, hampering the former's domination of the latter. In essence, the arm's-length principle embedded a paradox of exclusion and inclusion: a commitment to excellence and diversity, each an antidote to conformism and together an anchor for a multifocal society.

The Massey Report of 1951 proved to be the last and most momentous in a series of sweeping reviews of cultural matters chaired or guided by Vincent Massey, starting with the Methodist commission on schools in 1919. The 1951 report, while a complex document, reflective of a wide spectrum of concerns and worthy of study from a range of viewpoints, must be acknowledged to belong to the tremendous continuity, ambiguity, and transformation in the thought of Vincent Massey. Whether this valorizes or discredits him or, I hope, sheds light on Canadian cultural discourses more broadly, the final Massey Report made countless references to his earlier career. This was true with regard both to his wide-ranging experience in education and the arts and to the ideological position from which he mounted his cultural campaign.

Massey's promotion of a fully-rounded national life – that is, cultural as well as economic – had been driven initially by fears of Canadian sectionalism, but was inspired increasingly by apprehensions over American imperialism. It is abundantly clear that he came to view Canada's regional and ethnic diversity as a source of strength. There were other transformations in his thought, as evidenced in the Massey Report of

1951 – most significantly, his now-resounding endorsement of the fine arts and mass media as purveyors of culture and his increasing reliance on state support of culture, always in concert with volunteer, local, amateur, and private initiatives, and always, of course, at arm's length.

Massey's personal convictions about the arm's-length principle of government arts funding formed part of a discourse of autonomy – be it individual, national, or artistic – that preoccupied him throughout his life. In Massey's value system, however, the concern for autonomy had been unfailingly blunted by a deep appreciation of the need for collective action and a sense of community. Ultimately, Massey's life enterprise seems to have turned on a profound dichotomy of engagement and detachment. It was this hybrid that informed and structured the role that he envisioned for culture. In the absence of an unequivocal commitment to its culture – a commitment that honoured both accessibility and excellence, autonomy and diversity – Canada played host to profound contradictions in self-directedness and self-actualization, betraying its continuing colonialization. Only a well-developed, well-rounded national life – fully cognizant of its culture and strongly supported, but not controlled, by the state – ensured the sovereignty of Canada.

Conclusion:
The Force of Culture

Vincent Massey liked to use the expression 'the force(s) of geography.' He employed it first in the early 1920s; it reappeared in *On Being Canadian* in 1948 and again in the Massey Report in 1951. The phrase characterized the unique predicament of Canadian sovereignty, which Massey envisioned above all as the surmounting of physical obstacles. He was fully cognizant of Canada's wealth and exploitability as a resource-rich nation, its geographical affinities with the United States, and its history of colonialism. As counterweight to its immense vulnerability to geographical and material pressures, he invoked the force of culture. Only by recognizing and supporting its cultural – i.e., intellectual, moral, spiritual, and aesthetic – life could Canada survive as a community and nation.

As this study has endeavoured to illuminate, Massey's model of culture was deeply indebted to a transformation in late-nineteenth- and early-twentieth-century Methodist thought – that is, the emergence of what might be called the 'education gospel.' Education – specifically in the liberal arts – became Massey's panacea and early in his career was a virtual synonym for culture. It was the liberal arts, as distinct from purely technical or professional training, that rendered an education cultural.

The stated goal of such an education was the development of character. The notion of character encompassed at least four key elements. First, the whole person, intellectually and morally, became engaged in the educational process. This concept emerged from a humanistic faith in the individual's trustworthiness as a site of reasonablenes and goodness. Second, 'character' discourse signified a campaign against conformity, repelling 'undesirable' belief systems, whether emanating from American consumer society, the communist Soviet Union, or fascist

regimes. Fostering uniqueness was also essential to the humanistic mission of staving off the standardization of encroaching mass society. Third, 'character' (interchangeable today perhaps with autonomy, distinctiveness, or identity) was frequently aligned with virility and manliness, and juxtaposed with effeminacy, or an inability to withstand the crushing forces of homogenization. Fourth, character education came to connote a commitment to sustaining a diversity of beliefs. When this meaning crystallized remains unclear, but it had long been latent in the liberal arts tradition and had currency by the 1920s. It was widely understood that the breadth fostered by a liberal arts education bred tolerance for diversity and in turn societal harmony.[1] One manifestation in Canada was the growing practice of bilingual and multilingual study in schools by the early twentieth century. This strand of character's layered meaning had particular resonance for Massey.

Character education became integrally linked to citizenship. National character and citizenship became refrains in Canada during the 1920s. The notion of the citizen was still vague, as to both duties and rights, and was certainly far removed from the codified entitlements set out in the Charter of Rights and Freedoms of 1982. None the less, the idea of citizenship in the 1920s actively engaged an emerging sense of national, as opposed to colonial, identity – a process intensified in the wake of Canada's distinguished role in the First World War. The task at hand was to envision fully and to resolve Canadian sovereignty. This endeavour involved planting a number of signposts of Canadian identity and entailed a migration of the moral function from the predominantly individual realm to the domain of the state. Complex, multifaceted, and protracted, this process, which appears to have dated from the early nineteenth century,[2] gained momentum in the 1920s. As Sir Robert Falconer argued in 1919, the state was not an amoral, but a moral entity.[3] Grappling with how to realize such a conception of the state was a significant enterprise of the interwar years and would reach large-scale implementation only during and after the Second World War, as Ottawa became more demonstrative in the social and cultural sectors.

Massey was thus heir to the idea of culture as an education in the liberal arts aimed at fostering national character and citizenship, and it underpinned his entire career. He became deeply engaged in the project to convert individual to national character, to transform personal autonomy into collective sovereignty. The well-roundedness of a liberal arts education became for him the model of a nation. True sovereignty

entailed not only material comfort, but the development of a 'fully-rounded national life.'[4] Only then would Canada have the vigour (or virility or character) to surmount fully its colonial past and withstand the neocolonializing forces ahead.

While Massey has long been recognized for his support of the fine arts, I have shown here that they were little more than frills in his cultural enterprise until the later 1920s. The fine arts were slow to garner acceptance in mainstream Canada generally. While welcomed more by Roman Catholicism than by Protestantism, visual art only slowly divorced itself from morality, in the sense of literal, moralizing content or a Ruskin-style labour-intensiveness. The doctrine of art for art's sake, gaining ground in France and England during the 1870s, long had a tenuous hold in Canada. The vast majority of Canadians as Christians viewed the performing arts, except choral and organ music, with moral suspicion well into the twentieth century. They considered professional theatre downright profligate. As a consequence, they downplayed art's role as a cultural force. Many also regarded art with condescension as a female, amateur, and domestic preoccupation. The fine arts smacked of a refinement that was a threat to the vibrancy of a young nation and rendered it less able to resist the homogenizing influences of mass society, materialism, and colonialism.

The educational agenda of Canadian Methodism, under the influence of the Chautauqua model, helped to transform attitudes towards the fine arts. Here life was not so hierarchical. It was not divided so clearly into the sacred and secular realms; on the contrary, all was sacred. The fine arts took their place under a great sacred canopy. This model enveloped art within education and enlisted it to the cause of banishing idleness and fostering the constructive use of leisure. Art was sanctioned on the condition that its explicit meaning served an overtly moralizing function.

Massey's views were indebted to the democratizing, inclusive vision of his Methodist heritage and its enfolding of the arts in the education gospel. However, he came to view Puritanism (which he equated with Methodism) as the main culprit in the suppression of art's grander purpose. He firmly rejected art that sermonized or propagandized but became convinced of art's underlying moral and cultural purpose as an agent in the construction of national community. His model of national community for Canada, which came to rely on fine art as one of its

pillars, rested on balancing the principles of detachment and engagement, sovereignty and a multifocal collectivity.

The arts had acquired some legitimacy in Canada in the service of nationalism during the late 1870s and the 1880s. The Marquis of Lorne, governor general 1878–83 and founder of the Royal Canadian Academy of Arts and the National Gallery of Canada in 1880, clearly linked art and nationality. Lorne's Canadian cultural nationalism engaged both the early mystique of northern virility and the rhetoric of imperial expansion.[5] By the 1920s, with the self-proclaimed nation-building art of the Group of Seven, visual art achieved more widespread validation, and the arts began to figure prominently in ideas about the role of culture. Contemporary language about the group and its work was riddled with references to vitality and virility, associations that helped overcome the bias against art as effeminate.[6] The Group of Seven and Tom Thomson were campers and canoeists; they painted the wilderness, and they did so in a bold, forceful, and uncompromising style that offered assurances about the fine arts not being overly refined.

The group also validated the national (as opposed to international) function of art. Like Massey, his close associate and friend Lawren Harris was haunted by the spectre of conformism, whether emanating from totalitarian regimes, from mass production and consumer society, or from British and American imperialism. Heavily influenced by Walt Whitman's belief that one had to imbibe the immediate environment deeply in order to glimpse the universal, Harris adhered to the idea that Canada's local character resided in its northerliness, which he and his colleagues essentialized as a source of insight, spirituality, and creativity. A key tenet of Harris's scheme of art was the interrelation of diversity, creativity, and sovereignty. Massey relied on Harris's efforts to theorize diversity, but while Harris vested environmental diversity with extraordinary authority as a means of overcoming sectional difference, Massey was concerned more with regional and ethnic diversity as sources of Canadian sovereignty. Early on, Massey had identified sectionalism as the major obstacle to national identity, but as the threat of American influence mounted, he increasingly stressed Canada's diverse ethnic and regional character in the campaign to resist conformism and imperialism.

Moreover, unlike Harris, who rejected connections with Europe as outmoded, Massey argued that history as much as or more than geography had a role to play in securing Canadian autonomy. Particularly with Britain, Canada shared a humanism and commitment to public life that Massey admired and believed distinguished it from a more purely capi-

talistic society. Multilateral relationships, along with internal diversity, were anchors of his nationalizing agenda.

In his campaign for cultural sovereignty, Massey was acutely sensitive to Canada's difficulties in experiencing community. Aside from recognizing the geographical and climatic conditions that made habitation, let alone community-building, tenuous, he was deeply aware that Canada was becoming a transcontinental nation at a time when local community was suffering the inroads of mass society. Canada was obliged to reckon with issues of mass society before achieving any particular resolution of its local character (if a country of these proportions ever can). Massey recognized the opportunities offered by mass society – its new nuclei and structures of power and knowledge and its new means of communicating ideas, be they universal education, broadcasting, film, or the travelling art exhibition. Indeed, these mechanisms helped as much as hindered Canada's quest for nationhood. But he also recognized the costs of mass society – losses of identity, of community, of diversity. Indebted to his Methodist background, he adhered to the view that culture was the source of community and identity and kept alive the hope that life was more than a material, mundane, even sordid, solitary existence. Culture promised the almost-sacred sense of community that he believed validated life, rendering social cohesiveness and national sovereignty a spiritual trust.

It is perhaps useful here to consider Massey's position in the political spectrum. A liberal democrat from a wealthy, well-connected family with a vested interest in the economic status quo, he none the less sought to counter what he perceived to be the excesses of liberal democracy and pure capitalism, including unbridled individualism, consumerism, materialism, technological fetishism, mass production, homogeneity, lack of community, and mundanity. Coming from a Methodist background, he believed deeply in the forces of progress and in the possibility of creating a utopian kingdom on earth, both inclusive and elevated. While Canadian Methodism embraced a wide spectrum of political positions, from reactionary to progressive, by the early twentieth century it was clearly at the forefront of the social gospel movement and played a forceful democratizing, while Christianizing, role. The Masseys, as a family, belonged to the more progressive constituency of the Methodist church.

Officially, Massey was a Liberal. He served briefly in the federal cabinet in 1925, ran for Parliament (unsuccessfully) at that time, and served as president of the National Liberal Federation (1932–45). He was an admirer of Roosevelt's New Deal policies, recognizing the growing ap-

peal to the Canadian electorate of the Co-operative Commonwealth Federation (CCF) and believing that the Liberal Party would do well to embrace the welfare state.[7] Late in his career, he stated: 'I am one of those who would like to be remembered as a progressive.'[8] His challenge to the existing economic structure took the form of support for an enlarged public sector to manage the common good, framed in the context of cultural nationalism, but deeply interwoven with safeguards for personal and local autonomy.

It is necessary to comment on that highly suspect term 'nationalism.' Massey was unquestionably an agent for Canadian nationalism. How do we approach his stance as a nationalist, when the notion's virulent forms generally have so discredited the term in the twentieth century? There is no question that it continues to be often a rhetorical device of dubious value, a rallying cry for all means of self-serving deceptions. In Canada, as elsewhere, nationalism has sometimes descended into cheap sloganeering and been exploited to justify the scandalous confiscation of rights of minorities, notably of Canada's First Nations and of Japanese Canadians during the Second World War. Nevertheless, generally speaking, Canadian nationalism is a very different entity from nationalisms that are greedy, autocratic, monolithic, and combative. We might profitably situate it in the context of resistance theory.[9] Those who pride themselves on their transnationalism and denigrate Canadian nationalism as chauvinism may indeed mistake the matter. Nationalism in Canada is not characteristically an offensive thing; typically, it is not aimed at deflecting public attention away from so-called real issues such as health care, working conditions, and discrimination. Rather it might more accurately be viewed as defensive, deflecting some of the weight of superculture imperialism, as Canadians try to retain just enough sovereignty to make it possible to deal with the 'real' issues in a manner that is consistent with values that they claim to prize. Of course, the whole assumption that it is possible to discern and assign authority to any body of values that might be designated Canadian will always be problematic. But Canadians have achieved a measure of consensus about what they value, be it a public health care system or a desire not to carry guns. Further, it is difficult to accuse Canadian nationalism of being hegemonic, because it has always been so ill-defined. It is even unclear to what extent it has been aligned with elites – specifically the corporate, political, or intellectual elites. It clearly does have an identity, none the less, however contested and nebulous. This identity must be assessed critically, particularly with regard to its inclusiveness.

Massey, an affluent, Protestant, white male in a position of political influence, unquestionably legitimized and empowered a specific set of values by aligning them with nationalism. Were these values the product of consensus among Canada's citizens, or were they inflicted by Massey and a small coterie who were in a position of influence and sought to blunt internal differences?[10] To what extent was his quest for community merely a drive to co-opt opposition? In other words, did Massey abuse nationalism, and was he an elitist?

Massey's reputation has been dogged, certainly in recent years, by charges of elitism, not unlike the notion of culture itself. Maria Tippett has declared that 'he possessed an elitist vision of culture, one that made it accessible only to the educated and the well-informed.' She is correct that he was committed to the educated citizen, but to construe this as a symptom of elitism is to misunderstand his considerable populism.[11] The most sustained charge of elitism has come from Paul Litt in his 1992 book *The Muses, the Masses, and the Massey Commission*. He wrote: 'the cultural elite [typified by the Massey commissioners] liked to think that it spoke for the interests of all Canadians. ... This,' Litt declared flatly, 'was hogwash.' He accused the commission and, by implication, its chair of an assortment of elitist sins, among them of starting with a bias in favour of culture (hardly surprising), particularly a certain type of culture – that is, high art. Litt argued that the commissioners believed that certain disciplines were the storehouses of culture and did not appreciate fully the positive role of TV, radio, film, and the popular press. Litt appeared to align the commissioners with what he called 'the mass culture critics,' whom he described as 'simplistic, elitist, abstract, and moralistic' and engaged in a 'campaign against the culture of the crowd.'[12]

To view the major polarity in society as between elitism and populism may itself be simplistic. Nevertheless, the charges of elitism levelled against Massey beg to be sorted out, and somewhere in the complex marriage of elitism and populism in Massey's thought and practice we can perhaps locate some of the confusing attitudes of Canadians towards culture and the arts.

So much that might be said to be elitist can also be construed as populist. Liberalism has been called elitist, despite its claim to egalitarianism.[13] This is symptomatic of the muddle that seems to surround notions of elitism and populism. One problem is that the word 'elite' has become simply a bad word; Robert Fulford has called 'elite' 'the new scare word.'[14] To deny that the existence of elites is not widely endorsed in our society is patently dishonest. We are universally and perhaps

willingly governed by an elite of some sort. This is presumably because we are a society driven by the promise of betterment, be it material, social, or otherwise. We consider competition healthy. Improvement is our measure of things. Pervasively and deeply we esteem those who realize the good, the better, and the best, and we assign authority to them, be it the Olympic gold medallist or the Nobel Prize–winning scientist, be it those we endorse by opinion poll, by ballot, or by consumer dollar. The pursuit of excellence is in the nature of a moral imperative coursing through our society, moderated only by the also-compelling imperative for equality.

The more relevant issue may be deciding what kind of elite we want to tolerate. We need to distinguish between the hereditary elite and an elite of merit, between the exclusive elite and the consensual elite. Historically, elitists did not want to bother with the so-called masses, who, they assumed, lowered standards and were irrational and ignorant. One of the early arguments against democracy was that it bred mediocrity. Today, while we continue to empower elites, the elites of which we approve consist generally of experts (so-called or otherwise). The meritocracy is a pervasive structure, even though it jostles constantly with a still-rampant accumulation of privilege through cronyism.

Where the elitist trusts the authority of the few, the populist is guided by faith in the many. There, in the larger community, the populist believes, lies the source of vitality, renewal, authenticity, and, finally, truth. The most desirable model possible, under present societal circumstances, may be a mixture of the two – reciprocation and exchange between the elite and the larger community, rather than either the elite's dictating to the populace or the populace and the elite being galvanized into knee-jerk campaigns of mutual discreditation. Very simply, we seem to endorse elites, but we want them to remain in touch with and be guided by, in significant measure, the larger community. In short, we want them to transcend their own bias. We want the elite, which is advantageously situated to further its own interest, to transcend that interest. The challenge is to find mechanisms that safeguard that end.

Did Massey aspire to a consensual model or an exclusive model of culture? Was he committed to universal access to culture or, as Tippett claims, to a culture accessible only to the 'educated and well-informed'? The answer is that Massey advocated that everyone be 'educated and well-informed.' He honoured both intellectual and artistic quality and went to great lengths to advance universal access to its opportunities and

rewards. As he stated in 1923: 'education is everybody's business.'[15] Indeed, he viewed the viability and strength of a democracy as resting on an educated citizenry, not only on educated leaders.

But was this commitment to a community of educated citizens merely an effort to mould consent and co-opt opposition? It would be difficult to build a case against Massey on these grounds. Admittedly, integral to his concept of the ideal citizen was stability. However, such a citizen, in his view, was capable of resisting conformity and was tolerant of diversity. In assessing Massey's commitment to education, it is necessary to distinguish between education that indoctrinates and education that enables. The societal harmony that Massey sought was achieved not by dulling the so-called masses but by enabling a nation's citizenry. As he said on more than one occasion, it is ignorance, not hatred, that divides. While Massey was a masterful lobbyist and publicist and recognized education as the means to achieving societal stability, his consistent denunciation by words and actions of the use of education and art as propaganda is a critical corrective to the view that he was an unmitigated elitist, with an exclusively hierarchical view of society. This is not to deny that Massey was the promulgator of a very particular ideology; it is only to recognize that his ideology privileged personal autonomy, vesting faith in the individual regardless of class.

Furthermore, while Massey was acutely aware of the fragmentary and diverse nature of the Canadian population, rather than seeking to suppress that diversity, he prized it to a considerable degree. Relative to his time, his idea of community was complex. He was progressive in his view of Canada as a bicultural nation, which he espoused at least from the early 1920s. He was mindful of regional concerns, although he still had a considerable centralist bias. He was also sensitive to differences between urban and rural experience, as the Massey Report of 1951 makes evident.

As I noted above, however, his notion of a complex community was limited by both racial and gender biases. He assumed that northern races tended toward greater stability, and he clearly designated different roles to men and women. He remained resolutely opposed to co-education. At least early in his career, this was symptomatic of his concern that male character not be emasculated in the battle against standardization. He did endorse the inclusion of a woman, Hilda Neatby, on the Massey Commission, apparently as an acknowledgment of the role of women as volunteers in the arts and of the prominence of women artists (although Neatby was a history professor).[16] Once he had worked with Neatby, who

was a very active member of the commission and instrumental in the writing of its report, he accorded her significant recognition.[17] He later relied on her heavily as a speechwriter when he was governor general.[18] However, he insisted on secrecy concerning this arrangement. Was he uncomfortable because she was a woman? He had had male speechwriters earlier, under no particular shroud of secrecy. His commitment to community in the inspired realization of Hart House (and Massey College, completed 1963, also at the University of Toronto) showed complete insensitivity to the group needs of women. In this, the charge of exclusivity appears entirely just.

In short, his idea of a diverse community had major myopias, but it was far from monolithic and was consistent with, and even instrumental in, the construction of Canada as a pluralistic nation.[19] In *On Being Canadian* (1948), in a passage subtitled 'The Merits of Diversity,' Massey wrote with pride: 'we have plenty of colours and lights and shades in our make-up. Canada is no monochrome of uniformity.'[20] As early as 1926, as retiring president of the National Council of Education, he stated: 'Canada is a diversified country possessing different races, religions, social cultures. One hears this diversity often spoken of as a regrettable fact. Could anything be more fundamentally wrong?' He commended the council's efforts in helping Canadians 'to acquire a true understanding and tolerant respect for these precious contrasts in colours and differences in form with which our Dominion is endowed.'[21] The principle of diversity was crucial in protecting Canada from the many forces of conformism, not least American cultural and economic hegemony. While a privileged white male, he too felt some of the sting of otherness and marginalization as a member of a deeply colonialized state.

There remains the second charge of elitism against Massey, that he assigned more cultural worth to certain disciplines – that is, the 'high arts.' Ironically perhaps, early in his adult life he had esteemed the liberal arts and clearly devalued the fine arts, as the Massey Foundation Commission of 1919–21 made abundantly clear. But, by the time of the Massey Report of 1951, the fine arts had acquired legitimacy, even a certain pre-eminence, in their capacity to forge unity and community out of diversity. Massey and his fellow commissioners approached the popular arts with caution, it is true, especially as a pipeline for American culture. However, they treated that field as central to their mandate and report and focused on means of turning the mass media, especially broadcasting, to the so-called cultural cause. Admittedly, the documentary commanded far more of their attention than the feature film, which

they seemed to consider almost irretrievably lost to foreign, commercial interests. None the less, Massey and his colleagues recognized the media to be formidable forces and sought to secure some measure of domestic control by restructuring and enlarging government funding of the arts.

As for accusations that Massey tried to prescribe content, this is inconsistent with his long-held view that education and art that preached were anathema. A key tenet of his belief in the educated citizen was his conviction that it was possible to cultivate some degree of independent thought. The critical function, a product of self-awareness, was by extension presumed to remove one from self-interest in the quest for truth. It was there that the moral and intellectual functions so intertwined in Massey's thinking came to reside.[22] He sought a Canadian community composed of individuals who turned this disinterest towards the common good. This belief in the possibility of transcending bias lies behind such institutionalized notions as academic freedom in the university and the arm's-length policy of state support for culture. While bias is always present to a degree and needs to be named, these principles continue to have merit. Current cynicism regarding the pervasive presence of bias only illustrates the extent to which it continues to exercise contemporary thought.

The arm's-length principle, the keystone of Canadian cultural policy, however badly eroded today, rests on the belief that art must be supported without political interference or it descends into state sloganism. By its very nature, it is intended to prevent infliction of biases from above. The Canada Council, significantly a product of Massey's design, has had to an impressive degree a history of funding Canada's artistic counter-culture, whether the alternative, artist-run galleries across the country or artist's projects such as Image Bank in Vancouver (founded in 1970) or General Idea's *FILE Megazine* (founded in 1972). The arm's-length principle, it can be argued, helps keep alternative voices alive, and Massey deserves credit for helping to set Canada's cultural agencies on this course.

In short, to a substantial degree, though far from flawlessly, Massey promoted accessibility and a non-prescriptive, consensual, Canadian nationalism that accommodated diverse voices and diverse genres. This was perhaps the single most crucial transformation of the moral imperative in Canadian culture – the implanting of mechanisms in the foundation of Canadian cultural policy that attempted to counter the biases of political coteries and elites. The arm's-length principle was a means of resolving the 'high-minded' and the common. For authority and politi-

cal exigency, it substituted the principles of excellence and diversity. The hierarchy of quality can, of course, be just as repressive and exclusive as the tight grip of a political elite. But Massey's conception of culture partnered excellence with citizenship in a multifocal community. The high-minded and the inclusive, however paradoxically, resided together. Massey's notion of culture displayed elements of both elitism and populism.

Arguing for culture invariably placed Massey in a defensive position. He shared, even while challenging, the ambivalence that has bedevilled the subject in Canada. Whatever the fears and values that fuelled his anxiety and the resistance to culture's recognition more broadly, Massey understood the fight for Canadian sovereignty or identity as a struggle to secure its culture. He was concerned essentially with preserving enough freedom of action for Canadians not only to protect a certain corpus of values but to rearticulate them without undue pressure from outside. He sought to contain external influences at least to the extent that Canadian action was not reduced to the reflexes of a colony. Above all, his campaign to understand Canada as a cultural entity rested on his belief in a domestic tradition of humanism, one that emphasized personal autonomy, community, and diversity. His vision of culture privileged the humanities and later the fine arts; it validated the human capacity for self-actualization, understanding, and the making of meaning; its root significance was its recognition of human value and human values. Today, in a postmodern, more anti-humanistic world, culture, however defined, continues to have cogency. Despite its fragmentation into ever more sub-groups (the individual is understood to belong to several cultures concurrently), we continue to prize culture, not only as an industry or an assortment of commodities or a corpus of codes, but as a collection of values. In this, we betray our lingering humanism and perhaps find lessons about Canada in Vincent Massey's passionate defence of culture and nationalism.

Notes

Abbreviations

AGOA Art Gallery of Ontario Archives, Toronto
ALC Arts and Letters Club, Toronto
BC British Council, London, England
BCP British Council Papers, PRO, BW20
CHIA Chautauqua Institution Archives, Chautauqua, NY
HHA Hart House Archives, UT
HHP Hart House Papers, UTA
LSHP Lawren S. Harris Papers, NA
MF Massey Foundation
MFamP Massey Family Papers, NA, MG32 AI
MFG NGC, Gift of the Massey Foundation.
MFP Massey Foundation Papers, NA, MG28 I136
NA National Archives of Canada, Ottawa
NGC National Gallery of Canada, Ottawa
NGCA National Gallery of Canada Archives, Ottawa
PRO Public Record Office, London, England
TFRBL Thomas Fisher Rare Book Library, UT
TGA Tate Gallery Archive, London, England
UCC/VUA United Church of Canada / Victoria University Archives, Toronto
UT University of Toronto
UTA University of Toronto Archives
VMB NGC, Vincent Massey Bequest, 1968
VMP Vincent Massey Papers, UTA B87-0082

Preface

1 Finlay, *20th-Century British Art.* The Art Gallery of Ontario houses the largest public collection of Henry Moore's work.

Introduction

1 Lawren Harris, a Group of Seven member and Massey's close friend and associate, borrowed this statement from Adeney, 'The National Consciousness Idea.'

2 As early as 1910, he referred to 'that loathsome word "culture."' Massey, Diary, 23 June 1910, UTA, VMP, 301.

3 Massey, 'Postscript' (draft of an uncompleted book, 1966–7); NA, MFamP, vol. 42.

4 Most notably, these are the staples theory of Harold Innis (*The Fur Trade in Canada*, 1930) and the Laurentian thesis, advanced in particular by Donald Creighton (*The Commercial Empire of the St. Lawrence*, 1937).

5 Characteristically, while receiving assistance from speechwriters, he was intimately involved in framing and crafting his own prose.

6 An indication of the wide use of the expression was, for example, a Canadian Pacific Railway brochure of 1931 promoting the Chateau Frontenac Hotel, Quebec, that read: 'Canadian Pacific: The Expression of a Nation's Character,' and continued: 'worldwide in scope, international in activities, the Canadian Pacific is pre-eminently the expression of a progressive nation's character.' From a post card published by the CPR Archives.

7 Harris, 'Sir Edmund Walker.'

8 The phrase is borrowed from McKillop, *Contours of Canadian Thought.*

9 One bibliography boasts over 10,000 items. McFadyen et al., eds., *Cultural Development in Canada.*

10 Davies, *Cultural Studies and Beyond*, 164.

11 Chaney, *The Cultural Turn*, 1.

12 Owram, 'Writing about Ideas,' 54.

13 Berger, *The Writing of Canadian History*, 178–80, 192–4, and 292–7.

14 Chaney, *The Cultural Turn.*

15 Straw, 'Shifting Boundaries,' 92.

16 See, for example, Dorland, 'A Thoroughly Hidden Country'; Goldie, Lambert, and Lorimer, eds., *Canada*; Ioan Davies, 'Theory and Creativity in English Canada'; Ian Angus, 'Missing Links'; and Bordo, Kulchyski, Milloy, and Wadland, eds., 'Introduction.'

17 Granatstein, *The Ottawa Men*, 40, 84–5, and 244.

18 Bissell, *The Young Vincent Massey* and *The Imperial Canadian*; for the Massey family's history, see Denison, *Harvest Triumphant*, and Gillen, *The Masseys.*

19 Litt, *The Muses*; see also Erna Buffie, 'The Massey Report and the Intellectuals'; and Jasen, 'The English Canadian Liberal Arts Curriculum.'

20 Siddall, *The Prevailing Influence*; and Silcox, *Painting Place*; see also Montagnes,

An Uncommon Fellowship; Lee, *Love and Whisky*; and Chaiton, 'The History of the National Council of Education of Canada.'

Chapter 1: A Methodist Eductor, 1908–1921

1 Raymond Williams has referred to culture as 'one of the two or three most complicated words in the English language.' *Keywords*, 87.

2 Williams, *Culture and Society*, xiii.

3 apRoberts, *Arnold and God*, 25.

4 Williams, *Keywords*, 89.

5 Arnold, *Culture and Anarchy*, viii and 15.

6 Finlay, 'Early Notions of Culture in Canada,' in draft.

7 Canadian Methodism has been the subject of two valuable, recent studies – Airhart, *Serving the Present Age*, and Neil Semple, *The Lord's Dominion*. However, much remains to be illuminated about Methodist attitudes towards education and the arts and about the relationship of Methodism to its benefactors, such as the Masseys. Two existing studies of prominent Canadian Methodists are Bliss, *A Canadian Millionaire* (on Sir Joseph Flavelle) and Prang, *N.W. Rowell.*

8 Magney, 'The Methodist Church and the National Gospel,' 6.

9 See Westfall, *Two Worlds.*

10 Airhart, *Serving the Present Age*, 27.

11 Gauvreau, *The Evangelical Century*, 17.

12 'Hints for Helping a Revival,' *Christian Guardian*, 24 Jan. 1844, 54, quoted in Westfall, *Two Worlds*, 64.

13 Letter from S.T. Bartlett to Nathanael Burwash, Mar. 1907, UCC/VUA, Burwash Papers, Box 2/25; cited by Airhart, *Serving the Present Age*, 100 n. 26.

14 Gauvreau, *The Evangelical Century*, 8 and 47.

15 It also reported: 'In bound volumes, the New York Book Concern alone has published over six and a half million volumes, and over 19,000,000 tracts in the last twelve years.' *Canadian Methodist Magazine* 15, no. 5 (May 1882), 480.

16 Semple, *The Lord's Dominion*, 239–75.

17 Educational Society of the Methodist Church of Canada, *Annual Report*, 1896–7, 4; UCC/VUA, Yrbk box 8251, A10E43.

18 'Methodism and Education,' *Canadian Methodist Magazine* 2, no. 3 (March 1880), 277.

19 Wilson, 'The Pre-Ryerson Years'; see also Westfall, *Two Worlds*, 84–6.

20 *Appeal of the Wesleyan Conference on the Question of Liberal Education in Upper Canada*, n.d. (report from the *Christian Guardian*, 30 Nov. 1859).

21 Ryerson in 1847, quoted in Houston and Prentice, *Schooling and Scholars in Nineteenth-Century Ontario*, 99.

22 Victoria began to offer university-level courses in 1842 and granted its first degree within three years. Sissons, *A History of Victoria University*, v and 71.

23 Ryerson, *Christian Guardian*, quoted in Burwash, *The History of Victoria College*, 9.

24 *Christian Guardian*, 11 April 1832, 85, quoted in Semple, *The Lord's Dominion*, 239.

25 For Methodist policies and practices concerning female education, see Selles, *Methodists and Women's Education in Ontario*.

26 McKillop, 'The Founders of Victoria,' 25.

27 According to Burwash, Ryerson was governed by the principle of separating Canadian Methodism from American Methodism and bringing union with the British Wesleyans. *The History of Victoria College*, 5 and 21. See also Semple, *The Lord's Dominion*, 87ff. From as early as 1799, Upper Canada's school acts encouraged allegiance to Britain by censoring the hiring of American teachers. Wilson, 'The Pre-Ryerson Years,' 24. The Anglicans accused the Methodists of being too American, although in fact most were United Empire Loyalists. Conversely, their first-hand experience of American-style democracy left its imprint. For the complex story of how early Canadian Methodism came together out of a variety of factions, see Semple, *The Lord's Dominion*, 27–52. For the creation of denominational schools as a reaction against the state's Anglican affiliation and the exclusivity of early state-funded schools in Upper Canada, see Wilson, 'The Pre-Ryerson Years,' 16.

28 W.H. Withrow, *Methodist Magazine and Review*, Nov. 1897, 472, quoted in Magney, 'The Methodist Church and the National Gospel,' 36.

29 S.D. Chown, 1902, quoted in Magney, 'The Methodist Church and the National Gospel,' 59.

30 Educational Society of the Methodist Church, *Annual Report*, 1885–6.

31 Educational Society of the Methodist Church, *Annual Report*, 1898–9.

32 See, for example, Collini, *Public Moralists*, 91–118.

33 Samuel Nelles, 'Religion and Learning' (college address, 1857), UCC/VUA, Nelles Papers, quoted in Gauvreau, *The Evangelical Century*, 48.

34 Gauvreau, *The Evangelical Century*, 48.

35 The problems attendant on any presumption of wholeness are obvious; there cannot fail to be exclusions, however complete an educational system purports to be; in turn, hierarchies of accepted subject matter are created. A system that prizes wholeness may also fail to honour uniqueness. None the less, those who argued for a liberal arts education on the grounds of wholeness did so primarily to distinguish it from one whose goal was mercenary.

36 Benjamin Gregory, *Canadian Methodist Magazine* 2, no. 3 (March 1880), 276.

37 Educational Society of the Methodist Church, *Annual Report*, 1896–7, 4.

38 Grant, 'Theological Education at Victoria,' 87.

39 Lee, 'Victoria's Contribution to Canadian Literary Culture,' 69–85.

40 This is presumably indebted in part to the type of mission work practised by the early Methodist church, the obstacles that it faced in securing its presence, and how information collected at the mission sites was shared. For an account of the process by which Methodism made inroads into British North America, see Semple, *The Lord's Dominion*, 27–52.

41 He linked the Methodist sense of citizenship directly to the repudiation of connections with American Methodism in the early nineteenth century; Burwash, *A History of Victoria College*, 4.

42 John Potts, Educational Society of the Methodist Church, *Annual Report*, 1896–7, 5.

43 Methodist Church General Conference, *Temperance Committee Report*, 1902, quoted in Magney, 'The Methodist Church and the National Gospel,' 50–1.

44 Magney, 'The Methodist Church and the National Gospel,' 70.

45 Ibid., 82.

46 Goldwin French, 'The People Called Methodists in Canada,' in John Webster Grant, ed., *The Churches and the Canadian Experience*, 76. Magney has concurred: 'The most impressive aspect of the Canadian Methodist mind of these years is its overwhelmingly nationalistic cast.' He warned further: 'Historians of national sentiment in Canada who ignore the writings of Church journals, and the declarations of the institutional churches, do so at their peril, for they overlook one of the most fertile sources of nationalistic writing in existence.' 'The Methodist Church and the Nationalist Gospel,' 5.

47 James Woodsworth, *Journal*, 1902; quoted in Magney, 'The Methodist Church and the National Gospel,' 49.

48 French, 'The People Called Methodists in Canada,' 81.

49 Salem Bland (signed 'The Observer'), *Toronto Daily Star*, 11 Feb. 1927, quoted in Hill, *The Group of Seven*, 169.

50 Bliss, 'The Methodist Church and World War I,' 213.

51 Magney, 'The Methodist Church and the National Gospel,' 61.

52 For an intriguing introduction to the connections between the social gospel movement and education, see J.R. Kidd, 'The Social Gospel and Adult Education in Canada,' in Allen, ed., *The Social Gospel in Canada*, 227–62.

53 Magney, 'The Methodist Church and the National Gospel,' 19.

54 Sissons, *A History of Victoria University*, 72, and Burwash, *The History of Victoria College*, 116 and 129.

55 Massey, 'The Masseys in Canada' (1928?).

56 Burwash, *The History of Victoria College*, 452.

57 Sissons, *A History of Victoria University*, 217.

58 Burwash, *The History of Victoria College*, 453.

59 With his sisters-in-law Anna Vincent (Chester Massey's wife), Eliza Phelps (Hart's wife), and Susan Denton (Walter's wife), and others, Lillian Massey formed the Women's Education Association in support of the building project. Burwash, *The History of Victoria College*, 453. Regarding the history of Annesley Hall, see also Selles, *Methodists and Women's Education in Ontario*, 178ff. Lillian Massey also presented a fully equipped Domestic Science Building to the University of Toronto, on condition that it grant degrees in domestic science, and a building to Mount Allison's Ladies College at Sackville, New Brunswick, the future Home Economics Department of Mount Allison University. Gillen, *The Masseys*, 137. Like her brother Walter, she was very supportive of the deaconess movement; its school in Toronto trained deaconesses, Sunday school teachers, and home workers. Magney, 'The Methodist Church and the National Gospel,' 40.

60 Sissons, *A History of Victoria University*, 270.

61 The Hart Massey Estate gave $100,000 as an endowment to the college and a further $140,000 at this time. Burwash, *The History of Victoria College*, 447–8.

62 Ibid., 458.

63 Montagnes, *An Uncommon Fellowship*, 8.

64 Sissons, *A History of Victoria University*, 259.

65 The estate made at least one further benefaction, of $75,000, to the college in 1918 in response to a special appeal to reduce the school's deficit during the war. On the same occasion, Chester Massey gave an additional $25,000. Sissons, *A History of Victoria University*, 269.

66 Christian, *George Grant*, 246.

67 Bissell, *The Young Vincent Massey*, 4 and 43–7.

68 Massey, *What's Past Is Prologue*, 117; Bissell viewed it as a social rather than an ideological choice. *The Young Vincent Massey*, 115–16.

69 Alice Parkin Vincent Massey was an Anglican, although she made a concerted effort to support her husband's Methodist affiliation, especially while the couple was associated with Victoria College during the 1910s. Their son Hart was confirmed in an Anglican church in Toronto, and while he recalled that he and his brother, Lionel, were brought up in the context of Christian morality and that, especially for his mother, religion was important, institutional religion was not overly emphasized in his upbringing. Hart Massey to the author, 29 Jan. 1997.

70 Massey, Diary, 22 Feb. 1910.

71 Massey, Diary, 11 Aug. 1911.

72 Massey, 'Postscript.'
73 Methodist Church of Canada, *Report of the Massey Foundation Commission on the Secondary Schools and Colleges of the Methodist Church of Canada* (Massey Report of 1921).
74 Massey later wrote: 'My father was very insistent that I should become an undergraduate of Victoria College ... I was equally insistent that I should go to University College where most of my friends were going to be, and I won the battle.' 'Postscript.'
75 Chester Massey to Nathanael Burwash, 16 Sept. 1910, MFamP, vol. 21.
76 Massey, Diary, 25 Sept. 1911.
77 Rev. W.L. Brown, 'The Sunday School Movement in the Methodist Church in Canada.'
78 Massey, Diary, 23 June 1910.
79 Ibid., 14 Feb. 1911.
80 Massey, 'Address' (23 March 1928), 141.
81 Massey, Diary, 24 June 1910.
82 Ibid., 4 March 1910.
83 Ibid., 19 Aug. 1911.
84 Ibid., Aug. 1911.
85 Unidentified newspaper clipping in Massey, Diary, 1911.
86 Massey, Diary, 4 Sept. 1911.
87 Massey to Chester Massey, 4 Sept. 1911, MFamP, vol. 21.
88 Prang, *N.W. Rowell*, 238.
89 Massey, Diary, 23 Sept. 1911.
90 Ibid., 4 March 1911; and Vincent Massey, *What's Past Is Prologue*, 42.
91 His resignation to become dean was noted by the board of regents, 8 May 1914. UCC/VUA, Board of Regents Meeting Minutes, 87.125V Mfm 2. Massey, however, spent much of 1918 and 1919 in Ottawa in connection with his military duties, according to Bissell, *The Young Vincent Massey*, 62 and 102. Walter Bowles was made acting dean of residence while Massey was in Ottawa. Montagnes, *An Uncommon Fellowship*, 32. From 1919 to 1924 Massey shared the title of dean with George Malcolm Smith, and from 1924 to 1936 he was honorary dean of residence of Victoria College.
92 Vincent Tovell, interview, 8 Nov. 1995.
93 Sissons, *A History of Victoria University*, 277.
94 Massey, *What's Past Is Prologue*, 42.
95 Massey to Murray Wrong, undated letter, quoted in Bissell, *The Young Vincent Massey*, 79–80. Bissell dated it as likely from 1914.
96 Massey, *What's Past Is Prologue*, 42–3.
97 R.P. Bowles to Chester Massey, 28 Feb. 1919, MFamP, vol. 22.

98 Chester Massey to R.P. Bowles, 22 April 1919, MFamP, vol. 22. The letter includes considerable detail on the nature and conditions of the transfer. The plan did not go ahead for reasons that are unclear. No. 71 Queen's Park Crescent, including the Massey home, was purchased by Victoria University from Vincent Massey about 1928 for $50,000. Victoria University, Property Committee Meeting Minutes, 15 Oct. 1928, and 19 Dec. 1929; UCC/VUA, Board of Regents, Records of the Finance and Property Committee, Property Committee Minutes, 1928–9, 2000/4, 87.127V box 1, file 5.

99 Bissell, *The Young Vincent Massey*, 52.

100 Chester Massey to Byron E. Walker, Chairman of the Board of Directors, University of Toronto, 21 Feb. 1910, UTA, HHP.

101 Massey to Burgon Bickersteth, draft letter, Nov. 1928, VMP, 376/12. See also Ian Montagnes, 'The Founder and the Animator,' in Kilgour, ed., *A Strange Elation*, 7.

102 'A Splendid *Gift*,' *Varsity* 29, no. 37 (4 March 1910).

103 In a later issue of the *Varsity*, Massey corrected the perception that the gymnasium was part of the gift, stating that it was being financed by an allocation from the University of Toronto Board of Governors. *Varsity* 30, no. 23 (13 Jan. 1911).

104 'Plans Are Under Way for the New Buildings,' *Varsity* 29, no. 40 (15 March 1910).

105 *Varsity* 30, no. 23 (13 Jan. 1911).

106 *Globe* (Toronto), 6 June 1911 (clipping in Massey, Diary, 1911).

107 Burwash, *The History of Victoria College*, 472.

108 Ibid., 472–3.

109 Massey to Burgon Bickersteth (draft letter), Nov. 1928, VMP, 376/12. Ian Montagnes has described the first plan for Hart House, which would have exacerbated possible conflicts and division. 'The Founder and the Animator,' 8.

110 Massey to Burgon Bickersteth (draft letter), Nov. 1928, VMP, 376/12.

111 The Student Christian Movement (the Student Christian Association) was more willing to embrace political and social concerns as well as student issues than were the YMCA and the YWCA and was 'a seed-bed of political activism.' Gidney, 'Poisoning the Student Mind?' 148–9 and 163.

112 Massey to Rev. George Kilpatrick, 8 March 1922, VMP, 141/05.

113 Montagnes, *An Uncommon Fellowship*, 95.

114 Massey to Rev. W.C. Lockhart, 19 May 1938, VMP, 178/3

115 Montagnes, *An Uncommon Fellowship*, 20.

116 Burgon Bickersteth, quoted in ibid., 89.

117 Massey to Burgon Bickersteth (draft letter), Nov. 1928, VMP, 376/12.

118 Massey to W.S. Learned (Carnegie Corporation, New York), 22 March 1923, VMP, 384/04.

119 Massey to S.D. Chown, 6 July 1923, VMP, 384/04.

120 Massey, 'Address' (1919).

121 Porter Butts, *College Unions around the World* (1967), cited in Montagnes, *An Uncommon Fellowship*, 5.

122 Massey to Mrs. L.S. Amery, 1 April 1930, VMP, 28.

123 Montagnes, *An Uncommon Fellowship*, 5.

124 Friedland, *The University of Toronto*, 273–4.

125 Airhart, *Serving the Present Age*, 107.

126 In the summer of 1924, on behalf of Massey-Harris, Massey visited the Soviet Union; for a brief analysis of his views on the experience, which Bissell has described as having a 'democratizing influence on the young executive,' see Bissell, *The Young Vincent Massey*, 104–5.

127 It was only a few days earlier that it had been incorporated as the Massey Foundation.

128 Massey to J.W. Graham (a treasurer of the Department of Education of the Methodist Church of Canada), 5 Jan. 1921, VMP, 131/05; Educational Society of the Methodist Church of Canada, *Annual Report*, 1918–19.

129 Educational Society of the Methodist Church of Canada, *Annual Report*, 1918–19, 4–5.

130 The Board of Education decided further to create a second commission of seven members to survey all the 'connexional' institutions of the Methodist church; it would in turn use the information and recommendations of Massey's commission. This second body appears to have remained moribund until Massey's group carried out its work.

131 Methodist Church of Canada, *Report of the Massey Foundation Commission*, v and 3.

132 Ibid., 3–5.

133 Ibid., 6, 12–13, 18, 25, and 27.

134 Ibid., 7, 73, and 118–19.

135 Egerton Ryerson, *Report on a System of Public Elementary Instruction* (1847), quoted in Albert F. Fiorino, 'The Moral Foundation of Egerton Ryerson's Idea of Education,' in McDonald and Chaiton, eds., *Egerton Ryerson and His Times*, 69.

136 Ryerson, for example, established the Provincial Educational Museum in the Toronto Normal School in 1857 as part of the public system; it displayed plaster statuary and copies of European master paintings for the benefit of those seeking to study art. In the mid 1880s, the Ontario Department of Education commenced art classes at the Toronto Normal School, *Varsity* 6, no. 21 (10 April 1886). By the turn of the twentieth

century, vocational art training was being established in several public schools; see E.L. Panayotidis-Stortz, '"Every Artist would be a Workman, and Every Workman an Artist": Morrisian and Arts and Crafts Ideas and Ideals at the Ontario Educational Association, 1900–1920,' in Peter Faulkner and Peter Preston, eds., *William Morris: Centenary Essays: papers from the Morris centenary Conference organized by the William Morris Society at Exeter College, Oxford, 30 June–3 July 1996* (Exeter, 1996), 165–71 and 254–8. See also Harold Pearse, ed., From Drawing to Visual Culture: A History of Art Education in Canada,' unpublished manuscript.

137 Austin, *The Higher Education of Women*, 15.
138 Ibid.
139 'Book Notices,' *Methodist Magazine* 31, no. 4 (April 1890), 381.
140 Educational Society of the Methodist Church, annual reports, UCC/VUA, Yrbk box 8251, A10E43.
141 *Report of the Massey Foundation Commission*, 9.
142 Ibid., 51.
143 Ibid., 79.
144 Ibid., 97.
145 Ibid., 11–12.
146 Massey, Diary, Aug. 1911.
147 Selles, *Methodists and Women's Education in Ontario*, 189.
148 Selles, 'Manners and Morals,' in Heap and Prentice, eds., *Gender and Education in Ontario*, 257.
149 *Report of the Massey Foundation Commission*, 65.
150 Selles, *Methodists and Women's Education in Ontario*, 127.
151 *Report of the Massey Foundation Commission*, 50.
152 Ibid., 15.
153 Ibid., 17–18.
154 Carl Berger, 'The True North Strong and Free,' in Russell, ed., *Nationalism in Canada*, 7.
155 *Report of the Massey Foundation Commission*, 18–19.
156 Ibid., 61.
157 See, for example, Elizabeth Smyth, '"A Noble Proof of Excellence": The Culture and Curriculum of a Nineteenth-Century Ontario Convent Academy' in Heap and Prentice, eds., *Gender and Education in Ontario*, 284.
158 Austin, *Woman: Her Character, Culture and Calling*, 57–61.
159 *Report of the Massey Foundation Commission*, 36.
160 Richard Chenevix Trench, *On the Study of Words*, 27th ed. (New York, 1905), 114–15.
161 This was an extension and enlargement of the Commission of Seven

established in 1919 (see note 130 above), Methodist Church of Canada, Commission of Nine, Meeting Minutes, 30 May 1921, VMP, 140/16.

162 Methodist Church of Canada, Commission of Nine, 'The Common Report' (an interim report, late 1921 or early 1922), VMP, 139/05.

163 Ibid., Meeting Minutes, 4 Nov. 1921.

164 Ibid., 'The Common Problem.'

165 'The Common Problem' continued at some length about the employment of music teachers. Apparently, many of the Methodist colleges paid music teachers a percentage of their students' tuition, unlike the rest of the faculty. While the reasons given are not particularly relevant here, this is another indication of the lively and even disproportionate, if not fully legitimized, role of music in these schools.

166 Educational Society of the Methodist Church of Canada, 'Report to the Commission on Colleges and Higher Education,' UCC/VUA, Records of the Commission on Colleges and Higher Education, United Church of Canada General Council Committees Collection.

167 Letter to Massey, 15 May 1920, VMP, 142/05.

168 The Methodist Church Survey Commission was established in 1920, was active in 1920 and 1921, and survived until 1922. It produced an interim report on 21 December 1920 and what proved to be a final report on 27 May 1921. The termination of the commission was discussed in correspondence between Massey and Rev. S.D. Chown, general superintendent of the Methodist Church of Canada, 24 Oct. and 10 Nov. 1922, VMP, 140/16.

169 Massey, *What's Past Is Prologue*, 54.

170 *Report of the Massey Foundation Commission*, 16.

171 Massey, *What's Past Is Prologue*, 15.

Chapter 2: A National Platform for Education, 1920–1926

1 Education and Canadian citizenship were aligned from at least the early nineteenth century; see, for example, McDonald and Chaiton, eds., *Egerton Ryerson and His Times*; Karen Stanworth, 'Visual Culture and the Object(s) of Citizenship'; and J.E. Wells, 'Canadian Culture,' *Canadian Monthly and National Review* 8, no. 6 (Dec. 1875). In contrast, Robert M. Stamp has argued: 'Canadian educational institutions have *never* served the interests of Canadian nationalism.' 'Canadian Education and the National Identity,' in Chaiton and McDonald, eds., *Canadian Schools and Canadian Identity*, 29.

2 Massey, Diary, 4 March 1910.

3 Massey to the Hon. E.C. Drury, 14 Feb. 1920, MFamP, vol. 23.

4 Massey to Chester Massey, 27 Feb. 1920, MFamP, vol. 23.
5 Dr Eber Crummy (former principal of Wesley College, Winnipeg) in National Council of Education, *Monthly Notes* (March 1922), 3, VMP, 139/01.
6 National Conference on Character Education, *Report of the Proceedings*, 126.
7 Chaiton, 'The History of the National Council of Education,' 108.
8 National Conference, *Report*, 2.
9 Ibid., v.
10 National Council of Education (NCE), *Retrospective*, 3, VMP, 139/01.
11 Falconer and Massey worked together in various contexts. They were on the executive of a Canadian Round Table group during the late 1910s. Greenlee, *Sir Robert Falconer*, 231. Massey was appointed to the board of governors of the University of Toronto in 1920; he had contact with Falconer in the planning and realization of Hart House, which Falconer held in very high regard. Ibid., 148–9. Falconer was one of two Ontario members elected to the Resolutions Committee of the National Conference on Character Education. *Report*, 28.
12 National Conference, *Report*, 18.
13 Ibid., 19.
14 Berger, 'The True North Strong and Free,' 14.
15 National Conference, *Report*, 20–2.
16 Ibid., 23, 25, and 32. A Miss Helen MacMurchy is listed on the Faculty of Medicine at the University of Toronto; UTA, *University of Toronto President's Report for the Year Ending 30 June 1909*.
17 In a 1926 speech, Massey indicated that his knowledge of the achievements of the first conference was based on the accounts of others, not on personal experience. 'Address' (April 1926).
18 W.F. Osborne to Massey, 22 Jan. 1920, VMP, 139/01.
19 W.J. Bulman to Massey, 17 March 1920, VMP, 139/02.
20 Chaiton, 'History of the National Council of Education,' 25.
21 Massey to Major Fred J. Ney, 5 May 1921, VMP, 139/01.
22 Massey, 'Address' (Oct. 1922).
23 Ibid.
24 'Proceedings of the Educational Conference' (Toronto, 3–31 Oct. and 1 Nov. 1922), 3, quoted in Chaiton, 'Attempts to Establish a National Bureau of Education, 1892–1926,' in Chaiton and McDonald, eds., *Canadian Schools and Canadian Identity*, 128.
25 National Council of Education (NCE), *Bulletin No. 1*, VMP, 139/01.
26 Massey, 'Report of the Retiring President,' National Conference on Education and Citizenship, Montreal (April, 1926), cited in Chaiton 'The History of the National Council of Education,' 10–11.
27 Massey, *What's Past Is Prologue*, 85–6.

28 NCE, Central Committee Meeting Minutes, 12 Dec. 1923, VMP, 29; also NCE, *Bulletin No. 1*, 8 and 11–12.
29 NCE, *Second Interim Report of the General Secretary*, 11, VMP, 139/01.
30 Massey to W.J. Bulman, 6 June 1922, VMP 139/01.
31 Massey to Rev. E. Leslie Pigeon, 6 July 1922, VMP, 139/01.
32 Massey to Rev. E. Leslie Pigeon, 22 July 1922, VMP, 139/01.
33 Sadler was vice-chancellor of the University of Leeds and a leading British spokesperson on education; Mansbridge was chair of the World Association for Adult Education and founder of the Workers' Educational Association; and Newbolt was the author of the Newbolt Report to the British Board of Education on 'The Teaching of English in England' (1921).
34 Massey to Major Fred J. Ney, 7 July 1922, VMP, 139/01.
35 Massey to R.Y. Eaton, 10 Oct. 1922, VMP, 139/01.
36 NCE, *Monthly Notes* (March 1922), VMP, 139/01.
37 NCE, *Retrospective*, 4.
38 Ibid, 5–6.
39 Chaiton, 'History of the National Council of Education,' 53.
40 Massey, 20 Nov. 1922, VMP, 139/01.
41 Massey, 'Address' (April 1923).
42 NCE, *Retrospective*, 8–9.
43 The other two days of the conference were given to council business and miscellany. NCE, *Program* (National Conference on Education and Citizenship, 4–8 April 1923), VMP, 376/02.
44 This was decided at a meeting of the council's central committee, held in Sir Robert Falconer's offices, with W.L. Grant and George Locke (a member of the Massey Foundation Commission) in attendance. Massey to W.J. Bulman, 19 Dec. 1923, VMP, 138/03.
45 NCE (brochure, 1925–6?), VMP, 376/02.
46 Massey to Fred Ney, 29 Jan. 1924, and Massey to the Hon. Athanase David, 4 March 1925, VMP, 29/06.
47 Memo listing donations of the Massey Foundation to the NCE, n.d., VMP, 028/01.
48 Chaiton, 'History of the NCE,' 111.
49 Massey to Fred Ney, 5 May 1921, VMP, 139/01.
50 Massey to John Masefield, 17 Dec. 1923, VMP, 138/03.
51 W.L. Grant to J.L. Paton, 3 March 1924, VMP, 138/03.
52 J.L. Paton, 'Report for the NCE,' 1925, VMP, 29.
53 Ibid.
54 Deputy Minister of Education for the Province of Saskatchewan to Massey, April 1924, VMP, 138/03.
55 Massey, 'Address' (n.d.).

56 NCE (program listing, 1933–4), VMP, 29.

57 Massey to Fred Ney, 29 Jan. 1924, VMP, 29.

58 Vipond, 'The Nationalist Network,' 38–9.

59 Massey to the NCE membership (open letter), 26 March 1924, VMP, 138/03.

60 Massey to Fred Ney, 27 Sept. 1928, VMP, 30/08–09.

61 Fred Ney to Massey, 6 Dec. 1928, VMP, 138/03.

62 Massey to the NCE membership (open letter), 26 March 1924, VMP, 138/03.

63 Chaiton, 'History of the NCE,' 51.

64 Cochrane and Wallace, *This Canada of Ours*, xi.

65 Ibid., 163–5.

66 Ibid., 168.

67 NCE, Central Committee Meeting Minutes (Toronto), 4 Feb. 1926, VMP, 029. Whether it was used in any school system remains to be determined.

68 Gordana Lazarevich, 'The Role of the Canadian Pacific Railway in Promoting Canadian Culture,' in Carruthers and Lazarevich, eds., *A Celebration of Canada's Arts*, 5–13.

69 Massey to C.N. Gariépy, 10 April 1924, VMP, 138/03.

70 Massey, 'Address' (April 1926).

71 Ibid.

72 See, for example, Massey, 'Address' (26 Jan. 1924). Bissell has traced Massey's sensitization to French-speaking Canada to his friendship with the Wrong family, who included him in their holidays at Murray Bay on the St Lawrence. *The Young Vincent Massey*, 38–9.

73 Massey to Fred Ney, 17 June 1925, VMP, 29.

74 Massey, 'Address' (April 1926).

75 Bissell, *The Young Vincent Massey*, 149.

76 Fred Ney to Massey, 5 Nov. 1929, VMP, 30/09.

77 Massey to Henry Cockshutt, 22 March 1929, VMP, 30/08–09.

78 NCE, *Canada and the Foreign Film* (Winnipeg, n.d. [1929?]), 5, VMP, 30/08–09.

79 Ibid.

80 Massey to Fred Ney, 23 April 1934, VMP, 29.

81 Massey to H. Carl Goldenberg, 21 April 1934, and Massey to James A. Richardson (President, NCE), 21 April 1934, VMP, 29.

82 Massey to Fred Ney, 23 April 1934, VMP, 29.

83 Massey gave an address on education and character building on 17 November 1922 at the King Edward Hotel, Toronto. William H. Walters to Massey, 18 Nov. 1922, VMP, 139/01.

84 Massey, 'Address' (March 1923) and 'Address' (10 Oct. 1924).

85 Massey, 'Address' (March 1923).

86 Ibid.

87 Massey, 'Address' (10 Jan. 1929); see also 'Address' (10 Oct. 1924).

88 Massey, 'Address' (10 Jan. 1929).

89 Massey, 'Some Notes on Education' (c. 1950).

90 Section 93 referred only to denominational schooling; section 92 included education in its broadest sense.

91 Massey, 'Some Notes on Education.'

92 Massey, 'Address' (c. 1923–6).

93 Massey, 'Address' (March 1923).

94 Massey, 'Address' (c. 1923–6).

95 Ibid.

96 Massey, 'Address' [1929].

97 Canada, Royal Commission on National Development in the Arts, Letters, and Sciences, *Report* (Ottawa, 1951), 31 and passim.

98 For a useful overview of one strand of this intellectual quest, with particular reference to German aesthetics and art history, see Podro, *The Critical Historians of Art*.

99 Massey, 'Address' (from the early to mid-1920s), MFamP, 43, speech 5.

100 Massey, 'Address' (c. 1923–6).

101 Massey, 'Some Notes on Education.'

102 This comment was made in the context of a discussion of Bolshevism, which Massey argued should be fought not by censorship and repression, but by an educated citizenry. Ibid.

103 Friedland, *The University of Toronto*, 282–3.

104 Greenlee, *Sir Robert Falconer*, 253.

105 W.J. Dunlop (Director of the Department of University Extension and Publicity, University of Toronto) to Massey, 2 May 1935, VMP, 81/20.

106 Massey, 'Some Notes on Education.'

107 bid.

108 Massey, 'Address' (c. 1923–6).

109 Massey, 'Address' (26 Jan. 1924).

110 Massey, 'Some Notes on Education.'

111 Massey, 'Address' (c. 1923–6).

Chapter 3: Becoming 'Art-Minded,' 1902–1930

1 Massey, 'Art and Nationality in Canada' (22 May 1930).

2 Early music education in Canada was indebted to Egerton Ryerson, who prescribed vocal music as a subject in the Common School Act of 1846; however, music's appearance on school curricula was far from guaranteed. As a Methodist, Ryerson placed music within the moral foundation that he

sought for education; it fostered discipline in class and offered social benefits, such as the encouragement of temperance; see Green and Vogan, *Music Education in Canada*, especially 44–74.

3 As late as 1914, the 'Doctrine and Discipline of the Methodist Church of Canada' forbade theatre attendance; Saddlemyer and Plant, eds., *Later Stages*, 262.

4 Massey, *What's Past Is Prologue*, 5.

5 Bridle, *The Story of the Club*, 51.

6 Gillen, *The Masseys*, 148.

7 Massey, *What's Past Is Prologue*, 5.

8 Mrs R.P. Hopper, *Old-Time Primitive Methodism in Canada (1829–1884)* (Toronto, 1894), 77, quoted in Walter, ed., *Aspects of Music in Canada*, 40.

9 *The New Grove Dictionary of Music and Musicians* (London, 1980), 357.

10 'Instrumental Music in Methodist Churches,' *Christian Guardian* 13, no. 17 (Aug. 1842), 170, quoted in Tippett, *Making Culture*, 5.

11 Helmut Kallman and Gilles Potvin, eds., *Encyclopedia of Music in Canada*, 2nd ed. (Toronto, 1992), 1084.

12 Semple has called the Salvation Army 'quasi-Methodist'; *The Lord's Dominion*, 201. See also Green and Vogan, *Music Education in Canada*, 140–3.

13 Airhart, *Serving the Present Age*, 20.

14 Nathanael Burwash (pamphlet printed on the death of Anna Vincent Massey, Feb. 1906), VMP, 121/11.

15 Lewis Miller of Aultman, Miller & Co. Buckeye Mowers, Reapers, and Binders, of Akron, Ohio.

16 Chester Massey, *Chautauquan Daily*, no. 28 (1 Aug. 1916), 5, quoted in archival notes kindly provided by Alfreda L. Irwin, historian, CHIA.

17 Vincent, *The Chautauqua Movement* , 21.

18 Ibid., 2, 4, and 12.

19 Quoted in ibid., vii.

20 Ibid., 7–8.

21 Morrison, *Chautauqua*, 119–47, 149, and 156–7.

22 To the Earl of Aberdeen, Hart Massey wrote: 'I am one of the Chautauqua Trust Board, and have taken a great deal of interest in the Assembly since its organization in 1874.' 18 May 1885, MFamP, vol. 4. The family was involved almost exclusively with the founding Chautauqua, not with its offspring, although there is at least one piece of correspondence with a Mr Massey, presumably Hart or Chester, concerning the Niagara Assembly or the Canadian Chautauqua, Niagara-on-the-Lake. MFamP, vol. 2.

23 Bissell, *The Young Vincent Massey*, 20.

24 Arthur Bester to Chester Massey, 4 Dec. 1909, MFamP, vol. 19.
25 John Heyl Vincent to Hart Massey, 30 May 1895, MFamP, vol. 4.
26 Massey, Diary, Aug. 1902.
27 Raymond Massey, *When I Was Young*, 18.
28 Ibid., 18 and 38.
29 Raymond Massey, quoted in *Chautauquan Daily*, 3 Aug. 1974; I am grateful
 to Alfreda L. Irwin, CHIA, for this reference. Morrison has claimed that
 George Vincent, rather than his father, Bishop Vincent, was responsible for
 the support of theatre at Chautauqua. *Chautauqua*, 156.
30 Chester Massey to Arthur E. Bester (Director, Chautauqua Institution of
 New York), 2 June 1911, MFamP, vol. 21.
31 Massey, Diary, 31 July 1911.
32 Ibid. In 'Postscript' (1966–7), Massey wrote that, under the influence of
 George Vincent, Chautauqua struck a more intellectual note.
33 Morrison, *Chautauqua*, 83.
34 Although the Rockefeller Foundation was established in 1913, focusing in
 its early years on public health and medicine, it did not become involved
 with the humanities until the mid-1920s and with the fine arts until the late
 1920s. Fosdick, *The Story of the Rockefeller Foundation*, 238.
35 Charles Massey was the eldest or second-eldest child in the family; often it is
 stated that there were five children – Charles, Chester, Lillian, Walter, and
 Fred Victor – but George Wentworth died in infancy. The order in which he
 was born is unclear. *Massey Music Hall Festival* (Toronto, 1894), 7, MFamP,
 vols. 16–18.
36 Gillen, *The Masseys*, 53.
37 Denison, *Harvest Triumphant*, 89.
38 Gillen, *The Masseys*, 62.
39 *Trip Hammer* 1, no. 1 (Feb. 1885), 1.
40 Ibid., 2.
41 Ibid., 1, no. 11 (Dec. 1885), 169.
42 Ibid., 1, no. 4 (May 1885), 52.
43 Ibid., 1, no. 10 (Nov. 1885).
44 Ibid., 1, no. 12 (Jan. 1886), 181.
45 Ibid., 1, no. 2 (March 1885), 14.
46 Ibid., 1, no. 4 (May 1885), 44–5.
47 Gillen, *The Masseys*, 54.
48 Ibid., 105 and 119.
49 *Massey's Illustrated* 5, no. 1, 6.
50 Gillen, *The Masseys*, 106; see also Kilbourn, *Intimate Grandeur*.

51 *Massey Music Hall Festival,* 7.
52 *Methodist Magazine and Review* 47, no. 6 (June 1898), 515. Other denominations also booked the hall. Gillen, *The Masseys,* 106 and 108.
53 Deed of Trust (H.A. Massey and J.J. Withrow), Massey Music Hall, 5 June 1894, VMP, 121/07.
54 Walter Massey to Chester Massey, 4 July 1894, MFamP, vol. 3.
55 Toronto School of Music to Hart Massey, 8 May 1894, MFamP, vol. 4.
56 It was discontinued in 1918, according to *The Canadian Encyclopedia* (Edmonton, 1988), 2174.
57 Massey to Colonel Gooderham (President of the Toronto Symphony Orchestra), 25 July 1932, VMP, 51. Chester Massey was an early subscriber to the Toronto Conservatory Symphony Orchestra, according to correspondence from its chairman, Edward [Fisher?], 7 May 1908, MFamP, vol. 20.
58 Tippett, *Making Culture,* 119.
59 Massey, *What's Past Is Prologue,* 6.
60 Massey, 'The Masseys in Canada' (1928).
61 Massey, Diary, 6 Aug. 1903.
62 Marta H. Hurdalek, *The Hague School : Collecting in Canada at the Turn of the Century* (Toronto: Art Gallery of Ontario, 1983), 15.
63 'Chester D. Massey's Paintings,' *Saturday Night* (23 April 1910). I am grateful to David Kimmel for the reference.
64 His collection is known from photographs of his gallery and the contents of his estate sale in 1927. Jenkins' Galleries, *Catalogue of Highly Important Old and Modern Pictures and Drawings, Fine English and French Furniture, Engravings, Early English, Chinese and Continental Porcelain, Aubusson Tapestry, and Works of Art: Chester D. Massey, Sir William MacKenzie, Sir Edmund Walker Collections, Toronto,* 21–4 June 1927.
65 These commissions are mentioned in a letter from Nathanael Burwash to Chester Massey, 17 Jan. 1908, MFamP, vol. 20. However, it has not been possible to confirm their existence or whereabouts. In 1926 Vincent and Raymond Massey gave Annesley Hall a portrait of their grandmother, Mrs. Elizabeth (Hart A.) Massey, by McGillivray Knowles (date of execution undetermined). *Globe,* Toronto, 25 Nov. 1926.
 According to Colin S. MacDonald, Knowles also painted a portrait of Chester Massey. *A Dictionary of Canadian Artists,* rev. ed. (Ottawa, 1991), vol. 3, 662. MacDonald mentions that Knowles's second wife, Lila (Taylor) McGillivray Knowles, also an artist, taught at and became art director of Alma College in St Thomas, Ontario, a Methodist institution.
66 Chester Massey paid Harris $600 for the portrait of his first wife. Chester Massey to Robert Harris, 15 May 1907, MFamP, vol. 19.

67 Chester Massey to George E. Vincent, 2 Oct. 1911, MFamP, vol. 21.

68 William E. Dyer to Chester Massey, 14 Sept. 1908, MFamP, vol. 20.

69 Hamilton MacCarthy, 'The Encouragement of the Fine Arts and the Embellishment of Canadian Cities,' *Massey's Magazine* 1, no. 3 (March 1896), 156–7.

70 C.D. Massey and W.E.H. Massey are listed on the committee struck to form the Art Museum of Toronto, 1900; Minute Book, AGOA. C.D. Massey was also listed among the committee names on the Art Museum's Declaration for Incorporation, 1900. Minute Book, AGOA. At the first meeting of the Provisional Council of the Art Museum of Toronto, the Hart Massey Estate was among the subscribers (Hart's children Chester, Walter, and Lillian were the executors). On 12 April 1901, the estate paid a subscription of $5,000. J.E. Robertson (Secretary of the Estate) to B.E. Walker, 2 Oct. 1911, AGOA, 'Art Museum of Toronto: Letters. 1900–11. M.' Subsequent mention is made of a subscription from the estate in the amount of $25,000. Whether this included the original $5,000 remains undetermined; the final instalment of the $25,000 subscription was made in 1920. Massey Foundation to AGT, 10 Dec. 1920, AGOA, 'Art Museum of Toronto: Letters, 1919–20. M.' Anyone who donated $5,000 or more, at the gallery's inception or later, was designated a 'Founder,' according to a catalogue for the museum's second exhibition. Art Museum of Toronto, *Catalogue of a Loan Collection of Paintings.*

71 B.E. Walker to Chester Massey, 18 May 1910, MFamP, vol. 21.

72 Walker, president of the Canadian Bank of Commerce, also became chair of the National Gallery of Canada in 1910. He invested heavily in Massey-Harris and was a board member (1912–24). Fletcher, 'Industrial Algoma and the Myth of Wilderness,' 34 and 44, note 40.

73 I am grateful to David Kimmel, who has informed me that Walker acted as an art broker for Chester Massey; UTA, Sir Edmund Walker Papers, box 27A (invoices). Both collectors were interested in the Barbizon and The Hague Schools. Their collections were drawn on heavily for the Art Museum of Toronto's second exhibition, 24 November to 16 December 1909, at the new Public Library on College Street, which had opened that summer 'through the munificence of Mr. Andrew Carnegie' and housed a room designated as a picture gallery, according to the 181-page catalogue, *A Loan Collection of Paintings.*

74 Art Gallery of Ontario, acquisition no. 583; the first 'modern' Dutch paintings to enter the collection were the result of the 1916 gift. Hurdalek, *The Hague School*, 7.

75 Currelly, *I Brought the Ages Home*, 38.

76 Lochnan, 'The Walker Journals,' 61.
77 Currelly, *I Brought the Ages Home*, 35 and 38.
78 Northrop Frye, 'Editor's Introduction,' in ibid., vii.
79 Byron Edmund Walker was a fellow student of Currelly's at Victoria and in 1910 became chair of the board of governors of the University of Toronto. Currelly has described the meeting at which he enlisted Walker's support. See Lochnan, 'The Walker Journals,' 61.
80 Currelly, *I Brought the Ages Home*, 128–30.
81 A letter from C.D. (Chester) Massey as Executor of the Estate of H.A. Massey to Charles T. Currelly, 28 May 1909, enclosed 'the first payment on behalf of a fund to establish a Biblical Collection in the Museum of the University of Toronto, to be known as the Walter Massey Biblical Collection.' It is also apparent from the letter that the enclosed sum constituted payment for acquisitions already made. ROM, Curatorial files.
82 Chester Massey also supported the museum as a member of 'the Twenty Friends of the Arts,' which was formed in 1917 to help pay for acquisitions in the fine arts.
83 Raymond Massey, *When I Was Young*, 69.
84 Bissell, *The Young Vincent Massey*, 36.
85 This is confirmed by his university transcript. UTA, University of Toronto academic records, A89/200.
86 University of Toronto academic calendar for 1906–7. Massey probably came under the influence of W.J. Alexander, chair of English, who was deeply indebted to Arnold. Jasen, 'Arnoldian Humanism,' 555 and 558–9.
87 *University of Toronto Calendar*, 1906–7, 128, and 1909–10, 122.
88 Arnold, *Culture and Anarchy* (London, 1909) and (Cambridge, 1946); the 1909 edition has Massey's nameplate dated 1913, the year of many of his nameplated books. The volume Matthew Arnold, *Essays Literary and Critical*, which contains the essay 'The Function of Criticism,' is inscribed: 'C. Vincent Massey 1909' on the inside leaf and bears Massey's nameplate dated 1913. Also in the collection is Arnold's *Essays in Criticism* (1896), with 'Alice S. Parkin, 1901,' handwritten on the first page.
89 The markings can reasonably be attributed to Massey. Not only do the books bear his nameplate, but the written comments, which occasionally accompany the strokes, checkmarks, and other markings for emphasis, resemble his handwriting.
90 Arnold, *Culture and Anarchy*, 4–5 (Massey's 1909 edition).
91 Ibid., 15, 116, and 163.
92 For an examination of Canadian Methodism's reconciliation of faith and criticism, see Gauvreau, *The Evangelical Century*, 125–80. Margaret Prang has provided some insight into the Methodist milieu of Massey's home by

documenting Chester Massey's role, in 1909, in a heated and public debate about the literal truth of the Bible. In a letter to the *Globe*, he firmly supported subjecting the Bible to 'the searchlight of investigation.' *N.W. Rowell*, 71–2.

93 Arnold, *Culture and Anarchy*, 6 and 9.

94 Arnold, 'Democracy,' in *Mixed Essays* (London, 1903), 40 (Massey's copy).

95 Ibid., 72.

96 Massey, Diary, Aug. 1909.

97 Ibid., 13 Feb. 1910.

98 Ibid., 1 Jan. 1910.

99 Ibid. The other editors were students J.L. Duncan, A.M. Goulding, Harold Tovell, D.P. Wagner, and Murray Wrong (Goulding and Tovell married into the Massey family). All were in fourth year except Tovell, who was in third, and Wagner, in second. While Massey graduated in 1910 and went on to Oxford in 1911, he remained a regular contributor to the Arbor until its demise in April 1913. For a brief overview of Massey's literary and social activities at Balliol, see Bissell, *The Young Vincent Massey*, 98–100.

100 *Arbor* 3, no. 1 (Nov. 1911), 1.

101 George E. Vincent, 'Culture and the College,' *Arbor* 1, no. 1 (Feb. 1910), 9–10.

102 [Massey], 'On Thinking and Its Suppression,' *Arbor* 1, no. 1 (Feb. 1910), 57; in the copy of the *Arbor* in the VMP, although the essay was published anonymously, 'Vincent Massey' appears in handwriting beneath it.

103 [Massey], 'On Thinking and Its Suppression,' 58.

104 [Massey], 'The Uncritical Spirit,' *Arbor* 1, no. 2 (March 1910), 120–1. In the copy in the VMP, 'Vincent Massey' is handwritten at the end of the piece.

105 John Henry Cardinal Newman (1801–90), English theologian and author.

106 [Massey?], 'A Note on Music,' *Arbor* 3, no. 8 (April 1911), 273–4.

107 Chester Massey to John Heyl Vincent, 30 June 1910, MFamP, vol. 21.

108 Freeman and Rosita Tovell, interview, 22 Nov. 1996.

109 Harold Tovell, a distinguished physician and an Art Gallery of Toronto trustee, and Ruth Tovell, a respected art historian, were both active art collectors.

110 Massey to Raymond Massey, 10 July 1908, MFamP, vol. 20.

111 Massey, Diary, 24 July 1908.

112 Massey owned a copy of *Stones of Venice*; Robertson Davies Library, Massey College, has a 1906 edition, with a Vincent Massey bookplate, inscribed '1908,' along with seven other titles by Ruskin, also with Massey's bookplates, all editions dating from between 1903 and 1907, and mostly pertaining to art and architecture.

113 Robert Hewison, *John Ruskin: The Argument of the Eye* (London, 1976), 7.

114 George P. Landow, *The Aesthetic and Critical Theories of John Ruskin* (Princeton, NJ: 1971), 10.

115 His son Hart believed that Massey studied art as part of a university history course but otherwise learned about art informally. Hart Massey to author, 12 Dec. 1996.

116 Massey, Diary, 12 Aug. 1908.

117 Ibid., 20 Aug. 1908.

118 Ibid., Aug. 1909.

119 Lochnan, 'The Walker Journals,' 59.

120 Currelly, *I Brought the Ages Home*, 127–8; see also Lochnan, 'The Walker Journals,' 61–3.

121 Massey, Diary, 25 Feb. 1910.

122 Ibid., 2 July 1910.

123 Ibid., 10 Jan. 1911,

124 Ibid., 24 Jan. 1911.

125 Augustus Bridle to Massey, 13 Feb. 1911, VMP, 129/07.

126 Peter Mellen, *The Group of Seven*, 18.

127 Massey, 'V.M. on Art, Sculpture, Architecture,' excerpt from 'Postscript' (1966–7).

128 According to Augustus Bridle's highly anecdotal account of the club, Massey became keenly interested in both its musical and its dramatic activities. *The Story of the Club*, 16.

129 Bissell, *The Young Vincent Massey*, 66.

130 Usmiani, 'Roy Mitchell,' 151.

131 Ibid; see also Hill, *Group of Seven*, 125.

132 Merrill Denison, 'The Arts and Letters Players,' *Canadian Bookman* 2 (Feb. 1923), 32. At some point, it was apparently intended, though not realized, that a theatre/gallery would form part of the Studio Building, Toronto; the latter was financed primarily by Lawren Harris with assistance from Dr James MacCallum to provide studio space for artists and opened for use at the beginning of 1914. Hill, *The Group of Seven*, 125.

133 Denison, 'The Arts and Letters Players,' 32.

134 Ibid. The club did remain active during the 1920s. Saddlemyer and Plant, *Later Stages*, 267.

135 Vincent replied that he preferred a 'Grecian' idiom. John Heyl Vincent to Hart Massey, 9 July 1895, MFamP, vol. 4.

136 Among the books from the Massey collection at the Robertson Davies Library, Massey College, is John Ruskin's *The Complete Works* with Chester Massey's bookplate.

137 Massey, Diary, 16 Feb. 1910.

138 Henry Sproatt, quoted by Augustus Bridle, 'The World's Greatest Club House,' unidentified magazine clipping, 1919, UTA, HHP, Massey Hart House Scrapbook, A80–0030/002(37).

139 Paul Gary Russell, 'The Mutable Monument,' in Kilgour, ed., *A Strange Elation*, 20. For Morris and the University of Toronto, see E.L. Panayotidis-Stortz, 'Artist, Poet, and Socialist: Academic Deliberations on William Morris at the University of Toronto, Canada,' *Journal of the William Morris Society* (England), 12 (spring 1998), 36–43.

140 Massey's views on Neo-Gothic architecture remain to be delineated, but his appreciation of the style extended to its details. He explained to Burgon Bickersteth: 'In the quarries of the glass of the East window there appear, as you know, symbols of various games and of certain of the faculties and colleges and certain monograms including those of my wife and myself and the architects. No attempt was made to give these a logical complete-ness. They were selected and placed at random in the Gothic manner.' Massey to Bickersteth, draft letter, Nov. 1928.

141 Ibid.

142 Paul Gary Russell, 'The Mutable Monument,' in Kilgour, ed., *A Strange Elation*, 28.

143 Massey, 'Address' (8 Nov. 1929).

144 'Hart House' (brochure), undated (probably late 1920s), VMP, 109/02. Massey corrected Bickersteth's misunderstanding that the music room was not part of the orginal plan: 'You speak, by the way, of the music room and suggest that it was not originally planned for music. This is incorrect. The original idea of the room was that it should be used for music as is sug-gested by the character of the various stone corbels [which feature musi-cians].' Massey to Bickersteth, draft letter, Nov. 1928.

145 The Massey Foundation also gave Hart House four medieval viols in 1932, according to Burgon Bickersteth, cited in Montagnes, *An Uncommon Fel-lowship*, 69–70. Regarding the beginnings of the Music Club, see also Jim Bartley, Brian Pronger, and Rupert Shieder, 'Music: No Ragtime in the House,' in Kilgour, ed., *A Strange Elation*, 64.

146 Minutes, Hart House Music Committee, 3 Dec. 1919, HHA. The annual report of the Music Committee, 1921–2, stated that the acquisition of a new upright piano made it possible to spare the grand piano from 'the pseudo-pianists of the House [who] satisfy the jazz craze.' HHA; my gratitude to Myra Emsley, Hart House Warden's Office, for this reference.

147 Massey to Hart House Theatre Board of Syndics, 22 Jan. 1926, VMP, 376/09. See also Jim Bartley, Brian Pronger, and Rupert Schieder, 'Music: No Ragtime in the House,' in Kilgour, ed., *A Strange Elation*, 63.

148 Bickersteth, quoted in Montagnes, *An Uncommon Fellowship*, 69.
149 McInnes, originally from England and divorced from novelist Enid Bagnold (*National Velvet*), was father of art historian/diplomat Graham McInnes and British novelist Colin McInnes.
150 Bickersteth, in Montagnes, *An Uncommon Fellowship*, 70.
151 Massey to Burgon Bickersteth, draft letter, Nov. 1928.
152 Massey, *What's Past Is Prologue*, 55–6.
153 Massey to Bickersteth, 17 Jan. 1929, UTA, University of Toronto, office of the President, Hart House file, A75-0021/048.
154 Augustus Bridle, 'The World's Greatest Club-House,' unidentified press clipping 1919?, UTA, HHP, Massey Hart House Scrapbook, A80-0030/002(37).
155 Friedland, *The University of Toronto*, 272.
156 Merrill Denison, 'Hart House Theatre,' *Canadian Bookman* 20 (March 1923), rept. in Don Rubin, ed., *Canadian Theatre History: Selected Readings* (Toronto, 1996), 64.
157 Averill, *Dramatis Personae*, 4.
158 Lee, *Love and Whiskey*, 76.
159 Massey, *What's Past Is Prologue*, 42.
160 *Hart House Theatre*, 4–5.
161 *Varsity* 33, no. 6 (17 Oct. 1919).
162 Usmiani, 'Roy Mitchell,' 153.
163 *Hart House Theatre*. Alice and Vincent Massey were intimately involved in equipping the theatre. Saddlemyer and Plant, *Later Stages*, 266.
164 For details about Massey's involvement in the activities of Hart House Theatre, see Bissell, *The Young Vincent Massey*, 62–9.
165 Massey, *What's Past Is Prologue*, 60–1.
166 The Hart House Theatre's 1922–3 season included a series of eight lectures, delivered at 5 p.m. Fridays, preceding each production. Hart House Theatre 'Program,' 1922–3; HHP, A75-0009/051(09).
167 *Hart House Theatre*, 17.
168 Adamson, *The Hart House Collection of Canadian Paintings*, 11.
169 Bickersteth, cited in Montagnes, *An Uncommon Fellowship*, 52.
170 Siddall, *The Prevailing Influence*, 21.
171 Adamson, *The Hart House Collection*, 12.
172 Massey, 'Foreword,' in Harper, *Canadian Paintings in Hart House*, v.
173 Bickersteth, cited in Montagnes, *An Uncommon Fellowship*, 52–3.
174 Siddall, *The Prevailing Influence*, 33.
175 This effectively removed the art-collecting function from the Sketch Committee's responsibilities; minutes of an informal meeting in the

warden's office, 18 May 1925, to discuss the committee's future, VMP, 376/12.

176 Siddall, *The Prevailing Influence*, 35.
177 Harper, *Canadian Paintings in Hart House*, xii.
178 Siddall, *The Prevailing Influence*, 37.
179 Bickersteth, cited in Montagnes, *An Uncommon Fellowship*, 62.
180 Ibid.
181 Massey to Burgon Bickersteth, draft letter, Nov. 1928.
182 While the lecture series presumably came to fruition, there is no evidence that any monographs were published. Minutes of an informal meeting, 18 May 1925.
183 Bickersteth; quoted in Montagnes, *An Uncommon Fellowship*, 56.
184 Massey, 'Address.' (22 May 1930).
185 Massey, *What's Past Is Prologue*, 61.
186 Notably, Val Ross, 'The House as Home,' in Kilgour, ed., *A Strange Elation*, 133–47.
187 Significantly, the University College Women's Dramatic Club folded about 1920. According to Chaviva M. Hošek, joint activities for men and women at Victoria were still rare in 1916 but increased over the next decade; 'Women at Victoria,' in *From Cobourg to Toronto*, 61.
188 *Varsity* 34, no. 6 (7 Oct 1919).
189 Ross, 'The House as Home,' in Kilgour, ed., *A Strange Elation*, 144.
190 *University of Toronto President's Report for the Year ending 30 June 1909*, UTA.
191 'National Council of Education: Department of Art Appreciation' (typescript), n.d. (c. 1930?, probably written by Fred Ney), VMP, 389/18.
192 Robert Ayre, 'Fine Arts in Canadian Higher Education,' in Kirkconnell and Woodhouse, eds., *The Humanities in Canada*, 220.
193 Arnold Walter, 'Music in Canadian Higher Education,' in ibid., 217.
194 Massey, 'The Prospects of a Canadian Drama,' *Queen's Quarterly* 30 (Nov.–Dec. 1922), 205.
195 The Toronto Conservatory was founded in 1886 and became affiliated with the University of Toronto in 1896. *The University and Its Colleges, 1827–1906* (Toronto, 1906). It came fully under the university's jurisdiction in 1919. Friedland, *The University of Toronto*, 314.
196 Massey to Thomas W. Surette (Carnegie Corporation), 20 May 1926, VMP, 376/07.
197 Ibid.
198 Massey to Thomas W. Surette, 12 June 1926, VMP, 376/07.
199 Schabas, *Sir Ernest MacMillan*, 73.

200 Later that year, after the death of Dr Vogt, MacMillan became principal of the conservatory, and within a few months he was dean of music at the university. Ibid., 73 and 77.

201 Hart House Finance Committee Meeting Minutes, 26 April 1928, HHA.

202 Massey to Ernest MacMillan, 8 June 1928, UTA, 109/06.

203 Burgon Bickersteth, 19 April 1928, VMP, 109/06.

204 Hart House Board of Stewards, Meeting Minutes, 26 April 1928, HHA.

205 Panayotidis, 'Ruminations on the Value of the Fine Arts.'

206 Tippett, *Making Culture*, 41.

207 Kirkconnell and Woodhouse, eds., *The Humanities in Canada*, 222.

208 See also Tippet, *Making Culture*, 38–41; and Kirkconnell and Woodhouse, eds., *The Humanities in Canada*, 220–8.

209 Dating from 1921, the Ontario College of Art had its own building, the first in Canada devoted exclusively to art education. *The Canadian Encyclopedia* (Edmonton, 1988), 1577.

210 Massey to F.P. Keppel (Carnegie Corporation), 5 Oct. 1928, VMP, 15.

211 W.G. Constable to Massey, VMP, 28/6.

212 Eric Brown to Massey, 24 March 1933, VMP, 30/10.

213 W.G. Constable to Massey, 10 May 1933, VMP, 30/10.

214 Massey to W.G. Constable, 1 June 1933, VMP, 30/10.

215 Montagnes, *An Uncommon Fellowship*, 61.

216 Kirkconnell and Woodhouse, eds., *The Humanities in Canada*, 221.

217 Massey, 'Address' (6 June 1927).

218 Massey, 'Address' (8 Nov. 1929).

219 Massey, 'The Prospects of a Canadian Drama,' 208–9.

220 Massey, 'Address' (8 Nov. 1929).

221 Ibid.

222 Massey, 'The Prospects of a Canadian Drama,' 209.

223 Massey, 'Address' (8 Nov. 1929).

224 Massey, *On Being Canadian*, 29–43.

225 Massey, 'Address' (8 Nov. 1929).

226 'National Council of Education' (typescript), n.d. (c. 1930).

227 Arthur Lismer, 'Art Appreciation,' in Brooker, ed., *Yearbook*, 65–6.

228 Lismer, 'Art Appreciation,' 61.

229 The concern for integrating art into everyday life may be seen in the context of broader currents, particularly the arts and crafts movement emanating from England in the late nineteenth and early twentieth centuries, under the influence of Ruskin and William Morris, and the Bauhaus school in Germany during the 1920s and early 1930s. In the domain of art theory, John Dewey (1859–52), U.S. philosopher and educator, was

very influential in arguing grounds on which such a reunification might be understood: 'Works of art that are not remote from common life, that are widely enjoyed in a community, are signs of a unified collective life. But they are also marvelous aids in the creation of such a life.' *Art and Experience*, first pub. 1934 (New York, 1958), 81. Lismer, for example, was reading Dewey by 1928. Brooker, *Yearbook*, 60. Whether Massey was aware of Dewey's writing at this stage remains to be determined. While he would have agreed with Dewey that education was the essential way to reform society and foster a sense of community and co-operation, he would probably have challenged Dewey's heavy emphasis on its practical applications.

Massey and Hilda Neatby corresponded about Dewey in the early 1950s. Massey to Neatby, 27 Oct. 1953, VMP 585/07. Neatby regarded Dewey as too egalitarian. *So Little for the Mind*, 36 and 38.

230 Massey, 'Address' (16 May 1930). 'Art as a necessity' was a refrain that would echo throughout the first half of the twentieth century. It was a central notion in Wassily Kandinsky's *Concerning the Spiritual in Art* (1912); members of the Group of Seven employed the phrase – for example, Lismer, in Brooker, ed., *Yearbook*, 67. As late as 1948, Paul-Emile Borduas and his co-authors exclaimed in the artistic manifesto *Le Refus Global*: '*Make way for necessities!*,' quoted in Douglas Fetherling, *Documents in Canadian Art* (Peterborough, 1987), 121.

231 Massey, 'Address' (22 May 1930).

232 Ibid.

233 Brooker, ed., *Yearbook*, 16–17.

234 Massey, 'Address' (16 May 1930).

Chapter 4: Nationalizing the Arts, 1922–1935

1 Massey, *On Being Canadian*, 34.

2 Earlier writing on art and nationality in Canada awaits thorough investigation. Of relevance is the role of the governors general the Marquis of Lorne and Lord Dufferin during the 1870s and 1880s. For an introduction to this earlier period in Canadian nationalism and its connections with painting, see Dennis Reid, '*Our Own Country Canada*,' especially 274–95. The early activities of the Association of Canadian Clubs bear examination also; Nina L. Edwards has mentioned, for example, a paper by W.A. Sherwood, 'The National Spirit in Art,' given during the first year of the Canadian Club, 1893. *The Story of the First Canadian Club*, 13.

3 Harris, 'Sir Edmund Walker,' 109.

4 Massey, *What's Past Is Prologue,* 170.
5 Massey, 'The Prospects of a Canadian Drama' (1922), 197.
6 Ibid., 198.
7 This must be the amateur theatre mentioned by Richard Partington, 'Theatre: A Matter of Direction,' in Kilgour, ed., *A Strange Elation,* 96.
8 Robert B. Scott, 'Professional Performers and Companies,' in Saddlemyer and Plant, eds., *Later Stages,* 13–120.
9 Massey, 'The Prospects of a Canadian Drama' (1922), 206–7 and 212.
10 Ibid., 207.
11 J.E.H. MacDonald, 'Art and Our Friend in Flanders,' *Rebel* 2, no. 5 (Feb. 1918), 186.
12 J.E.H. MacDonald, 'The Canadian Spirit in Art,' *Statesman* (Toronto) 1, no. 35 (22 March 1919), 7.
13 Tippett, *Art in the Service of War,* 89–100.
14 Ibid., 89. For Walker's role in the Canadian War Memorials, see Boggs, *The National Gallery of Canada,* 16; and King, 'The National Gallery of Canada,' 15.
15 Lawren Harris, 'Foreword,' in Art Gallery of Toronto, *The Group of Seven* (Toronto, 1920), n.p.
16 Jackson, *A Painter's Country,* 24.
17 Lawren Harris, 'The Greatest Book by a Canadian and Another,' *Canadian Bookman* 6, 2 (Feb. 1924), 38.
18 Harris, Notebook (1930s), NA, LSHP, 2–10.
19 Bissell, *The Young Vincent Massey,* 63–4.
20 Laing, *Memoires of an Art Dealer,* 93.
21 Massey, *What's Past Is Prologue,* 87.
22 Massey, Diary, 1909. Both attended St Andrew's College, a Presbyterian boys' school that opened in Toronto in 1899; their enrolment overlapped for one year, 1903, but they did not get to know each other at that time.
23 Massey, Diary, 2 Oct. 1906. Harris had enrolled as an undergraduate at the University of Toronto in 1903, but the following year he left to study art in Berlin, where he had an uncle. He was home during the summer of 1906 and left again for overseas that autumn, returning to Canada finally in 1908. Peter Larisey, 'Chronology,' in Adamson, *Lawren S. Harris,* 14.
24 Vipond, 'The Nationalist Network,' 41.
25 Siddall, *The Prevailing Influence,* 15 and 17.
26 Freeman and Rosita Tovell, interview, 22 Nov. 1996.
27 Theosophy was a religion-cum-philosophy popular in the early twentieth century that drew on Eastern and Western sources in an effort to seek out an underlying unity. It relied heavily on colour and form symbolism, which

had particular relevance for visual artists such as Harris. For Harris and Theosophy, see Davis, *The Logic of Ecstasy.*

28 Harris, 'Creative Art and Canada,' 180.
29 Massey, 'Address' (22 May 1930).
30 Harris, 'Creative Art and Canada,' 180.
31 Ibid.
32 Massey, 'Address' (22 May 1930).
33 See Davis, *The Logic of Ecstasy.*
34 Harris, 'Sectarianism in Art,' LSHP, 6–25.
35 Massey, 'Address' (c. 1923–6).
36 Ibid.
37 Harris, Notebook (1930s), LSHP, 2–10.
38 Harris, Notebook, LSHP, 2–11.
39 Harris, 'Sectarianism and Art,' LSHP, 6–25.
40 Harris, 'Winning a Canadian Background,' *Canadian Bookman* 5, no. 2 (Feb. 1923), 38, quoted by Adamson, *Lawren S. Harris,* 137.
41 Harris, 'Creative Art and Canada,' 184.
42 Harris, 'Canadian Art and Internationalism,' LSHP, 5–4.
43 Harris, 'Miscellaneous Notes,' LSHP, 6–14.
44 Harris, Notebook (1920s), LSHP, 2–9.
45 Harris, 'Revelation of Art in Canada,' 179.
46 Harris, Notebook, LSHP, 2–8.
47 Harris, 'Democracy and the Arts,' (early 1940s), LSHP, 5–15. His writings suggest that Harris was a social democrat. Writing during the Second World War, he argued for a compromise of socialism and capitalism – 'a balance between the organizing power of the state and the driving force of the free individual.' 'Democracy and Art' (a variation on 'Democracy and the Arts'), LSHP, 5–15.
48 Harris, 'Canada and the Arts,' LSHP, 5–2.
49 Harris, Notebook, LSHP, 2–12.
50 Harris, 'Spirituality and Art' (after 1930), LSHP, 6–27.
51 Harris, 'Canadian Art and Internationalism,' LSHP, 5–4.
52 Ibid.
53 Harris, 'Democracy and the Arts,' LSHP, 5–15.
54 Harris, 'Creative Art and Canada,' 182–3.
55 Massey, 'Address' (c. 1923–6).
56 Harris, 'Creative Art and Canada,' 181–3 and 185.
57 Massey, 'Address' (22 May 1930).
58 Joseph Ernest Renan (1823–92), French historian and philologist.
59 Massey, 'Address' (22 May 1930).

60 Davis, *The Logic of Ecstasy*, 42–94.
61 Massey had digested the contents of Brooker, ed., *Yearbook*, before preparing this speech; many of his themes echo those made in that volume, and Brooker specifically excerpted the passage that Massey quoted from Whitman as his introduction.
62 Massey, 'Address' (22 May 1930).
63 Ibid.
64 Harold Palmer, 'Reluctant Hosts: Anglo-Canadian Views of Multiculturalism in the Twentieth-Century,' in Tulchinsky, ed., *Immigration in Canada*, 297–333, and Marilyn Barber, 'Nationalism, Nativism and the Social Gospel: The Protestant Church Response to Foreign Immigrants in Western Canada, 1897–1914,' in Allen, ed., *The Social Gospel in Canada*, 221–2.
65 For an alternative view, see Robert Linsley, 'Landscapes in Motion: Lawren Harris, Emily Carr and the Heterogeneous Modern Nation,' *Oxford Art Journal* 19, no. 1 (1996), 80–95.
66 Bissell, *The Imperial Canadian*, 101–6. I am not able to add to this debate significantly; of the three anti-Semitic remarks that I have identified among Massey's personal papers, two were not written by him. The third is a resentful slur that he made in 1922 in response to New York's control over Canada's professional stage: 'We take thankfully and with necessary docility the dramatic diet which a group of New York gentlemen, with Old Testament names, choose to send us,' 'The Prospects of a Canadian Drama' (1922), 197. Alice Massey sympathized with, and was deeply troubled by, the plight of European Jewish refugees during the 1930s but clearly viewed them as 'others.' Alice Massey to Lionel Massey, 18 Nov. 1938, MfamP, vol. 65. The extent to which Massey's personal papers were edited (sanitized) by him or his family prior to deposit with Massey College and the University of Toronto Archives remains undetermined.
67 Massey, *On Being Canadian*, 29–30.
68 Massey, 'Address on the 1931 Biannual Conference of the Institute of Pacific Relations in Shanghai' (to the Canadian Institute of International Affairs, Toronto, 15 Jan. 1932), VMP, 41/20. He argued that restrictions on the attendance of Chinese students at Canada's universities and technical schools, the hindering of Chinese merchants, and the discouraging of Chinese tourists placed Canada in an unfavourable light as a trading partner with China.
69 Palmer, 'Reluctant Hosts.'
70 Hurdalek, *The Hague School*.
71 Hill, *The Group of Seven*, 223–4.

72 Charles Hill provides an overview of Canadian collecting patterns in ibid., 223–37.
73 Massey, 'V.M. on Art, Sculpture, Architecture' (1966–7).
74 Ibid.
75 Massey, *What's Past Is Prologue*, 86. Alice and Vincent Massey corresponded on the acquisition while Vincent was in Ottawa on military duty in 1918. Vincent wrote: 'I have put the Tom Thomson in the hall directly in front of me – its a wonderful thing. I love to think we can possess two or three of them.' Vincent to Alice Massey, 25 Feb. 1918, MFamP, vol. 53. Alice wrote: 'I have written to Dr. MacCallum asking if we [may have?] some more of T.T.'s pictures.' Alice to Vincent, 27 Feb. 1918, MFamP, vol. 33. In a diary entry of Saturday 23 March 1918, Massey noted that he had spent a quiet evening enjoying the newly acquired Thomson sketches.
76 According to Eric Brown, who visited the exhibition in April 1918, the lighting was terrible. Reid, *Tom Thomson*, 31–2.
77 A.Y. Jackson thought that there were about 145 Thomson sketches still left at the Studio Building in 1922. Harold Town and David Silcox, *Tom Thomson: The Silence and the Storm* (Toronto, 1977), 207.
78 Christopher Varley, *F.H. Varley*, 64.
79 Housser, *A Canadian Art Movement*, 215.
80 Christian, *George Grant*, 378, n 15.
81 Siddall, *The Prevailing Influence*, 39.
82 An apparent anomaly in the Masseys' collecting was an interesting group of revolutionary posters and prints acquired by Massey during his trip to the Soviet Union in 1924; my gratitude to Vincent Tovell for bringing this collection to my attention. It was gifted to the Art Gallery of Ontario by Hart Massey between 1982 and 1985.
83 Alice Massey was instrumental in the choice of the property, according to Massey. *What's Past Is Prologue*, 130–1.
84 Massey to A.G. Doughty, 18 March 1927, VMP, 57/03.
85 Massey to the Secretary of State for Canada, 21 July 1927, VMP, 57/03.
86 Eric Brown to Massey, 2 Aug. 1927, VMP, 57/03.
87 According to a list in Massey's papers, 'Canadian Legation Loan 1927–8, Washington, D.C.,' the works were: 1. from the Masseys: A.Y. Jackson's *Winter Road* and *Quebec Village, Winter* (although there is a question mark beside the second one); 2. from the collection of the National Gallery of Canada: Franklin Carmichael, *The Hilltop*; Cornelius Krieghoff, *Indians Running a Rapid* and *Autumn Scenery*; Ernest Lawson, *Winter*; Arthur Lismer, *Big Rock, Bon Echo*; Mabel May, *Boats on the St. Lawrence*;

James Wilson Morrice, *La Britonne*; Charles H. Shannon, *Princess Patricia* (the only non-Canadian work other than the Brant portrait); and Tom Thomson, *Spring Ice*; and 3. from the artists: A.J. Casson, *Cool Weather*; R.S. Hewton, *Nude in Landscape*; G.A. Kulmala, *Sturgeon Lake, Winter*; A.H. Robinson, *Bend in the Road*; and Anne Savage, *April in the Laurentians*; VMP, 57/03. On a separate crate list for the shipment, A.Y. Jackson, *Winter Road*, was crossed off, and the Shannon was not included.

88 Massey to H.O. McCurry, 27 Sept. 1927, VMP, 57/03.

89 Massey to Emma H. Little, 31 January 1928, VMP, 57/03.

90 Ada Rainey, 'Paintings in the Canadian Legation,' *Washington Post*, 2 June 1929.

91 They acquired one of their first works by Jackson, *Winter, Quebec*, under rather unpleasant circumstances. The painting was included in a group show in Ottawa in February 1928. Apparently unbeknownst to the Masseys, who viewed it and left a cheque for it, the artist had sold it to Elise Kingman of Montreal just before the exhibition opened. On the Masseys's behalf, McCurry wrote to Jackson, who in turn wrote to Kingman and asked her to relinquish the picture. McCurry wrote that Vincent Massey 'is most anxious to have the picture as a permanent possession for the Legation. The Canadian Legation is a very important centre and the Canadian pictures there receive constant publicity of an usually desirable kind and I feel that, as you suggest, it would be of considerable importance to the artist to have this particular picture there.' H.O. McCurry to Abner Kingman (Elise Kingman's brother), 5 March 1928, NGC, Acc. file 'A.Y. Jackson: *Winter, Quebec*.' Aside from the apparently inaccurate statement that the picture would be a 'permanent Legation possession,' the pressure on the Kingmans is distasteful; whether it emanated from the Masseys (Alice or Vincent) or McCurry or both is unclear.

On another occasion, in 1934, the Masseys were careful not to be coercive. Alice Massey wrote to Jackson to revise an earlier request for him to approach Brooke Claxton and his wife, Helen, about a picture by Anne Savage (Helen's sister). Learning of Alice's original inquiry to the Claxtons, Vincent worried that even making the inquiry put pressure on the couple, who clearly treasured the picture, which was a view from their house; he asked that Alice withdraw the request, which she did. Alice Massey to A.Y. Jackson, 28 May 1934, VMP, 6.

92 Massey to Lawren Harris, 27 June 1928, VMP, 57/03. By 1928, the Masseys owned Harris's *In the Ward, Toronto*. Later, they acquired three other works

by him: *Lake Superior I, Lake Superior II,* and *Iceberg, Smith Sound.* Art Gallery of Toronto, *Canadian Paintings, the Collection of the Hon. Vincent and Mrs. Massey,* cat. nos. 109–12.

93 Lawren Harris to Alice Massey, 28 Oct. 1929, VMP, 6; whether this was 'Afternoon Sun, Lake Superior' is unclear. See also Massey to Harris, 27 June 1928, VMP, 57/03.

94 Massey to Lawren Harris, 10 April 1929, VMP, 57/03. Later, Massey had reservations about Harris's abstract paintings. 'While I could see the beauty of movement and rhythm in some of the designs,' he could 'never quite enjoy them.' Massey, 'V.M. on Art, Sculpture, Architecture' (1966–7).

95 Massey to Lawren Harris, 27 June 1928, VMP, 57/03.

96 Massey, 'Address' (16 May 1930).

97 Vincent Massey met the prominent American collector and benefactor Duncan Phillips during his Washington stay; Massey to Lawren Harris, 27 June 1928, VMP, 57/03. Through Massey, Phillips offered to lend the Art Gallery of Toronto thirty to forty French masterworks; this led presumably to the show 'Paintings lent by the Phillips Memorial Gallery, Washington,' held at the gallery 3–28 November, 1928. McKenzie and Pfaff, 'The Art Gallery of Ontario,' 69.

98 Massey, 'Address' (16 May 1930).

99 In 1933–4, its membership numbered 627; Canadian Institute of International Affairs, 'Annual Report,' 1933–4, VMP, 33/10.

100 Massey reported that three reports by study groups were appearing in 1934: 'Canadian Economic Policies,' by Professor H.A. Innis; 'Monetary Policy with Particular Reference to Canada,' ed. A.F.W. Plumptre; and 'Canada and the Collective System.' Massey, 'The Canadian Institute of International Affairs,' 1934, VMP, 33/6.

101 Massey to chairman (unnamed), CIIA, 26 January 1932, VMP, 33/09.

102 It is unclear from Massey's papers if he was elected or re-elected president in February 1934. His term of office is not given. CIIA, 'Annual Report,' 1933–4, VMP, 33/10.

103 Massey, 'Address on the 1931 Biannual Conference of the Institute of Pacific Relations in Shanghai' (to the CIIA, Toronto, 15 Jan. 1932), VMP, 41/20.

104 *Catalogue of Highly Important Old and Modern Pictures and Drawings, Fine English and French Furniture, Engravings, Early English, Chinese and Continental Porcelain, Aubusson Tapestry, and Works of Art/Chester Massey, Sir William Mackenzie, Sir Edmund Walker Collections* (Toronto, 1927).

105 Massey to A.Y. Jackson, 4 June 1930, VMP, 6.

106 Jackson, *A Painter's Country*, 96.

107 A.Y. Jackson to Massey, 31 May (1930), VMP, 6.

108 Massey to Charles Stewart (Minister of the Interior), 6 June 1930, VMP, 6.

109 Added Jackson in 1958, 'nowadays this country has become as remote as Wall Street. If a Canadian wishes to visit the Canadian Arctic, he has to get permission from Washington.' *A Painter's Country*, 113.

110 A.Y. Jackson to Massey, 23 Jan. (1932), VMP, 6.

111 Ibid.

112 A.Y. Jackson to Massey, 27 Sept. (1933), VMP, 6.

113 A.Y. Jackson to Massey, 27 April (1934), VMP, 6.

114 A.Y. Jackson to Alice Massey, 27 April (1934), VMP, 6.

115 Alice Massey to A.Y. Jackson, 30 April 1934, VMP, 6.

116 A.Y. Jackson to Alice Massey, 6 May (1934), VMP, 6.

117 A.Y. Jackson to Massey, n.d. (July/Aug. 1934), VMP, 6.

118 Massey to A.Y. Jackson, 10 Aug. 1934, VMP, 6.

119 A.Y. Jackson to Alice Massey, 3 March (1935), VMP, 6.

120 A.Y. Jackson to Alice Massey, 27 April (1934), VMP, 6.

121 Lilias Torrance Newton to Alice Massey, 17 Jan. 1934, VMP, 7.

122 Lilias Torrance Newton to Alice Massey, 30 Sept., 1934, VMP, 7.

123 Bissell, *The Young Vincent Massey*, 187.

124 Colin S. MacDonald, *A Dictionary of Canadian Artists*, rept 3rd ed. (Ottawa, 1989), vol. 4, 1067.

125 The Masseys proposed the commission in October 1934. It was authorized as an expenditure in Massey Foundation, meeting minutes, 12 April 1934, VMP, 106/07. Payments totalling $4,000 were made to Ogilvie in 1935 and 1936. Massey bequeathed the studies for the chapel murals to Hart House; R.H. Hubbard, 'Vincent Massey and the Arts,' in Hubbard, *Vincent Massey Bequest*, 7.

126 F. Maud Brown, *Breaking Barriers*, 66.

127 David Silcox has recently examined the Massey–Milne correspondence in some detail, providing many helpful insights. *Painting Place*, 250–61. Nevertheless, after sifting through the documentation, I conclude that their complex relationship warrants review for the insights that it yields into Massey's nationalism.

128 Massey, *What's Past Is Prologue*, 88.

129 Presumably the *7th Annual Exhibition of Canadian Art*, organized by the National Gallery of Canada, 22 Jan.–23 Feb. 1932 (cat. 198, *Window*).

130 Alice Massey to David Milne, 28 March 1932, VMP, 376/17.

131 The letter is paginated to number 26, but Milne added a '10B,' and there

is a covering memorandum of two pages. David Milne to Alice and Vincent Massey, 20 Aug. 1934, VMP, 585/01.

132 Dorothy Farr, *Lilias Torrance Newton*, 23, n 10.

133 Alice Massey to David Milne, 17 Sept. 1934, VMP, 376/17.

134 Silcox, *Painting Place*, 252ff.

135 David Milne to Alice and Vincent Massey, 20 Aug. 1934, VMP, 585/09.

136 The 300 works were those that Milne had sent and constituted his entire production since returning to Canada in 1928, except for about a half-dozen that he had sold before 1934 and about forty still in Buffalo, but not the New York group.

137 Alice Massey to David Milne, 3 Oct. 1934, VMP, 376/17.

138 David Milne to Alice Massey, 10 Oct. 1934, MFamP, vol. 34.

139 Massey to David Milne, 13 Oct. 1934, VMP, 376/17.

140 David Milne to Alice Massey, 28 Oct. 1934, VMP, 376/17.

141 Donald W. Buchanan, 'An Artist Who Lives in the Woods,' *Saturday Night* 50, no. 4 (1 Dec. 1934), 2; 'David B. Milne,' *Canadian Forum* 15, no. 173 (Feb. 1935), 191–3.

142 She sent Milne copies of the *Studio* magazine, a newly published three-volume collection of Vincent Van Gogh's letters for Christmas 1935, and periodic other gifts. Alice Massey to David Milne, 11 Dec. 1935, MFamP, vol. 34.

143 Alice Massey to David Milne, 5 Nov. 1934, VMP, 376/17.

144 Alice Massey to David Milne, 29 Nov. 1934, VMP, 376/17.

145 David Milne to Alice Massey, 28 Nov. 1934, VMP, 376/17.

146 R. Mellors to Massey, 10 Dec. 1934, VMP, 386. G. Blair Laing stated that the gallery had no verbal or written contract with Milne or the Masseys between 1934 and 1938. *Memories of an Art Dealer*, 60.

147 Robert Mellors to Massey, 10 Sept. 1936, MFamP, vol. 34.

148 Massey to H.S. Southam, 6 March 1935, VMP, 4.

149 Silcox, *Painting Place*, 11.

150 Alice Massey to David Milne, 2 March 1935, VMP, 376/17.

151 W.M. O'Connor wrote that in a recent meeting 'Mr. Laing of Mellors Galleries explained that they had regarded all Mr. Milne's paintings as part of the contract with you and naturally had not made any attempt to keep a detailed schedule of expenses on any one or group of Mr. Milne's paintings.' W.M. O'Connor to Massey, 1 Nov. 1938, MFamP, vol. 34.

152 David Milne to Alice Massey, 17 Oct. 1935, VMP, 376/17.

153 David Milne to Alice Massey, 24 Feb. 1938, MFamP, vol. 34.

154 Massey to W.M. O'Connor, 20 Sept. 1938, MFamP, vol. 34.

155 To confuse the matter further, the Masseys evidently believed that they had

indeed bought a second allotment of sixty-five pictures from Milne in 1935 for $250, which would amount to less than $5 a piece. Massey to W.M. O'Connor, 20 Sept. 1938, MFamP, vol. 34. Alice Massey made the same assumption in a letter to Milne when she referred to 'the second lot' being purchases. Alice Massey to David Milne, 30 Nov. 1937, MFamP, vol. 34. To Milne's mind, the money that he was paid for this second lot was merely an advance; as he said, the pricing of the original deal of $5 per work was hardly sustainable from his standpoint. Milne eventually relinquished claim to this second group, ostensibly as the path of least resistance. Massey did concede that subsequent works, from the years after 1935, were clearly owned by Milne and were wrongfully grouped together with the Massey works. Massey to W.M. O'Connor, 6 Oct. 1938, MFamP, vol. 34.

156 David Milne to Alice Massey, 25 Jan. 1938, MFamP, vol. 34.

157 David Milne to Alice Massey, 28 Aug. 1938, MFamP, vol. 34.

158 Massey to the National Trust Company Ltd., 20 Sept. 1938, MFamP, vol. 34.

159 David Milne to Alice Massey, 11 Feb. 1938, MFamP, vol. 34.

160 Memo, March, 1937, MFamP, vol. 34. Some Milnes were also hung in the Oxford rooms of their two sons, Lionel and Hart.

161 Alice Massey to David Milne, 29 April 1936, MFamP, vol. 34.

162 Alice Massey to David Milne, 17 Feb. 1938, MFamP, vol. 34.

163 Alice Massey to David Milne, 29 April 1936, MFamP, vol. 34.

164 David Milne to Alice Massey, 24 Feb. 1938, MFamP, vol. 34.

165 Alice Massey to David Milne, 27 Jan. 1938, MFamP, vol. 34.

166 Alice Massey to David Milne, 17 Feb. 1938, MFamP, vol. 34.

167 J.S. McLean, 'On the Pleasures of Collecting Paintings,' *Canadian Art* 10, no. 1 (Oct. 1952), 4.

168 Alice Massey to Robert Mellors, 11 Dec. 1935, MFamP, vol. 34.

169 Charles S. Band to Massey, 3 Nov. 1932, and Massey to Band, VMP, 389/17.

170 Hill, *The Group of Seven*, 18.

171 David Milne to Alice Massey, 28 Aug. 1938, MFamP, vol. 34.

172 Massey to W.M. O'Connor, 6 Oct. 1938, MFamP, vol. 34.

173 Massey to W.M. O'Connor, 20 Sept. 1938, MFamP, vol. 34.

174 David Milne to Vincent and Alice Massey, 6 May 1939, VMP, 376/16.

175 Alice Massey to Will Ogilvie, 29 Nov. 1939, VMP, 106/07.

176 Alice Massey to David Milne, 29 Nov. 1934, VMP, 376/17.

177 The exhibition catalogue – Art Gallery of Toronto, *Canadian Paintings, the Collection of the Hon. Vincent and Mrs. Massey* – listed a total of 134 works (nos. 100–232, including 207a), although a contents list for insurance purposes had 132 works. AGOA, Ex. File.

178 'Notable Collection of Canadian Paintings,' *Canadian Homes and Gardens* 12, no. 1–2 (Jan.–Feb. 1935), 20.

179 Ibid.

180 Pearl McCarthy, *Mail and Empire*, Toronto, 7 Dec. 1934, VMP, 5.

181 Augustus Bridle, 'Massey's Canadiana Feature at Gallery,' *Toronto Daily Star*, 7 Dec. 1934, VMP, 5.

182 For a brief but helpful overview, see Villeneuve, *Baroque to Neo-Classical Sculpture in Quebec*, 18–21.

183 'Canadian Week' (pamphlet), New York (Oct. 1927), VMP, 51.

184 Massey to Marius Barbeau, 11 Jan. 1928, and Barbeau to Massey, 11 Jan. 1928, VMP, 51.

185 Marius Barbeau to Massey, 14 Feb. 1929, and Massey to Barbeau, 21 Feb. 1929, VMP, 51.

186 Barbeau had also organized *Painting, Sculpture, and Wood Carving of French Canada*, shown with the Group of Seven's 1926 exhibition at the Art Gallery of Toronto. Villeneuve, *Baroque to Neo-Classical Sculpture in Quebec*, 20.

187 Martin Baldwin to Massey, 16 Jan. 1935, VMP, 5.

188 Massey's contact with the Carnegie Corporation in fact went back to at least early 1923. W.S. Learned of the corporation wrote that he was trying to find out about organizations engaged in similar work. An exchange of information followed: Learned to Massey, 4 Feb. 1923; Massey to Learned, 22 March 1923; and Learned to Massey, 27 March 1923, VMP, 384/04.

189 Eric Brown, 'Foreword,' in *Contemporary Paintings by Artists of the United States; Canadian Paintings, the Collection of the Hon. Vincent and Mrs. Massey; and in the Print Room Scissors Cuts by Rene Kulbach* (Toronto, 1934). (It was not unusual at this time for catalogues of more than one exhibition to appear together in one volume).

190 One product of this continentalism was a series of conferences on Canadian–American affairs, sponsored by the Carnegie Corporation beginning in 1935. The final one, in Kingston in 1941, coincided with a seminal conference of Canadian artists, the 'Kingston Conference.'

191 Alice Massey to David Milne, 29 Nov. 1935, VMP, 376/17.

192 David Milne to Alice Massey, Dec. 1934, VMP, 376/17.

193 For example, they bought two works by Carl Schaefer in December 1936. H.O. McCurry to Carl Schaefer, 10 Dec. 1936, NGCA, 9.2M Trustees: Vincent Massey, file 1. Massey bought a canvas by Alexander Bercovitch of Montreal as a gift for his wife in May 1936. H.O. McCurry, 6 May 1936, NGCA, 9.2M Trustees: Vincent Massey, file 1. On Massey's death in 1967, 101 Canadian works from his collection were bequeathed to the National

Gallery of Canada, including twenty-seven Milnes. Hubbard, *Vincent Massey Bequest.*

194 Massey was elected to fill a vacancy on the Collections and Exhibitions Committee created by the death of Edmund Morris in 1913. Michael Macaulay (for Finlay), 'An incomplete list of the executive members of the Art Museum/Gallery of Toronto, 1900–1966,' 1987, AGOA.

195 He ensured that Lawren Harris was consulted by the architects, Darling and Pearson, regarding the lighting of the new gallery space. C.B. Cleveland, of Darling and Pearson, to Massey, 24 Nov. 1924, VMP, 32–3.

196 Massey, 'Address at the Laying of the Corner Stone of the New Buildings of the Art Gallery of Toronto' (Toronto, 26 May 1925), MFamP, vol. 43, speech no. 15.

197 Bissell discusses briefly the political circumstances that led to Massey's appointment as a trustee. *The Young Vincent Massey*, 181.

198 Eric Brown, National Gallery of Canada, *Annual Report*, 1923–4, quoted in F. Maud Brown, *Breaking Barriers*, 62–3.

199 Eric Brown to Sir Robert Witt (copy for Vincent Massey), 8 Aug. 1933, VMP, 2/3.

200 Canada showed again in a second Wembley exhibition in 1925. Maud Brown discusses the Wembley controversy and its aftermath in *Breaking Barriers*, 69–75; see also Hill, *The Group of Seven*, 142–51.

201 Massey to Hon. J.C. Elliott (Minister of Public Works), March 1927, VMP, 3.

202 Massey to H.S. Southam, 1 March 1934, VMP, 4.

203 For a study of the gallery's relation to government, see King, 'The National Gallery of Canada at Arm's Length.'

204 A.Y. Jackson to Massey, 18 Nov. (no year), VMP, 3.

205 Massey to Sir Robert Falconer, 29 Jan. 1929, VMP, 3. There is no evidence that Brown received this honour.

206 Massey had considerable contact with the American Federation of Arts (AFA) during his Washington years; he spoke to its twenty-first annual convention. 'Address' (16 May 1930).

207 W.L.M. King to Massey, 4 Oct. 1929, VMP, 2/3.

208 King, 'The National Gallery of Canada at Arm's Length,' 17.

209 Massey to W.L.M. King, 10 Oct. 1929, VMP, 2/3.

210 A.Y. Jackson to Massey, 10 Dec. (1929), VMP, 2/3.

211 Massey to W.L.M. King, 4 Oct. 1929, VMP, 2/3.

212 Lawren Harris to Massey, 3 Feb. 1930, VMP, 2/3. The Masseys bought two pictures in the AFA show: Sarah Robertson's *Joseph and Marie Louise* (National Gallery of Canada) and George Pepper's *A Street in Hull.*

213 Leila Mechlin (Secretary of the AFA) to Massey, 29 April 1930, VMP, 40/7.
214 'Canadian Pictures at Corcoran "Sing a Saga of the North,"' *Art Digest* 4, no. 12 (mid-March 1930).
215 Frederic Allen Whiting to Massey (n.d.), and Massey to Whiting, 5 Jan. 1931, VMP, 376/23.
216 Frederic Allen Whiting to Massey, 15 Jan. 1931, VMP, 376/23.
217 Tippett, *Making Culture*, 145.
218 They had carried out a similar examination in Britain and produced a report on British museums in 1927. S.F. Markham to Massey, 19 June 1931, VMP, 15.
219 Massey met with the two at their request in July 1931.
220 Miers and Markham, *A Report on the Museums of Canada*, 19, 39, 53–4, and 59–62.
221 F.P. Keppel to Massey, 1 June 1933, VMP, 4.
222 H.S. Southam to P.S. Fisher (Southam Publishing Company Limited, Montreal), 7 Feb. 1934, VMP, 4.
223 H.O. McCurry to Massey, 29 May 1933, VMP, 4.
224 H.O. McCurry to Massey, 29 May 1933, Frederick Keppel to Massey, 1 June 1933, and Massey to McCurry, 1 June 1933, VMP, 4. Keppel was listed as first vice-president of the AFA on its letterhead in the spring of 1930. Leila Mechlin to Massey, 29 April 1930, VMP, 40/7.
225 McCurry to Massey, 10 Sept. 1933, VMP, 4.
226 Massey to F.P. Keppel, 5 June 1934, VMP, 4. Currelly never became a member of the committee. I am grateful to Cyndie Campbell, archivist, NGCA, and Jeffrey D. Brisen, fellow in historical Canadian Art, NGC, for this information.
227 Frederick Keppel to Massey, 12 June 1934, VMP, 4.
228 It has been pointed out that Carnegie funds were directed more towards training staff members (who often migrated south to the United States, attracted by its more developed art museum system) than to building the museum infrastructure in Canada. Tippett, *Making Culture*, 145–54.
229 Frederick Keppel to Clarence J. Webster, 10 Sept. 1934, VMP, 4.
230 By contrast, its 1931–32 Parliamentary appropriation had been $100,000.
231 Massey to H.S. Southam, 2 Jan. 1935, VMP, 4. For a sampling of the projects that the Carnegie Corporation supported in Canada, see Tippett, *Making Culture*, 145–54.
232 'In January 1935 a cheque for $7,457.81 Canadian funds was received from Carnegie to be used in cases of emergency only.' NGCA, Carnegie files. I am grateful again to Cyndie Campbell and Jeffrey D. Brison for this infor-

mation. Parliament's appropriation to the gallery was $25,000. National Gallery of Canada, *Annual Report, 1934–1935* (Ottawa, 1936), 23. It was raised to $73,470.45 the following year. *Annual Report, 1935–36* (Ottawa, 1937), 20.

233 Tippett, *Making Culture*, 124.

234 Massey, *What's Past Is Prologue*, 59.

235 Bissell, *The Young Vincent Massey*, 66.

236 'Massey Prize for Canadian Drama: The gift of Mr. and Mrs. Vincent Massey' (typed statement), VMP, 384/18. The committee was made up of Vincent and Alice Massey, the director of Hart House Theatre, and two others. Whether the prize was awarded by the Masseys personally or by the Massey Foundation, or indeed was ever awarded, is unclear.

237 Alice Massey to Mrs. W.J. Kernohan of Toronto, 19 March 1935: 'both Mr. Massey and I are very keen about the fact that we and the other Syndics of Hart House Theatre have appointed its first woman director in Nancy Pyper. Her support by the various women's organizations will mean a great deal.' VMP, 57–8.

238 Saddlemyer and Plant, *Later Stages*, 263.

239 Lord Bessborough, 'Extract from an Address Given by His Excellency The Governor General at The Little Theatre, Ottawa' (Nov. 10, 1931), VMP, 376/26.

240 Bissell, *The Young Vincent Massey*, 178.

241 Massey to Captain A.F. Lascelles (Secretary to the Governor-General, Lord Bessborough), 4 Jan. 1932, VMP, 376/26.

242 Lee, *Love and Whisky*, 105.

243 Massey to G. Dickson Kerwin, 2 Dec. 1929, VMP, 21.

244 Massey, 'Address' (24 April 1933), quoted in Lee, *Love and Whiskey*, 114.

245 Massey to R.S. McLaughlin, 21 May 1935, VMP, 22/23.

246 As late as 1949, the Massey Foundation accounts show $600 paid to the Dominion Drama Festival. MFP, vol. 1, file 6.

247 Lee, *Love and Whisky*, 96–7.

248 Ibid., 287–98.

249 Ibid., 131–2.

250 H.T. Patterson (Stratford Shakespearean Festival of Canada Foundation) to Lionel Massey, 14 May 1953, and Lionel Massey to H.T. Patterson, 1 June 1953, VMP, 368/10.

251 Massey made his personal donation at the last minute in response to a request by Dora Mavor Moore. Paula Sperdakos, *Dora Mavor Moore*, 203.

252 Some indication of its inclusiveness was the 1938 festival winner, Theatre of Action's production of John Wesley's *Steel*, a play of political and social activism. Saddlemyer and Plant, *Later Stages*, 58.

253 Unlike British investment – typically loans – American investment was more fundamental – the creation of branch plants. Susan Crean and Marcel Rioux, *Two Nations: An Essay on the Culture and Politics of Canada and Quebec in a World of American Pre-eminence* (Toronto, 1983), 30.

254 Bissell, *The Young Vincent Massey*, 194.

255 Massey, Diary, 14 April 1928/25 Sept. 1930; cited by ibid., 261, n 37.

256 Charles Bowman to Massey, 11 Dec. 1928, VMP, 59.

257 Charles Bowman to Massey, 10 Dec. 1928, VMP, 59.

258 Massey to Charles Bowman, 2 Jan. 1930, VMP, 59.

259 Massey to Charles A. Bowman, 7 Feb. 1930, VMP, 59.

260 Charles A. Bowman to Sir John Aird, 20 Feb. 1920, VMP, 59.

261 Charles A. Bowman to F.R. MacKelcan, 14 Feb. 1930, VMP, 59.

262 Massey to Bowman, 18 Feb. 1930, VMP, 59.

263 Geza de Kresz to William Lyon Mackenzie King, 24 March 1930, VMP, 59.

264 F.R. MacKelcan to Massey, 7 April 1932, VMP, 59.

265 Massey to O.D. Skelton, 13 March 1930, VMP, 59.

266 Massey to Bowman, 10 Feb. 1930, VMP, 59.

267 Potvin, ed., *Passion and Conviction*, 2.

268 Brooke Claxton, 'Alan Plaunt Memorial Lecture,' 1958, quoted in ibid., 3.

269 Graham Spry (Radio League's brief to the Parliamentary Committee of 1932), quoted in Weir, *The Struggle for National Broadcasting in Canada*, 132.

270 Alan Plaunt to Massey, 14 March 1932, VMP, 59.

271 Alan Plaunt to Massey, 21 March 1932, VMP, 59.

272 Massey to Graham Spry, 25 May 1932, VMP, 59.

273 Alan Plaunt to Massey, 2 June 1932, VMP, 59.

274 Alan Plaunt to Massey, 11 May 1934, VMP, 59.

275 Gladstone Murray to Massey, 16 Feb. 1937, VMP, 166/08.

276 Massey to C.D. Howe, 24 Nov. 1938, VMP, 166/07.

277 Massey, 'Address' (22 May 1930).

Chapter 5: The State and the Arts: British Models

1 Massey was acting secretary of the Round Table Society at a meeting in Toronto on 9 June 1911 and still active with the group in 1917. In 1918, he asked that the records of the Round Table office be transferred to Arthur J. Glazebrook, VMP 414/08. Edward Kylie was a friend of Massey's in the Department of History at the University of Toronto. According to Massey, Kylie attended Oxford, became a history don at Toronto, and played an important role in the Round Table movement. It was Kylie who 'principally induced' Massey to apply for admission to Balliol. Massey, 'Postscript' (1966–7).

2 Massey to Rev. H.J. Cody (Chairman, Board of Governors), University of Toronto, 10 Feb. 1931, VMP, 86/03.

3 Massey, 'Address' (on the occasion of the first Massey Lecture, March 1932, given by Lord Irwin), VMP, 85/01.

4 Massey, 'Address' (to the Canada Club, London, 1935), VMP, 172/08. During the war, for example, a memo from Britain's Dominions Office stated: 'The Britain to portray to the young nations of the Commonwealth is not so much the land of winding lanes, Tudor cottages, rustic accents, venerable shrines and beefeaters at the Tower ... as the country of modern inventions, up to date classrooms and canteens, new factories, broad highways, great airfields, the home of an energetic and enterprising race.' Dominions Office memo from Boyd Shannon, 26 July 1943; PRO, DO35/1911/2441/5, quoted in Diana Eastment, 'The Policies and Position of the British Council,' 259.

5 Prime Minister King named Massey high commissioner in 1930, but with the change in government in July the appointment ended. With King's return to power in 1935, the appointment was made a second time.

6 Eric Brown to the Governor-General (Viscount Willingdon), 10 Feb. 1930, NGCA, 9.2M Trustees: Vincent Massey, file 1.

7 H.O. McCurry to Alice Massey, 7 Feb. 1930, VMP, 160/03. McCurry pointed out that Labour Prime Minister Ramsay MacDonald had commended the growing practice of exhibition exchange within the Commonwealth.

8 Massey to H.O. McCurry, 6 June 1930, NGCA, 9.2M Trustees: Vincent Massey, file 1.

9 Massey had been well acquainted with Ricketts and his views on collecting, visiting him in London as early as 1926. Boggs, *The National Gallery*, 19.

10 Eric Brown to Massey, 31 May 1937, VMP, 170/07. Oppé helped to build the gallery's drawings collection until his death in 1956; see Boggs, *The National Gallery*, 33.

11 Eric Brown to Massey, 5 July 1937, VMP, 170/07.

12 Rigaud, *Self-Portrait*, signed and dated 1699.

13 Massey to Eric Brown, 1 March 1938, VMP, 170/07.

14 Massey to Kenneth Clark, 9 Nov. 1937, NA, Canada House Records, RG 25 A5, vol. 390, file M376/HC/37.

15 Albert H. Robson to Massey, 20 July 1938, VMP, 170/08.

16 Martin Baldwin to Massey, 6 Dec. 1938, and Baldwin to Massey, 22 Nov. 1938, VMP, 170/08.

17 The collection of 132 works (which did not include all the Milnes) was sent to England with the assistance of the National Gallery of Canada, 'Pictures Packed by the National Gallery to be Shipped to London, England,' with a

note dated 7 Nov. 1935, VMP, 5. Massey and McCurry corresponded about who should bear the cost; Massey acknowledged uncertainty as to transportation from Port Hope to Ottawa, but he considered the insurance premium on the collection's voyage overseas to be 'clearly a Government responsibilility.' Massey to H.O. McCurry, 3 April 1936, VMP, 170. In the end, the National Gallery picked up the shipping costs, because it had neglected to issue a statement of costs to Massey until after he had submitted his moving expenses to External Affairs. As McCurry added, the expenses would only be coming from another government department anyway(!). H.O. McCurry to Massey, 14 April 1936, VMP, 170. There are other instances of the National Gallery's doing the Masseys 'favours' – principally making contact with artists for them to purchase works. This was fairly acceptable practice at the time (though unethical by today's museum standards), particularly because public galleries then held exhibitions in which art was for sale.

18 Massey to H.O. McCurry, 3 April 1936, VMP, 170.

19 Eric Newton wrote to Massey to introduce Shadbolt. 22 March 1938, VMP, 195. Shadbolt went to England to study art in the autumn of 1937 and was among the first class of students at the Euston Road School. He and Alice Massey corresponded during 1938 and 1939. VMP, 366/10.

20 Bissell, *The Imperial Canadian*, 45.

21 H.W. Maxwell to Massey, 2 May 1936, VMP, 180/07.

22 Massey to H.W. Maxwell, 5 May 1936, VMP, 180/07.

23 Eric Brown to Massey, 5 July 1937, VMP, 170/07.

24 H.O. McCurry to Massey, 9 Aug. 1937, NGCA, 92.M Trustees: Vincent Massey, file 1.

25 Massey to Eric Brown, 5 July 1938, VMP, 170.

26 John Rothenstein to C. Goodyear, Chairman, Museum of Modern Art, New York, 16 July 1938, VMP, 192/21.

27 Massey, 15 Dec. 1937, VMP, 366/10.

28 Massey to H.O. McCurry, 10 Jan. 1938, VMP, 170.

29 Eric Brown stated that the National Gallery intended to create an advisory committee 'consisting of the Presidents of the Royal Canadian Academy, Canadian Group [of Painters], Sculptors' Society, Water Colour Society; also [the] Curator of the Toronto Gallery and [the] Professor of Art at Toronto University, with Clarence Gagnon to represent French Canada.' This body was to select the artists and priorize their inclusion in the Tate exhibition, while Brown and McCurry were to make the actual selection of works. Brown to Massey, 15 March 1938, NGCA, 9.2M Trustees: Vincent Massey, file 1.

30 Massey to Brown, 24 March 1938, VMP, 366/10.

31 Ibid.

32 Ibid.

33 Eric Brown to Massey, 23 Feb. 1938, VMP, 170; Massey to Brown, 27 May
 1938, VMP, 366/10. Alice Massey was also involved, hosting two parties in
 connection with the event. However, her role is difficult to profile in detail.
 Evan Charteris to Alice and Vincent Massey, 16 Oct. 1938, MFamP, vol. 72.
 The Masseys bought at least one painting from the exhibition – a work by
 Pegi Nicol MacLeod, *School in a Garden* (National Gallery of Canada). H.O.
 McCurry to Massey, 1 Aug. 1939, VMP, 170.

34 The only published survey of Canadian art to that date was Newton
 MacTavish, *The Fine Arts in Canada* (Toronto, 1925); while it began with
 Native art, it eclipsed early Quebec art.

35 Massey, 'Foreword,' in *A Century of Canadian Art.*

36 Massey, 'Address' (14 Oct. 1938).

37 Ibid.

38 Massey to H.S. Southam (cable), 17 Oct. 1938, VMP, 170.

39 Massey to Eric Brown, 8 Nov. 1938, VMP, 170.

40 Eric Brown to Massey, 19 Nov. 1938, VMP, 170.

41 Eric Brown to Massey, 16 June 1938, VMP, 366/10.

42 Massey to Lionel Massey, 10 Nov. 1938, MFamP, vol. 64.

43 Both their sons, Lionel and Hart, attended Oxford during the Masseys' stay
 in England. Lionel was president of the New Oxford Art Society (as distinct
 from the Oxford Art Club), in which capacity he arranged lectures on art
 with the help of the London Gallery. Lecturers included Laszlo Moholy-
 Nagy, Hungarian-born Constructivist painter and sculptor, English painter
 John Piper, and art critic Eric Newton. Lionel Massey to the Director of the
 London Gallery, April 1937, MFamP, vol. 64.

44 City of Gloucester Municipal School of Art and Crafts to Massey, 17 May
 1939, VMP, 198.

45 Massey, 'Address' (4 Feb. 1938).

46 H.O. McCurry to Massey, 18 July 1941, NGCA, 9.2M Trustees: Vincent
 Massey, file 2. McCurry had initially planned to make the first film on Tom
 Thomson 'while Dr. MacCallum and others associated with Thompson's
 development were still with us. I got Graham McInnes to do a script and
 ['Budge'] Crawley [of Crawley Films, Ottawa,] to do the film as a specula-
 tion for $300.00.' The Thompson project was abandoned, however, for the
 time being; 'it was too difficult to do an artist who was dead as a first film.'
 They began work on a film on Jackson instead. When Grierson saw the
 'take,' he was 'tremendously impressed and offered the services of the

Film Board to finish it.' However, McCurry received this assistance as a mixed blessing: 'The Film Board is not too well organized yet and at times Grierson takes a rather dictatorial attitude which is not wise when an experimental film of this kind is involved.' McCurry to Massey, 18 June 1942, VMP, 387/38.

47 Massey to Lionel Massey 4 Dec. 1942, MFamP, vol. 65.

48 Massey to Lionel Massey, 1 Jan. 1944, MFamP, vol. 65.

49 Mellor, ed., *A Paradise Lost*, 11 and 110; and John Piper, *British Romantic Artists* (London, 1942, 1946). See also Clark, *The Other Half*, 24–5.

50 McMurry and Lee, *The Cultural Approach*, 12.

51 The BBC was established initially in 1922 as a private company, but in 1927 it was made public. While funded by the government, it was set up as a virtually autonomous entity.

52 For the events leading to its creation, see Taylor, *The Projection of Britain*, 125–52.

53 In 1994, the Arts Council of Great Britain was divided into councils for England, Northern Ireland, Scotland, and Wales.

54 Minihan, *The Nationalization of Culture*, 219ff.

55 Ibid., 226.

56 Ibid., 225–6.

57 Massey, 'Address' (30 May 1947). The 'picture of the month' was displayed during the day and placed in a strongroom during the night.

58 Massey, 'Address' (21 June 1945).

59 The government established the 'British Restaurants' during the war. Often located in parish halls and apparently unfailingly dismal, they were intended to provide civilians with a supplementary food source (beyond rations) at low prices. Jane Clark was recruited to improve the decor of those of Greater London. Kenneth Clark, *The Other Half*, 56.

60 Massey to Lionel Massey, 14 April 1943, MFamP, vol. 65.

61 Massey, 'Address' (7 April 1943).

62 Massey to Kenneth Clark, 20 Dec. 1939, VMP, 246/08.

63 Robertson, *A Terrible Beauty*, 14.

64 'Britain at War Exhibition Soon to Thrill Canadians,' *Spectator* (Hamilton), 26 July 1941.

65 Harries and Harries, *The War Artists*, 269.

66 H.O. McCurry to A.Y. Jackson, 16 Sept. 1941, NGCA, 4.3–D.W. Buchanan.

67 Correspondence between Massey and the National Trust Company, Jan. 1940, VMP, 248/08.

68 Correspondence between Massey and David Milne, July and Sept. 1939, VMP 246/08.

69 H.O. McCurry to Massey, 18 June 1942, VMP, 387/38.

70 H.O. McCurry to Massey, 18 July 1941, NGCA, 9.2M Trustees: Vincent Massey, file 1.

71 Alice and Vincent Massey to Lionel Massey, 11 Sept. 1941, MFamP, vol. 65.

72 Alice Massey to Lionel Massey, n.d. (Sept. 1941), MFamP, vol. 65.

73 Massey to H.O. McCurry, 14 Aug. 1942, NGCA 9.2–M Trustees, Vincent Massey, file 2.

74 Alice Massey to Lionel Massey, 26 Aug. 1943, MFamP, vol. 65.

75 Alice Massey to Lionel Massey, 2 Dec. 1943, MFamP, vol. 65.

76 Others participants were Julian Huxley, Desmond MacCarthy, Stephen Spender, and W.J. Turner. Massey, 'Postscript.' (1966–7).

77 Massey to Captain the Lord Herbert, St. James's Palace, 8 Jan. 1944, VMP 192 2/3.

78 It showed at the National Gallery of Canada from 10 May to 10 July, 1946, and circulated from September 1946 to August 1947.

79 Massey, 'Foreword,' in *Exhibition of Canadian War Art* (Ottawa, 1946).

80 Massey to W.L.M. King, 16 Nov. 1945, VMP, 387/38.

81 Massey to Captain the Lord Herbert (St. James's Palace), 3 Feb. 1944, VMP, 192/2–3.

82 H.O. McCurry to Massey, 8 Dec. 1944, NGCA, 9.2M Trustees: Vincent Massey, file 2.

83 Joyce Zemans, 'Envisioning Nation: Nationhood, Identity and the Sampson-Matthews Silkscreen Project: The Wartime Prints,' *Journal of Canadian Art History/Annales d'histoire de l'art canadien* 19, no. 1 (1998), 34.

84 Kenneth Clark to Massey, 16 May 1941, VMP 371/05.

85 Alice Massey to Lionel Massey, 30 May 1941, MFamP, vol. 65.

86 Massey to H.S. Southam, 1 June 1943, VMP, 371/05.

87 Kenneth Clark to Massey, 3 Dec. 1943, VMP, 371/05.

88 Kenneth Clark to Massey, 3 Dec. 1943, VMP, 371/05.

89 Massey to Kenneth Clark, 7 Dec. 1943, VMP, 371/05.

90 Others were Leigh Ashton, Sir Eric MacLagan, and Hon. Jasper Ridley.

91 A report on the committee's recommendations was then prepared by the Standing Commission on Museums and Galleries, dated 21 December 1945, and the two were published as United Kingdom, *The Report of the Committee,* TGA.

92 The report also tackled the Tate's mandate as a national collection of modern foreign art, noting that contemporary foreign art was virtually unrepresented in the national collections. While the report recommended strengthening this area of the Tate's mandate, it emphasized that the two

collections should be managed separately. United Kingdom, *Report of the Committee* (confidential copy), 7, VMP, 387/03.

93 United Kingdom, *Report of the Committee*, 15.

94 Ibid., 21.

95 Ibid., 22.

96 When Massey was notified of the bill's passage, his correspondent wrote: 'It is only 8 1/2 years since your original report was published, which was the inspiration for this measure, and I think we should score this as rapid and satisfactory progress in this very controversial and delicate operation.' The Rt. Hon. R.A. Butler to Massey, 3 Dec. 1954, VMP, 386/07. A further indication of the trust and respect that Massey had secured in art circles in London was his appointment to Britain's Committee on the Preservation and Restoration of Works of Art, Archives, and Other Material in Enemy Hands, set up in 1944. Massey, *What's Past Is Prologue*, 377.

97 Massey to H.V. Laughton, National Trust Company, 29 March 1938, VMP, 250.

98 Alice Massey to Lionel Massey, 25 Oct. 1942, MFamP, vol. 65. Vincent, Alice, Lionel, and Hart Massey were the four trustees of the foundation in 1946. Massey to H.O. McCurry, 29 March 1946, NGCA, Gifts: Bequests/ Oils 1.71–M Presented by Massey Foundation. The other project was Garnons, a convalescent home for Canadian officers about 150 miles west of London. Bissell, *The Imperial Canadian*, 154–9.

99 Eric Brown to Alice and Vincent Massey, 24 Sept. 1938, VMP, 250.

100 Alice Massey to Lionel Massey, 21 Oct. 1942, MFamP, vol. 65.

101 Dudley Tooth to Alice Massey, 8 June 1938, VMP, 198. They purchased art also from the Barbizon House, Ernest Brown & Phillips Ltd./The Leicester Galleries, Redfern Gallery, Zwemmers Gallery, as well as from P. & D. Colnaghi & Co. Ltd. On occasion they also bought from Roland, Browse and Delbanco (from which they acquired a William Nicholson) and from the Matthiesen Gallery (Gwen John's *Young Woman in Grey Cloak*). John Piper's *House of Commons, 1941, AYE Chamber*, came from J. Leger & Son.

102 Alice Massey to Will Ogilvie, 13 Jan. 1936, VMP, 366/10.

103 This was John's *An Equihen Fisher Girl* (c. 1900, oil on canvas, 45.7 × 38.1 cm). Massey to Lionel Massey, 30 July 1941, MFamP, vol. 65.

104 Alice Massey to Lionel Massey, 3 Sept, 1941, MFamP, vol. 65.

105 Massey to Lionel Massey, 28 May 1942, MFamP, vol. 65.

106 The works that they acquired for Lionel were mostly British and included examples by Tristram Hillier, Ivon Hitchens, Augustus John, David Jones,

Paul Nash, Sickert, and Gilbert Spencer. For themselves, they bought
works by Frances Hodgkins, Augustus John, and Matthew Smith, while
Hart acquired at least one painting by Matthew Smith. 'Pictures (Per-
sonal),' a typed list in Massey's London papers, undated but with a hand-
written addendum, Nov. 1944, VMP, 238/1.

107 Clark explained that there were very few good books in English; most
were in German. This in itself was revealing about the study of art in
England at the time. Nevertheless, Clark helped the Masseys follow the
book auctions. In 1944, for example, they acquired art books from the
collection of Michael Sadler, one of the leading collectors of contempor-
ary art in Britain. While they had some of the books mailed to Lionel by
Zwemmers, they kept many in London for his return. Alice Massey to
Lionel Massey, 15 March 1944 and n.d. (April 1942), MFamP, vol. 65.

108 Massey to Lionel Massey, 7 July 1943, MFamP, vol. 65.

109 Massey to H.O. Southam, 28 April 1939, VMP, 192 2/3.

110 Massey to Lionel Massey, 30 Jan. 1942, MFamP, vol. 65.

111 Ibid.

112 This is confirmed by an interim list of works purchased by mid-1939.
Massey to John Rothenstein, 6 June 1939, VMP, 250.

113 Alice Massey to Lionel Massey, 3 April 1941, MFamP, vol. 65.

114 Alice Massey to Lionel Massey, 28 March 1941, MFamP, vol. 65.

115 Alice Massey to Lionel Massey, 9 Sept. 1941, MFamP, vol. 65. The painting
is entitled *Portrait of T.E. Lawrence as Aircraftman Shaw*. Lawrence took the
name 'Shaw' in 1922.

116 Alice Massey to Lionel Massey, 9 Sept. 1941, MFamP, vol. 65.

117 Cork, *A Bitter Truth*, 204 and 206. The Masseys intended that the cartoon
be installed on the north wall of the Great Hall at Hart House. The price
was £3,000, to be paid in three annual instalments. The drawing was stored
at Garnons until the end of the war. Massey to W. O'Connor, 18 Feb. 1941,
VMP, vol. 250. By 1946, the Masseys' plan had changed. Massey contacted
H.O. McCurry to say that they intended to present it to a Canadian institu-
tion but had not decided which one. 'We will certainly see to it that it will
not suffer the fate of the collection of war pictures which has reposed in
darkness for the last twenty-five years.' Massey to McCurry, 23 April 1946,
VMP, 250. In the meantime, they asked McCurry to store the drawing for
them. The drawing entered the National Gallery of Canada's collection in
1972, a gift of the Massey Foundation.

118 For Clark's friendship with and patronage of Moore, Piper, Sutherland,
and Victor Pasmore, see Clark, *A Self-Portrait: Another Part of the Wood*
(London, c. 1974, 1985), 254–6; and *The Other Half*, 42–3. The Sutherlands

lived with the Clarks for two years during the war. See also Dennis Farr, *English Art*, 362–3.

119 Alice Massey was not entirely uncritical of the Clarks: 'I sometimes think, although I like him very much, he is rather arrogant and intolerant. I think they have made the mistake of keeping too much in touch with the extremely smart world in London.' Alice Massey to Lionel Massey, 18 Nov. 1938, MFamP, vol. 64.

120 Jane Clark to Alice Massey, n.d. (Nov. 1938?), VMP, 193/27.

121 Kenneth Clark to Alice Massey, 27 July 1939, VMP, 192 2/3.

122 Massey to Kenneth Clark, 2 Aug. 1939, VMP, 192 2/3.

123 Massey to Lionel Massey, 30 Jan. 1942, MFamP, vol. 65.

124 Alice Massey to Lionel Massey, 28 July 1943, MFamP, vol. 65.

125 Massey to Lionel Massey, 23 April 1942, MFamP, vol. 65.

126 Massey to Lionel Massey, Jan. 1944, MFamP, vol. 65.

127 Massey to H.S. Southam, 29 March 1946, NGCA 1.71–M Gifts/Bequests: Presented by the Massey Foundation.

128 John Rothenstein to Massey, 26 May 1939, VMP, 250.

129 Massey to John Rothenstein, 6 June and 13 June 1939, VMP, 250.

130 Eric Newton, U.K. Information Office press release, April 1946, NGCA 1.71–M Gifts: Bequests/Oils: Presented by the Massey Foundation.

131 National Gallery of Canada, *The Massey Collection of English Painting* (Ottawa, 1946). Accompanying the Tate showing of the exhibition was *A Selection of Contemporary English Painting* (London, 1946).

132 W.L. Mackenzie King, Diaries, 20 April 1946, NA, W.L.M. King Papers, MG 26J, quoted in Bissell, *The Imperial Canadian*, 173.

133 W.L.M. King to Massey, 10 April 1946, VMP, 250.

134 H.O. McCurry to Massey, 26 April 1946, NGCA Gifts: Bequests/Oils 1.71–M Presented by the Massey Foundation.

135 National Gallery of Canada, *The Massey Collection of English Painting*.

136 Ibid.

137 Press releases, 1946–7; 'Massey Collection of English Painting,' NGCA, 1.71M Gifts: Bequests/Oils: Presented by the Massey Foundation.

138 Massey to W.L.M. King (two letters), 18 March 1946; NGCA 1.71–M Gifts: Bequests/Oils: Presented by the Massey Foundation.

139 Massey to W.L.M. King, 18 March 1946, VMP, 250. He pressed the point home in a second letter to King: 'We hope that it [the collection] will give pleasure to the large picture-loving public which is now to be found throughout the country.' Massey to King, 18 March 1946, VMP, 250.

140 R.H. Hubbard, *Evening Citizen* (Ottawa), 31 Oct. 1946, NGCA, Gifts: Bequests/Oils 1.71M Presented by the Massey Foundation.

141 Bess Harris to Alice Massey, 11 April 1947, MFamP, vol. 53.
142 Graham McInnes, 'British Art Presented to National Gallery,' *Saturday Night* 62, no. 9 (2 Nov. 1946), 16.
143 Massey to H.O. McCurry, 4 Feb. 1949, VMP, 391/09. A further two works (Duncan Grant, *Market Day* and Paul Nash, *Solstice of the Sunflower*) were added to the collection on 22 May 1952. On 16 April 1958, the Massey Foundation gave three additional works which did not constitute part of the Massey Collection of English Painting. E. McLaren, Memo to file, 24 June 1970, NGC, Acc. file no. 4925: 'Moore: *Family Group*.'
144 Lawren Harris to H.O. McCurry, 13 Jan. 1952, NGCA 5.4 M Canadian Exhibitions/Foreign: Massey Collection of English Painting Exhibition, 1949–52, file 2.
145 In 1906, the first work to be purchased by the Art Gallery of Ontario (then the Art Museum of Toronto) was by British artist Edward Hornel, *The Captive Butterfly*. The Vancouver Art Gallery, founded in 1931, made its first collecting priority the acquisition of British art. Lorna Farrell-Ward, 'Tradition/Transition: The Keys to Change,' in *Vancouver: Art and Artists*, 23.
146 It was founded in 1886 and became in 1954 the Commonwealth Society of Artists.
147 Eric Brown, *An Exhibition of Contemporary British Painting*.
148 Eric Brown to W.G. Constable, 12 June 1934, NGCA, British Contemporary Painting Exhibition, 1935, file 5.5B, no. 1.
149 McMurry and Lee, *The Cultural Approach*, 12.
150 Eastment, 'The Policies and Position of the British Council.'
151 Ibid., 58 and 60.
152 Taylor, *The Projection of Britain*, 153.
153 A vociferous propaganda campaign during the First World War had been conducted under the direction of newspaper magnates Lord Northcliffe and the Canadian Lord Beaverbrook, head of Britain's wartime Ministry of Information, set up in early 1918. Beaverbrook was the first person to employ photography and film in the promulgation of state news. Donaldson, *The British Council*, 13.
154 Ibid., 13–14.
155 Eastment, 'The Policies and Position of the British Council,' 3.
156 Ibid., 4.
157 This is readily apparent in Fine Arts Committee, meeting minutes during the 1930s and 1940s, PRO, BCP.
158 James Spence to E.D. O'Brien, 17 Oct. 1938, PRO, BCP (NA copy).
159 E.D. O'Brien to Miss Barrington[?] (memo), 20 Oct. 1938, PRO, BCP (NA copy).

160 Memo, 31 March 1939, with extract of draft minutes, Fine Arts Committee meeting of 27 March, PRO, BCP (NA copy).

161 Eastment, 'The Policies and Position of the British Council,' 128.

162 Minute by K. Johnstone, 20 Aug. 1939, PRO, BCP, BW2/88; quoted by Eastment, 'The Policies and Position of the British Council,' 128.

163 Eastment, 'The Policies and Position of the British Council,' 128.

164 U.S. Foreign Agents Registration Act, 1937, quoted in Taylor, *The Projection of Britain*, 75.

165 This organization, along with the British Press Service, founded in 1940, were merged into the new British Information Services in 1942; McMurry and Lee, *The Cultural Approach*, 175.

166 Massey to Sir Lionel Faudel-Phillips, Fine Arts Committee, British Council, 1 Feb. 1939, VMP, 198. Massey also encouraged both his sons to loan works to the British Council exhibitions, which he considered important ventures. Massey to Hart Massey, 30 Nov. 1938, VMP, 198; and Lilian Somerville, Fine Art Dept., British Council, to Massey, 6 July 1945, MFamP, vol. 65.

167 Taylor, *The Projection of Britain*, 119.

168 A.A. Longden to H.O. McCurry, 14 Sept. 1939, PRO, BCP.

169 Rothenstein stayed on to give a lecture on 'British Art since 1900' and an address that was broadcast across Canada on the CBC.

170 Fine Arts Advisory Committee Meeting Minutes, 3 Sept. 1940, British Council Library copy of Minute Book.

171 A.A. Longden to H.O. McCurry, 12 Dec. 1942, and McCurry to Longden, 10 Nov. 1943, PRO, BCP.

172 Dominions Office memo to Sir Malcolm Robertson, 16 Feb. 1944, PRO, BCP. The inquiry led to the 'Exhibition of Contemporary British Painting,' approximately sixty works that toured Canada as far west as Winnipeg from late 1944 to May 1945.

173 The donation was made by Sir Eugene Millinton-Drake, British minister to Uruguay (1934–41). Eastment, 'The Policies and Position of the British Council,' 150 and 313.

174 British Council, Finance and Agenda Committee Minutes, 10 Nov. 1942, quoted in ibid., 150.

175 Bissell, *The Imperial Canadian*, 137–8. For Massey's role in this initiative, see also Hatch, *Aerodrome of Democracy*, 13–14.

176 A.A. Longden to file, 25 Jan. 1944, PRO, BCP, Fine Art Advisory Committee Correspondence.

177 At the end of the war, the committee gave rise to the Canada Foundation, an entirely private foundation incorporated in May 1945 and funded by 'a

thousand associates,' under the direction of Walter Herbert. Walter Herbert, 'The Canada Foundation,' *Canadian Art* 16, no. 1 (Feb. 1959), 29.

178 Memo, Miss Collihole to Sir Angus Gillan, Director, British Council, Empire Division, 22 May 1944, PRO, BCP, (NA copy).

179 Massey is quoted in a memo from Sir Shuldham Redfern to Sir Angus Gillan, 18 Aug. 1947, PRO, BCP (NA copy).

180 Memo, Sir Shuldham Redfern to Sir Angus Gillan, 25 Nov. 1947, PRO, BCP (NA copy).

181 Canada, Royal Commission, *Massey Report*, 1951, 264.

182 Massey to Martin Baldwin, 15 Dec. 1937, VMP, 170/08.

183 Finlay, *20th-Century British Art*, 4. There is no evidence that Massey spent Gallery funds on purchases.

184 Finlay, *Twentieth-Century British Art*, 6.

185 Massey to Robin Ironside (the CAS's secretary), 5 March 1945, VMP, 258.

186 Finlay, *Twentieth-Century British Art*, 6.

187 Ibid., 7–8.

188 Massey to H.O. McCurry, 10 Nov. 1948; McCurry to Massey, 26 May 1948; and McCurry to Anthony Blunt, 19 Oct. 1948, VMP, 391/10. See also Myron Laskin, Jr, and Michael Pantazzi, *National Gallery of Canada: European and American Painting, Sculpture, and Decorative Arts* (Ottawa, 1987), vol. 1, xiv.

189 Massey to Charles S. Band, 24 April 1946, VMP, 234/11.

190 Canadian Information Service press release, 24 Jan. 1947, NGCA, Massey Collection of English Painting DOC NG/EX Jan. 1947–Feb. 1949.

191 Finlay, 'Identifying with Nature,' 48.

192 'New Acquisitions by Canadian Galleries,' *Canadian Art*, 9, no. 2 (Christmas–New Year 1951–2), 75.

193 Finlay, 'Identifying with Nature,' 50.

194 H.O. McCurry to Massey, 11 Feb. 1947, NGCA, 9.2–M Trustees: Vincent Massey, file 2.

195 A further outcome of Massey's London stay was his friendship with the collectors Lord and Lady Lee of Fareham, the former a fellow trustee of the National Gallery. Massey arranged for their collection of medieval and Renaissance art objects to be stored in Toronto for safekeeping during the war. The couple subsequently donated the collection to the Massey Foundation, and it was housed in Hart House until 1960, when it was transferred to the Royal Ontario Museum. Adamson, *The Hart House Collection*, 14–15.

196 Robert Fulford, 'The Canada Council at Twenty-five,' *Saturday Night* 97,

no. 3 (March 1982), 36–7; and 'Canada's Great British Invasion,' *Globe and Mail*, 7 July 1993.

197 J.A. Cross, 'Appraising the Commonwealth,' *Political Studies* 32 (1984), 107.

198 Charles Comfort, 'Painting,' in Canada, *Royal Commission Studies*, 413.

199 *The Canadian Encyclopedia* (Edmonton: Hurtig Publishers, 1988) 427.

200 Massey, 'Address' (30 May 1947).

Chapter 6: Arm's Length

1 Massey, 'Address' (21 June 1945).

2 Alice Massey to Joan [Lady Lascelles], 24 March 1947, MFamP, vol. 53.

3 Bissell, *The Imperial Canadian*, 151–60.

4 Alice Massey to Joan [Lady Lascelles], 24 March 1947, MFamP, vol. 53.

5 Alice Massey to [Molly?], 20 March 1947, MFamP, vol. 53.

6 Alice Massey to Joan [Lady Lascelles], 24 March 1947, MFamP, vol. 53.

7 Massey, 'Address' (30 May 1947).

8 Ibid.

9 Ibid.

10 Ibid.

11 Massey, as chair of the board of the National Gallery in London, had authorized its organization; he was gratified to report that in Toronto over 76,000 people – nearly 10 per cent of those living there – saw the exhibition.

12 See *Arts of French Canada*; the show, curated by Marius Barbeau, travelled to the Detroit Institute of Arts, the Cleveland Museum of Art, and the Albany Institute of History and Art, as well as to the National Gallery of Canada and the Musée de la province de Québec, Quebec.

13 For a discussion of excellence in relation to Canadian cultural policy, see Molloy, 'Towards the Pursuit of Excellence'.

14 Massey to W.L.M. King, 16 Nov. 1945, VMP, 387/38.

15 As late as November 1949, Massey was still working on this problem. In correspondence with King's successor, Louis St Laurent, Massey reversed his earlier view that artists should not sit on the board and recommended that Lawren Harris, then resident in Vancouver, be invited to become a member. Massey to Louis St Laurent, 9 Nov. 1949, VMP, 391/09.

16 At about this time, the gallery received 'A Plan for the Extension of the National Gallery of Canada' (typescript, unidentified authorship, but possibly from the Canadian Federation of Artists, 1946–8?). It proposed an ambitious scheme of branch galleries across the country, each with staff working in support of a program of travelling exhibition. VMP, 387/38.

17 H.O. McCurry to Massey, 24 Jan. 1947, VMP, 391/10.

18 In 1948, an order-in-council gave the gallery a supplementary appropriation of $10,000 for the work of the newly formed National Industrial Design Committee. D.W. Buchanan to Massey, 21 June 1948, VMP, 391/10.

19 Alice Massey to Lionel Massey, 19 Feb. 1941, MFamP, vol. 65.

20 H.O. McCurry to Massey, 13 Jan. 1945, NGCA, 9.2–M Trustees: Vincent Massey, file 2.

21 Massey to H.O. McCurry, 21 Jan. 1945, VMP, 387/38.

22 Massey to W.L.M. King, 31 Jan. 1948, VMP, 391/10. This is a reference to the Gréber Plan (1950) for Ottawa; see Richard Scott and Mark Seasons, 'Planning Canada's Capital: The Roles of Landscape,' *International Journal of Canadian Studies* 4 (fall, 1991), 172–3.

23 National Gallery of Canada, Board of Trustees, Meeting Minutes, 18 March 1948, VMP, 391/10.

24 Alphonse Fournier to Massey, 21 June 1948, NGCA, 9.2M Trustees: Vincent Massey, file 1.

25 Massey to Alphonse Fournier, 17 Aug. 1949, VMP, 391/09.

26 Alphonse Fournier to Massey, 25 Aug. 1949, VMP, 391/09.

27 Alice Massey to Mrs. Vivian Bulkeley-Johnson, 30 April 1949, MFamP, vol. 52.

28 Massey, 'The Other Canada,' a handwritten book outline loose in his diary.

29 Massey's library includes an edition of Arnold's *Culture and Anarchy* from 1946, with handwritten annotations apparently by Massey.

30 Massey, *On Being Canadian*, 33.

31 Ibid., 12, 16, and 18–20.

32 Ibid., 29–30.

33 Ibid., 13.

34 Ibid., 5–6.

35 Ibid., 7–9.

36 Massey had employed the same juxtaposition as early as 1924 in 'Address' (26 Jan. 1924).

37 Walter Gordon chaired the Royal Commission on Canada's Economic Prospects (1955–7) and, as Liberal minister of finance under Lester B. Pearson, presented a budget in 1963 that proposed a tax on foreign takeovers of Canadian companies. The proposal was subsequently withdrawn.

38 Massey, *On Being Canadian*, 125–6.

39 Ibid., 47–55.

40 Owram, *The Government Generation*, and Granatstein, *The Ottawa Men*.

41 Granatstein, *The Ottawa Men*, 19–20.

42 Michael Bliss, 'Canada in the Age of the Visible Hand,' in Kent, ed., *In Pursuit of the Public Good*, 26.

43 Tippett, *Making Culture*, 156–85.
44 Litt, *The Muses*, 11–37; his account wavers between an unfavourable and a favourable view, with the former clearly predominating.
45 Media reaction to the report is summarized by ibid., 223–33.
46 Hilda Neatby was apparently warned after the commissioners' first meeting that its chair had already sketched out his report. Hayden, ed., *So Much to Do*, 25. None the less, and despite the need for further assessment of the commissioners' respective roles, there is ample evidence that Neatby, Larry MacKenzie, and Georges-Henri Lévesque each had a forceful presence on the commission; Arthur Surveyer submitted a written dissenting opinion, concerned primarily with broadcasting, as part of the report. See Litt, *The Muses, 209–10*, regarding Neatby's crucial role in the report's final writing.
47 Out of respect for the bilingual nature of the commission's mandate and the active role played by Lévesque, it is often referred to now as the Massey–Lévesque Commission. This is more in the nature of political correctness, however, for Massey was clearly sole chair. Lévesque was neither co-chair nor vice-chair and was himself explicit on this point. *Souvenances II*, 236.
48 Canada, Royal Commission on National Development in the Arts, Letters, and Sciences, *Report* (Massey Report), 8.
49 Massey, 'Postscript' (1966–7).
50 Massey to Lester B. Pearson, 20 Jan. 1949, VMP, 585/10.
51 Alice Massey to Mary and Sidney, Lord and Lady Herbert, 30 April 1949; MFamP, vol. 53.
52 Massey Report, 3.
53 Ibid., 4 and 271.
54 According to Litt, Lévesque wrote the argument justifying federal support of the cultural sector in the chapter 'The Nature of the Task.' *The Muses*, 211.
55 Massey Report, 6–7.
56 Massey Commission Proceedings, 'A Brief Presented by the Canadian Catholic Conference,' March 1950, annotated by Massey, VMP, 346.
57 Ibid.
58 Massey Commission, 'A Brief Submitted on Behalf of the Church of England in Canada to the Royal Commission on National Development in the Arts, Letters, and Sciences,' VMP, 346.
59 Ibid.
60 Massey Report, 5.
61 Massey Commission, 'A Brief Presented by the Canadian Catholic Conference' (March 1950), VMP, 346.
62 Massey Report, 69.

63 Ibid., 7–8 and 31.

64 Ibid., 66–7 and 73.

65 Massey, 'Address' (30 May 1947).

66 Litt, *The Muses*, 211.

67 Massey Report, 11.

68 Ibid., 682.

69 Ibid., 15 and 18.

70 Morton, *The Canadian Identity*, 76.

71 Massey Report, 14–16.

72 Ibid., 20, 24, and 36.

73 Ibid., 27, 30, and 36–7.

74 Ibid., 32 and 276–7.

75 Ibid., 287, 297, and 299.

76 Ibid., 287 and 296.

77 Michael Dorland has blamed the Massey Commission: 'Curiously, it made no effort to understand either the organizational mechanisms or the political economy of this awesome deployment of U.S. cultural power.' *So Close to the State/s*, 15. See also Manjunath Pendakur, *Canadian Dreams and American Control*, 142–3.

78 In 1948 the Canadian Cooperative Project was created, and in return for the free flow of dollars into the United States, the American film lobby committed itself to promoting Canadian tourism and making references to Canada in U.S. films. The rise in tourist dollars never materialized.

79 Massey Report, 50.

80 Pendakur, *Canadian Dreams and American Control*; and Dorland, *So Close to the State/s*.

81 Massey Report, 58–9.

82 Gallery director H.O. McCurry forwarded the gallery's brief to Massey for his criticism and amendments before it was submitted to the commission. McCurry to Massey, 7 July 1949; and Massey to McCurry, 8 July, 1949, VMP, 391/09.

83 A permanent national gallery, built specifically for its needs, was not realized until 1988, although in 1960 Massey directed funds to the refitting of an office building, the Lorne Building, for its use. King, 'The National Gallery of Canada at Arm's Length,' 55.

84 Massey Report, 76 and 317–18.

85 Ibid., 102–3, 107–8, and 331–3.

86 Ibid., 113, 120–2, and 338–9.

87 Massey, *What's Past Is Prologue*, 170.

88 Massey added that the chapters on the universities (parts I and II) had been prepared 'in the belief that they will meet with the approval of all five Commissioners' and would be forwarded to MacKenzie from Ottawa shortly. Massey to N.A.M. MacKenzie, 15 Sept. 1950, VMP, 585/10; also 391/13.

89 Massey Report, 131, 138–9, 143–4, 171, and 355.

90 Ibid., 9.

91 Ibid., 182, and 'Brief to the Royal Commission on National Development in the Arts, Letters, and Sciences by the Canadian Arts Council,' VMP, 585/09.

92 Massey Report, 193 and 199.

93 Ibid., 234 and 243.

94 Ibid., 207–8.

95 Ibid., 76, 272, and 374.

96 J.M. Keynes, 1945, in Massey Report, 375.

97 It was founded in 1934, not 1935, as the report stated.

98 Massey Report, 263, 367, 375, and 377.

99 Ibid., 377–9.

100 Frank Milligan provides a helpful summary of the features of the Canada Council that define its exact relationship to government in 'The Ambiguities of the Canada Council,' 68.

101 Susan Crean in the *Canadian Forum* (August 1978) describes 'the pursuit of excellence ... [as] often the most arbitrary and capricious of all [criteria].' Quoted in ibid., 64.

Conclusion

1 Questioning the legitimacy of particular literary canons as the foundation of a liberal arts education and in turn their circumscriptions on diversity awaited a later generation of intellectuals and educators.

2 As early as the 1840s, Egerton Ryerson invoked 'the public good' as a means of transcending party politics. Neil McDonald, 'Egerton Ryerson and the School as an Agent of Political Socialization,' in McDonald and Chaiton, eds., *Egerton Ryerson and His Times*, 93.

3 Falconer, 'The Education of National Character,' in National Conference on Character Education, *Report of the Proceedings*, 1919, 18.

4 Massey, 'Address' (14 Oct. 1938).

5 While Lorne was wildly enthusiastic about Canada, especially its terrain and climate, and facilitated several gains in independence from Britain, his

brand of nationalism might be rightly labelled imperializing, coloured as it was by the rhetoric of expansionism and the glory of the empire.

6 For some discussion of male sexuality with reference to the Group of Seven, see Linsley, 'Landscapes in Motion.'

7 See Bissell for an overview of Massey's political views and activities during the 1930s. *The Young Vincent Massey*, 197–238. Also see Douglas Owram for Massey's pivotal role in the redefinition of the federal Liberal Party in the early 1930s. *The Government Generation*, 183 and 187–8. Owram also notes Alice Massey's influence on Massey's reformist views (183–4).

8 Massey, 'The Crown in Canada' (8 Feb. 1965).

9 See, for example, Said, *Culture and Imperialism*. It is necessary to distinguish between imperializing nationalisms and local, popular nationalisms (Anderson, *Imagined Communities*, 113–14), as well as between ethnically based and inclusive nationalisms. Jonathon Bordo, Peter Kulchyski, John Milloy, and John Wadland have situated Canadian nationalism in opposition to Euro-American hegemony. 'Introduction,' 4. In short, to reject all nationalisms as hegemonic and imperializing is clearly inadequate.

10 Litt, *The Muses*.

11 Tippett, *Making Culture*, 123.

12 Litt, *The Muses*, 53 and 97.

13 G. Lowell Field and John Higley, *Elitism* (London, 1980), 66.

14 Robert Fulford, 'Elite: The New Scare Word,' *Globe and Mail*, Toronto, 8 June 1996.

15 Massey, 'Address' (4 April 1923).

16 Litt, *The Muses*, 34; Bissell, *The Imperial Canadian*, 206.

17 Massey wrote about Neatby in 'Postscript' (1966–7): 'Hilda Neatby has the reputation of being a feminist. I can only say she was very gentle and forgiving about our masculine neglect, of which she was conscious in the work of the Commission.' By way of a 'public apology,' he confessed to an incident in Newfoundland, in which the male commissioners 'behaved inexcusably' towards her, by neglecting to include her in the evening's social plans. MFamP, vol. 42.

18 Through the Massey Foundation, he also helped finance her book *So Little for the Mind*. While he was supportive of the project, it is unclear to what extent he shared her specific views. They were both committed to the fight for humanism and the role of the liberal arts in education; this is apparent in their correspondence concerning her book and the speeches that she was preparing for him. VMP, 362/05 and 585/07. In general, however, her orientation appears to have been rather different from his. Her book, which is deeply concerned with 'standards' and their erosion in the present school

system, called for a return to a 'traditional' education and sought to discredit 'progressivism.' Her denigration of the proliferation of 'options' in the school system at the expense of the liberal arts sounds more like Massey about 1920 in the Methodist schools commission than thirty years later. Her tone is pessimistic and judgmental, quite unlike the generally optimistic and more extroverted and conciliatory approach of the mature Massey. Bissell, however, viewed the two as firm allies in the elitist orientation of the Massey Commission's major recommendations. While he supported this claim with a very persuasive quote from Neatby, he did not provide similar evidence on Massey, and we are left to surmise in what manner his views were elitist. *The Imperial Canadian*, 234.

19 A pluralist vision of Canada is the current majority view. Bibby, *The Bibby Report.*
20 Massey, *On Being Canadian*, 17.
21 Massey, 'Address,' (April 1926).
22 A.B. McKillop has extracted from Victorian Canada's intellectual history the expression 'disciplined intelligence' to characterize the Anglo-Canadian propensity to twin the moral and intellectual faculties. *A Disciplined Intelligence.*

Bibliography

- **Archival Sources**
- **Books, Articles, Dissertations, and Theses**
- **Vincent Massey on Education and the Arts**

Archival Sources

Art Gallery of Ontario, Toronto
 Curatorial/Acquisition Files.
Art Gallery of Ontario Archives, Toronto
 Board of Trustees Files.
 Exhibition Files
British Council, London
 Fine Arts Committee Papers.
Chautauqua Institution Archives, Chautauqua, NY
 Massey Family Records.
Hart House Archives, University of Toronto, Toronto
 Board of Stewards Records.
National Archives of Canada, Ottawa
 British Council Papers.
 Canada House, London, Papers.
 Dept. of External Affairs, High Commission, London, Staff Records.
 Wm. L. and Maude Grant Papers.
 Lawren S. Harris Papers.
 W.L.M. King Papers.
 H.O. McCurry Papers.
 Massey Family Papers.
 Massey Foundation Papers.
 Parkin Family Papers.

Royal Commission on National Development in the Arts, Letters,
and Sciences Papers.
National Gallery Archives, London, England
Board of Trustee Records.
National Gallery of Canada, Ottawa
Artists Files.
Curatorial/Acquisition Files.
National Gallery of Canada Archives, Ottawa
Board of Trustees Files.
Exhibition Files.
Public Records Office, London, England
British Council Papers.
Robertson Davies Library, Massey College, University of Toronto, Toronto
Massey Book Collection (annotations).
Royal Ontario Museum, Toronto
Curatorial files
Tate Gallery Archive, London, England
Board of Trustees Records.
Contemporary Art Society Papers.
Thomas Fisher Rare Book Library, University of Toronto, Toronto
Arts & Letters Club Papers.
Sir Edmund Walker Papers.
United Church of Canada/Victoria University Archives, Toronto, Toronto
Methodist Church of Canada, Educational Society Papers.
United Church of Canada General Council Records.
Victoria University Board of Regents Records.
Victoria University House Committee Records.
Victoria University Property Committee Records.
University of Toronto Archives, Toronto
Hart House Theatre Papers.
University Records.
Vincent Massey Papers.
Vancouver Art Gallery, Vancouver
Board of Trustee Records.
Curatorial/Acquisitions Records.
Exhibition and Collection Committee Records.

Books, Articles, Dissertations, and Theses

Abella, Irving, and Harold Troper. *None Is Too Many: Canada and the Jews of Europe, 1933–1948.* Toronto: Lester & Orpen Dennys, 1983.

Adamson, Jeremy. *The Hart House Collection of Canadian Paintings.* Toronto: University of Toronto Press, 1969.

– *Lawren S. Harris: Urban Scenes and Wilderness Landscapes, 1906–1930.* Toronto: Art Gallery of Ontario, 1978.

Adenay, Marcus. 'The National Consciousness Idea: A Criticism,' *Canadian Bookman* (May 1929), 113–16; NA, LSHP, 5–18.

Airhart, Phyllis D. *Serving the Present Age: Revivalism, Progressivism and the Methodist Tradition in Canada.* Montreal: McGill-Queen's University Press, 1992.

Allen, Richard, ed. *The Social Gospel in Canada: Papers of the Interdisciplinary Conference on the Social Gospel in Canada at the University of Regina, Mar. 21–24, 1973.* Ottawa: National Musuems of Canada, 1975.

– *The Social Passion: Religion and Social Reform in Canada, 1914–28.* Toronto: University of Toronto Press, 1971.

Anderson, Benedict. *Imagined Communities: Reflections on the Origin and Spread of Nationalism.* Rev. ed. London: Verso, 1991; rept. 1994.

Angus, Ian. 'Missing Links: Canadian Theoretical Discourse.' *Journal of Canadian Studies/Revue d'études canadiennes* 31, no. 1 (spring 1996), 141–58.

Appeal of the Wesleyan Conference on the Question of Liberal Education in Upper Canada, n.d. Reprint from *Christian Guardian,* 30 Nov. 1859.

apRoberts, Ruth. *Arnold and God.* Berkeley: University of California Press, 1983.

Arnold, Matthew. *Culture and Anarchy: An Essay in Political and Social Criticism.* London: Smith, Elder, and Co., 1869; London: Smith, Elder, & Co., 1909; Cambridge: Cambridge University Press, 1946.

Art Gallery of Toronto. *Canadian Paintings: The Collection of the Hon. Vincent and Mrs. Massey.* Toronto, 1934.

Art Museum of Toronto. *Catalogue of a Loan Collection of Paintings of the English, Old Dutch, Modern Dutch, and Other European Schools.* Toronto, 1909.

Arts of French Canada, 1613–1870. Detroit: Detroit Institute of Arts, 1946.

Austin, B.F. *Woman: Her Character, Culture and Calling.* Brantford, Ont.: The Book and Bible House, 1890.

Austin, B.F. *The Higher Education of Women: Its Mission and Its Method, Inaugural Lecture.* St Thomas, Ont., 1882.

Averill, Harold, *Dramatis Personae: An Exhibition of Amateur Theatre at the University of Toronto, 1879–1939.* Toronto: Thomas Fisher Rare Book Library, University of Toronto, 1992.

Ayre, Robert. 'The Press Debates the Massey Report.' *Canadian Art* 9, no. 1 (Oct. 1951), 25–30 and 36–8.

Barbeau, Marius. *The Arts of French Canada, 1613–1870.* Detroit: Detroit Institute of Arts, 1946.

'Batterwood House, Canton, Ontario.' *Journal, Royal Architectural Institute of Canada* 6, no. 12 (Dec. 1929), 419–25.

Bercuson, David Jay. *True Patriot: The Life of Brooke Claxton, 1898–1960*. Toronto: University of Toronto Press, 1993.

Berger, Carl. *The Writing of Canadian History: Aspects of English-Canadian Historical Writing since 1900*. 2nd ed. Toronto: University of Toronto Press, 1986.

Bibby, Reginal W. *The Bibby Report: Social Trends Canadian Style*. Toronto: Stoddart, 1995.

Bissell, Claude. *The Imperial Canadian: Vincent Massey in Office*. Toronto: University of Toronto Press, 1986.

– *The Massey Report and Canadian Culture*. The 1982 John Porter Memorial Lecture. Ottawa: Carleton University Information Office, 1982(?).

– *The Young Vincent Massey*. Toronto: University of Toronto Press, 1981.

Bliss, Michael. *A Canadian Millionaire: The Life and Business Times of Sir Joseph Flavelle, Bart., 1858–1939*. Toronto: University of Toronto Press, 1978.

– 'The Methodist Church and World War I.' *Canadian Historical Review* 49, no. 3 (Sept. 1968), 213–33.

Boggs, Jean Sutherland. *The National Gallery of Canada*. London: Thames and Hudson, 1971.

Bordo, Jonathan, Peter Kulchyski, John Milloy, and John Wadland. 'Introduction: Refiguring Wilderness / Re-conceptualiser les espaces sauvages,' *Journal of Canadian Studies / Revue d'études canadiennes* 33, no. 2 (summer 1998), 3–6.

Boyanoski, Christine. *The 1940s: A Decade of Painting in Ontario*. Toronto: Art Gallery of Ontario, 1984.

Bridle, Augustus. 'Massey's Canadiana Feature at Gallery,' *Toronto Daily Star*, 7 Dec. 1934.

– *The Story of the Club*. Toronto: Arts and Letters Club, 1945.

The British Neo-Romantics, 1935–1950. London: Fischer Fine Art Limited; Cardiff: National Museum of Wales, 1983.

Brooker, Bertram, ed. *Yearbook of the Arts in Canada, 1928–1929*. Toronto: Macmillan, 1929.

Brown, Eric. *An Exhibition of Contemporary British Painting*. Ottawa: National Gallery of Canada, 1925.

Brown, F. Maud. *Breaking Barriers: Eric Brown and the National Gallery*. [Toronto]: Society for Art Publications, 1964.

Brown, Rev. W.L. 'The Sunday School Movement in the Methodist Church in Canada, 1875–1925.' MA thesis, University of Toronto, 1960.

Buchanan, Donald W. 'An Artist Who Lives in the Woods.' *Saturday Night* 50, no. 4 (1 Dec. 1934), 2.

– 'David B. Milne.' *Canadian Forum* 15, no. 173 (Feb. 1935), 191–3.

Buffie, Erna. 'The Massey Report and the Intellectuals: Cultural Nationalism in Ontario in the 1950s.' MA thesis, University of Toronto, 1982.

Burwash, Nathanael. *The History of Victoria College.* Toronto: Victoria College Press, 1927.

Cameron, David M. *More Than an Academic Question: Universities, Government, and Public Policy in Canada.* Halifax: Institute for Research on Public Policy, 1991.

Canada. *Royal Commission Studies: A Selection of Essays Prepared for the Royal Commission on National Development in the Arts, Letters, and Sciences.* Ottawa: Edmond Cloutier, 1951.

– Royal Commission on National Development in the Arts, Letters, and Sciences. *Report.* (Massey Report). Ottawa: Edmond Cloutier, 1951.

'Canadian Pictures at Corcoran "Sing a Saga of the North."' *Art Digest* 4, no. 12 (mid-March 1930).

Careless, J.M.S. 'Frontierism, Metropolitanism and Canadian History.' *Canadian Historical Review* 35, no. 1 (March 1954), 1–21.

Carroll, Joseph. *The Cultural Theory of Matthew Arnold.* Berkeley: University of California Press, 1982.

Carruthers, Glen, and Gordana Lazarevich. *A Celebration of Canada's Arts, 1930–1970.* Toronto: Canadian Scholars' Press, 1996.

Catalogue of Highly Important Old and Modern Pictures and Drawings, Fine English and French Furniture, Engravings, Early English, Chinese and Continental Porcelain, Aubusson Tapestry, and Works of Art / Chester D. Massey, Sir William MacKenzie, Sir Edmund Walker Collections. Toronto: Jenkins' Galleries, 1927.

A Century of Canadian Art. London: Tate Gallery, 1938.

Chaiton, Alf. 'The History of the National Council of Education of Canada.' MA thesis, University of Toronto, 1974.

Chaiton, Alf, and Neil McDonald, eds. *Canadian Schools and Canadian Identity.* Toronto: Gage Educational Publishing, 1977.

Chaney, David. *The Cultural Turn: Scene-Setting Essays on Contemporary Cultural History.* London: Routledge, 1994.

Charlesworth, Hector. 'A Magnificent Home of Art.' *Saturday Night* 41, no. 12 (6 Feb. 1926), 5.

'Chester D. Massey's Paintings.' *Saturday Night* 23, no. 28 (23 April 1910).

Christian, William. *George Grant: A Biography.* Toronto: University of Toronto Press, 1993.

Clark, Kenneth. *The Other Half: A Self-Portrait.* Rev. ed. London: Hamish Hamilton, 1987.

– 'The Romanticism in British Painting.' *Art News (New York)* 45 (Feb. 1947), 24–9 and 56–7.

Cochrane, Charles Norris, and William Stewart Wallace. *This Canada of Ours: An Introduction to Canadian Civics.* Rev. ed. Toronto: J.M. Dent and Sons Limited, 1931.

Collini, Stefan. *Public Moralists: Political Thought and Intellectual Life in Britain, 1850–1930.* Oxford: Clarendon Press, 1991.

Comfort, Charles. '1938–46: Observations on a Decade – Canadian Painting, Sculpture, and Print Making.' *Royal Architectural Institute of Canada Journal* 25, no. 1 (Jan. 1948), 3–9.

Compton, Susan, ed. *British Art in the Twentieth Century: The Modern Movement.* Munich: Prestel-Verlag, 1987.

Contemporary Art from Great Britain, the United States and France with Sculpture from the United States. Toronto: Art Gallery of Toronto, 1949.

Contemporary Paintings by Artists of the United States; Canadian Paintings, the Collection of the Hon. Vincent and Mrs. Massey; and in the Print Room Scissor Cuts by Rene Kulbach. Toronto: Art Gallery of Toronto, 1934.

Cork, Richard. *A Bitter Truth: Avant-Garde Art and the Great War.* New Haven, Conn., and London: Yale University Press in association with Barbican Art Gallery, 1994.

Crean, Susan, and Marcel Rioux. *Two Nations: An Essay on the Culture and Politics of Canada and Quebec in a World of American Pre-eminence.* Toronto: Lorimer, 1983.

Creighton, Donald. *The Commercial Empire of the St. Lawrence, 1760–1850.* Toronto: Ryerson Press, 1937.

Cuff, R.D., and J.L. Granatstein. *Ties That Bind: Canadian–American Relations in Wartime from the Great War to the Cold War.* 2nd ed. Toronto and Sarasota: Samuel Stevens and Hakkert & Company, 1977.

Currelly, Charles Trick. *I Brought the Ages Home.* Toronto: Ryerson Press, 1956.

Davies, Ioan. *Cultural Studies and Beyond: Fragments of Empire.* London: Routledge, 1995.

– 'Theory and Creativity in English Canada: Magazines, the State and Cultural Movement.' *Journal of Canadian Studies / Revue d'études canadiennes* 30, no. 1 (spring 1995), 5–19.

Davis, Ann. *The Logic of Ecstasy: Canadian Mystical Painting, 1920–1940.* Toronto: University of Toronto Press, 1992.

Denison, Merrill. 'The Arts and Letters Players.' *Canadian Bookman* 2 (Feb. 1923), 31–2.

– *Harvest Triumphant: The Story of Massey-Harris.* Toronto: McClelland and Stewart, 1948.

Donaldson, Frances. *The British Council: The First Fifty Years.* London: Jonathan Cape Ltd, 1984.

Dorland, Michael. *So Close to the State/s: The Emergence of Canadian Feature Film Policy.* Toronto: University of Toronto Press, 1998.

– 'A Thoroughly Hidden Country: *Ressentiment,* Canadian Nationalism, Canadian Culture.' *Canadian Journal of Political and Social Theory / Revue canadienne de théorie politique et sociale* 12, nos. 1–2 (1988), 130–64.

Eastment, Diana. 'The Policies and Position of the British Council from the Outbreak of War to 1950.' PhD thesis, University of Leeds, 1982.

Edwards, Nina L. *The Story of the First Canadian Club, Told on the Occasion of Its Diamond Jubilee, 1893–1953*. Hamilton, 1953.

Evans, Gary. *In the National Interest: A Chronicle of the National Film Board of Canada from 1949 to 1989*. Toronto: University of Toronto Press, 1991.

Farr, Dennis. *English Art, 1870–1940*. Oxford: Oxford University Press, 1984.

Farr, Dorothy. *Lilias Torrance Newton, 1896–1980*. Kingston, Ont.: Agnes Etherington Art Centre, 1981.

Fenwick, Kathleen. 'Revival of British Painting.' *Canadian Art* 4, no. 3 (May 1947), 118–20.

Field, G. Lowell, and John Higley. *Elitism*. London: Routledge and Kegan Paul, 1980.

Finlay, Karen. 'Identifying with Nature: Graham Sutherland and Canadian Art, 1939–1955,' *RACAR* 21, nos. 1–2 (1994), 48.

– *Twentieth-Century British Art from the Collection of the Art Gallery of Ontario*. Toronto: Art Gallery of Ontario, 1987.

Fletcher, Allan. 'Industrial Algoma and the Myth of Wilderness: Algoma Landscapes and the Emergence of the Group of Seven, 1918–1920.' MA thesis, University of British Columbia, 1989.

Fosdick, Raymond B. *The Story of the Rockefeller Foundation*. New York: Harper, 1952.

French, Goldwin S., and Gordon L. McLennan, eds. *From Cobourg to Toronto: Victoria University in Retrospect*. The Sesquicentennial Lectures, 1986. Toronto: Chartres Books, 1989.

Friedland, Martin L. *The University of Toronto: A History*. Toronto: University of Toronto Press, 2002.

Fulford, Robert. 'The Canada Council at Twenty-five.' *Saturday Night* 97, no. 3 (March 1982), 34–45.

Gauvreau, Michael. *The Evangelical Century: College and Creed in English Canada from the Great Revival to the Great Depression*. Montreal: McGill-Queen's University Press, 1991.

Gibbon, J. Murray, ed. *Canadian Folk Songs (Old and New)*. London: J.M. Dent & Sons, Ltd, 1927.

Gidney, Catherine. 'Poisoning the Student Mind? The Student Christian Movement at the University of Toronto, 1920–1965.' *Journal of the Canadian Historical Association*, new series, 8 (1998), 147–63.

Gillen, Mollie. *The Masseys: Founding Family*. Toronto: Ryerson Press, 1965.

Glazebrook, G.P. de T. *Sir Edmund Walker*. Oxford: Oxford University Press, 1933.

Goldie, Terry, Carmen Lambert, and Rowland Lorimer, eds. *Canada: Theoretical Discourse / Discours théoriques*. Montreal: Association of Canadian Studies, 1994.

Granatstein, J.L. *The Ottawa Men: The Civil Service Mandarins, 1935–1957.* Toronto: Oxford University Press, 1982.

Grant, John Webster. 'Theological Education at Victoria.' In French and McLennan, eds., *From Cobourg to Toronto,* 87–99.

Grant, John Webster, ed. *The Churches and the Canadian Experience: A Faith and Order Study of the Christian Tradition.* Toronto: Ryerson Press, 1963.

Grant, Judith Skelton. *Robertson Davies: Man of Myth.* Toronto: Penguin Books Canada Limited, 1994.

Green, J. Paul, and Nancy F. Vogan. *Music Education in Canada: A Historical Account.* Toronto: University of Toronto Press, 1991.

Greenlee, James G. *Sir Robert Falconer: A Biography.* Toronto: University of Toronto Press, 1988.

Guillet, Edwin C. *In the Cause of Education: Centennial History of the Ontario Educational Association, 1861–1960.* Toronto: University of Toronto Press, 1960.

Harper, J. Russell. *Canadian Paintings in Hart House.* Toronto: Art Committee of Hart House, University of Toronto, 1955.

Harries, Meirion, and Susie Harries. *The War Artists: British Official War Art of the Twentieth Century.* London: Michael Joseph in Association with the Imperial War Museum and the Tate Gallery, 1983.

Harris, Lawren S. 'Creative Art and Canada.' In Brooker, ed., *Yearbook,* 177–86.

– 'Revelation of Art in Canada.' *Canadian Theosophist* 7, no. 5 (15 July 1926), 85–8.

– 'Sir Edmund Walker.' *Canadian Bookman* 6, no. 5 (May 1924), 109.

Hart House Theatre: A Description of the Theatre and the Record of Its First Nine Seasons, 1919–1928. Toronto, 1928?

Hatch, F.J. *Aerodrome of Democracy: Canada and the British Commonwealth Air Training Plan, 1939–1945.* Ottawa: Directorate of History, Department of National Defence, 1983.

Hayden, Michael, ed. *So Much to Do, So Little Time: The Writings of Hilda Neatby.* Vancouver: University of British Columbia Press, 1983.

Heap, Ruby, and Alison Prentice, eds. *Gender and Education in Ontario: An Historical Reader.* Toronto: Canadian Scholars' Press, 1991.

Hewison, Robert. *John Ruskin: The Argument of the Eye.* London: Thames and Hudson, 1976.

Hill, Charles C. *The Group of Seven: Art for a Nation.* Ottawa: National Gallery of Canada, 1995.

Hošek, Chaviva M. 'Women at Victoria.' In French and McLennan, eds., *From Cobourg to Toronto,* 55–67.

Housser, F.B. *A Canadian Art Movement: The Story of the Group of Seven.* Toronto: Macmillan, 1926.

Houston, Susan E., and Alison A. Prentice. *Schooling and Scholars in Nineteenth-Century Ontario.* Toronto: University of Toronto Press, 1988.

Hubbard, R.H. *Vincent Massey Bequest: The Canadian Paintings.* Ottawa: National Gallery of Canada, 1968.

Hurdalek, Martha H. *The Hague School: Collecting in Canada at the Turn of the Century.* Toronto: Art Gallery of Ontario, 1983.

Innis, Harold. *The Fur Trade in Canada.* New Haven, Conn.: Yale University Press, 1930.

Jackson, A.Y. *A Painter's Country: The Autobiography of A.Y. Jackson.* First pub. 1958. Toronto: Clarke, Irwin, 1967.

Jameson, Sheilagh S. *Chautauqua in Canada.* Calgary: Glenbow-Alberta Institute, 1979.

Jarvis, Alan. *David Milne.* Toronto: Society for Art Publications, 1962.

Jasen, Patricia J. 'Arnoldian Humanism, English Studies, and the Canadian University.' *Queen's Quarterly* 95, no. 3 (autumn 1988), 550–66.

– 'The English Canadian Liberal Arts Curriculum: An Intellectual History, 1800–1950.' PhD dissertation, University of Manitoba, 1987.

Kallmann, Helmut. *A History of Music in Canada, 1534–1914.* Toronto: University of Toronto Press, 1960.

Kallmann, Helmut, and Gilles Potrin, eds. *Encyclopedia of Music in Canada,* 2nd ed. Toronto: University of Toronto Press, 1992.

Kent, Tom, ed. *In Pursuit of the Public Good: Essays in Honour of Allan J. MacEachen.* Montreal: McGill-Queen's University Press, 1997.

Kilbourn, William. *Intimate Grandeur: One Hundred Years at Massey Hall.* Toronto: Stoddart, 1993.

Kilgour, David, ed. *A Strange Elation: Hart House, The First Eighty Years.* Toronto: Hart House, 1999.

King, Martha. 'The National Gallery of Canada at Arm's Length from the Government of Canada: A Precarious Balancing Act.' MA. thesis, Carleton University, 1996.

Kirkconnell, Watson, and A.S.P. Woodhouse, eds. *The Humanities in Canada.* Ottawa: Humanities Research Council of Canada, 1947.

Kirkey, Donald Layton. '"Building the City of God": The Founding of the Student Christian Movement of Canada.' MA thesis, McMaster University, 1983.

Laing, G. Blair. *Memoirs of an Art Dealer.* Toronto: McClelland and Stewart, 1979.

Landow, George P. *The Aesthetic and Critical Theories of John Ruskin.* Princeton, NJ: Princeton University Press, 1971.

LaSelva, Samuel V. *The Moral Foundations of Canadian Federalism: Paradoxes,*

Achievements, and Tragedies of Nationhood. Montreal: McGill-Queen's University Press, 1996.

Laughton, Bruce. *The Euston Road School: A Study in Objective Painting.* Aldershot, Hampshire: Scolar Press, 1986.

Lears, T.J. Jackson. *No Place of Grace: Antimodernism and the Transformation of American Culture, 1880–1920.* New York: Pantheon Books, 1981.

Lee, Alvin A. 'Victoria's Contribution to Canadian Literary Culture.' In French and McLennan, eds., *From Cobourg to Toronto*, 69–85.

Lee, Betty. *Love and Whisky: The Story of the Dominion Drama Festival.* Toronto: McClelland and Stewart, 1973.

Lévesque, Georges-Henri. *Souvenances I: entretiens avec Simon Jutras.* First pub. 1983. Montreal: Les éditions la presse, 1984.

– *Souvenances II: entretiens avec Simon Jutras.* Montreal: Les éditions la presse, 1988.

Linsley, Robert. 'Landscapes in Motion: Lawren Harris, Emily Carr and the Heterogeneous Modern Nation.' *Oxford Art Journal* 19, no. 1 (1996), 80–95.

Lismer, Arthur. 'Art Appreciation.' In Brooker, ed., *Yearbook*, 57–71.

Litt, Paul. 'The Donnish Inquisition: The Massey Commission and the Campaign for State-Sponsored Cultural Nationalism, 1949–1951.' PhD dissertation, University of Toronto, 1990.

– 'The Massey Commission, Americanization, and Canadian Cultural Nationalism.' *Queen's Quarterly* (summer 1991), 357–87.

– *The Muses, the Masses, and the Massey Commission.* Toronto: University of Toronto Press, 1992.

Livingston, James C. *Matthew Arnold and Christianity: His Religious Prose Writings.* Columbia: University of South Carolina Press, 1986.

Lochnan, Katharine A. 'The Walker Journals: Reminiscences of John Lavery and William Holman Hunt.' *RACAR* 9, nos. 1–2 (1982), 57–63.

MacDonald, J.E.H. 'Art and Our Friend in Flanders.' *Rebel* 2, no. 5 (Feb. 1918), 186.

– 'The Canadian Spirit in Art.' *Statesman* (Toronto) 1, no. 35 (22 March 1919), 7.

McDonald, Neil, and Alf Chaiton, eds. *Egerton Ryerson and His Times.* Toronto: Macmillan, 1978.

McFayden et al., eds., *Cultural Development in Canada: Bibliography.* Edmonton: Cultural Development Bibliography, 1993.

McInnes, Graham. 'British Art Presented to the National Gallery.' *Saturday Night* 62, no. 9 (2 Nov. 1946), 16.

McKenzie, Karen and Larry Pfaff. 'The Art Gallery of Ontario: Sixty Years of Exhibitions, 1906–1966.' *RACAR* 7, nos. 1–2 (1980), 62–91.

McKillop, A.B. *Contours of Canadian Thought.* Toronto: University of Toronto Press, 1987.
– *A Disciplined Intelligence: Critical Inquiry and Canadian Thought in the Victorian Era.* Montreal: McGill-Queen's University Press, 1979.
– 'The Founders of Victoria.' In French and McLennen, eds., *From Cobourg to Toronto,* 11–30.
– *Matters of the Mind: The University in Ontario, 1791–1951.* Toronto: University of Toronto Press, 1994.
McLean, J.S. 'On the Pleasures of Collecting Paintings.' *Canadian Art* 10, no. 1 (Oct. 1952), 4.
MacMillan, Ernest, ed. *A Canadian Song Book.* Melody edition. Toronto: J.M. Dent & Sons, 1959.
McMurry, Ruth and Muna Lee. *The Cultural Approach, Another Way in International Relations.* First pub. 1947. Port Washington, NY: Kennikat Press, 1972.
McPherson, Hugo, 'The Resonance of Batterwood House.' *Canadian Art* 21, no. 2 (March–April 1964), 96–103.
Magney, William H. 'The Methodist Church and the National Gospel, 1884–1914.' *Bulletin of the Committee on Archives, the United Church of Canada,* no. 20 (1968), 3–95.
Mainprize, Garry. 'The National Gallery of Canada: A Hundred Years of Exhibitions – List and Index.' *RACAR* 11, nos. 1–2 (1984), 3–78.
Massey, Raymond. *When I Was Young.* Toronto: McClelland and Stewart, 1976.
Mellen, Peter. *The Group of Seven.* Toronto: McClelland and Stewart, 1970.
Mellor, David, ed. *A Paradise Lost: The Neo-Romantic Imagination in Britain, 1935–55.* London: Lund Humphries in association wtih the Barbican Art Gallery, 1987.
Methodist Church of Canada. *Report of the Massey Foundation Commission on the Secondary Schools and Colleges of the Methodist Church of Canada.* Toronto, 1921.
Miers, Henry A., and S.F. Markham. *A Report on the Museums of Canada to the Carnegie Corporation of New York.* London, 1932.
Milligan, Frank. 'The Ambiguities of the Canada Council.' In David Helwig, ed., *Love and Money: The Politics of Culture.* Ottawa: Oberon Press, 1980.
Milner, W.S. 'The Higher National Life.' In Adam Shortt and Arthur G. Doughty, eds., *Canada and Its Provinces: A History of the Canadian People and Their Institutions by One Hundred Associates.* Toronto/Glasgow: Brook, 1914.
Minihan, Janet. *The Nationalization of Culture: The Development of State Subsidies to the Arts in Great Britain.* New York: New York University Press, 1977.
Molloy, Patricia. 'Towards the Pursuit of Excellence: Changing Perspectives on Cultural Policy and the Social Functions of the Visual Arts in Canada, 1930–1960.' MA thesis, York University, Toronto, 1990.

Montagnes, Ian. *An Uncommon Fellowship: The Story of Hart House.* Toronto: University of Toronto Press, 1969.

Morris, Peter. *Embattled Shadows: A History of Canadian Cinema, 1895–1939.* Montreal: McGill-Queen's University Press, 1978.

Morrison, Theodore. *Chautauqua: A Center for Education, Religion and the Arts in America.* Chicago: University of Chicago Press, 1974.

Morton, W.L. *The Canadian Identity.* 2nd ed. Toronto: University of Toronto Press, 1987.

Nasgaard, Roald. *The Mystic North: Symbolist Landscape Painting in Northern Europe and North America, 1890–1940.* Toronto: Art Gallery of Ontario, 1984.

National Conference on Character Education in Relation to Canadian Citizenship. *Report of the Proceedings.* Winnipeg, 1919.

National Council of Education (NCE). *Bulletin No. 1: An Inter-Provincial Bureau of Educational Enquiry and Report.* Toronto, late 1922 or 1923.

– *Monthly Notes* (March 1922).

– *Retrospective/A Canadian Ideal in Education/Prospective.* Toronto, 1922.

– *Second Interim Report of the General Secretary.*

National Gallery of Canada. *Massey Collection of English Painting.* Ottawa: 1946.

Neatby, Hilda. 'Cultural Evolution.' In *Canada's Tomorrow: Papers and Discussion, Canada's Tomorrow Conference, Quebec City, November, 1953*, 187–223. Toronto: Macmillan, 1954.

– *So Little for the Mind.* Toronto: Clarke, Irwin, 1953.

Newton, Eric. 'The Massey Collection.' *Canadian Art* 4, no. 1 (Nov.–Dec. 1946), 24–7.

'Notable Collection of Canadian Paintings.' *Canadian Homes and Gardens* 12, nos. 1–2 (Jan.–Feb. 1935), 20 and 52.

Nowry, Laurence. *Man of Mana: Marius Barbeau.* Toronto: NC Press, 1995.

Nurse, Andrew. 'Prelude to Massey: The Canadian Artistic Community and the State, 1941–1949.' MA thesis, Queen's University, 1989.

Opala, Beatrice Barbara. 'Matthew Arnold in Canada.' MA thesis, McGill University, 1968.

Owram, Douglas. *The Government Generation: Canadian Intellectuals and the State 1900–1945.* Toronto: University of Toronto Press, 1986.

– 'Writing about Ideas.' In John Schultz, ed., *Writing about Canada: A Handbook for Modern Canadian History.* 47–70. Scarborough, Ont.: Prentice-Hall, 1990.

Panayotidis, E. Lisa. 'Ruminations on the Value of the Fine Arts at the University of Toronto, 1934–1946.' Paper at Universities Art Association of Canada Annual Conference, Nov. 1999.

Panayotidis-Stortz, E.L. '"Every Artist Would Be a Workman, and Every Workman an Artist": Morrison and Arts and Crafts Ideas and Ideals at the Ontario

Educational Association, 1900–1920.' In Peter Faulkner and Peter Preston, eds., *William Morris: Centenary Essays: Papers from the Morris Centenary Conference organized by the William Morris Society at Exeter College, Oxford, 30 June–3 July 1996*, 165–71 and 254–8. Exeter: 1996.

Pantazzi, Sybille. 'Foreign Art at the Canadian National Exhibition, 1905–1938.' *National Gallery of Canada Bulletin*, no. 22 (1973), 22–41.

Park, Julian. *The Culture of Contemporary Canada*. Ithaca, NY: Cornell University Press, 1957.

Pendakur, Manjunath. *Canadian Dreams and American Control: The Political Economy of the Canadian Film Industry*. Toronto: Garamond Press, 1990.

Podro, Michael. *The Critical Historians of Art*. New Haven, Conn.: Yale University Press, 1982.

Potvin, Rose, ed. *Passion and Conviction: The Letters of Graham Spry*. Regina: Canadian Plains Research Center, University of Regina, 1992.

Prang, Margaret. *N.W. Rowell: Ontario Nationalist*. Toronto: University of Toronto Press, 1975.

Rainey, Ada. 'Paintings in the Canadian Legation.' *Washington Post*, 2 June 1929.

Reid, Dennis. *'Our Own Country Canada': Being an Account of the National Aspirations of the Principal Landscape Artists in Montreal and Toronto*. Ottawa: National Gallery of Canada / National Museums of Canada, 1979.

– *Tom Thomson: The Jack Pine / Le pin*. Masterpieces in the National Gallery of Canada, no. 5. Ottawa: National Gallery of Canada, 1975.

Ritchie, Andrew C. *British Contemporary Painters*. Toronto: Art Gallery of Toronto, 1947.

Ritchie, Charles. *The Siren Years: Undiplomatic Diaries, 1937–1945*. London: Macmillan, 1974.

Robertson, Heather. *A Terrible Beauty: The Art of Canada at War*. Oshawa and Ottawa: James Lorimer, in association with the Robert McLaughlin Gallery and National Museums of Man, 1977.

Rubin, Don, ed. *Canadian Theatre History: Selected Readings*. Toronto: Clark Copp, 1996.

Russell, Peter, ed. *Nationalism in Canada*. Toronto: McGraw-Hill, 1966.

Saddlemyer, Ann, and Richard Plant, eds. *Later Stages: Essays in Ontario Theatre from the First World War to the 1970s*. Toronto: University of Toronto Press, 1997.

Said, Edward W. *Culture and Imperialism*. New York: Alfred A. Knopf, 1993; Vintage Books, 1994.

Schabas, Ezra. *Sir Ernest MacMillan: The Importance of Being Canadian*. Toronto: University of Toronto Press, 1994.

Schafer, D. Paul, and André Fortier. *Review of Federal Policies for the Arts in Canada (1944–1988)*. Ottawa: Canadian Conference of the Arts, 1989.

Schea, Albert. *Culture in Canada: A Study of the Findings of the Royal Commission on National Development in the Arts, Letters and Sciences, 1949–1951.* Toronto, 1952.

Scott, Richard, and Mark Seasons. 'Planning Canada's Capital: The Roles of Landscape.' *International Journal of Canadian Studies* 4 (fall 1991), 167–77.

Selles, Johanna M. *Methodists and Women's Education in Ontario, 1836–1925.* Montreal: McGill-Queen's University Press, 1996.

Semple, Neil. *The Lord's Dominion: The History of Canadian Methodism.* Montreal: McGill-Queen's University Press, 1996.

Siddall, Catherine D. *The Prevailing Influence: Hart House and the Group of Seven / 1919–1953 / Influence majeure: Hart House et le Groupe de sept, 1919–1953.* Oakville, Ont.: Oakville Galleries, 1988.

Silcox, David. *Painting Place: The Life and Work of David B. Milne.* Toronto: University of Toronto Press, 1996.

Sissons, C.B. *A History of Victoria University.* Toronto: University of Toronto Press, 1952.

Sperkados, Paula. *Dora Mavor Moore: Pioneer of the Canadian Theatre.* Toronto: ECW Press, 1995.

Stacey, C.P. and Barbara M. Wilson. *The Half-Million: The Canadians in Britain, 1939–1946.* Toronto: University of Toronto Press, 1987.

Stanworth, Karen. 'Visual Culture and the Object(s) of Citizenship in the Education of Nineteenth-Century Canadians.' *Universities Art Association of Canada Annual Conference.* London, Ont., Nov. 1999.

Straw, Will. 'Shifting Boundaries, Lines of Descent: Cultural Studies and Institutional Realignments.' In Valda Blundell, John Shepherd, and Ian Taylor, eds., *Relocating Cultural Studies: Developments in Theory and Research.* London: Routledge, 1993

Surrey, Philip. 'Silk Screen Prints Enlist.' *Canadian Art* I, no. 2 (Dec. 1943–Jan.1944), 58–61.

Taylor, Philip. *The Projection of Britain: British Overseas Publicity and Propaganda, 1919–1939.* Cambridge: Cambridge University Press, 1984.

Tippett, Maria. *Art in the Service of War: Canada, Art, and the Great War.* Toronto: University of Toronto Press, 1984.

– *Making Culture: English-Canadian Institutions and the Arts before the Massey Commission.* Toronto: University of Toronto Press, 1990.

Tulchinsky, Gerald, ed. *Immigration in Canada: Historical Perspectives.* Toronto: Copp Clark Longman, 1994.

United Kingdom. Office of the Chancellor of the Exchequer and the Minister of Education. *Report of the Committee on the Functions of the National Gallery and Tate Gallery and, in Respect of Paintings, of the Victoria and Albert Museum* (Confidential Copy). London: His Majesty's Stationery Office, 1945.

— *The Report of the Committee on the Functions of the National Gallery and Tate Gallery and, in Respect of Paintings, of the Victoria and Albert Museum Together with a Memorandum Thereon by the Standing Commission on Museums and Galleries.* London: His Majesty's Stationery Office, 1946.

The University of Toronto and Its Colleges, 1827–1906. Toronto: University of Toronto Press, 1906.

Usmiani, Renate. 'Roy Mitchell: Prophet in Our Past.' *Theatre History in Canada* 7, no. 2 (fall 1987), 147–68.

Vancouver: Art and Artists, 1931–1983. Vancouver: Vancouver Art Gallery, 1983.

Varley, Christopher. *F.H. Varley: A Centennial Exhibition.* Edmonton: Edmonton Art Gallery, 1981.

Varley, Peter. *Frederick H. Varley.* Toronto: Key Porter Books, 1983.

Villeneuve, René. *Baroque to Neo-Classical Sculpture in Quebec.* Ottawa: National Gallery of Canada, 1997.

Vincent, John Heyl. *The Chautauqua Movement.* First pub. 1885. Reprint, Freeport, NY: Books for Libraries Press, 1971.

Vipond, Mary. 'The Nationalist Network: English Canada's Intellectuals and Artists in the 1920s.' *Canadian Review of Studies in Nationalism* 7–8 (1980–1), 32–52.

Waite, P.B. *Lord of Point Grey: Larry MacKenzie of UBC.* Vancouver: UBC Press, 1987.

Walter, Arnold, ed. *Aspects of Music in Canada.* Toronto: University of Toronto Press, 1969.

Weir, R. Austin. *The Struggle for National Broadcasting in Canada.* Toronto: McClelland and Stewart, 1965.

Westfall, William. *Two Worlds: The Protestant Culture of Nineteenth-Century Ontario.* Montreal: McGill-Queen's University Press, 1989.

White, A.J.S. *The British Council, The First Twenty-Five Years, 1934–1959: A Personal Account Written for the Information of the Staff.* London: British Council, 1965.

Whittaker, Walter Leslie. 'The Canada Council for the Encouragement of the Arts, Humanities, and Social Sciences: Its Origin, Formation, Operation, and Influence upon Theatre in Canada, 1957–63.' PhD dissertation, University of Michigan, 1965.

Williams, Raymond. *Culture and Society, 1780–1950.* London: Chatto and Windus, 1958.

— *Keywords: A Vocabulary of Culture and Society.* First pub. 1983. Rev. ed. London: Fontana Press, 1988.

Woodcock, George. *Strange Bedfellows: The State and the Arts in Canada.* Vancouver: Douglas and McIntyre, 1985.

Zemans, Joyce. 'Envisioning Nation: Nationhood, Identity and the Sampson-Matthews Silkscreen Project: The Wartime Prints.' *Journal of Canadian Art History / Annales d'histoire de l'art canadien* 19, no. 1 (1998), 6–47.

Vincent Massey on Education and the Arts

n.d. Address. [on Canadian universities]). MFamP, speech 5.

11 Nov. 1919. *Order of Proceeding at the Presentation to the University [of Toronto] of Hart House by the Massey Foundation and the Formal Opening of the Building by His Excellency, the Duke of Devonshire.* Pamphlet. VMP, 133/01.

Oct. 1922. 'Address to the Ministers and Deputy Ministers of Education of Canada.' Conference on Education, Toronto. MFamP, speech 7.

Oct.–Dec. 1922. 'The Prospects of a Canadian Drama,' *Queen's Quarterly* 30: 194–212.

c. 1923–6. 'Education and Nationality.' Address to the Rotary Club, n.d. MFamP, speech 9.

March 1923. 'The Place of the Canadian University in the Community.' Address to the Canadian Club, Montreal. VMP. Synopsis in *University of Toronto Monthly* (April 1923).

4 April 1923. Address. National Conference on Education and Citizenship, Toronto. MFamP, speech 10.

26 Jan. 1924. 'Some Canadian Problems.' Address to the Canadian Club of Ottawa. MFamP, speeches 10A and 12.

10 Oct. 1924. 'The University and the College.' Address on Charter Day Convocation, Victoria College. MFamP, speeches 13 and 50.

April 1926. Address. National Conference on Education and Citizenship, Montreal. MFamP, speech 25.

1926–7. *Canadian Plays from Hart House Theatre.* Vincent Massey, ed. 2 vols. Toronto: Macmillan.

6 June 1927. 'The College and the Community.' Address at the annual commencement of Swarthmore College, Pennsylvania. VMP. Reprinted in Vincent Massey, *Good Neighbourhood and Other Addresses in the United States.* Freeport, NY: Books for Libraries Press, 1930; Essay Index Reprint Series, 1969. 61–71.

22 Feb. 1928. 'Education and the Balanced Life.' Address on Commemoration Day, Johns Hopkins University, Baltimore. Reprinted in Vincent Massey, *Good Neighbourhood and Other Addresses in the United States.* Freeport, NY: Books for Libraries Press, 1930; Essay Index Reprint Series, 1969. 111–26.

23 March 1928. 'The University and the International Mind.' Address on the 60th anniversary of the founding of the University of California, Berkeley.

Reprinted in Vincent Massey, *Good Neighbourhood and Other Addresses in the United States.* Freeport, NY: Books for Libraries Press, 1930; Essay Index Reprint Series, 1969. 141–63.

1928. 'The Masseys in Canada.' VMP, 119/06.

[1929]. Address. On the occasion of the 100th birthday of Upper Canada College, Toronto. VMP, 60.

10 Jan. 1929. 'The Colleges of Canada.' Address to the Association of American Colleges, Chattanooga, Tenn., VMP. Reprinted in *School and Society* 29, no. 743 (1929). MFamP, speech 45.

1 Feb. 1929. Address at the opening of the Toronto Chapter Exhibition of Architecture and Allied Arts at the Art Gallery of Toronto. MFamP, speech 46. Reprinted *Journal, Royal Architectural Institute of Canada*, Ser. 42, vol. 6, no. 2: 37–9.

April 1929. Address. Jefferson Day, University of Virginia. VMP.

23 April 1929. 'The Arts and Nationality.' Address to the American Academy of Arts and Letters on its twenty-fifth anniversary, New York. Reprinted in Vincent Massey, *Good Neighbourhood and Other Addresses in the United States.* Freeport, NY: Books for Libraries Press, 1930; Essay Index Reprint Series, 1969. 264–73.

8 Nov. 1929. Address. Founder's Day, Mount Holyobke College, South Hadley, Mass. VMP, 45/5.

16 May 1930. Address. American Federation of Arts, Washington, DC. MFamP, speech 53.

22 May 1930. 'Art and Nationality in Canada.' Address to the Royal Society of Canada, Montreal, MFamP, speech 51; and VMP, 46/16. Reprinted in *Proceedings and Transactions of the Royal Society of Canada*, 3rd ser., 24 (1930), (Appendix B), 59–72.

[1930–5?] 'The Other Canada.' Handwritten book outline loose in Massey's diary. VMP

24 April 1933. Address. Opening night at the Dominion Drama Festival. Cited in Lee, *Love and Whisky*, 114.

4 Feb. 1938. Address. Royal Scottish Society of Painters in Water-Colours on the occasion of the opening of the annual exhibition, Edinburgh. VMP and MFamP, speech 131.

14 Oct. 1938. Address. Opening of *A Century of Candian Art* exhibition at the Tate Gallery, London. MFamP, speech 137, and VMP, 170.

7 Feb. 1939. Notes for an address to the Oxford Art Club. MFamP, speech 141.

7 April 1943. Address. Opening of the John Piper murals at the Morden British Restaurant. VMP, 258/08.

21 June 1945. Address. National Art-Collection Fund. VMP, 192. Reprinted as 'Foreword' in *Exhibition of Canadian War Art.* Ottawa: National Gallery of Canada, 1946.

30 May 1947. Address. American Association of Museums, Quebec. NGCA, 9.2M Trustees: Vincent Massey, file 2.

1948. *On Being Canadian.* Toronto: J.M. Dent and Sons.

[c. 1950]. 'Some Notes on Education.' MFamP, speech 172.

1963. *What's Past Is Prologue: The Memoirs of Vincent Massey.* London: Macmillan.

[1966–7]. 'Postscript.' Uncompleted book manuscript. MFamP.

[1966–7]. 'V. M. on Art, Sculpture, Architecture.' Excerpt from 'Postscript.' MFamP.

Index